OVER™
CANADA

AN AERIAL ADVENTURE

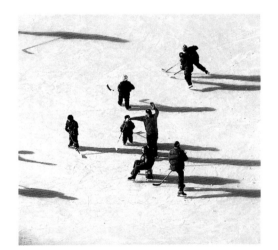

OVER CANADA

AN AERIAL ADVENTURE

Principal Photographer:

RUSS HEINL

Written and edited by:

ROSEMARY NEERING

BRUCE OBEE

BEAUTIFUL
BRITISH COLUMBIA

OVER CANADA
AN AERIAL ADVENTURE

Editor: BRYAN MCGILL
Project Editors and Writers: ROSEMARY NEERING, BRUCE OBEE
Principal Photographer: RUSS HEINL
Photo Editor: TONY OWEN
Designer: KEN SEABROOK
Photo Co-ordinator: LYNN GREEN
Copy Editor: ANITA WILLIS
Maps by: DENNIS AND STRUTHERS VISUAL COMMUNCIATIONS
French translation by: JEAN-GUY DUGUAY
Editorial Assistants: NICOLE OBEE, JOEL SCHAEFER

Publisher: ROBERT HUNT
Assistant to the Publisher: PAUL GRESCOE
Creative Consultant: GARY MCCARTIE

Contributing Photographers:
WAYNE BARRETT, MIKE BEEDELL, SPIKE BELL, ADRIAN DORST, JOSEPH DUFF, PIERRE DUNNIGAN, BARRY FERGUSON, GORDON J. FISHER, GAÉTAN FONTAINE, JANET FOSTER, RON GARNETT, GARY GREEN, PATRICE HALLEY, AL HARVEY, PHIL HOFFMAN, WOLF KUTNAHORSKY, MATHIEU LAMARRE, GUY LAVIGUEUR, LESLIE LEONG, RANDY LINCKS, WAYNE LYNCH, GRAHAM OSBORNE, TERRY A. PARKER, ROBERT SEMENIUK, KAREN SMITH, ROY TANAMI, TOM THOMSON, HARVEY THORLEIFSON, WAYNE TOWRISS, DOUGLAS E. WALKER, GLEN WILLIAMS.

Photo Agencies:
IMAGE NETWORK, LONE PINE PHOTO, MASTERFILE, SPECTRUM STOCK, URSUS PHOTOGRAPHY
Russ Heinl is represented by Image Network Inc., 16 East 3rd Ave., Vancouver, B.C., V5T 1C3; 1-888-511-3939;
e-mail: info@imagenetworkinc.com

For their contribution of knowledge and time to this project, the *Over Canada* team thanks
MICHAEL BURZYNSKI, SILVER DONALD CAMERON, LESLEY CHRISTIAN, LORI DALTON, NICK DESMARALS, JON DEVANEY, CAROL HENNESSY, KIRK HENDERSON, RUTH HEYES, ROB HINGSTON, LAURA JACKSON, ROBIN KARPAN, CATHY LEACH, SANDI LEE, KATHE LIEBER, NORTON LUCYK, WAYNE LYNCH, ALICIA MALUTA, JULIA MATUSKY, MICHAEL O'REILLY, EARL SCHMIDT, MICHAEL SCHMIDT, JENNIFER SMIDT, DR. IAN STIRLING, HARVEY THORLEIFSON, CHRISTY VODDEN AND THE GEOLOGICAL SURVEY OF CANADA, CHERYL WARD, JULIE WATSON, AND JOHN WEIER.
We are grateful to the helicopter pilots who contributed their patience, local knowledge, and professionalism
to the taking of the photographs in this book.

The Over Canada project is the Royal Bank Financial Group's *Millennium Tribute* to the people of Canada.

The Over Canada project is produced by Beautiful British Columbia and Over Canada Productions Inc., divisions of The Jim Pattison Group of Vancouver, B.C., and Gary McCartie Productions and KCTS Television.

Special thanks to John Thomson and Mel Cooper for getting *Over Canada* off the ground, and to Parks Canada/Parcs Canada for all their help.

BEAUTIFUL BRITISH COLUMBIA
Ste. 301, 1401 West 8th Ave.,
Vancouver, B.C., V6H 1C9 (604) 669-8755

Printed on Luna 100 lb. paper and bound in Canada by Friesens, Altona, Manitoba

Colour separations and film in Canada by WYSIWYG Prepress, Vancouver, B.C.

Distributed in Canada by Whitecap Books, Vancouver and Toronto.

To order copies of this book call
1-800-663-7611 in Canada or the U.S.
250-384-5456 worldwide.
Fax: 250-384-2812
E-mail: **orders@beautifulbc.ca**
Visit us on the World Wide Web:
www.beautifulbc.ca

Canadian Cataloguing in Publication Data
Heinl, Russ, 1949-
Over Canada
Includes index. ISBN 0-920431-87-9 (bound) — ISBN 0-920431-91-7 (pbk.)

1. Canada—Pictorial works. I. Neering, Rosemary, 1945- II. Obee, Bruce, 1951- III. Beautiful British Columbia Magazine (Firm) IV. Title.
FC59.H44 1999 971.064'8'0222 C99-910665-1
F1017.H44 1999

front cover:

British Columbia's Mount Assiniboine is part of the Canadian Rocky Mountain Parks World Heritage Site. RUSS HEINL

opposite:
The sheer limestone cliffs at Quebec's Cape Gaspé rise to 130 metres near the mouth of the St. Lawrence River. RUSS HEINL

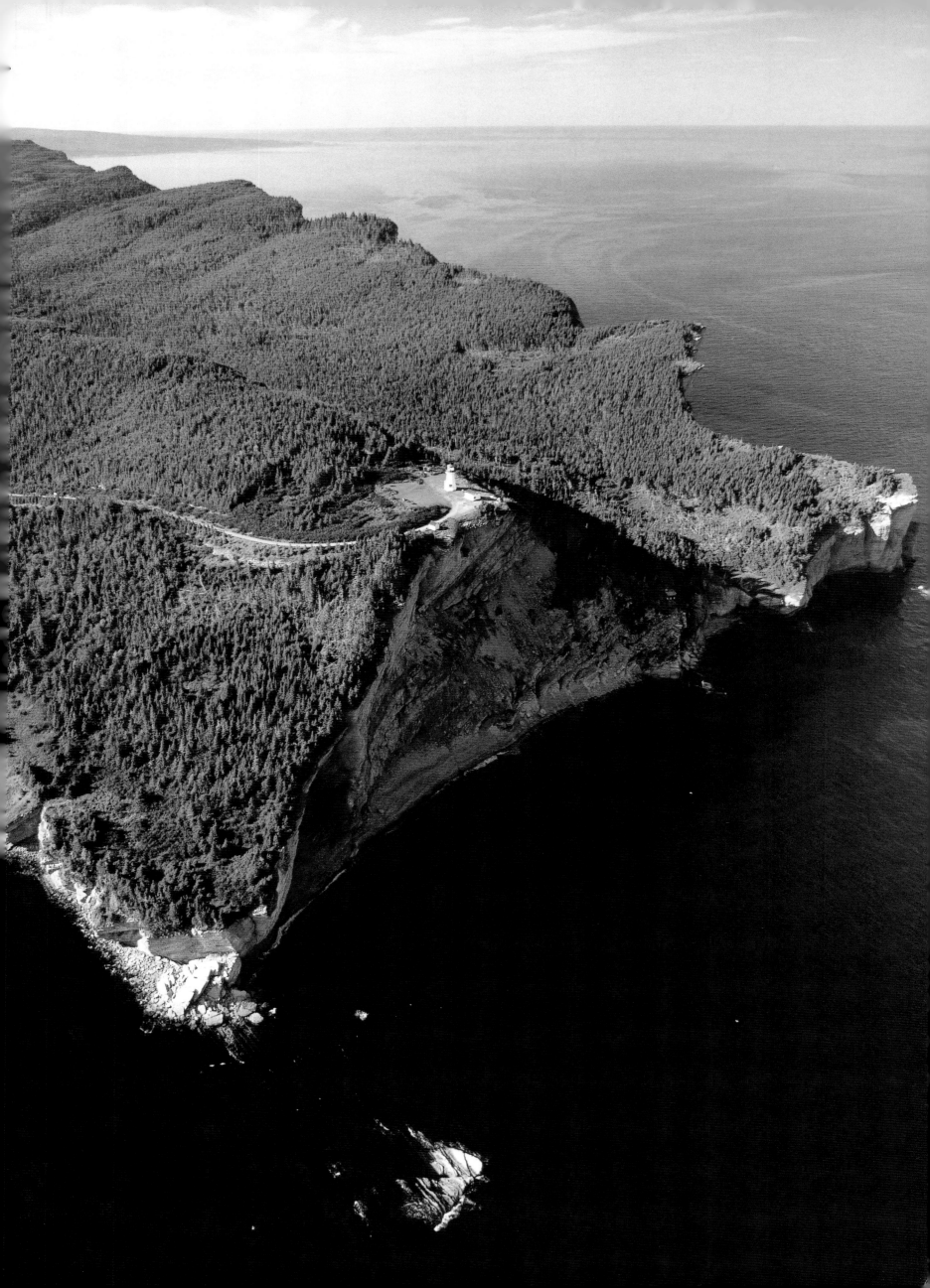

CONTENTS

AN AERIAL

ADVENTURE

AN AERIAL ADVENTURE
REVEALING CANADA'S ESSENCE

previous pages:

The flat, squared peninsula of West Point, at Prince Edward Island's southwest corner, is surrounded by water turned red by sandstone sediments. Red water occurs when winds drive waves onto the land. When the waves retreat, they carry the suspended sediments with them.
RON GARNETT/BIRDS EYE VIEW

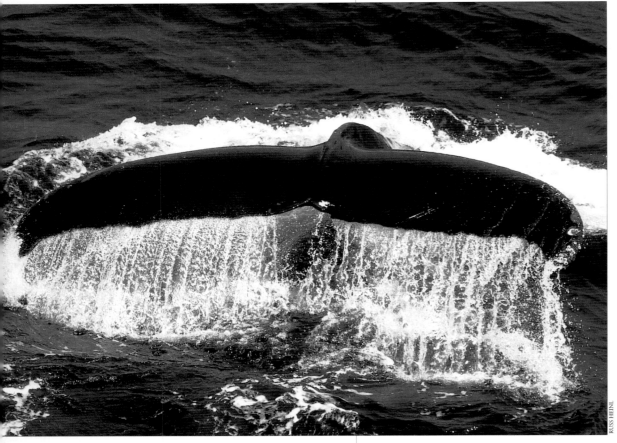

above:

A humpback whale hoists its ponderous flukes up from the sea off Newfoundland. Like West Coast humpbacks, these leviathans fatten up in northern feeding waters during summer before returning to breed in the subtropics during winter.

opposite:
The pedestrian village at Mount Tremblant, in Quebec's Laurentian Mountains north of Montreal, contains seven hotels and some 70 shops. The four-season resort is best known for its skiing and it has the longest vertical descent in Eastern Canada. RUSS HEINL

The auburn glow of sunset in the Rockies. Contoured crops on the Prairie as neat as lines on a page. A lighthouse beaming from a wind-worn cape across Atlantic, or Pacific, or Great Lakes waters. Scenes that portray Canada to the world: each is inspiring, yet none is definitive, for no single image can define a country whose essence is diversity and size.

When *Over Canada* photographer Russ Heinl set off on his *Aerial Adventure* he had no illusions about capturing the quintessential image. His mission was to reveal the essence, to bring back a portfolio that left little doubt about the variety and vastness of the Canadian landscape. And his challenge was to surprise us, to lift us from the ground and show us the country from its most dramatic perspective — looking down from the height of an eagle, or a helicopter.

A seasoned national and international traveller, Heinl confirmed with this cross-country assignment what he'd always suspected: there's no place like home. "We have the wildest mountains and most rugged coastlines; we have rainforests, deserts, volcanoes, and icebergs. That list alone touches every corner of the Earth."

From the tidy symmetry of furrowed fields to the abstract chaos of subarctic muskeg, the Canadian landscape is a collage of visual patterns, each as distinct as the next. Many are seasonal: summer break-up in the Arctic, the explosion of autumn colours in the Laurentians, the stark black-and-whites of winter. Others are ancient, the products of natural forces that lifted mountains, carved out glacial valleys, and eroded river corridors deep into the nation's heartland.

More recent patterns on the land are manmade: houses and summer cottages clustered on the lakes and seashores, cities spilling into the forests and farmlands of southern Ontario and southwestern British Columbia, and 1.4 million kilometres of roads and highways fanning out to all but the most isolated communities.

Accustomed to watching the world from ground level, we are easily disoriented by the aerial view. Familiar scenes become strange as whole countrysides are compressed into a single photographic frame. Buildings and mountains are diminished or magnified at the photographer's whim. Scale and angles, light and shadows, are manipulated by simple changes in direction or altitude. Colours and textures — and those pervasive patterns — are more vividly delineated, giving a fresh perspective to everyday places around us.

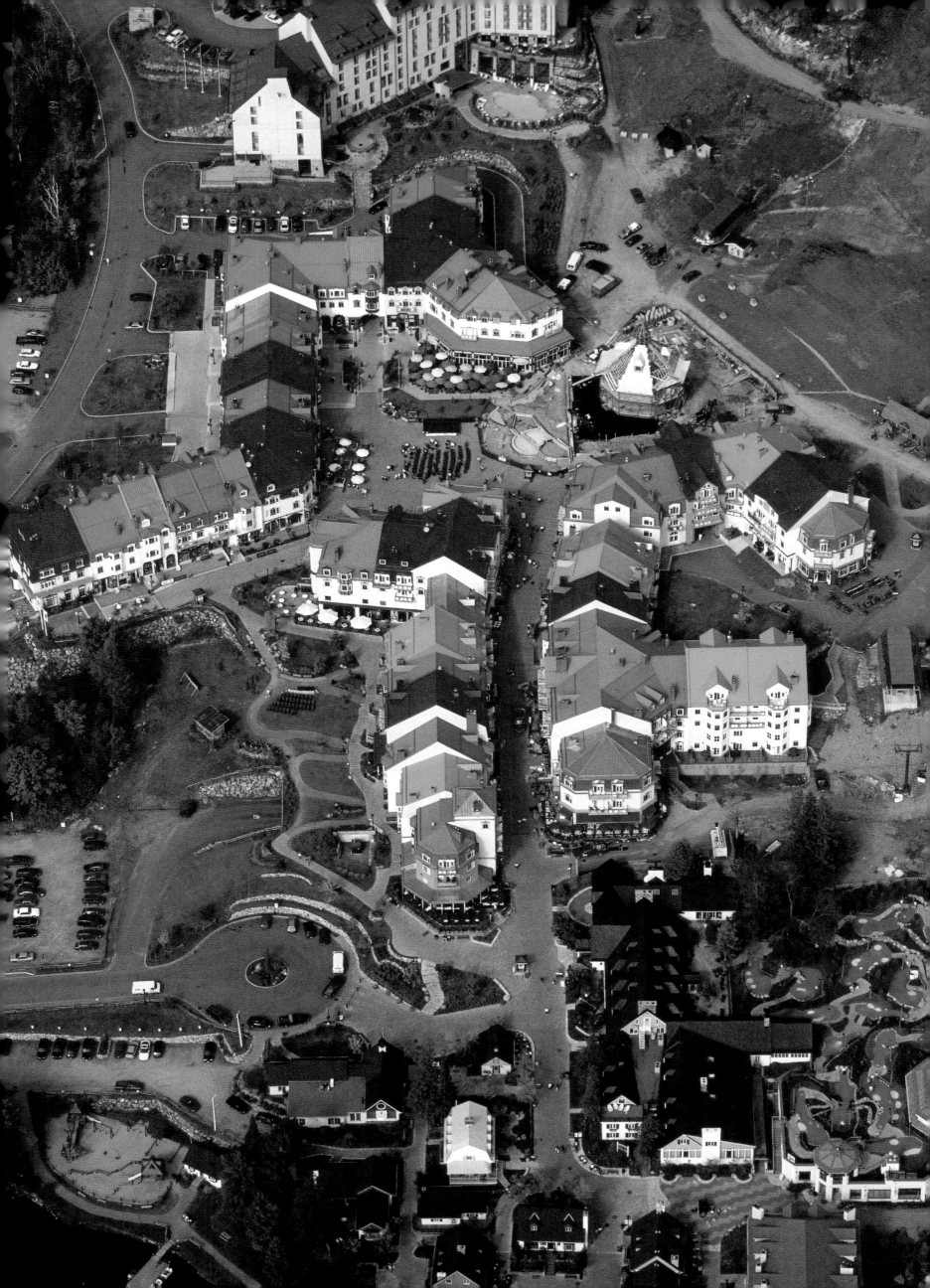

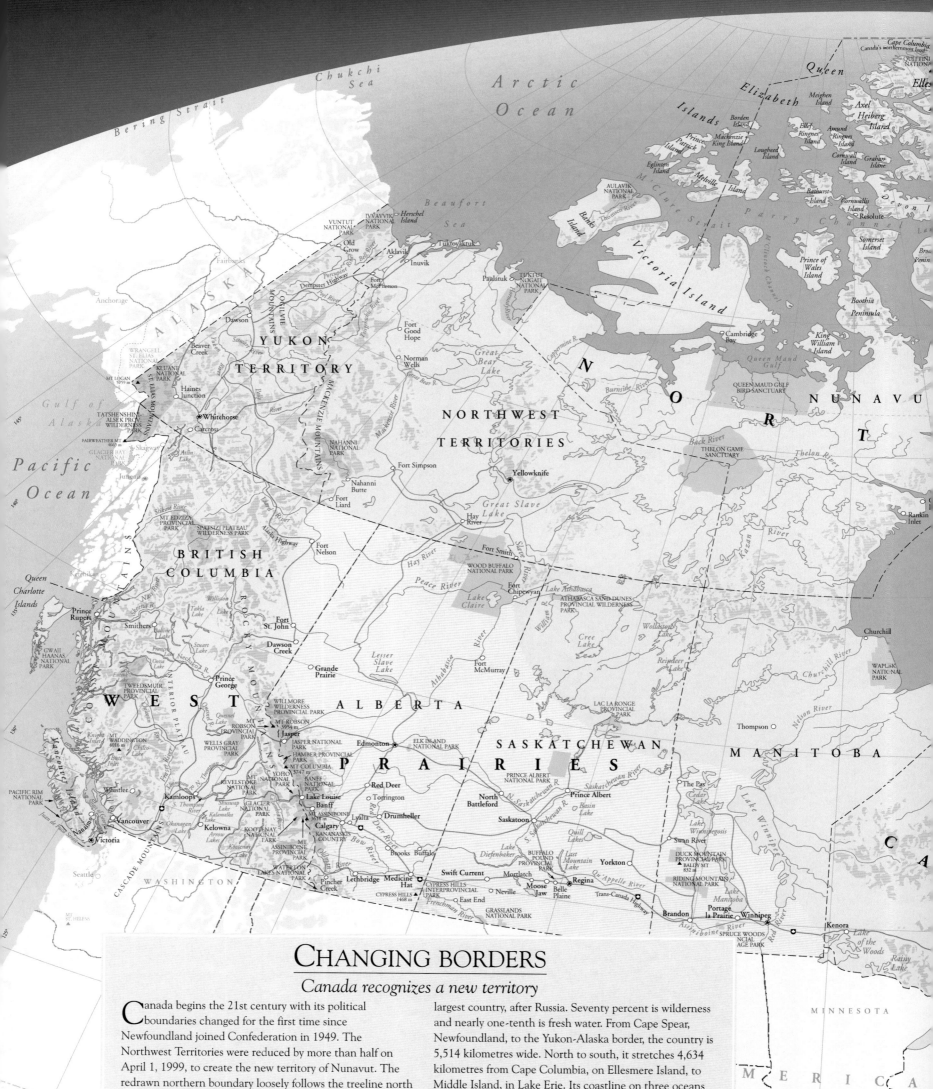

CHANGING BORDERS

Canada recognizes a new territory

Canada begins the 21st century with its political boundaries changed for the first time since Newfoundland joined Confederation in 1949. The Northwest Territories were reduced by more than half on April 1, 1999, to create the new territory of Nunavut. The redrawn northern boundary loosely follows the treeline north of the Prairie provinces, taking in most of the Arctic islands and eastern mainland above 60 degrees north.

Canada's three northern territories and 10 provinces cover 9,970,610 square kilometres, making it the second-largest country, after Russia. Seventy percent is wilderness and nearly one-tenth is fresh water. From Cape Spear, Newfoundland, to the Yukon-Alaska border, the country is 5,514 kilometres wide. North to south, it stretches 4,634 kilometres from Cape Columbia, on Ellesmere Island, to Middle Island, in Lake Erie. Its coastline on three oceans totals 243,791 kilometres, the longest in the world.

At last count, 30,300,400 people were living in Canada. It is a multicultural country, in which more than 100 languages are spoken.

WHERE CANADIANS LIVE

Provinces, territories, and capitals

Newfoundland and Labrador: 405,720 sq. km.; pop. 544,400; St. John's.
Nova Scotia: 55,490 sq. km.; pop. 934,600; Halifax.
Prince Edward Island: 5,660 sq. km.; pop. 136,400; Charlottetown.
New Brunswick: 73,440 sq. km.; pop. 753,000; Fredericton.
Quebec: 1,540,680 sq. km.; pop. 7,333,300; Quebec City.
Ontario: 1,068,580 sq. km.; pop. 11,411,500; Toronto.
Manitoba: 649,950 sq. km.; pop. 1,138,900; Winnipeg.
Saskatchewan: 652,330 sq. km.; pop. 1,024,400; Regina.
Alberta: 661,190 sq. km.; pop. 2,914,900; Edmonton.
British Columbia: 947,800 sq. km.; pop. 4,009,900; Victoria.
Nunavut: 1,994,000 sq. km.; pop. 27,200; Iqaluit.
Northwest Territories: 1,299,070 sq. km.; pop. 40,300; Yellowknife.
Yukon: 483,450 sq. km.; pop. 31,700; Whitehorse.

"When you go up in the air, what you see is no longer what is in front of you, it's what's below," observes Montreal photographer Guy Lavigueur, one of several contributors whose work complements the *Over Canada* collection. "The patterns and shapes and colours you see from the air are very different from the ones you see on the ground. It's like a big ball below you, and it rolls very fast."

Colour film and aerial photography are 20th-century phenomena. If there'd been aerial cameras in 1900 they would have documented a much different Canada from the one we see today. A hundred years ago, two-thirds of the country's 5.4 million residents lived in rural areas; now, three-quarters of our 30.3 million people live in towns and cities, almost all within a two-hour drive of the American border. One-third of our population lives in the largest urban centres: Toronto, Montreal, and Vancouver.

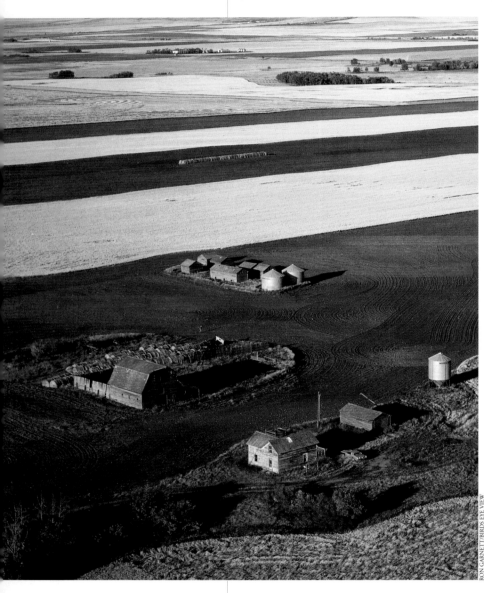

The changes recorded by the aerial camera, however, go far beyond our urbanization. A hundred years ago, much of southern Ontario and the St. Lawrence Valley had been logged and put to the plough, but the boreal forests of the Canadian Shield and the rainforests of the West Coast were still largely intact. Saskatchewan and Alberta were yet to become provinces, and untouched expanses of natural grassland stretched beneath the Prairie sky. The North was virtually unknown to non-aboriginals, and the cod were plentiful on Newfoundland's Grand Banks.

RON GARNETT/BIRDS EYE VIEW

above:

An old farm sits on the Alberta prairie southeast of Calgary, near the community of Vulcan, named in 1910 by the Canadian Pacific Railway after the Roman god of fire and metalworking.

Today, East Coast fishboats are tied to the docks and a ghostly quiet lingers over many villages. Only a few patches of the original Prairie grasslands have escaped the farmer's plough, and clearcuts in the New Brunswick interior, in northern Ontario and Quebec, and across B.C. testify to a voracious forest industry. Mounds of mine tailings litter isolated pockets of the northern outback, and sprawling reservoirs appear behind manmade dams.

Today's aerial pictures also portray a country in transition as photographers catch historic icons that are disappearing from the landscape. Brightly painted grain elevators — splashes of colour in the midst of the bald-headed Prairie — are becoming obsolete and being torn down. Railways that figured so prominently in Canadian Confederation continue to lose ground to highways and airways.

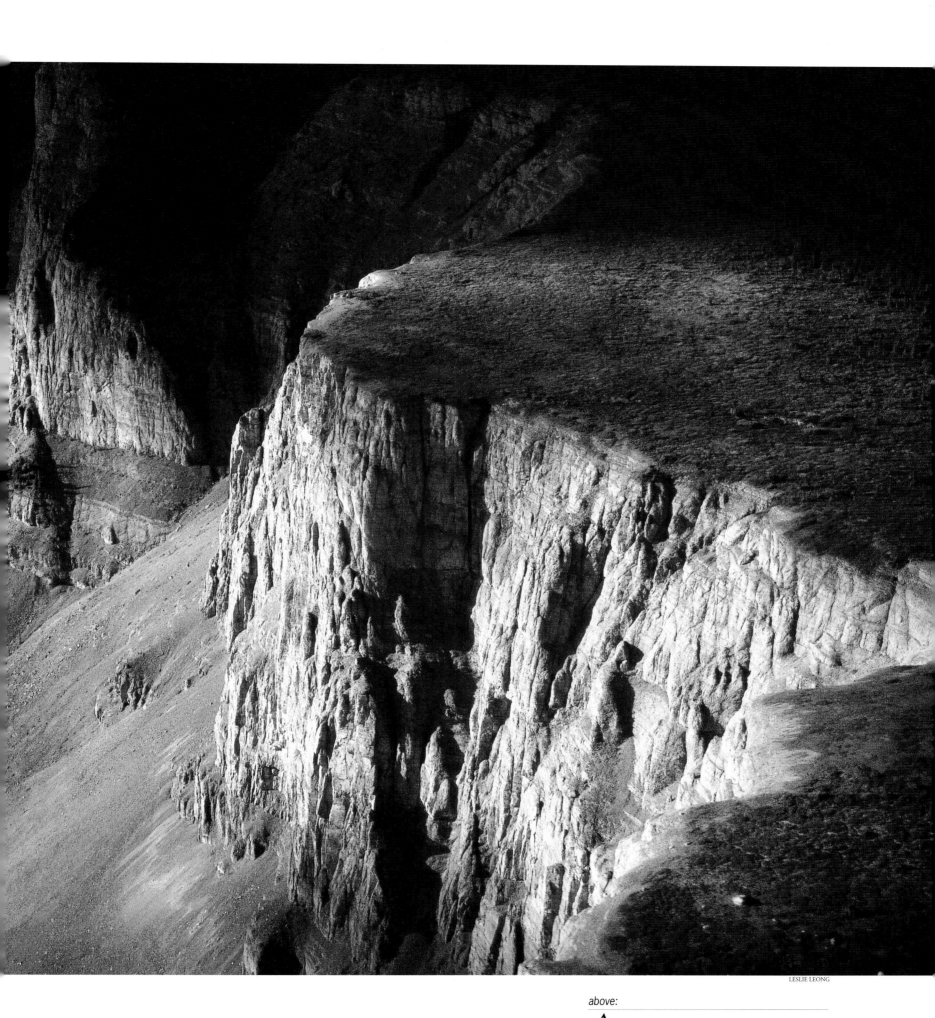

LESLIE LEONG

above:

Alpine tundra blankets the top of Ram
Plateau, 40 kilometres north of Nahanni
National Park in the Northwest Territories. The
scenery here, with plunging canyons and
whitewater rivers, is typical of that found within
the 4,765-square-kilometre park reserve,
established in 1976.

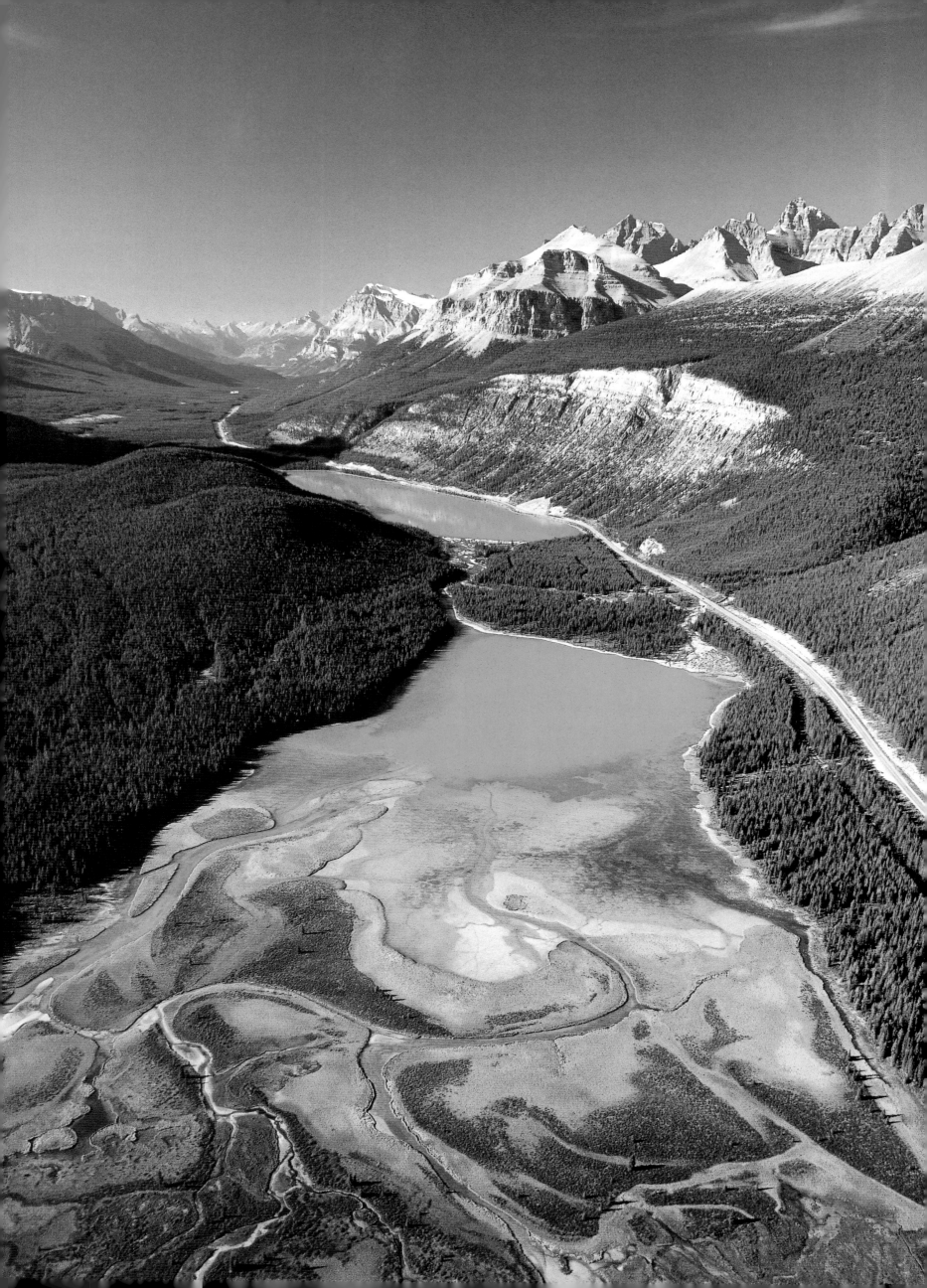

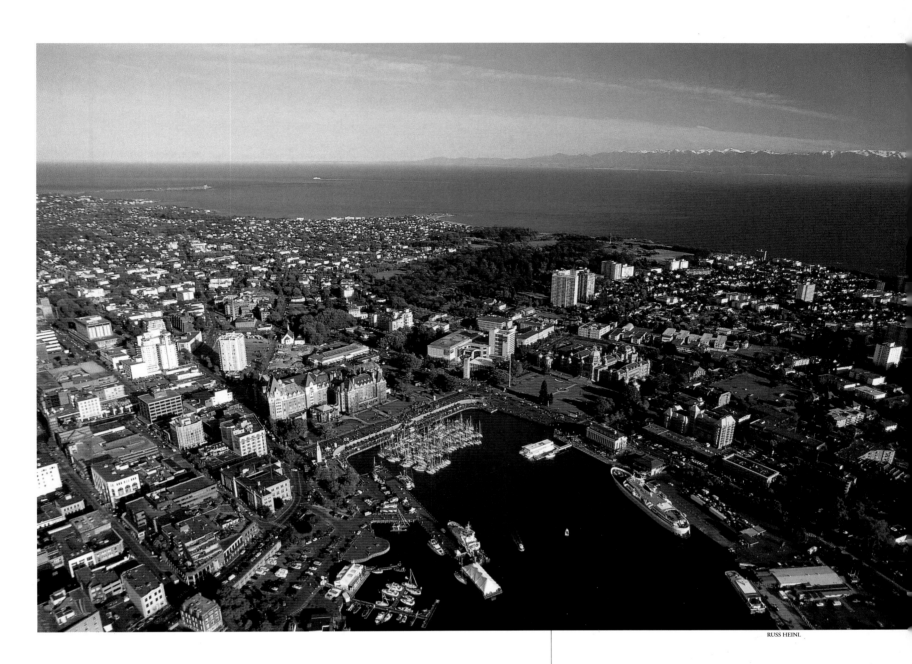

RUSS HEINL

Yet elemental Canada has not been lost in these changes. "More and more people would like to go where humans have not yet destroyed the Earth, and Canada is imagined to be one of those places," wrote David Plante, a U.S. novelist of Canadian ancestry, in 1998. Though we have cities of several million people, Canada remains one of the world's most sparsely populated nations. Seventy percent of the country is still wilderness, with little sign of human settlement. There are places unexplored, unnamed, and unbelievably wild.

That sense of wilderness runs deep in our national psyche. Though comparatively few Canadians venture far beyond the cities and roadways, the intrinsic value of our forests and seashores, our fresh water and wildlife, is recognized nationwide. The great diversity of landscapes that distinguishes Canada from all other places is the soul of the nation, and those who live here are increasingly adamant about its protection.

Change is inevitable, but there's a permanence in the true essence of a country. The global perception of Canada as a land of wilderness and opportunity is unchanged since the last time we rang in a new century. And while the definitive image of Canada is more elusive than the Canadian identity, principal photographer Russ Heinl, and others who have contributed to *Over Canada*, continue their quest nonetheless. ❦

above:

*T*he stately Empress Hotel, the Parliament Buildings, and other architectural landmarks surround Victoria Harbour, the hub of British Columbia's capital city. Washington's Olympic Mountains appear in the background across Juan de Fuca Strait.

opposite:
Waterfowl Lakes, north of Lake Louise, are a widening of the Mistaya River along the Icefields Parkway in Alberta's Banff National Park. Encompassing 6,641 square kilometres of Rocky Mountain scenery, Banff is Canada's first national park, established in 1885. RUSS HEINL

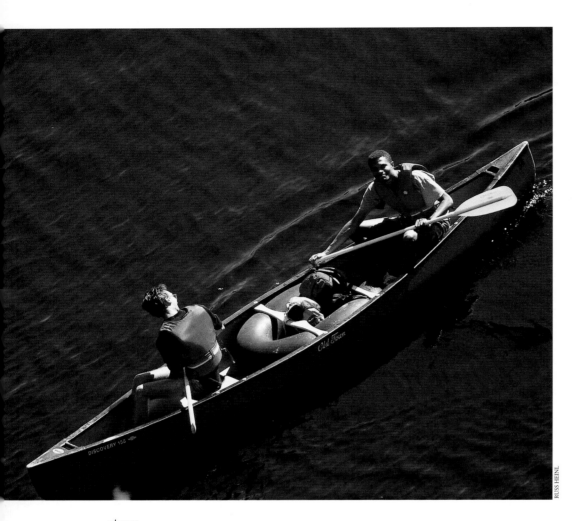

RUSS HEINL

above:

*I*f a quintessential Canadian image exists, this is it: canoeists on a river in the summer sunshine.

previous pages:
Hot-air balloons float above Gatineau, across the Ottawa and Gatineau rivers from Ottawa and Hull. Held in the first weekend in September, the four-day Gatineau Hot Air Balloon Festival attracts more than 100 balloons and features concerts, fairgrounds, and fireworks. PIERRE DUNNIGAN

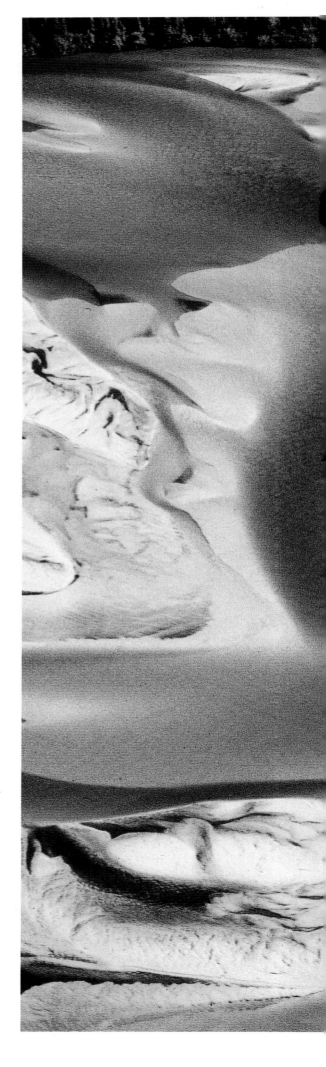

right:

*T*he braided riverbed of the William River delta near Lake Athabasca in northern Saskatchewan is patched with the cream, copper, and deep brown of sandbars and river water.

following pages:
Sunset turns Yarmouth Bar golden. The bar and spit reach out into the Atlantic in southwest Nova Scotia. Yarmouth is both a major port for the lobster fishery and the terminus for ferry traffic from Maine.
BARRETT AND MACKAY

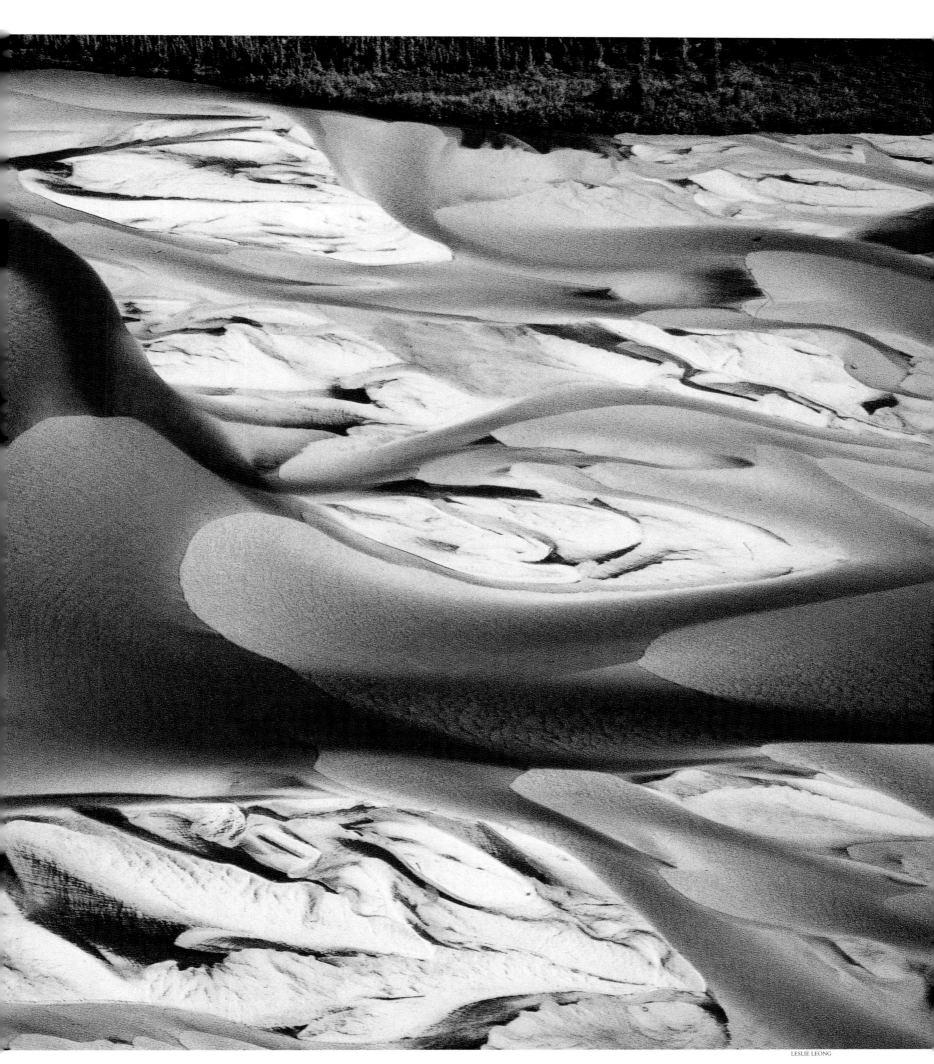

LESLIE LEONG

ATLANTIC
CANADA

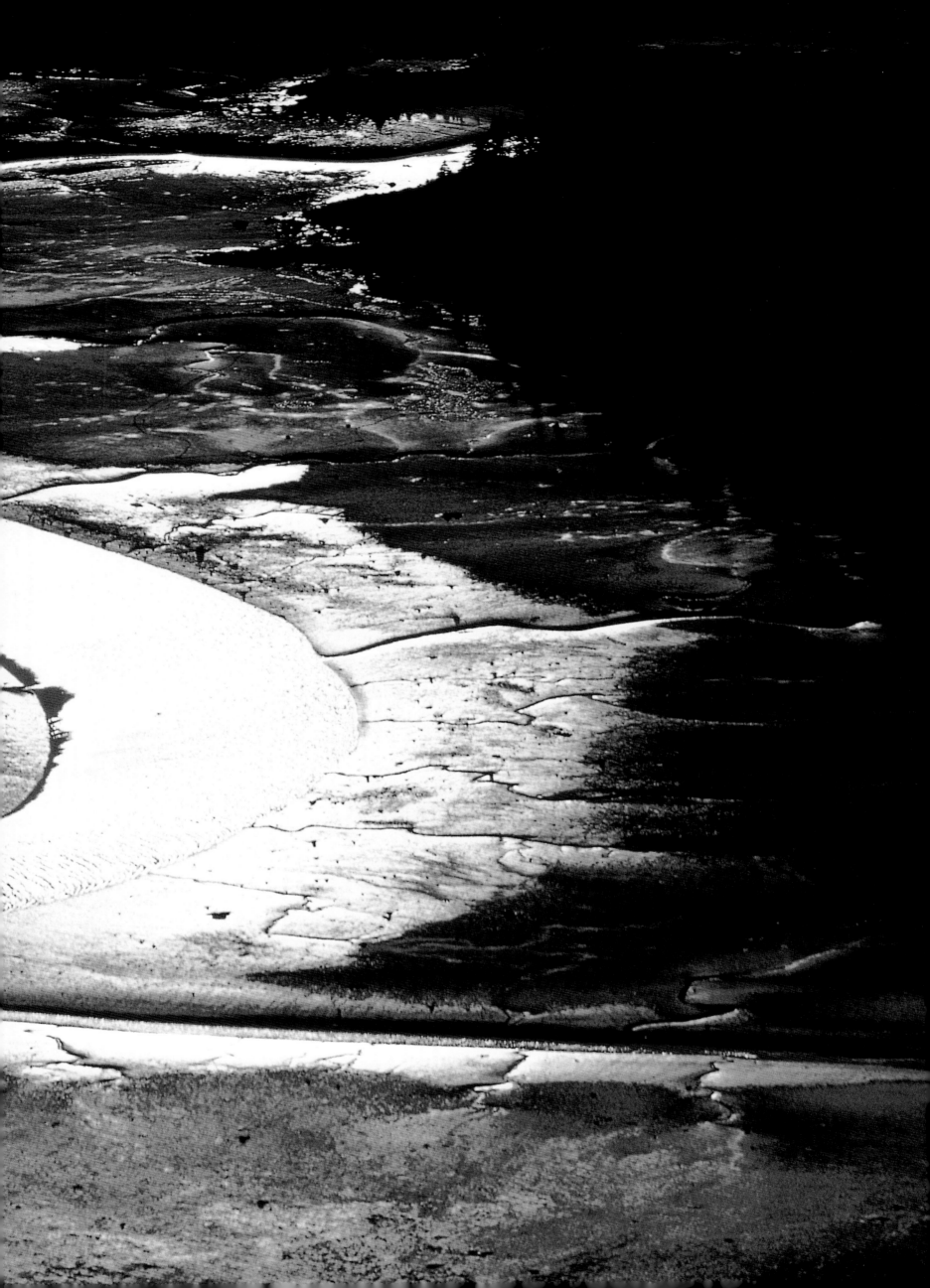

ATLANTIC CANADA
A COASTAL WORLD OF CONTRASTS

The view from above the northwestern edge of the Atlantic Ocean is daunting: harsh stripes of grey and black stone, scantily topped by low grass or windswept tuckamore anchored in thin soil. The people of Newfoundland call their home The Rock, and no more fitting name could apply to the visage the island presents to those looking down from the air.

Some might call this landscape bleak. Others, both native Newfoundlanders and "come-from-aways," call it magnificent and elemental, and are entranced by its strength.

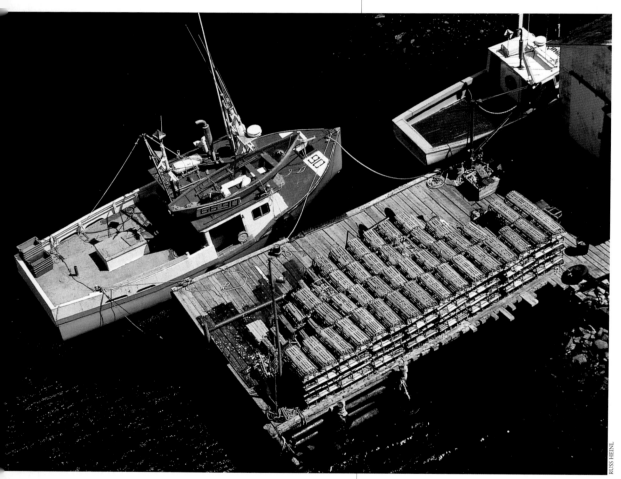

Newfoundland is Canada farthest east, with Ireland just 3,000 kilometres across the North Atlantic. Sweep southwest from this formidable island, across the Gulf of St. Lawrence — invitingly blue on the clearest days, fog-ridden and fearsome on many others — and you will look down upon the contrasts that exemplify Atlantic Canada. Nova Scotia from the air is all contrast, the craggy Cape Breton highlands dipping into the lake-strewn interior, the rocky south shore, and the farmlands and red tidal flats of the Bay of Fundy basin. Over Prince Edward Island, the depth and colour of the sea, the dunes, and the farm fields overwhelm, so that mere green, blue, red, and white seem quite inadequate terms. The aerial view summons up such words as cerulean and sapphire, emerald, garnet, and shining iridescent opal. To fly over New Brunswick is to see a rectangle of forest, edged with an embroidery of river valley and seacoast.

Three ancient, violent, and unimaginably slow geological events moulded the landscape of Atlantic Canada. Between 500 and 350 million years ago, tectonic plates collided, creating the continent of Pangaea, and thrusting the Appalachian Mountains up out of the Earth. The greatly eroded remains of this ancient collision form the uplands of Nova Scotia, New Brunswick, and Newfoundland; the soil from this erosion lies at the base of Prince Edward Island. Still eons ago, the massive continent of Pangaea broke apart, creating the Atlantic Ocean and the continents that rim the Atlantic today. Closer to historical time, the glaciers moved across the region, then retreated, carving valleys and inlets, removing soil and depositing sediment, giving the Atlantic region the form we recognize today.

above:

Boats lie alongside a dock in Louisbourg, Nova Scotia, on Cape Breton Island's south coast, the site of an historic fort built by the French in 1713 and captured by the British in 1758.

opposite:
The Cape Bonavista lighthouse, atop the stark and jagged rocks of Bonavista's cliffs, has warned seafarers of the dangers off Newfoundland's east coast since 1843. RUSS HEINL

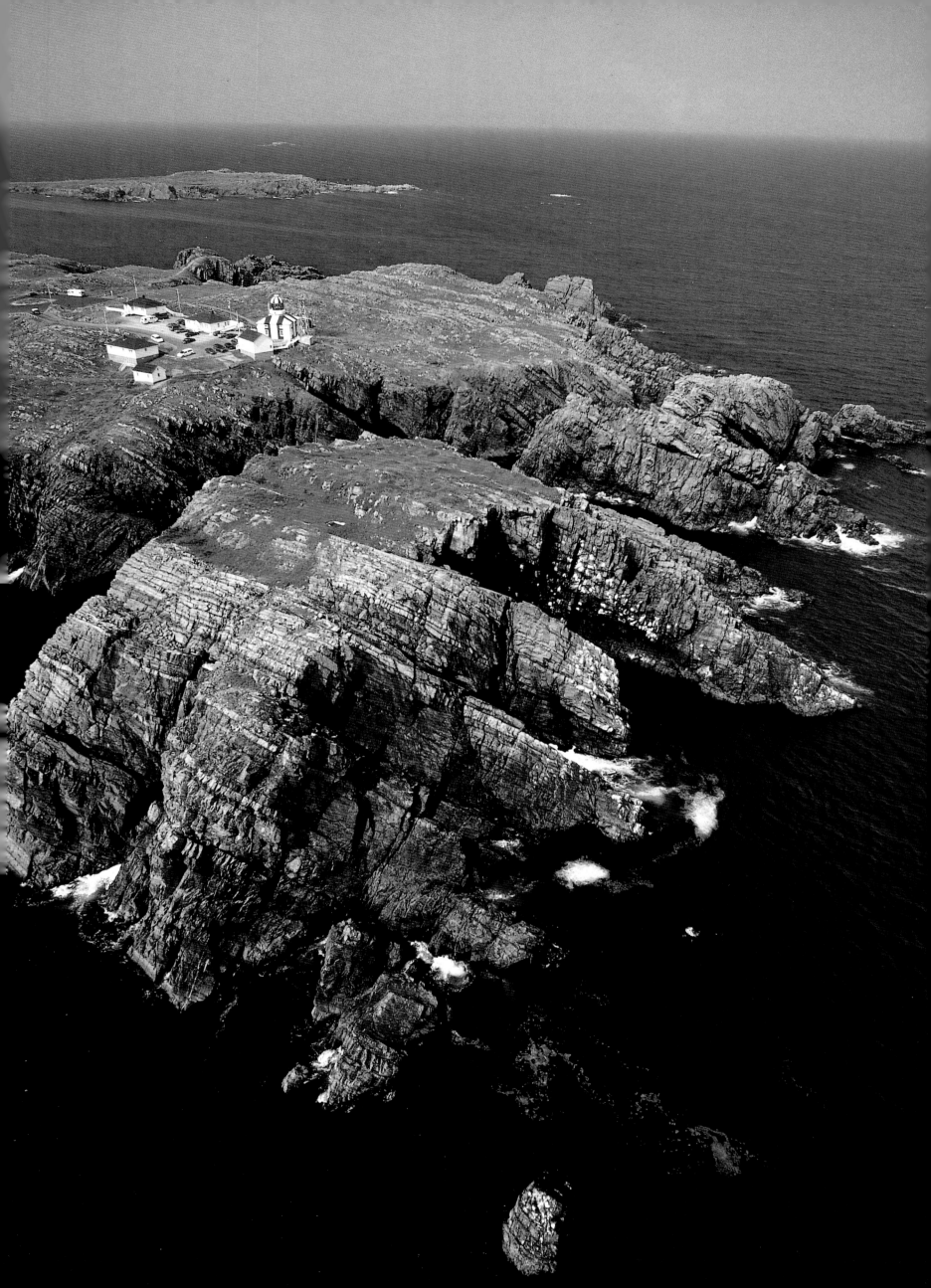

The angled rocks that make the Newfoundland coastline so nakedly rugged are a product of these great events, as are the worn-down mountains of northern New Brunswick and the steep cliffs of Nova Scotia's Cape Breton Island. When you cross from Newfoundland's Avalon Peninsula to the rest of the island, the landscape change is evident — and explicable, for both the Avalon and parts of Nova Scotia were once part of ancient Africa and Europe, left glued to North America when Pangaea broke apart. And the forces of geological evolution are never-ending: the Atlantic Ocean continues to widen and erosion constantly reshapes Atlantic coasts.

above:

*F*arm fields and apple orchards lie below Blomidon Look-Off in Nova Scotia's fertile Annapolis Valley.

Also strongly visible from above are the patterns of settlement in Atlantic Canada, dominated by villages, towns, and cities that fringe the sea. "It struck me," observed the narrator of Wayne Johnston's *Colony of Unrequited Dreams* as he traversed Newfoundland in the 1920s, " . . . that virtually the whole population lived on the coast, as if ready to abandon ship at a moment's notice." Living beside and from the sea here dates as far back as the earliest of Atlantic native cultures, thousands of years ago. In later times, the Beothuk, now extinct, ranged forth from the coasts of Newfoundland in their distinctive bark canoes, fishing and hunting sea mammals; the Mi'kmaq roamed much of the rest of coastal Atlantic Canada, harvesting fish, seals, and crustaceans from the ocean waters.

Wandering Vikings established temporary settlements on the coast of Newfoundland in the 10th century. Sixteenth-century European fishermen thronged to the Gulf of St. Lawrence and the Grand Banks, and came ashore to dry and salt their fish. Year-round settlements established by the fishermen continued the pattern, which took on a new but still seaward-looking face when the French settled the shore of Acadia along the Bay of Fundy, and were followed by successive waves of English, Scottish, German, Dutch, and United Empire Loyalist settlers. Seaside settlement then thrived with the expansion of the fisheries and the growth of Maritime port traffic.

Confederation forced Maritimers, and later Newfoundlanders, to look landward. Now, as the 21st century begins, the fishery has foundered, and towns and cities have grown up with new industries inland along highways and rivers. Yet one thing remains immutable: each cove and bay and island has its scatter of brightly painted houses and wharves pointed to the sea.

Newfoundland is the farthest north and farthest east of the Atlantic provinces. Most of its people cluster on the coastal land that borders the interior forest and barrens of this island. The Trans-Canada Highway cuts inland, and towns such as Gander and Grand Falls-Windsor have prospered well away from the coast on industries such as timber cutting and milling. But the tradition of living near the sea persists, especially on the east coast and the Avalon Peninsula, where old houses survey what were once the world's richest fishing grounds. St. John's, the historic capital founded in the 16th century, celebrates the oceanfront: from The Battery, the clutch of sea-facing houses at the har-

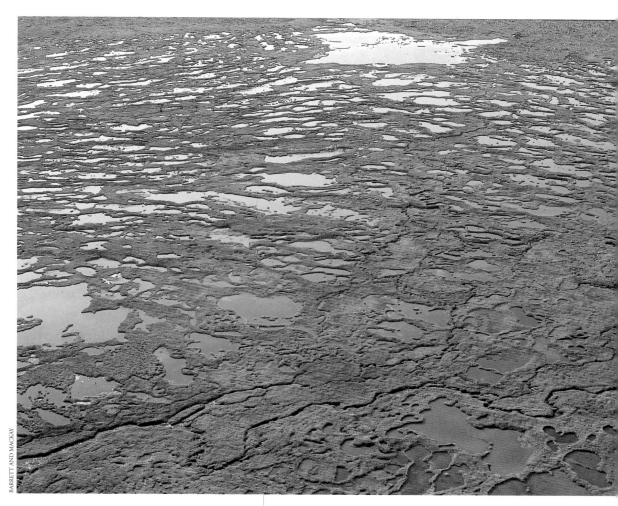

bour's mouth, to the downtown that climbs up steep slopes from the docks. For many a Newfoundlander, visits to the interior are limited to trips along the "TCH" and visits to the barrens and forests for berry picking, moose hunting, and trout fishing.

Some say Nova Scotia, to the south, is shaped like a lobster, its single claw waving toward the Gulf of St. Lawrence, its tail pointed at the New England states. Cape Breton Island — linked to the mainland by a causeway across the Strait of Canso — lies at the province's eastern end. Cape Breton, its shape indeed claw-like from the air, is bounded by a rough and serrated coastline that contains its wild and wooded hills.

above:

A wetland mosaic of boggy fens patterns the tablelands of northwest Newfoundland. Peat-bog habitats cover about one-sixth of the island.

Southwest lie the lobster's head and body. Here, the south shore's rocky coves and capes contrast with the foggy reaches of the shore northeast of Yarmouth, the long-settled farm and orchard lands of the Annapolis Valley, and the sandy beaches that face Northumberland Strait. No place in this province is more than 55 kilometres from the sea. Halifax, with one-third of Nova Scotia's people, faces the Atlantic, and is the closest harbour to Europe on the North American mainland.

This province's towns and villages — New Glasgow, on Northumberland Strait; Yarmouth, turned toward the state of Maine; Truro, where Minas Basin cuts deep inward into the peninsula; Sydney, at the end of Cape Breton Island; these and a hundred more — were born of the sea. For Nova Scotians, the interior forests and lakes are more places to visit than to live, locations for recreation and logging. Though roads have long crossed the land and linked the coasts, the sea was the first highway, the route for the first natives and the first settlers alike, and the fundamental fact of their existence.

The Appalachian Mountains of Eastern Canada were once as high as the soaring Rocky Mountains of Western Canada. But time has worn them down, their rounded tops now rarely higher than 800 metres. Over the ages, debris from that erosion filled the valleys and was swept down to the sea. Compressed into sandstone and mudstone, it underlies most of Atlantic Canada's farmland and forms the basis of today's Prince Edward Island.

The patterns of the island are unlike those in much of Atlantic Canada. Though half the island is forested, the overwhelming impression, from the air or from the land, is of red roads and farm fields, rusty cliffs, silvery sand beaches and dunes, and long shallows from the shore to the far-off ocean deeps.

"The shaping of the Island's whole north coast," notes Atlantic writer Harry Bruce in *Down Home*, "the beaches, bluffs, shifting dunes, and symmetrical spits — is the work not of farmers, gardeners, or landscape artists, but of an ancient conspiracy of winds, tides, ice, ocean currents, river currents and tough grass and shrubs. The red sandstone of the cliffs may be 250 million

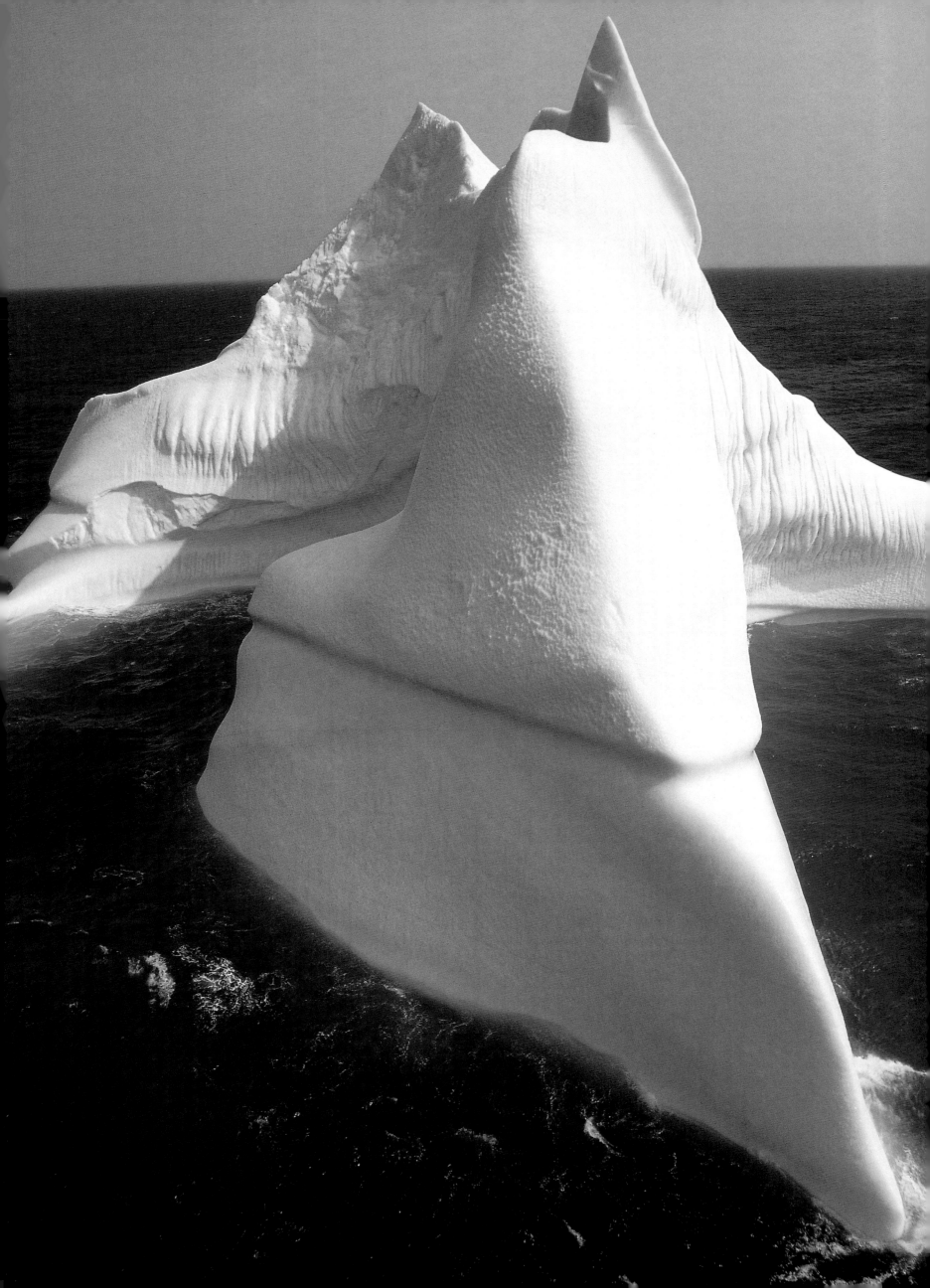

years old, but the arrangement of beach and dune is always newer than this morning's sunrise."

Prince Edward Island is the most densely populated of all Canadian provinces, at 23 people per square kilometre. It is also the least urban: 56 percent of islanders live in what Statistics Canada calls rural areas. The aerial eye sees houses, cottages, farms, and hamlets dotted across the landscape, rather than dwellings compressed into cities and suburbs. Charlottetown, the capital and largest city, contains just 32,000 people.

New Brunswick is the most solidly mainland of the Atlantic provinces, set squarely below the St. Lawrence and north and east of the New England states and Maine. As befits a mainland region, its landscape is defined not only by its seacoast but also by its forests and rivers. From the heights of the Appalachian Uplands in the north and centre of the province, the forested hills sweep down to seacoasts on the Bay of Fundy, Northumberland Strait, and the Gulf of St. Lawrence. In the north, the Miramichi runs down from the mountains to the sea. In the south and west, the Saint John River defines the border with the United States, then cuts southeast through a corner of the province, its wide valley providing room for both farms and towns.

The pattern of settlement in the province is likewise twofold. Two of New Brunswick's major cities —Fredericton, the capital, and Moncton — lie inland; Saint John, the oldest city, stands stoutly as a port town on the Bay of Fundy shore. All the Atlantic provinces have residents whose origins were French; New Brunswick, with its Acadian Shore and heritage, is Canada's only officially bilingual province, with almost a third of the residents listing French as their mother tongue. Most trace their heritage back to the original Acadians. Dispossessed in the 18th century when the conquering British drove them from their colonies, they and their descendants filtered back over the decades, until their culture today is stronger than it ever was.

The Acadians wanted to come back to the land and the landscape they had made their own. Their determination is echoed today by people throughout Atlantic Canada. Though a lack of industry and the near-death of the fishery can make life difficult and employment hard to come by, they want to stay at home.

Even from a satellite perspective, it wouldn't be easy to encompass all four provinces in this region. Photographs taken from a helicopter or an airplane can give us only glimpses, small clues to this world at Canada's eastern edge. Yet the images add up to strong impressions: rocks and red soil, forest and waves breaking on a stony shore, and a people linked by their love for this Atlantic landscape. ❧

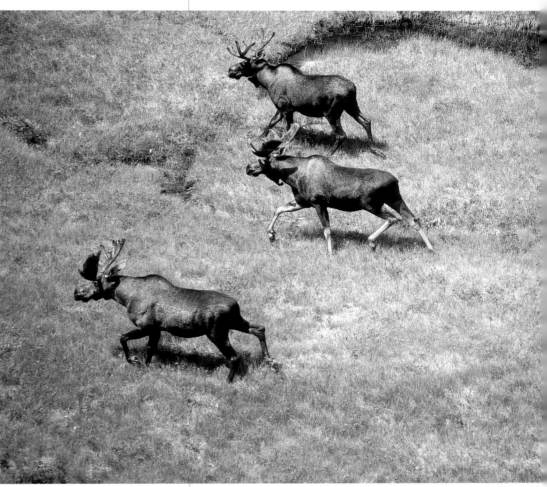

below:

Moose introduced into Newfoundland at the turn of the century found the terrain and lack of predators to their liking: they now number about 160,000.

opposite:

Icebergs that calve from the glaciers of Greenland move in stately procession with the currents north, then south along the coast of Labrador. Each year, several hundred survive the two- to three-year journey to arrive off Newfoundland, where they are most often seen between March and July. RUSS HEINL

following pages:
Reachable only by sea or air, Grand Bruit is tucked into an inlet on the southwest coast of Newfoundland. The name of the outport — "great noise" in French — stems from the sound of the falls at its centre, and dates from the days of the French fishery on the coast. About 60 people live in Grand Bruit.
RUSS HEINL

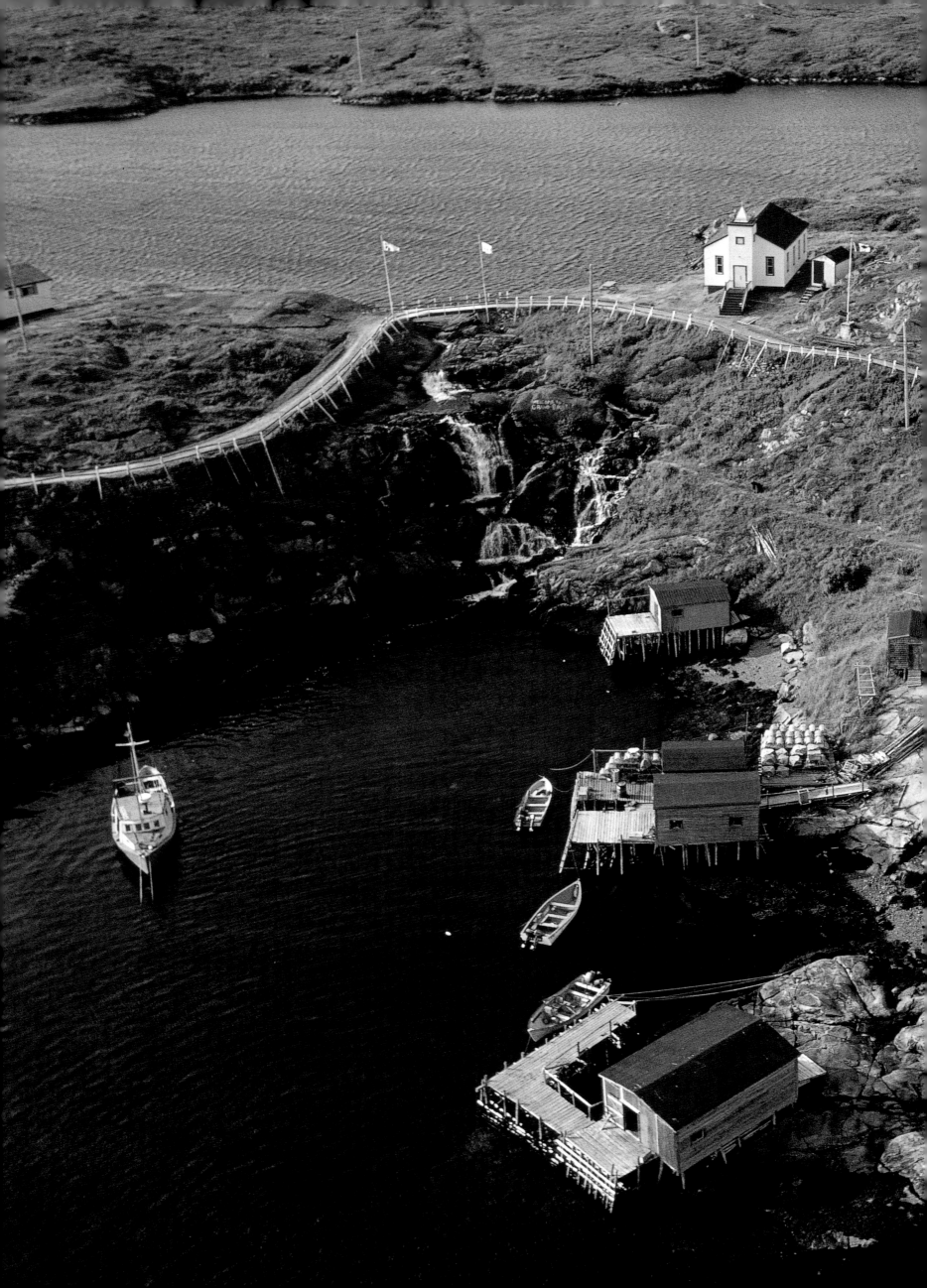

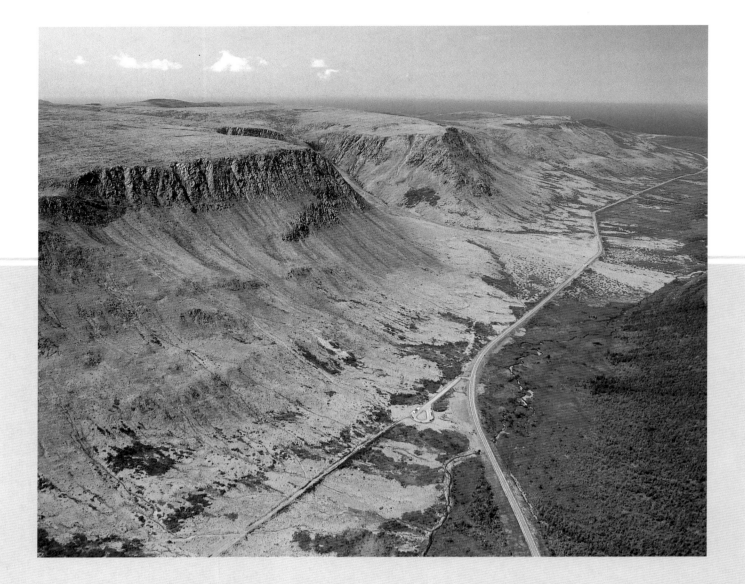

GROS MORNE NATIONAL PARK

A shifting Earth revealed

In Newfoundland's west-coast mountains, great outcroppings of orange-brown rock tell an ancient story about the history of the Earth. Millennia ago, parts of the Earth's mantle usually hidden deep beneath the crust were thrust to the surface here, where they now present evidence of tectonic plate movement.

The drifting of the great plates is a continuing chapter in the story of how the Earth took on its present shape. When the ancient European and North American plates collided half a billion years ago, the collision thrust to the surface the orange peridotite visible at Gros Morne and in few other places on the Earth's surface. Also visible here is greyish-green basalt and gabbro, once part of the Earth's oceanic crust. The peridotite is almost bare of vegetation – its high concentrations of iron, nickel, and magnesium are toxic to most plants.

The geology of Gros Morne National Park's 1,805 square kilometres underlies its selection as one of the 12 UNESCO World Heritage Sites in Canada. (Other sites in the Atlantic region are L'Anse aux Meadows, the only authenticated Viking landfall in North America, north of Gros Morne; and Lunenburg's 18th-century townscape in Nova Scotia.) Gros Morne is in good company: other World Heritage Sites are Australia's Great Barrier Reef, the Galapagos Islands, and Canada's own Rocky Mountain parks.

Adding to Gros Morne's geological drama are deep, landlocked fiords gouged by glaciers thousand of years ago, their exits to the sea blocked when the land rose after the ice melted. Caribou, black bear, moose, Arctic hare, land birds, shorebirds, and a great diversity of plant life are found in the region.

above:

Reddish rock and green vegetation are evidence of tectonic plate theory in Newfoundland's Gros Morne National Park.
RUSS HEINL

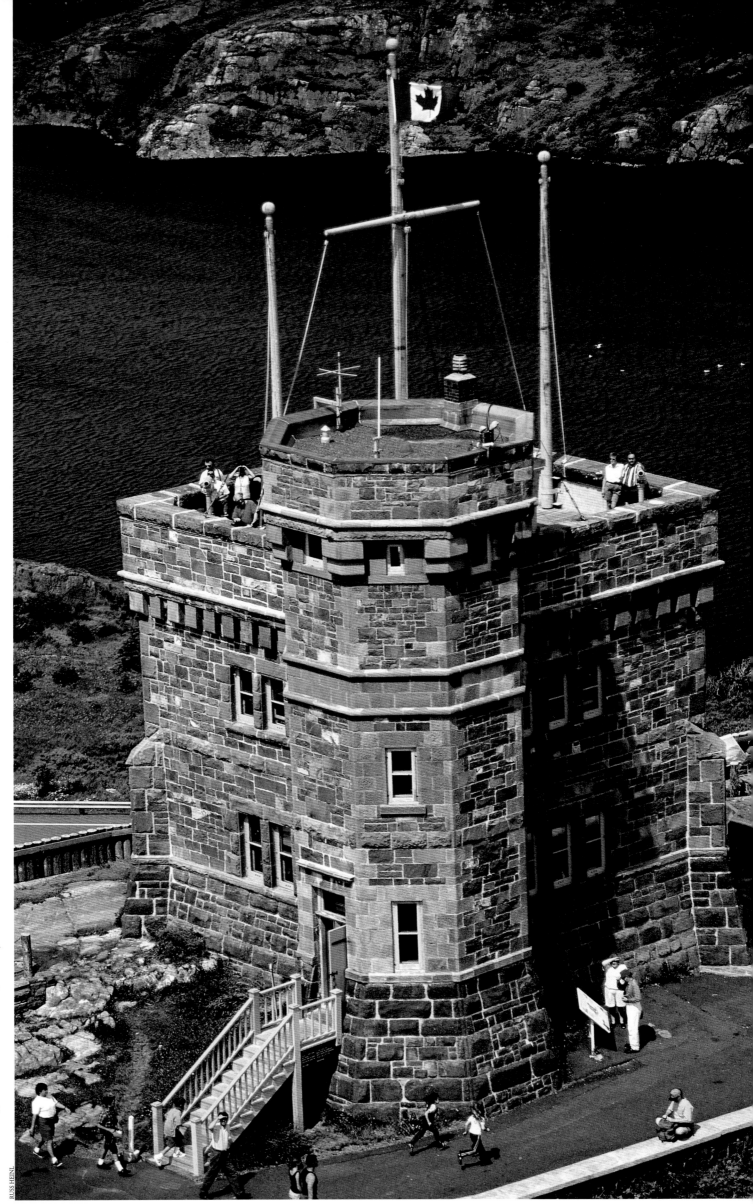

right:

*T*he Cabot Tower
stands atop Signal Hill,
at the entrance to the
harbour of St. John's,
Newfoundland. The
tower was built in
1898-1900, to com-
memorate Queen
Victoria's Diamond
Jubilee and John Cabot's
voyage in 1497 to
Newfoundland.

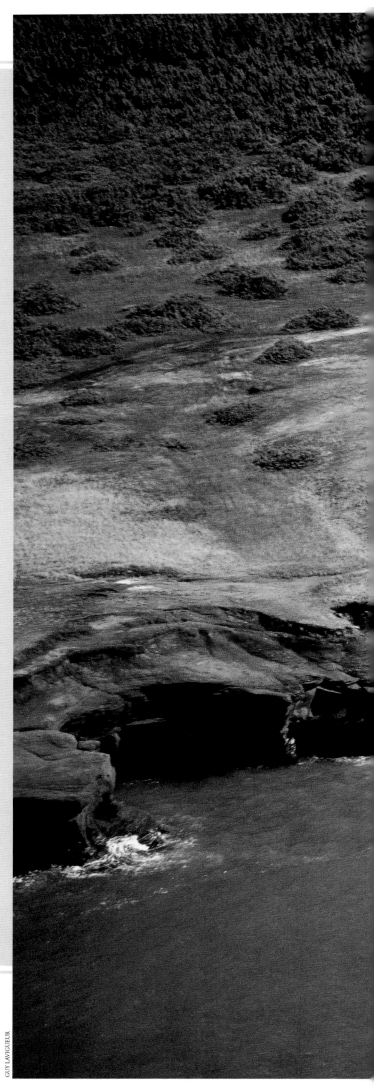

LES ÎLES-DE-LA-MADELEINE
An archipelago of cliffs and changing dunes

They lie like an elongated string of seaweed in the curve of the Gulf of St. Lawrence, northeast of Prince Edward Island: 16 islands and outcroppings, the largest of them tenuously linked by narrow sand dunes thrown up by the advance and retreat of the waves. Politically, they are part of Quebec. In geology and location, Les Îles-de-la-Madeleine — the Magdalen Islands — are kin to the Atlantic lands that cradle them.

Jacques Cartier made landfall here in 1534. The archipelago was later named for Madeleine Fontaine, wife of the islands' seigneur. The French population today is descended from Acadians exiled from their original lands around the Bay of Fundy when the British conquered the region, and from settlers who came here from the French island of Miquelon to the northeast. The anglophones are mostly descendants of Scots and Irish fishermen who have lived here for generations. Altogether, some 15,000 residents live in the villages and along the few roads of this island chain.

The islands are characterized by long stretches of pale sand and eroded cliffs of deep red sandstone. Their dunes held in place by dune grasses, their water supply limited to what exists in underground aquifers, and their cliffs subject to the action of wind and waves, they contain both a changing and a timeless environment. Île Brion is a sanctuary for nesting seabirds. In the centuries before walruses were hunted to extinction in the Gulf of St. Lawrence, the huge sea mammals clustered near these islands. Many thousands of harp seals still give birth on offshore ice each spring.

The archipelago evokes a deep loyalty, both in the Madelinots who live here and in those who visit. Each summer thousands of visitors cross by ferry from Prince Edward Island or Nova Scotia — some even by cargo ship from Montreal — to walk the paths through the dunes, windsurf in the lagoons, kayak the shores, examine the work produced by artisans, and share, for a week or two, the lifestyle, culture, and beauty of Les Îles-de-la-Madeleine.

right:

Red cliffs rise on the coast of Île du Cap aux Meules, one of the main islands of Les Îles-de-la-Madeleine.

previous pages:

Farm fields surround Hunter River, a crossroads community at Prince Edward Island's centre.
RON GARNETT/BIRDS EYE VIEW

GUY LAVIGUEUR

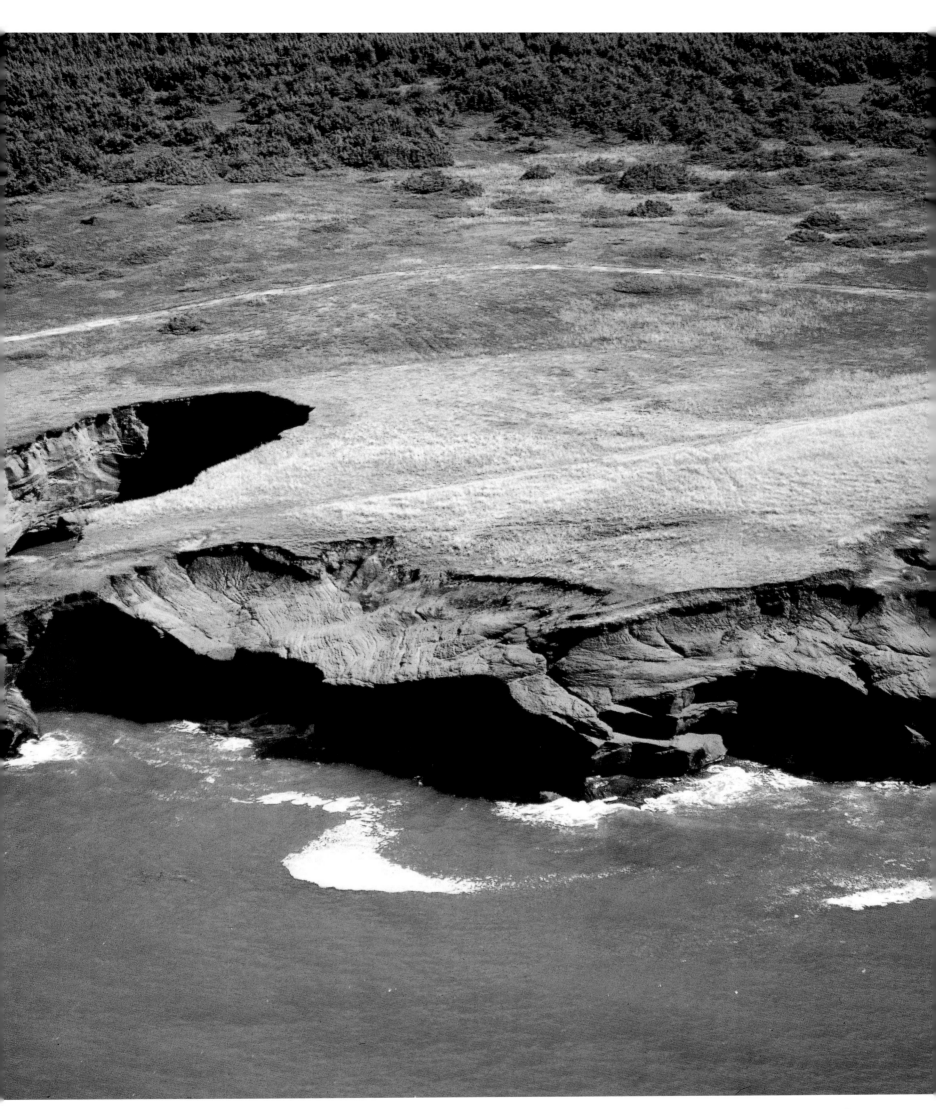

above:

Charlottetown, Prince
Edward Island's capital, borders
Charlottetown Harbour, a
protected inlet off
Northumberland Strait.

right:

Kayakers paddle the waters off
North Rustico Harbour on Prince
Edward Island's north shore, at the
entrance to Rustico Bay.

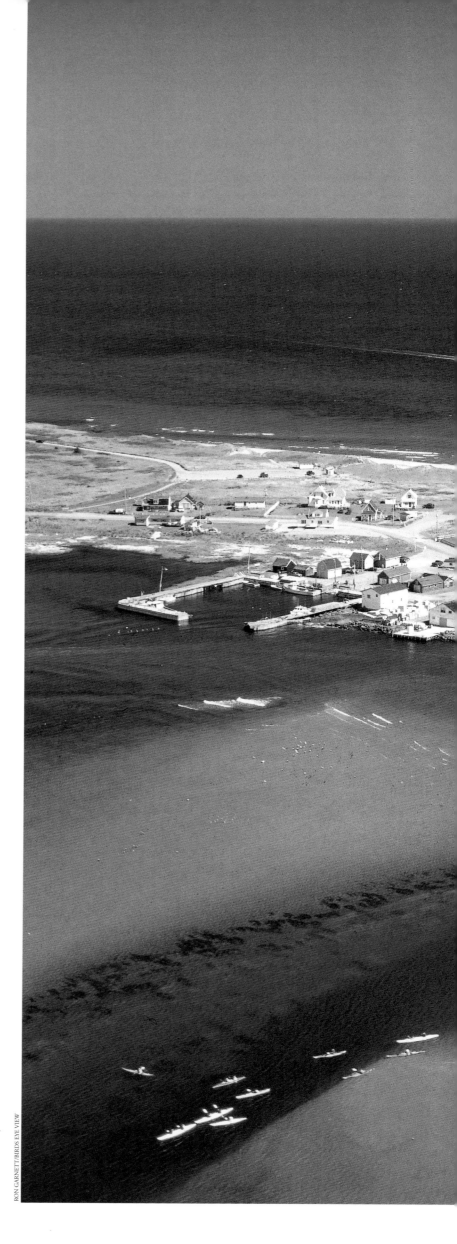

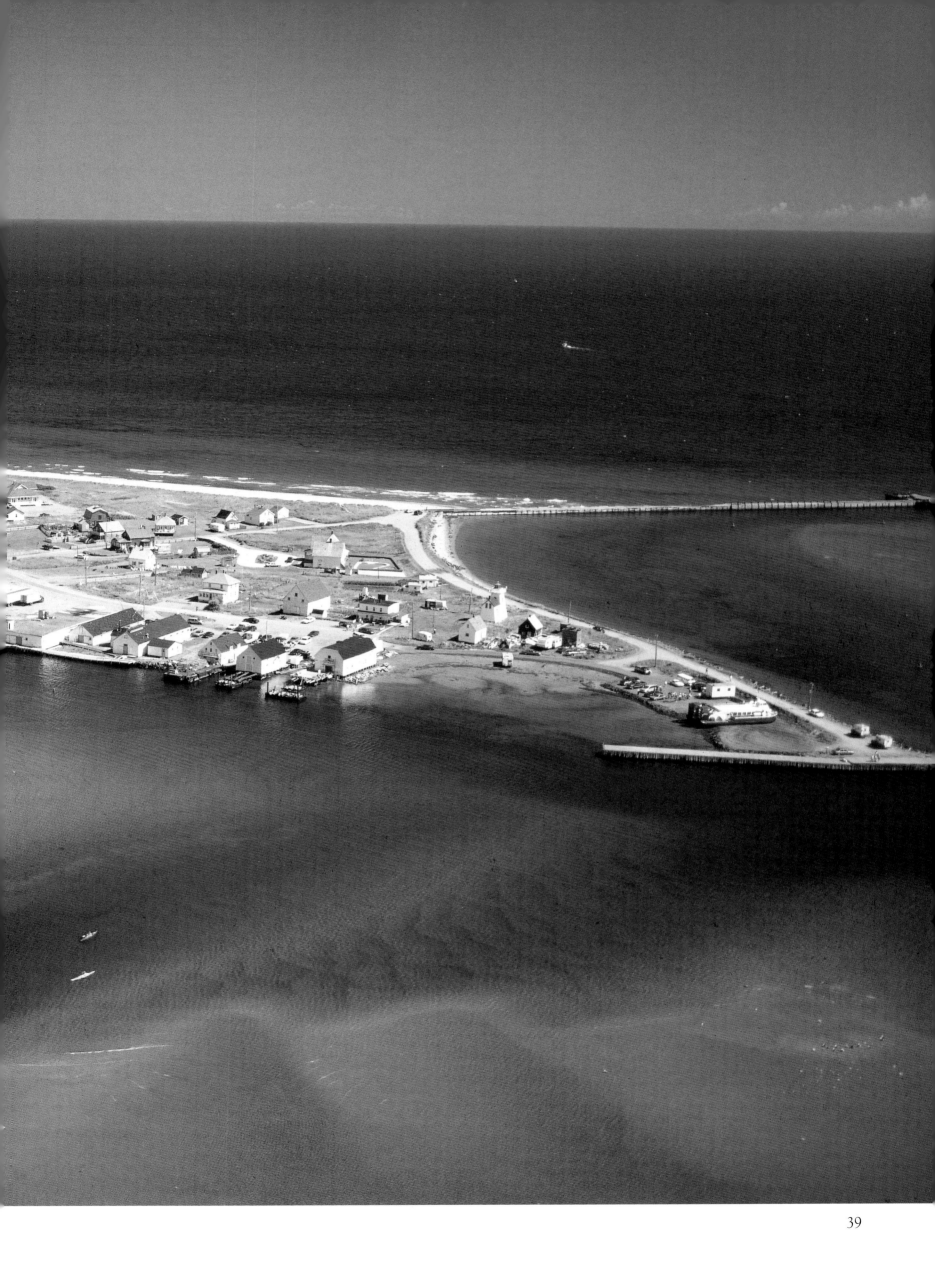

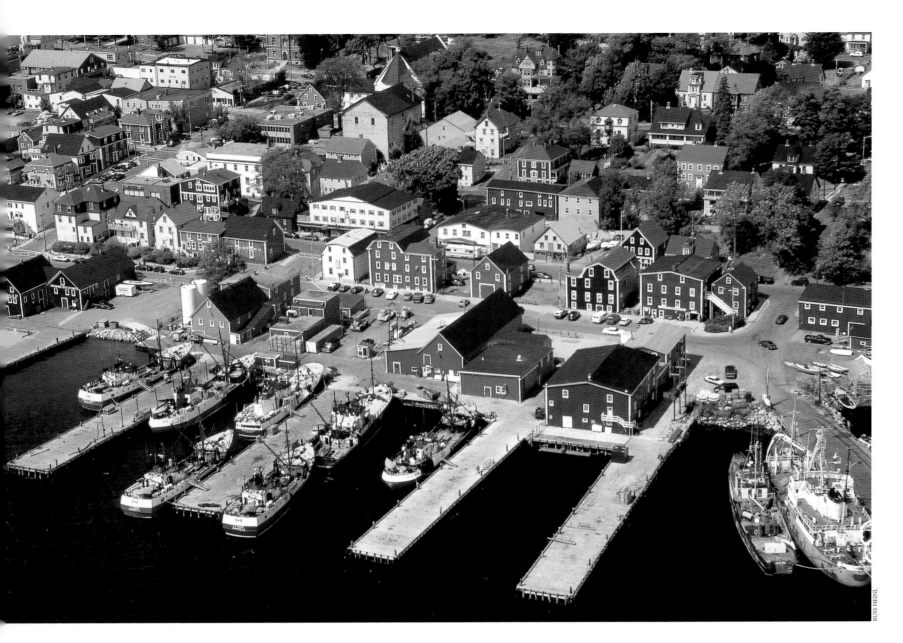

RUSS HEINL

above:

*I*n the mid-18th century, settlers came to Lunenburg, on Nova Scotia's south coast, from Germany, Switzerland, and France. The well-preserved late 18th- and early 19th-century buildings of Old Town shown here have earned the town designation as a UNESCO World Heritage Site and as a National Historic Site.

right:
For 10 days each August, jugglers, musicians, actors, and other per-forming artists play the waterfront at the Halifax Busker Festival.

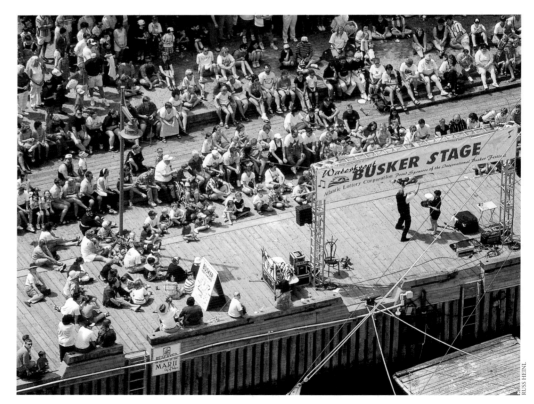

previous pages:

*E*arly morning sheds a gentle light on visitors to Cavendish Beach in Prince Edward Island National Park. The park, created in 1937, consists of 40 kilometres of sand spits, beaches, and dunes on the Gulf of St. Lawrence.
BARRETT AND MACKAY

opposite:

*T*he estuary of the Chebogue River, surrounded by one of the largest salt marshes in Nova Scotia, provides safe harbour for boats at the province's southwest corner.
BARRETT AND MACKAY

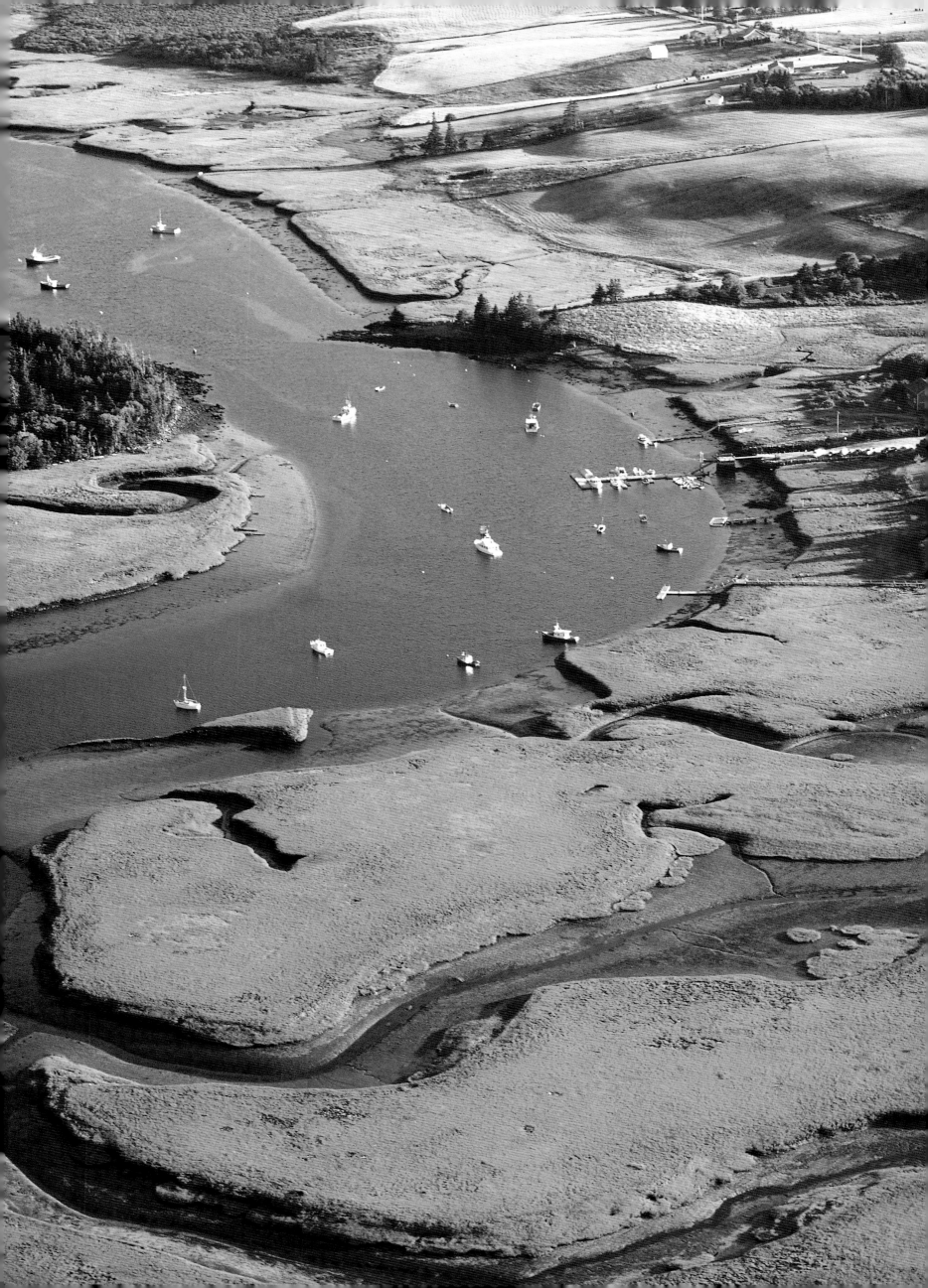

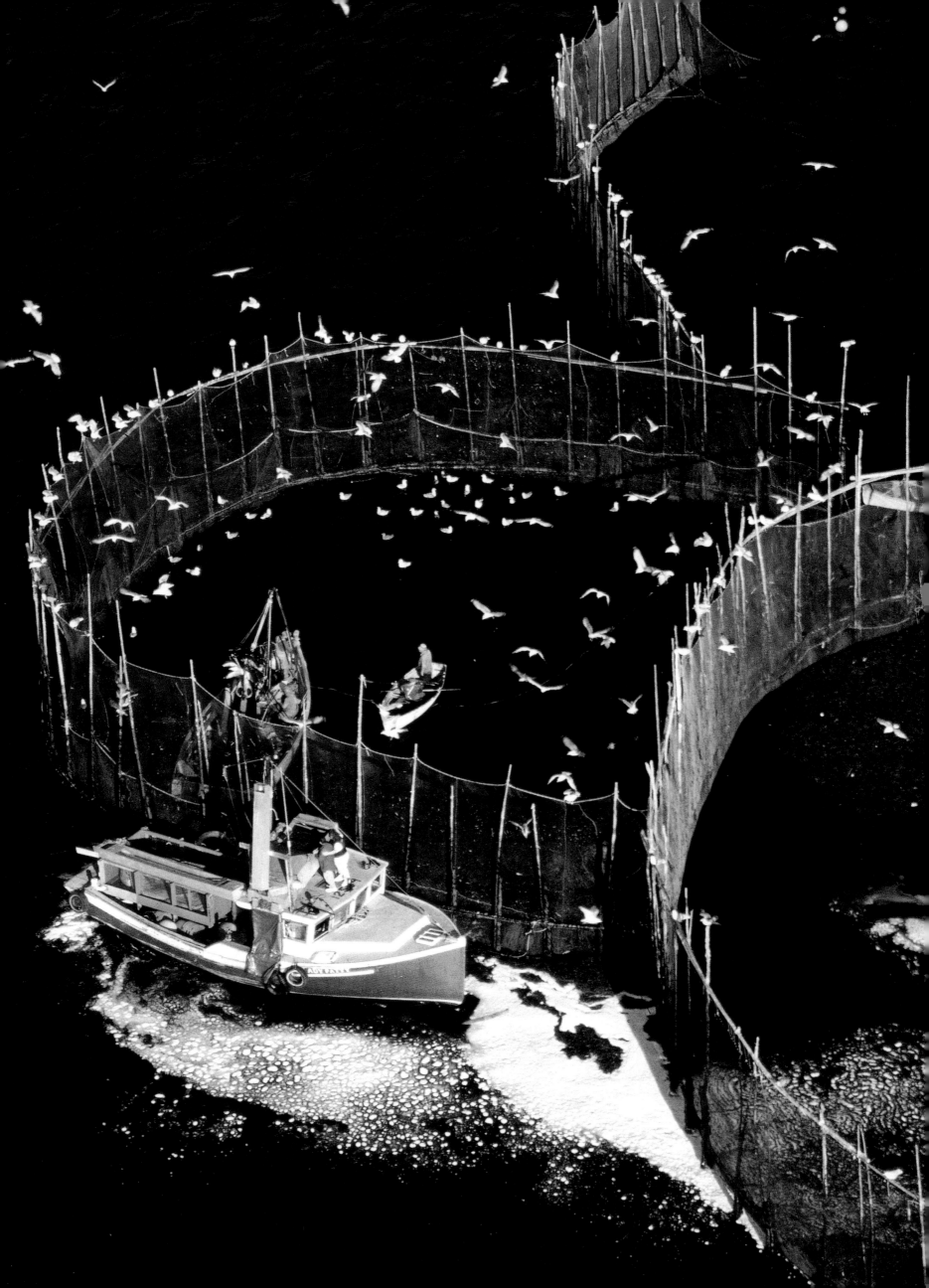

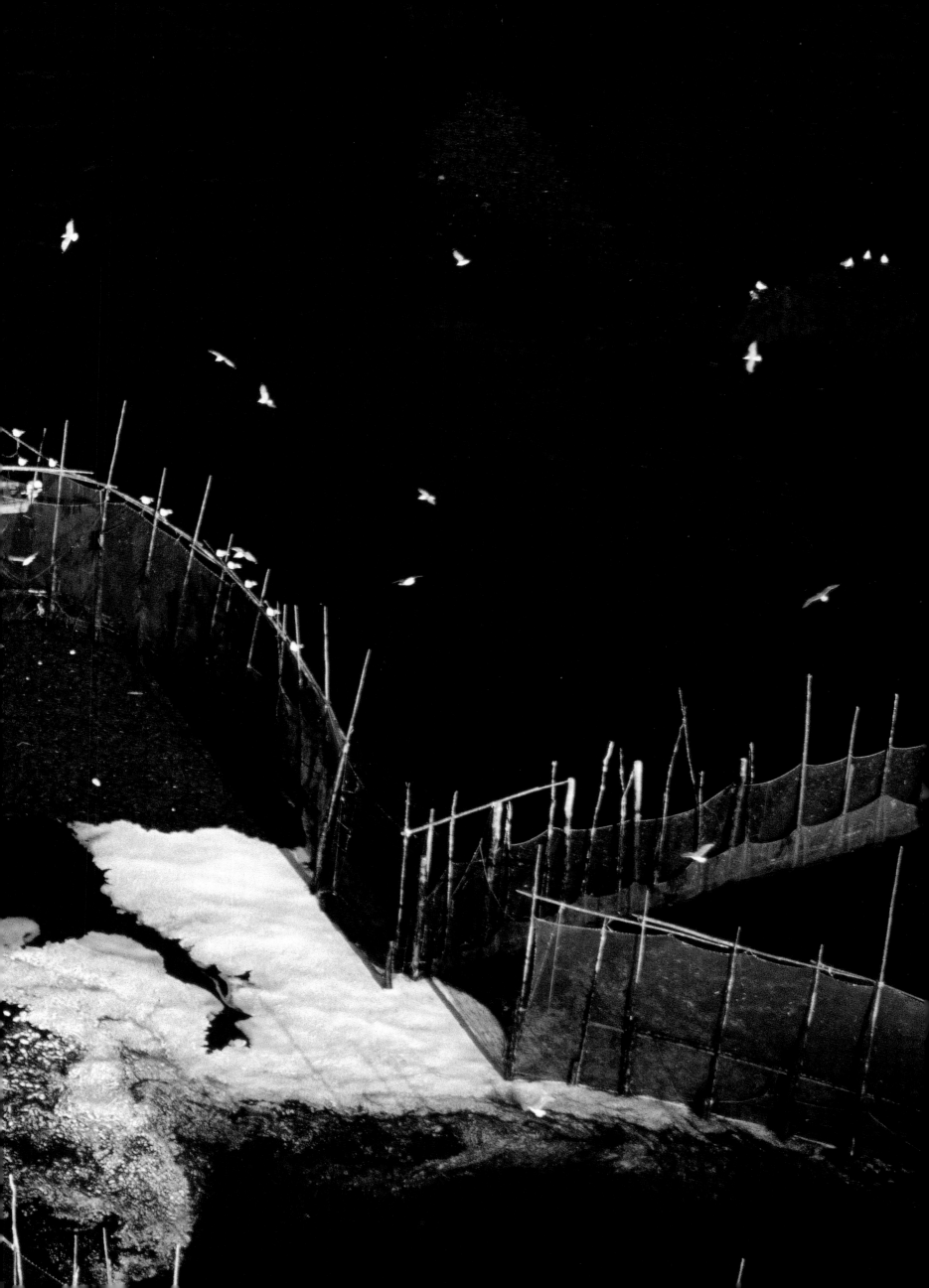

Fishboats harvest herring in a weir off Campobello Island, at the Bay of Fundy's entrance. About 20,000 tonnes are caught in the 150 weirs along the south coast of New Brunswick each year between early May and late October. RUSS HEINL

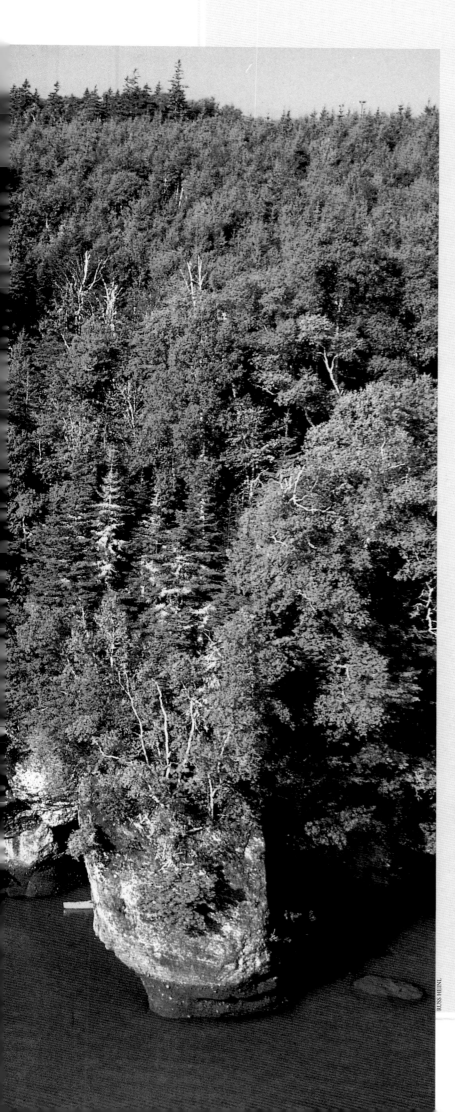

On Location

The Bay of Fundy's Hopewell Rocks

Fog banks hide the shore of the bay as photographer Russ Heinl and the helicopter pilot fly southeast, hugging the coast, outbound from Fredericton for Halifax. "We knew we would see Hopewell Rocks in the morning," says Heinl of the vase-shaped rocks on the New Brunswick shore of the Bay of Fundy south of Moncton. "The plan was for low tide and bright sunshine."

Those conditions would allow Heinl to photograph the eroded pillars completely out of the water, in the best possible light. But neither tide nor weather is co-operating: the fog is thick and the tide is halfway between ebb and flood. Loath to lose the opportunity, Heinl asks the pilot to put down in a nearby field and wait.

Remarkably, in less than 10 minutes, the fog slides seaward off the rocks to reveal kayakers about to launch and paddle along the shore. "We usually don't like to bother kayakers — they're there for peace and quiet, not the noise of a helicopter — but we waved at them and they waved back, so we followed them for 10 or 15 minutes. And it was perfect: the rocks, the water, the colour of the kayaks, the beauty of the human scale they provided."

It's a necessary scale in Bay of Fundy waters, between New Brunswick and Nova Scotia, where the world's highest tides reach their peak at 16 metres at the bay's eastern end, in Nova Scotia's Minas Basin. They're not quite that high here at Hopewell, but without some human scale in the photograph, it would be difficult to comprehend that the rocks on the tidal flats — normally covered almost to their treed tops at high tide — stand up to 15 metres tall at low tide.

Two tidal systems contribute to the height of Fundy's tides: that from the Bay of Fundy and the Gulf of Maine and that from the adjoining North Atlantic. From those tides come such natural phenomena as the tidal bore that crests along the Petitcodiac River near Moncton, the reversing falls on the Saint John River, and wide mud flats on both sides of the bay that may stretch more than a kilometre from the shore at low tide.

left:

Kayakers paddle near Hopewell Rocks on the New Brunswick side of the Bay of Fundy.

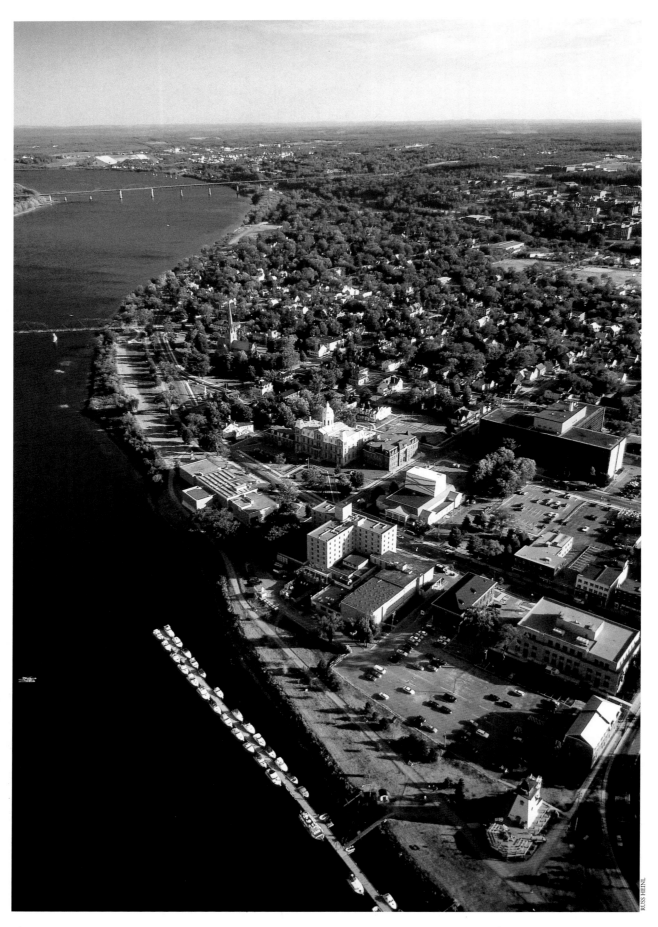

above:

F*redericton, the capital of New Brunswick with a population of 47,000, was founded on the Saint John River by Loyalists who came here in the 1780s during and after the American Revolution.*

opposite:

C*loser to Maine than to New Brunswick, Grand Manan is the largest of the islands at the Bay of Fundy's entrance. The 3,000 islanders live along the gentle eastern shore; the western shore is marked by steep cliffs.* RUSS HEINL

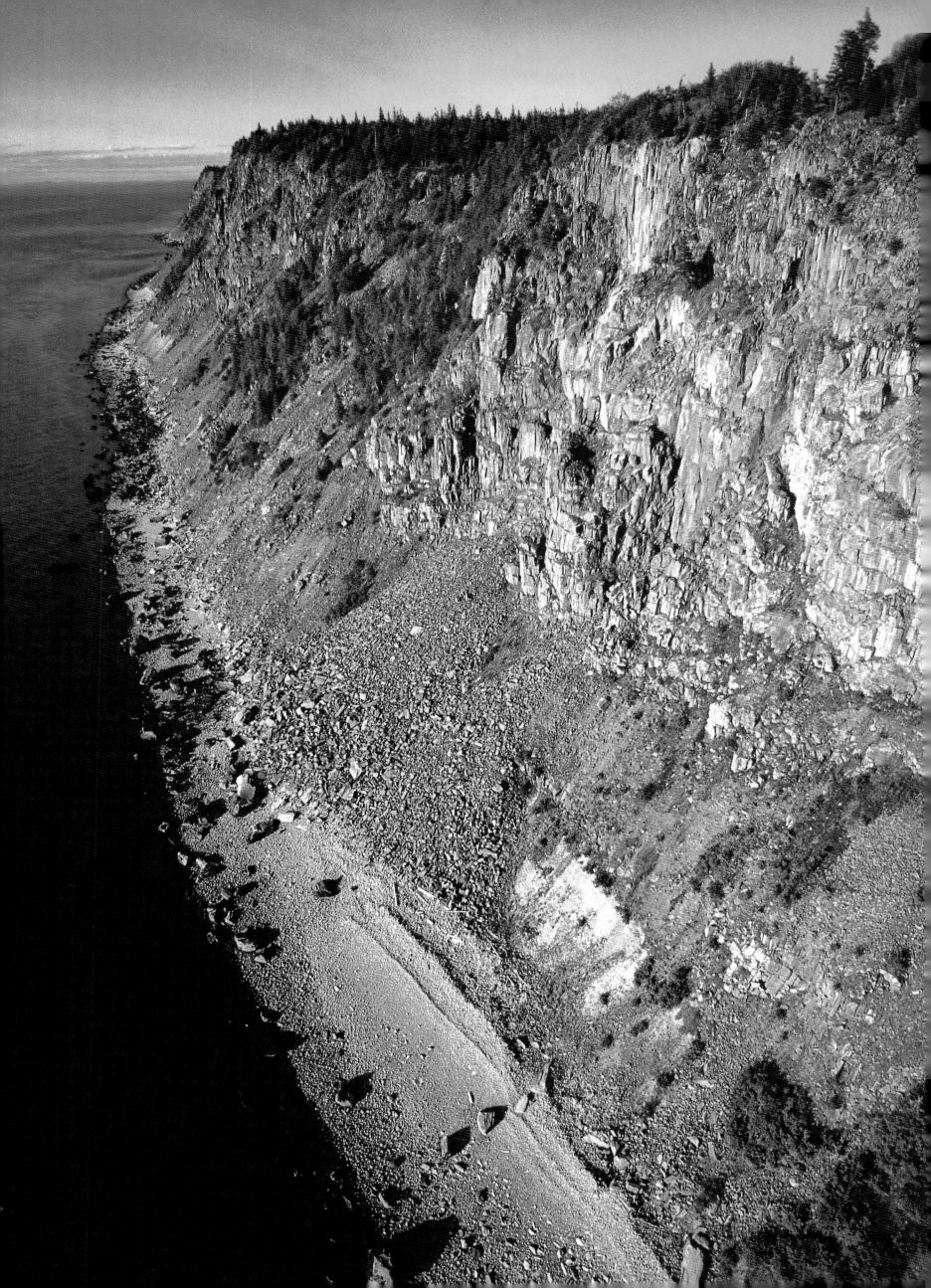

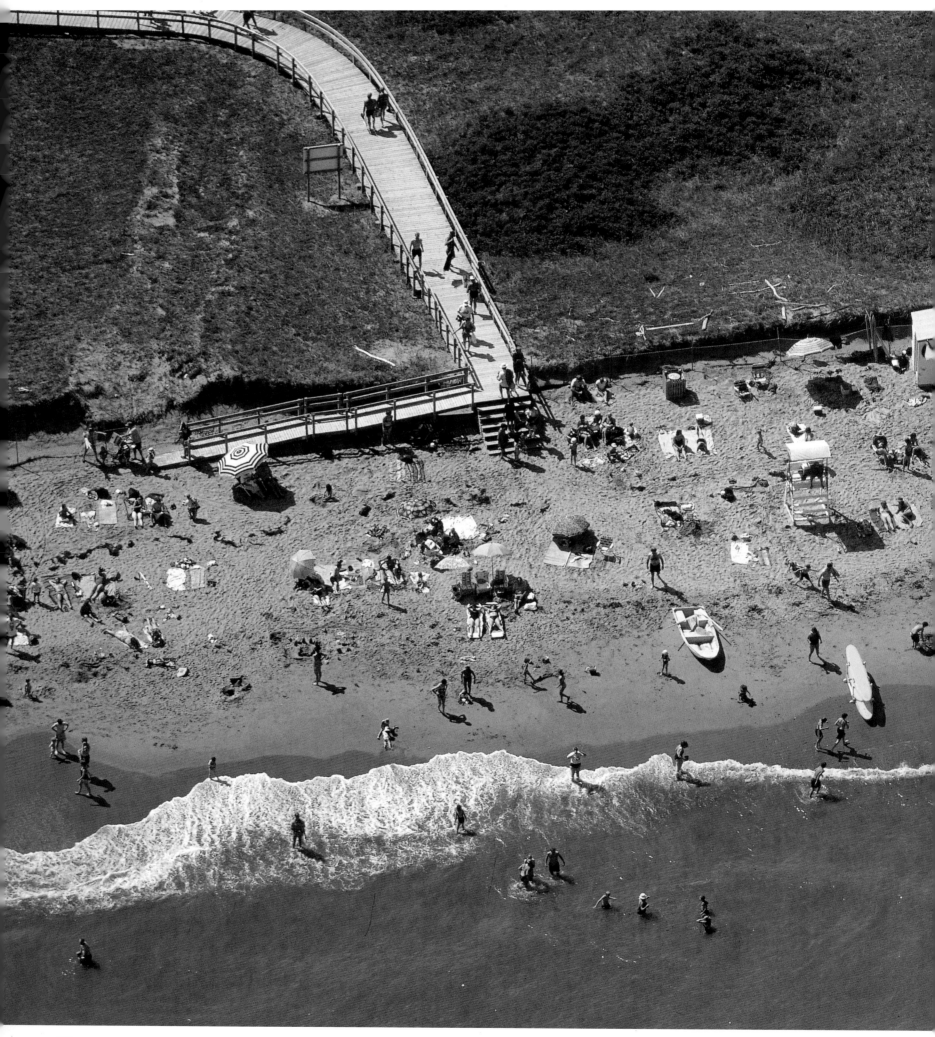

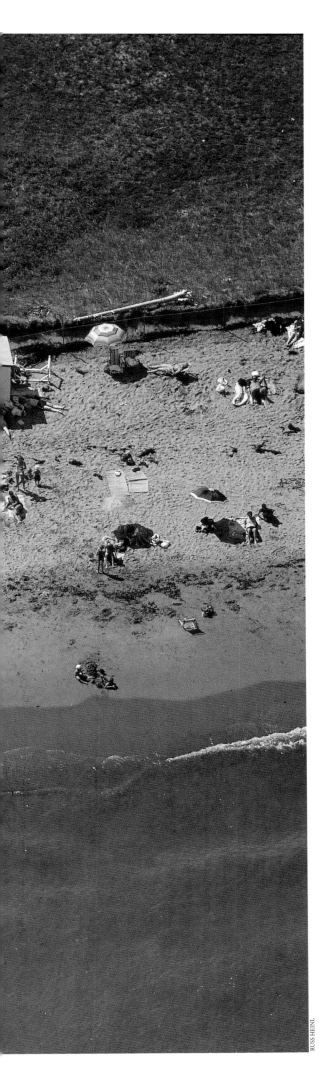

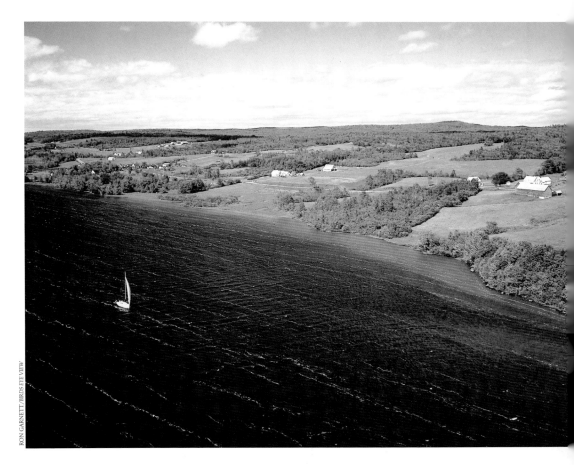

RON GARNETT / BIRDS EYE VIEW

above:

A sailboat plies the waters of the
Saint John River near Wickham,
New Brunswick, southeast of
Fredericton.

left:

The white sand beaches of
Kouchibouguac National Park, on
the shore of New Brunswick's
Northumberland Strait, stretch for
kilometres, and are backed by ever-
changing sand dunes.

RUSS HEINL

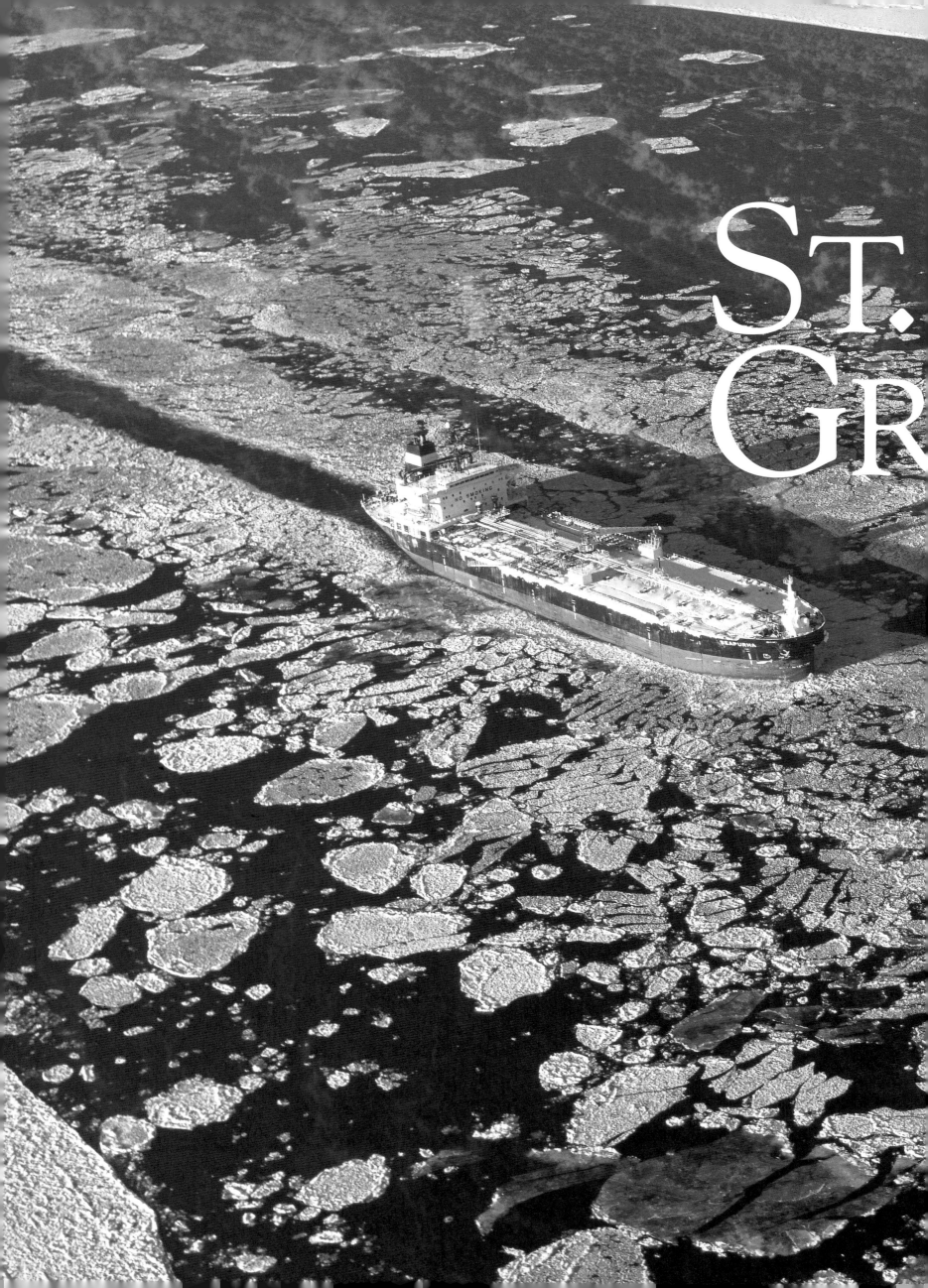

ST.
GR

Lawrence/
EAT LAKES

St. Lawrence/Great Lakes
A Waterway Through History

previous pages:

The tanker Seapurha *navigates the St. Lawrence River through January ice near Varennes, Quebec, on its way to port at Montreal.*
GUY LAVIGUEUR

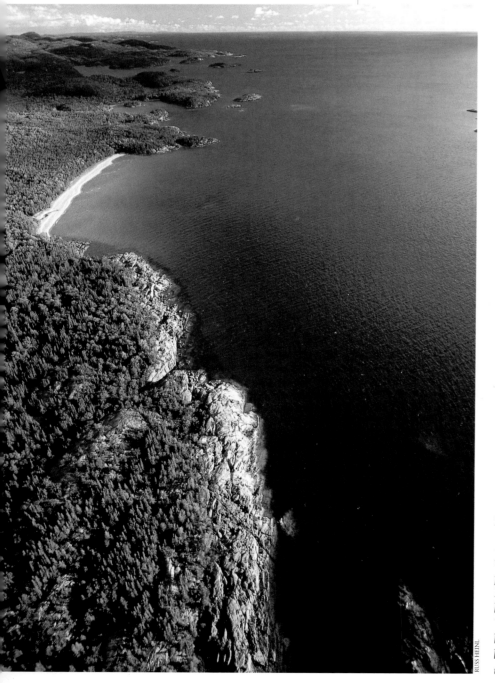

The old stone buildings crowd in upon the narrow streets of Upper Town. From the clifftop boardwalk, shining in the summer sunshine, tourists contemplate the steep staircases that lead down to the oldest part of the city. The green-roofed Château Frontenac hotel stands sentinel over all, looking out across the cliff, the river, and four centuries of Canadian history.

At the foot of Quebec City's 100-metre-high cliff, the French built their first permanent settlement on the St. Lawrence River. To the west of the Château, French and British troops fought the battle that effectively ended French control of Canada. Not far away, in 1864, delegates from the colonies of British North America hammered out the proposals that would lead to Canadian Confederation.

Below and beyond the 19th century hotel, the St. Lawrence River sweeps through a constricted channel, halfway on its journey between the Great Lakes and the sea. The river is the connecting link in a 3,800-kilometre waterway that cuts far into the heart of the continent and runs deep in Canada's soul.

In geological time, this is a young waterway, the lakes and the river hollowed out little more than 12,000 years ago during the last ice age, and filled with the meltwater of retreating glaciers. Between the Gulf of St. Lawrence and the easternmost of the Great Lakes, the St. Lawrence flows through a valley bounded by the abrupt rise of the Canadian Shield to the north, the gentler uplift of the Appalachian Mountains to the south. Just beyond Montreal, the Ottawa River rolls in from the north country, marking the boundary between Ontario and Quebec. To the southwest, the chain of Great Lakes begins: Ontario, Erie, and Huron, with the farm fields, freeways, cities, and woods of southern Ontario poised in the triangle between them; Michigan, dipping into the United States; and Superior, vast, deep, northern, stretching almost to Manitoba.

left:

Lake Superior's stark and rocky north shore is portrayed in this photograph taken over Ontario's Pukaskwa National Park, midway between Sault Ste. Marie and Thunder Bay. The 1,888-square-kilometre park features massive headlands, boulder beaches, and wilderness lakes and forest.
RUSS HEINL

opposite:

Quebec City's Château Frontenac, built high on the cliff overlooking the St. Lawrence River in the 1890s, was one of the first of the famed Canadian Pacific Railway hotels. RUSS HEINL

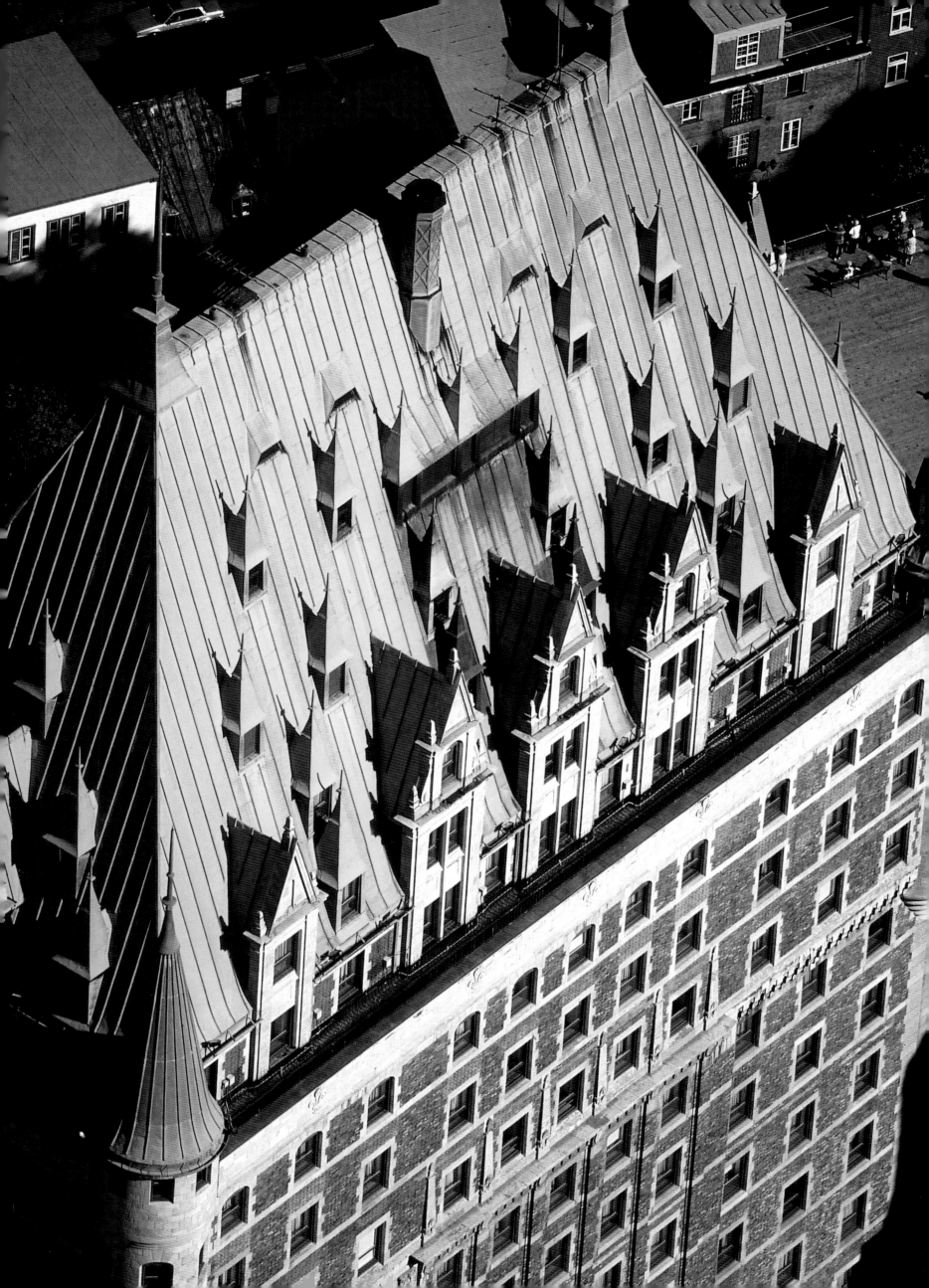

Along the riverbanks and in the region defined by the lakes, more than half of Canada's population lives on about 5 percent of the country's land. Little of the land and water between the mouth of the St. Lawrence and Lake Superior remains untouched by man: forests cleared, fields put to the plough, cities spilling ever farther outward, rivers dammed, canals built. The landscape the aerial photographer sees in this region is often an artificial one of human habitation and use. Yet that photographer can still find the patterns of nature in the path of the river, the arc of the lakes, and the contours of rocks and forests.

The St. Lawrence River sweeps into the Gulf of St. Lawrence just below the 50th parallel of latitude. It is bounded on the south by the downward curve of the Gaspé Peninsula, on the north by the rocky beginnings of the Canadian Shield. Fittingly called by a Mi'kmaq word meaning "land's end," Gaspé is mountains and trees, with a skein of towns and villages looped along the coast. At Gaspé's end, dramatic from the air, Percé Rock points a craggy finger into the Gulf of St. Lawrence, the last mainland appearance of the Appalachian Mountain chain. Across the river — here at its mouth more than 40 kilometres wide — the north shore is isolated and almost uninhabited, marked by the eroded pillars of the Îles de Mingan.

The estuary of the St. Lawrence River — where salt water from the gulf mixes with fresh water that flows down from the lakes, the rivers, and the rain — persists almost to Quebec City, more than 600 kilometres upstream. As the mountains recede from the river and the rough terrain at the river's mouth gives way to cultivated fields, a distinctive pattern emerges in the landscape, one that dates from the 17th century, when the river was the road. The best land was that closest to the river; each settler needed river frontage, for transportation, communication, and defence. The land was divided not into the square plots more familiar to Ontario or Prairie dwellers, but into long narrow strips running back from the river. The aerial view is unmistakably rural Quebec.

Aerial photographer Guy Lavigueur has documented the river from its mouth to Montreal. "It's two different worlds, the north and the south shores. The south is agricultural, very green, with the hills well away from the St. Lawrence, the land slowly rising from the river. There are more people here, more villages, with farms between the villages. The rivers that run down to the St. Lawrence run very slow."

The north shore is different: here, the mountains are generally much closer to the shore. "The rivers fall very fast — some cascade right into the St. Lawrence — and there's some very rough terrain, forested with woodcutting in the hills and rivers dammed for electricity."

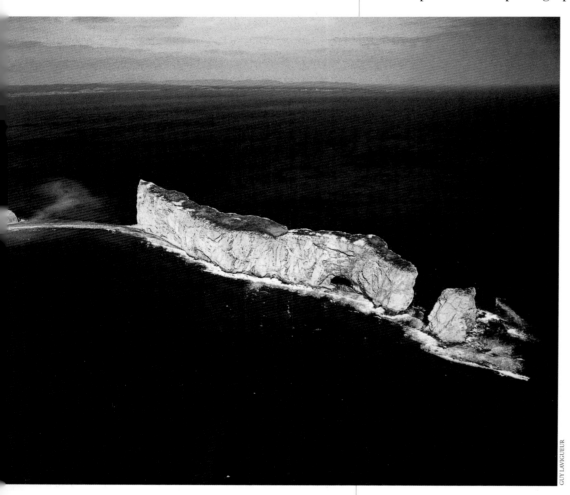

GUY LAVIGUEUR

above:

The 88-metre-high Percé Rock extends 400 metres eastward from the end of Quebec's Gaspé Peninsula into the Gulf of St. Lawrence.

Where the Rivière Saint-Charles enters the St. Lawrence, the big river narrows to little more than a kilometre wide. Iroquois and Algonquin in turn used this site for hunting, fishing, and farming. Samuel de Champlain established France's first permanent settlement here in 1608. In the age of sail, Quebec City was the port, the military headquarters, and the commercial capital of Quebec. It lost its dominant position to Montreal only in the 19th century, and remains the capital of Quebec.

West from Quebec City to Montreal, the river twists through narrow passages and flows across shallow "lakes." For centuries, Montreal marked the journey's end for ocean-going ships: they could not ascend past the rapids that quickened the waters from here to Lake Ontario. But most of those rapids are gone now, bypassed or drained during the building of the St. Lawrence Seaway; no longer do the Côteau, the Long Sault, the Galop, or the Rapide Plat challenge boatmen. Only the Lachine Rapids, upstream from Montreal, remain, and ships detour around them by means of a canal. When the seaway opened in 1959, canals, dams, diversions, and locks allowed ocean-going traffic passage all the way to the head of Lake Superior from mid-April to freeze-up in mid-December.

Long before then, however, Montreal was on its way to becoming a great and cosmopolitan city. From above, you can see the spill of the city from its original base between the river and Mont Royal, spreading across all the island of Montreal and onto the river's north and south shores. And you can see the city's changing face, from Old Montreal's narrow streets and sturdy stone to the modern cityscape of glass and concrete.

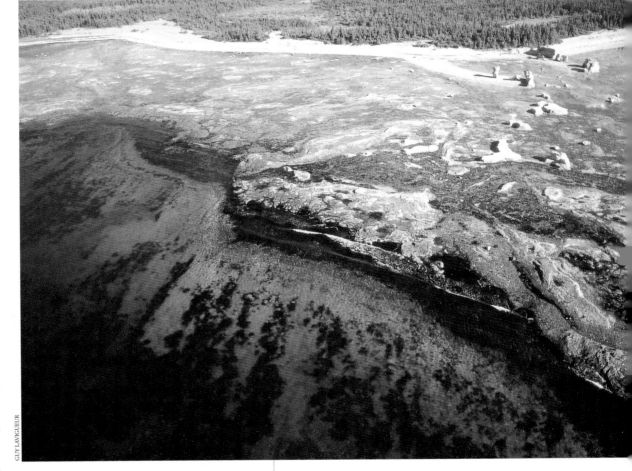

GUY LAVIGUEUR

Waves have sculpted the limestone of Quebec's Mingan Archipelago, east of Sept-Îles, into fantastic towers. This photograph shows the aptly named Anse des Érosions, on the Île à la Proie.

Just west of Montreal, the Ottawa River enters the St. Lawrence. To the north is Ottawa, Canada's capital, its turreted Parliament Buildings high above the river a distinctive symbol of the country. To the south, an aerial view reveals a river course dotted with the Thousand Islands, a boater's paradise of islands and islets. At Kingston, the St. Lawrence River ends and the lakes begin.

The Great Lakes exhaust superlatives: biggest, greatest freshwater reservoir, longest shoreline. Lake Ontario, farthest east of the lakes, is the smallest, its shoreline the most urban. A helicopter can follow the multiple lines of highway and railway along the shore to the ever-growing agglomeration of Toronto, Canada's largest city.

From the ground, Toronto's downtown cityscape can seem unfriendly and overwhelming, centred on what Toronto writer and critic John Bentley

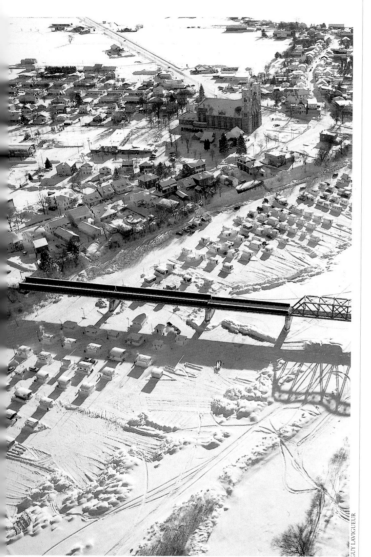

above:

*E*ach winter hundreds of ice-fishing huts are set up on the river at Ste-Anne-de-la Pérade, between Quebec City and Montreal. People come here to fish for tomcod, "the little channel fish."

Mays described as "the vast indifference . . . to human scale . . . the unrelenting impersonality of the soaring walls of glass and blackened steel." But the aerial perspective reveals, by day or by night, the beauty of the downtown city of towers on the edge of the lake. The CN Tower, which author Robert Fulford likens to a "thick concrete pencil pushed through a gleaming steel donut," reaches up to and dwarfs the helicopter that buzzes around it like a lovelorn insect.

Between the south shore of Lake Ontario and the north shore of Lake Erie lies the Niagara Peninsula, its farm fields and vineyards neat and green. Niagara Falls is a cauldron of power, an absolute block to navigation on the lakes until the first Welland Canal was built in 1829. The present canal — the fourth in history — cuts a straight line across the peninsula from Lake Ontario to Lake Erie, the shallowest and second smallest of the lakes. Erie has been the most threatened of all the lakes, at one time almost choked by the pollution that intensive farming and urban living dumped on its shores and in its waters. Farther upstream, Lake Huron is two lakes in one, the broad, open, deep waters of the lake proper contrasting with the island-strewn reaches of Georgian Bay.

Within the triangle created by those three lakes lie the heavily populated areas of southern Ontario. This is an urban land, one of Canada's most citified corridors. The landscape from the air is one of tall buildings, tidy rows of houses, swimming pools of improbable blue, interlocking lines of streets and highways. Even the farmlands seem ordered: rectangles of green or gold squared by concession roads, with farmhouses neatly placed beside the roads.

The lakes, now slowly recovering from years of misuse and pollution, provide a refuge for city dwellers, who flock to the islands just off the Toronto waterfront, to the wineries and bed-and-breakfasts of Niagara, to the bird sanctuaries on the spits that reach out into Lake Erie, and to the beaches that line Huron's shores.

They go, also, to cottage country, the rocky forested area on the edge of the Canadian Shield between the Ottawa River and Georgian Bay, where cottages perch on rocky islets scarcely larger than themselves, on lakeshores, on riverbanks, by back roads through the woods. They go in all seasons, but none is more spectacular than autumn when a burnished sea of colour flows across the region from Quebec's Laurentians to the edge of Lake Superior. Writer Margaret Laurence disliked Ontario's urban landscape, but the countryside in autumn enthralled her. "These scarlet flames of trees," she wrote in *Heart of a Stranger*, "a shouting of pure colour like some proclamation of glory."

Beyond the urban reaches of southern Ontario, Lake Superior stretches: the farthest north, farthest west, deepest, coldest and, on its Canadian shore at least, the most untouched and wildest of the Great Lakes. Its windswept, rocky shores have inspired poets and songwriters such as Ian Tamblyn, who wrote in *Higher Plane*, "And the light goes on beyond my dreams,/Where the spirit grows and it never dies,/ Where the west wind blows and the jack pine leans."

At the end of the lake, Fort William and Port Arthur have been subsumed into the city of Thunder Bay. But the old names, one for a fur-trading fort, the other for a Great Lakes port, carry the romance of these Great Lakes and their history. Here, Lake Superior forms a closing curve to the great waterway that begins almost half a continent away. ❧

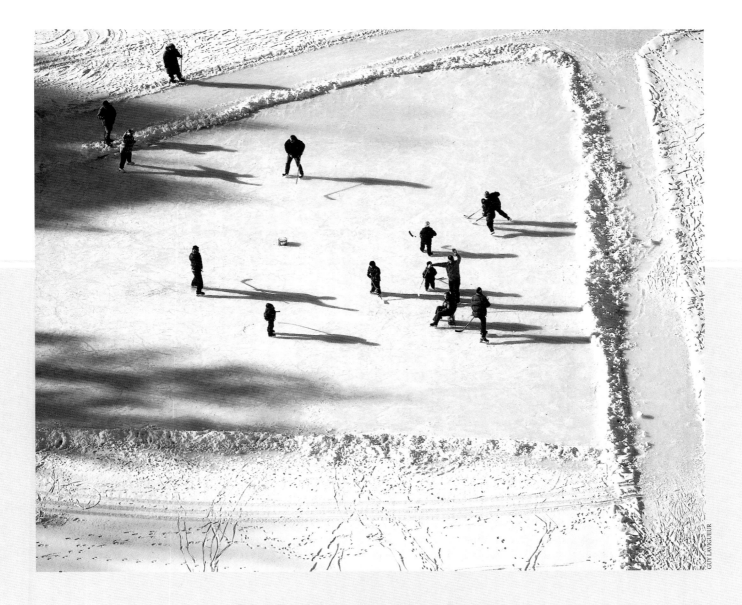

GUY LAVIGUEUR

ST. LAWRENCE WINTER

The cold, the storms, the exhilaration

In perhaps his best-known lyrics, Québecois singer-songwriter Gilles Vigneault declares that winter is the very soul of his country. Three centuries earlier, the cold, the deprivation — and the exhilaration — of winter played a large part in the words of almost every commentator who wrote about New France. For all the years that settlement on the St. Lawrence has existed, the storms and the playful pursuits of winter have loomed large in the collective consciousness of everyone who lives in this region.

The first snow usually falls in early November. By late November, ponds and lakes are beginning to freeze over. By mid-December, ice is slowly spreading out from the shore of the St. Lawrence near Quebec City

and along other narrow stretches of the river. By early January, icebreakers are at work in the river, keeping a channel open for ships destined for Montreal: since 1964, the port has operated year-round.

No one doubts that winter can be a serious matter: the paralyzing ice storm of January 1998 was a chilling reminder of winter's power. But the people of Quebec can also celebrate the season. At Christmas, vacationers latch skis on their roof racks and head for the Laurentians, the Eastern Townships, the Gatineau hills, the Gaspésie. At Ste-Anne-de-la-Pérade, downstream from Trois Rivières, and on a dozen other lakes and rivers, hundreds of ice-fishing huts are set up, and visitors engage in the yearly ritual of fishing for tomcod or lake fish.

January is the month for Carnaval: Quebec City's week-long winter celebration is the world's largest, with dozens of events ranging from the traditional — sleigh rides, dogsled races, ice canoe races across the St. Lawrence, snow sculpture — to the novel — ice mini-golf, group balloon-blowing, snow baths. Quebec City is not alone in celebrating winter. Towns from Chicoutimi to Sept-Îles to Baie Comeau to Montreal also stage winter carnivals.

above:

A pick-up hockey game takes place near Pointe-au-Chêne, northwest of Montreal.

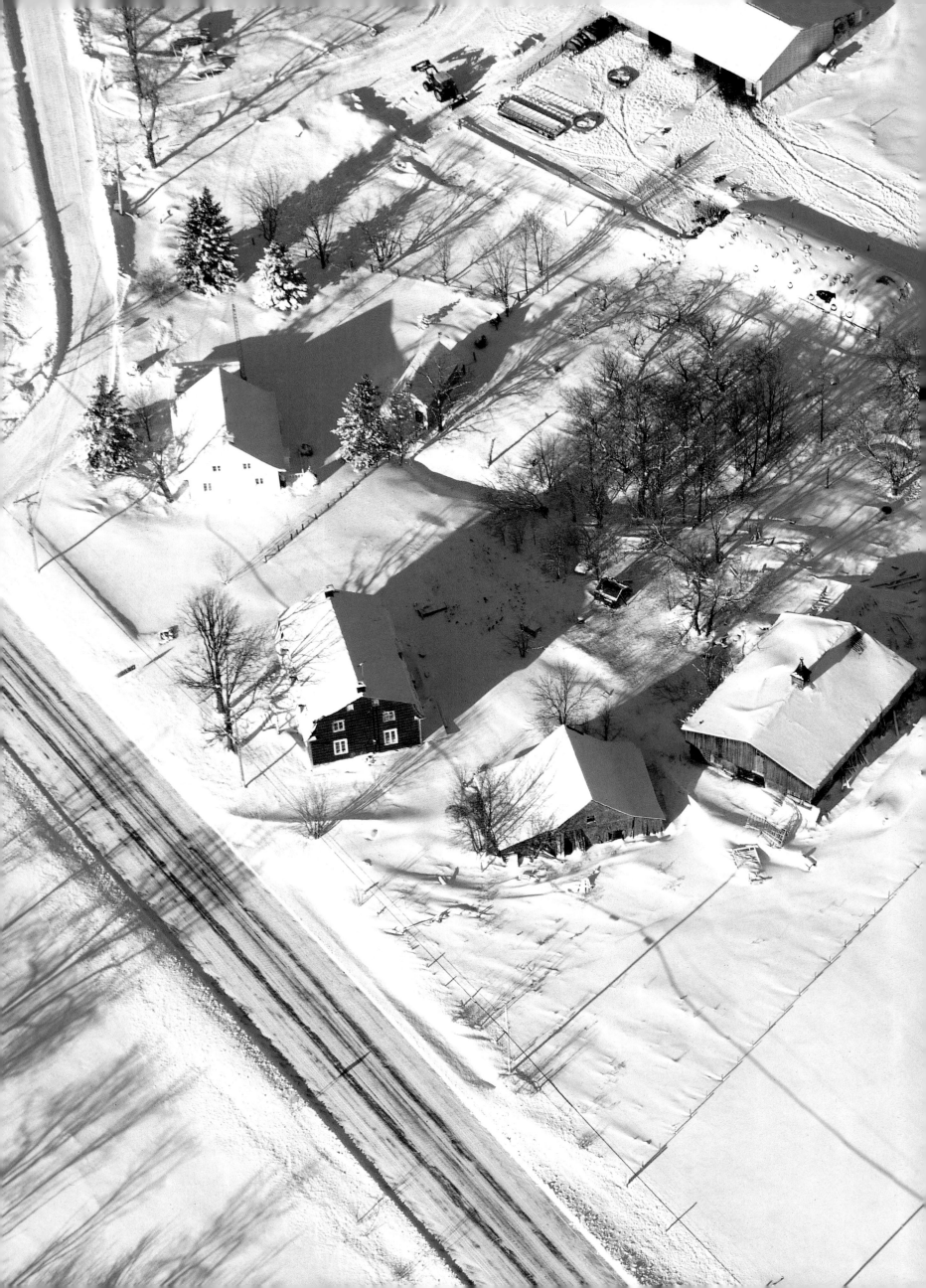

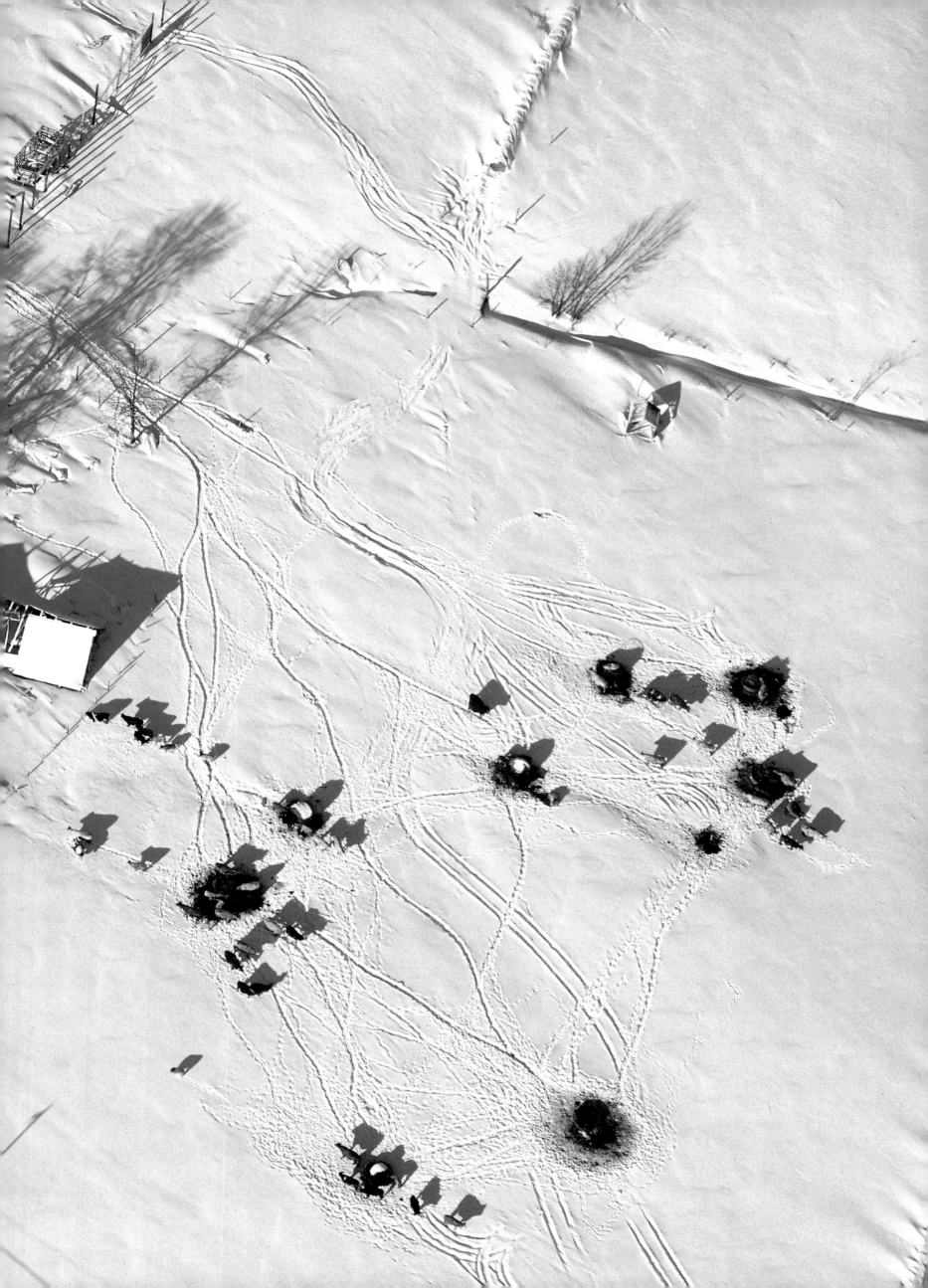

previous pages:

Cattle stand in the snow on a
farm on the St. Lawrence River's
north shore, between Quebec City
and Trois Rivières. GUY LAVIGUEUR

RUSS HEINL

above:

Montreal's City Hall, in Old
Montreal, was built in 1878 in
Second Empire style. It may be best
known as the building where French
president Charles de Gaulle made
his famous "Vive le Québec libre"
remark.

right:

North of the St. Lawrence in
Quebec, the Laurentians are famed
for the depth and brilliance of the fall
foliage that clothes the trees, hill
after hill.

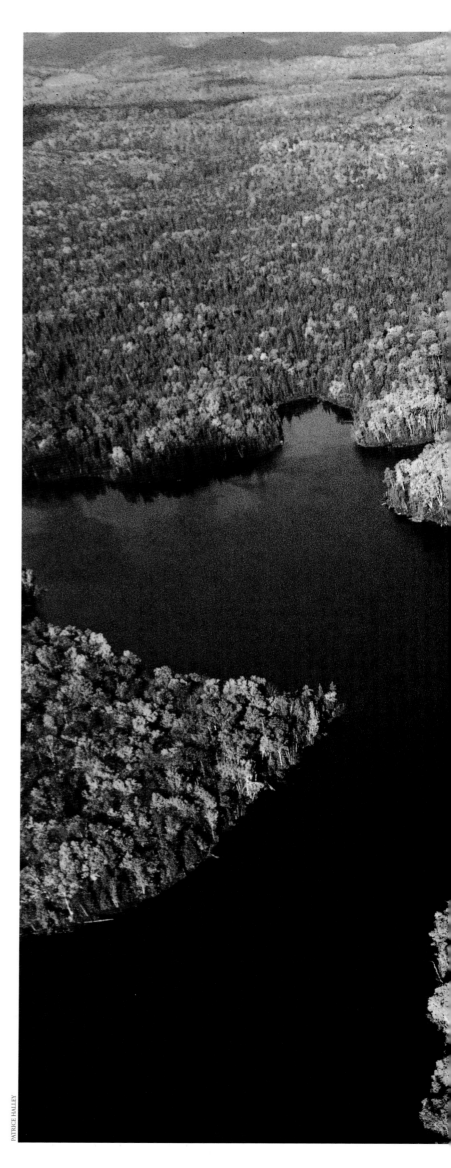

PATRICE HALLEY

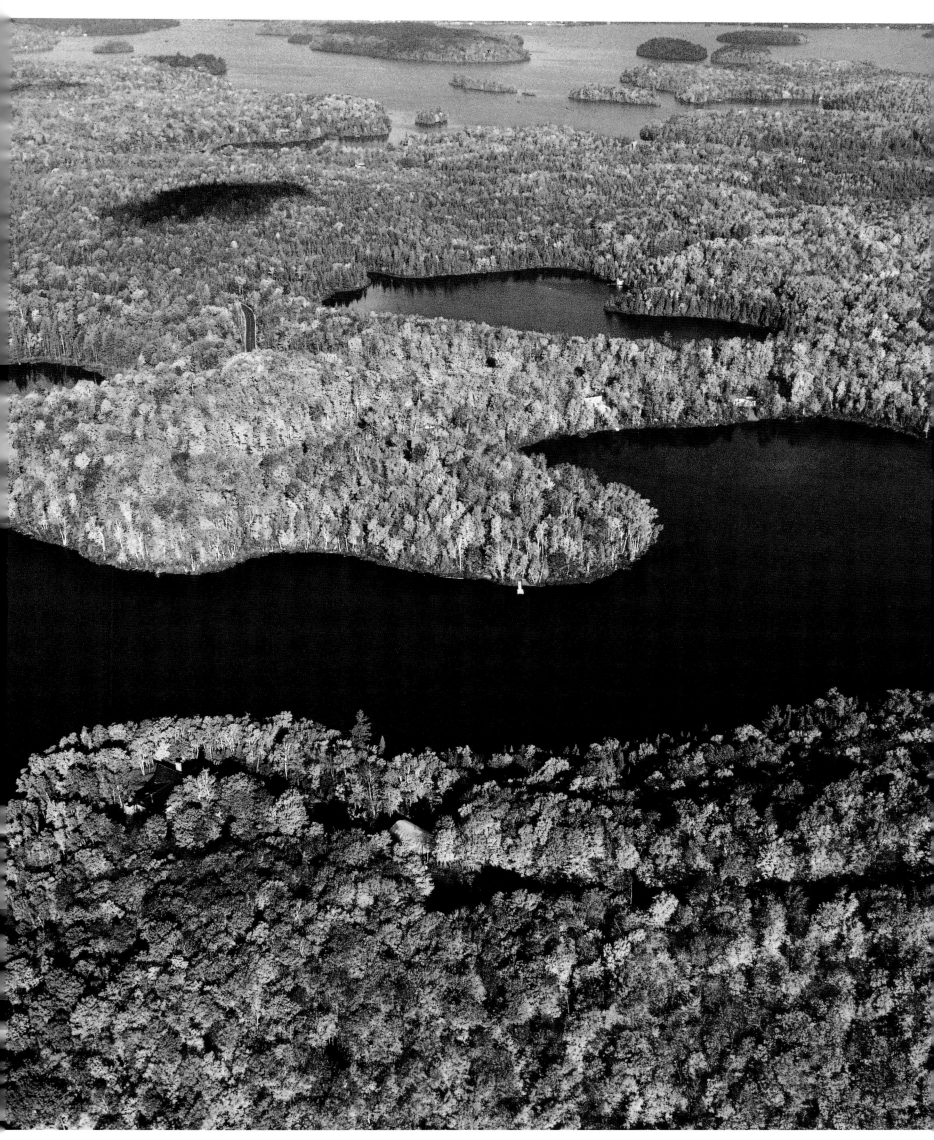

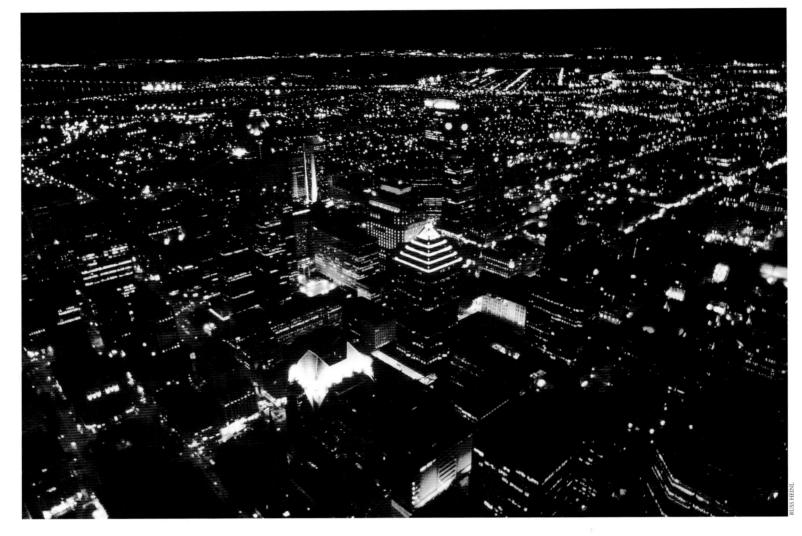

RUSS HEINL

above:

*T*he lighted buildings of Montreal in the city's night skyline stand against the dark flow of the St. Lawrence River.

right:

*F*arm crops form straight-line contrasting patterns in narrow fields near the St. Lawrence River.

GUY LAVIGUEUR

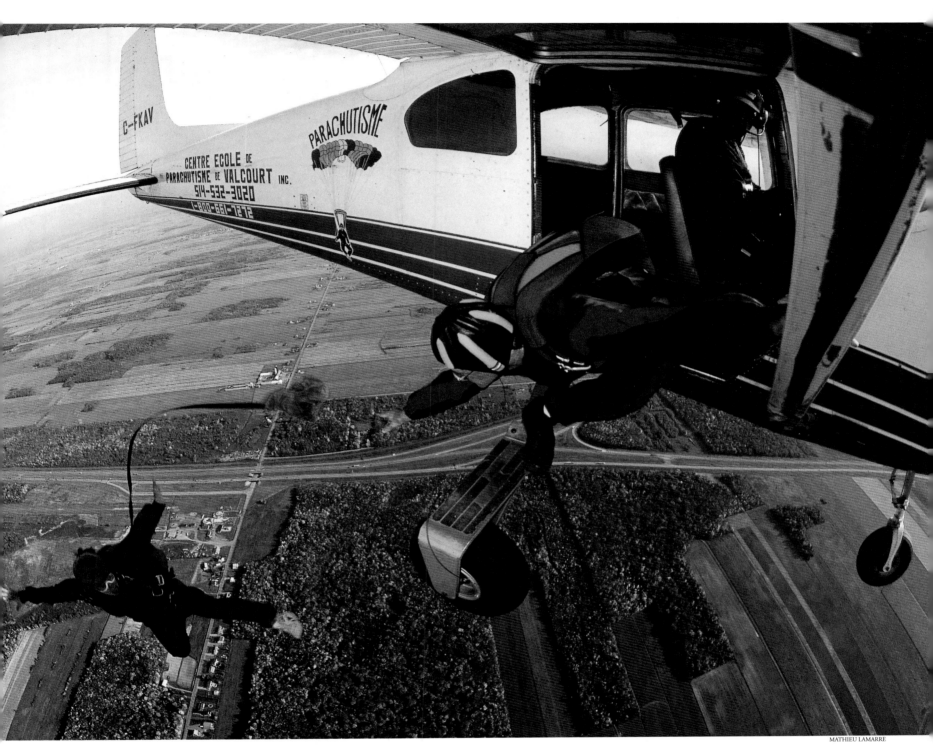

above:

A skydiver plunges toward the Earth over the autumn-coloured Montérégie region south of Montreal.

RUSS HEINL

above:

The long narrow fields established centuries ago in colonial Quebec still run back from the St. Lawrence River.

opposite:

Canada's Parliament Buildings, with the Parliamentary Library prominent on the left and the Peace Tower at the centre, rise above the Ottawa River in the nation's capital. The East and West blocks date from the mid-19th century, and the Centre Block was rebuilt after a fire in 1916. These Ottawa buildings are considered among Canada's best examples of Gothic revival architectural style. RUSS HEINL

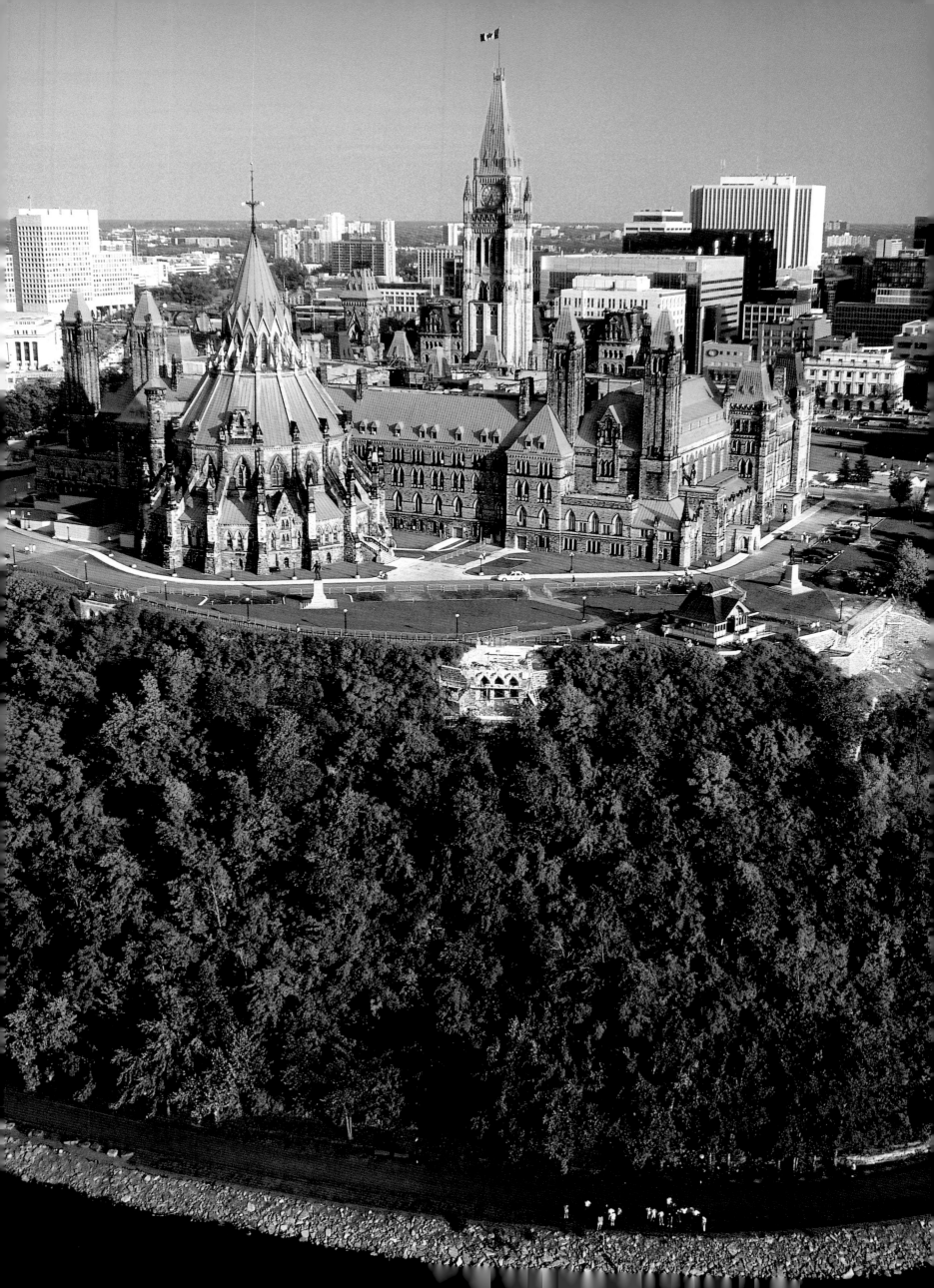

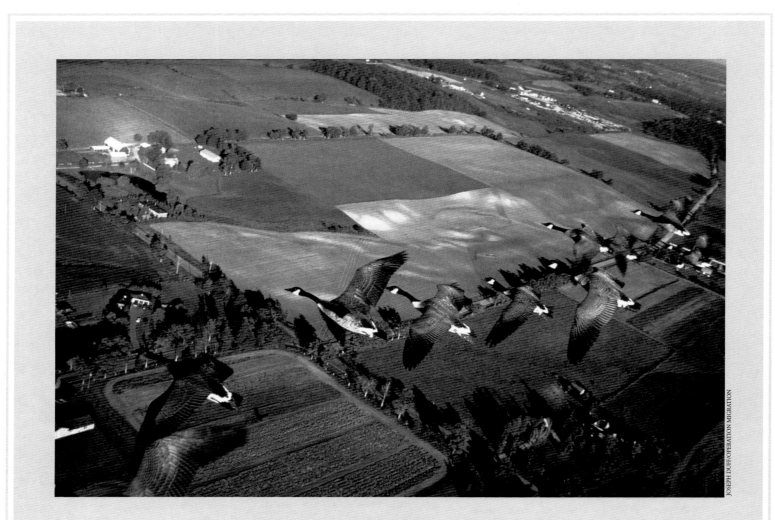

JOSEPH DUFF/OPERATION MIGRATION

OPERATION MIGRATION

Leading the wild geese

The wide V of Canada geese glides over southern Ontario farmland, their wings soft on autumn air that is filled with the sound of their hoarse cries. At the point of the V flies not a lead goose but an ultralight airplane.

It's been more than a decade since pilot Bill Lishman conceived his plan to imprint an ultralight on the consciousness of captive-raised migratory birds, so that he could lead them to their winter home in the United States. Birds raised in captivity, notes Lishman, have no leader to take them south; without this natural imprinting, they tend not to migrate. With an ultralight to lead them, he speculated, they would learn their traditional routes, and endangered or threatened waterfowl could be restored to areas where they had become scarce.

The initial experiments with Canada geese inspired the feature film *Fly Away Home*. Lishman and partner Joseph Duff then set their sights on helping to restore the North American population of whooping cranes, which now number fewer than 200 in just one migrating flock. Some whooping cranes have been raised in captivity, but they won't migrate; perhaps an ultralight imprinting course could teach them how.

Since an experiment with the very few whooping cranes and their eggs might further endanger that population, Lishman and Duff set to work with sandhill cranes, a non-endangered species. In the fall of 1997, the two led seven sandhills south to Virginia; the following spring, six of those birds returned to the vicinity of the fledging grounds near Port Perry, Ontario. "The whooping crane has been considered the icon of endangered species since that term was coined," notes Duff. "If we can help save this magnificent bird from extinction, maybe it will inspire others to take up the cause and return some of what man has taken from the world of nature."

above:

Canada geese, photographed from an ultralight, fly high above Ontario's Port Perry, northeast of Toronto.

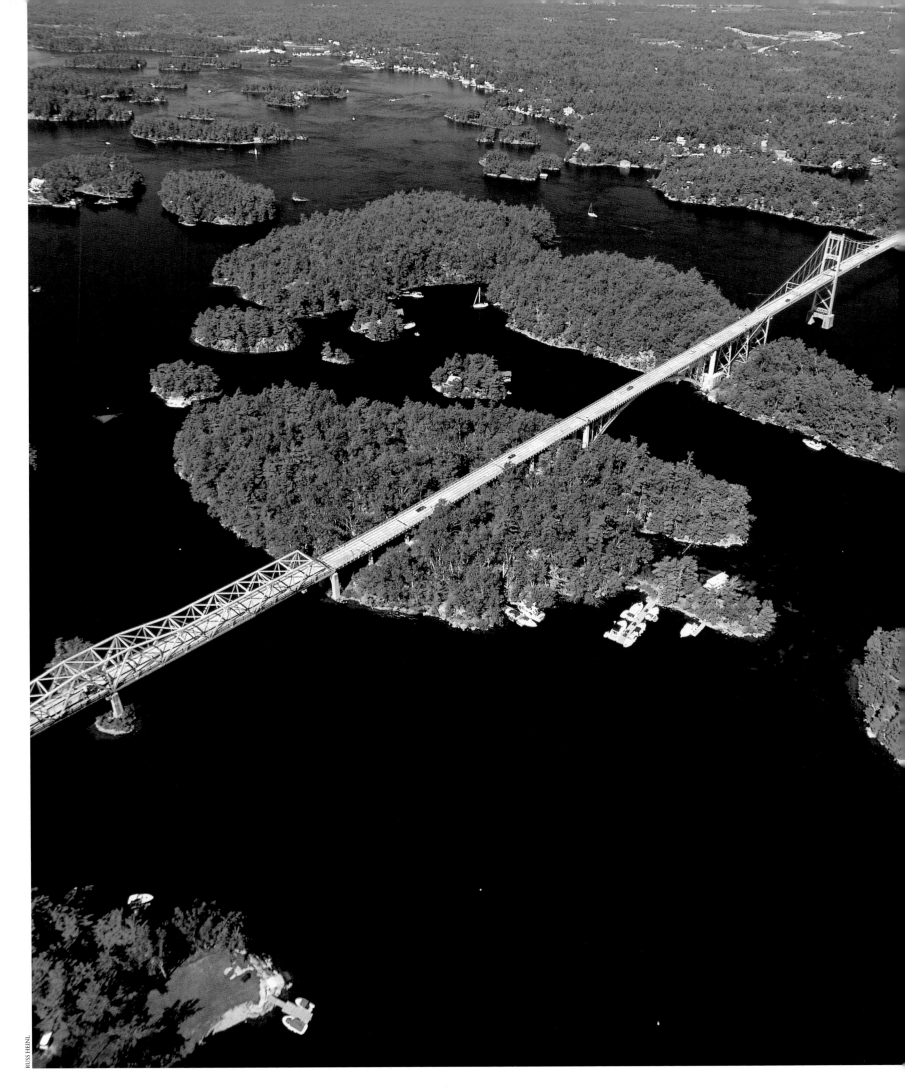

above:

*T*he Thousand Islands
International Bridge island-hops
across the St. Lawrence River near
Gananoque, Ontario, between the
Canadian north shore and the
American south shore.

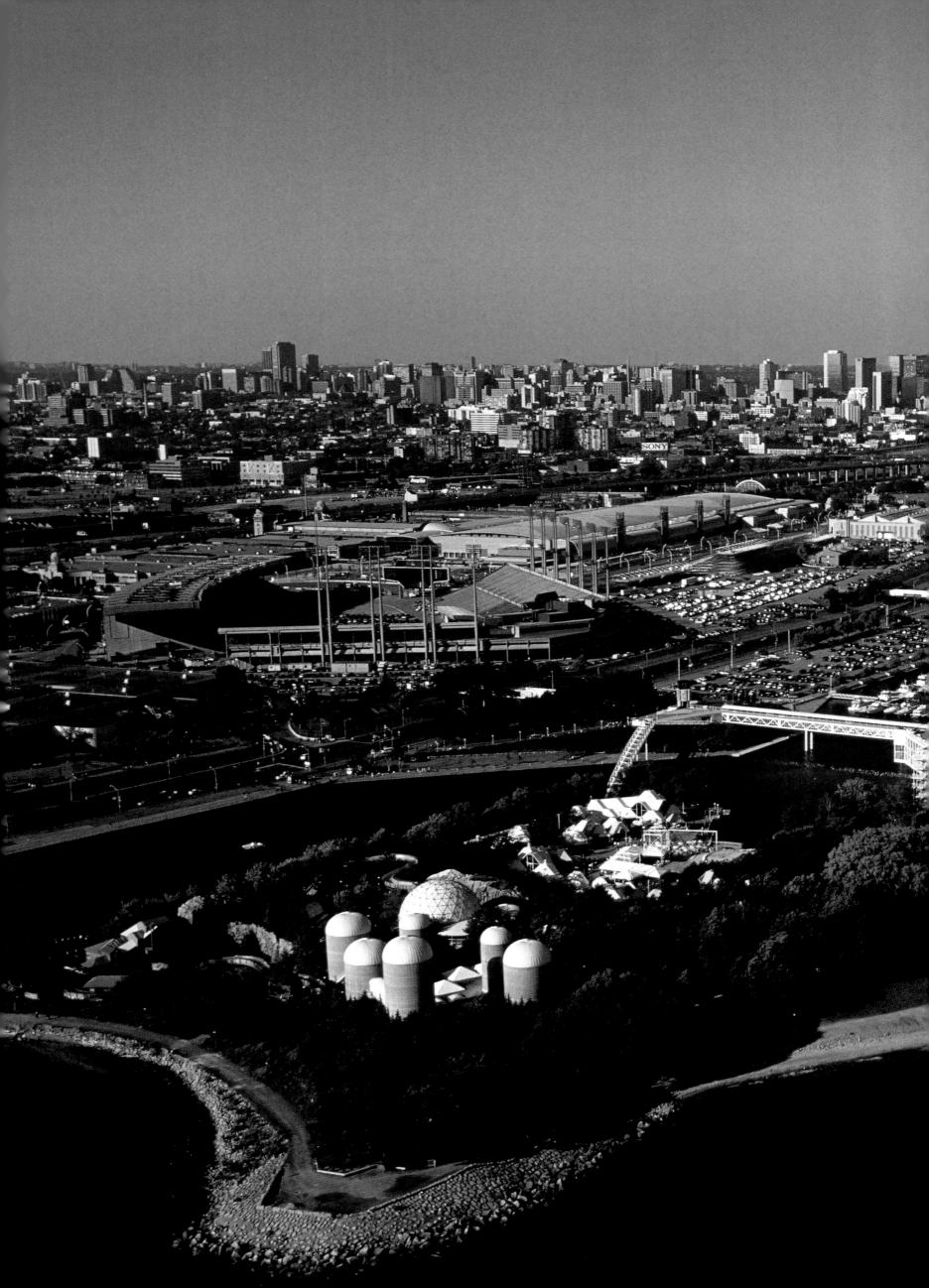

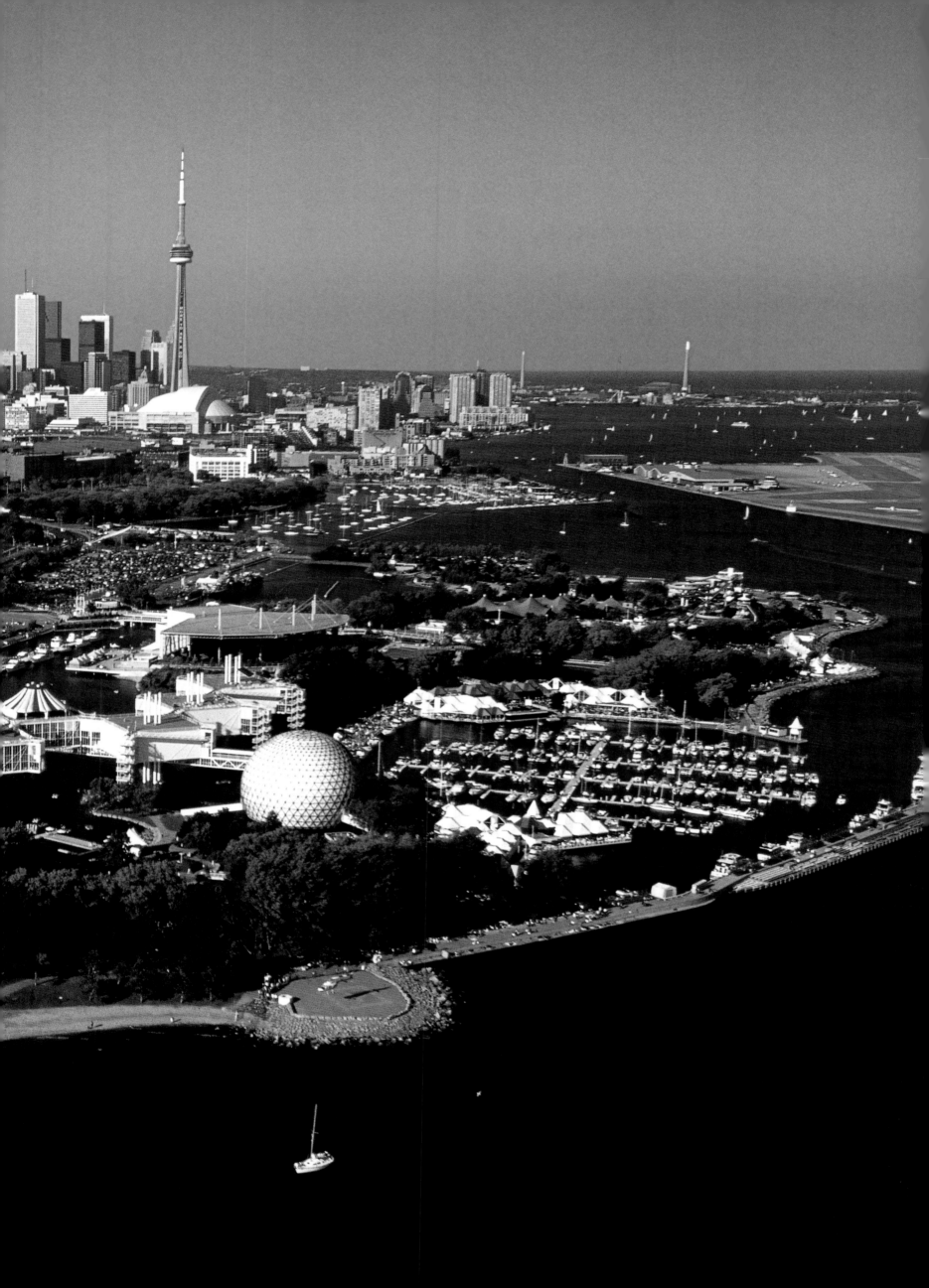

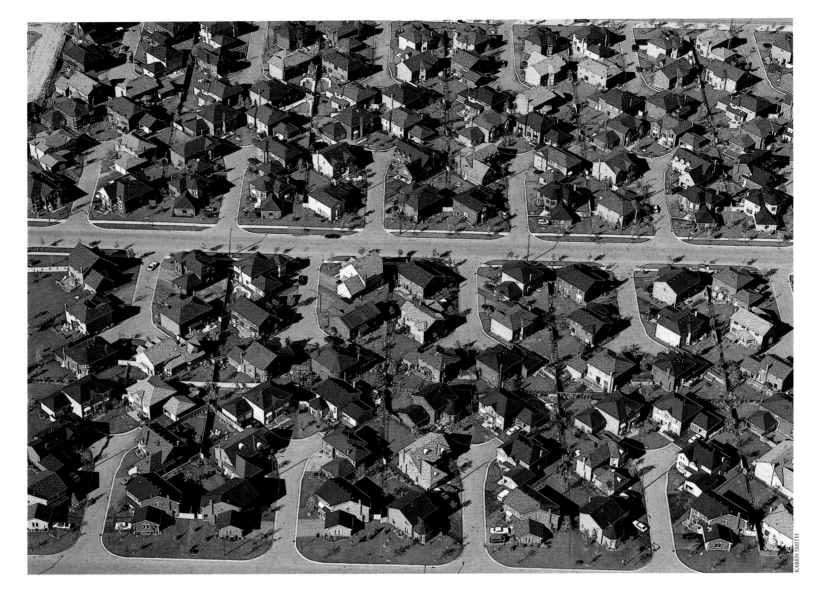

above:

*S*ubdivision houses in Meadowvale, just west of Toronto, create an unusual pattern.

previous pages:
Built on three manmade islands in 1971 as a cultural, leisure, and entertainment complex, Ontario Place fronts Lake Ontario near Toronto's downtown towers. With 2.4 million people, Toronto is Canada's largest city. RUSS HEINL

opposite:

*T*he original idea behind Toronto's CN Tower was to provide a television and radio antenna that would be taller than any other existing or future structure in the Ontario city. The idea grew: the world's tallest building, at 553.33 metres, the tower houses microwave receivers, a transmission antenna, entertainment facilities, restaurants, and elevators that convey almost two million visitors every year high above the city. RUSS HEINL

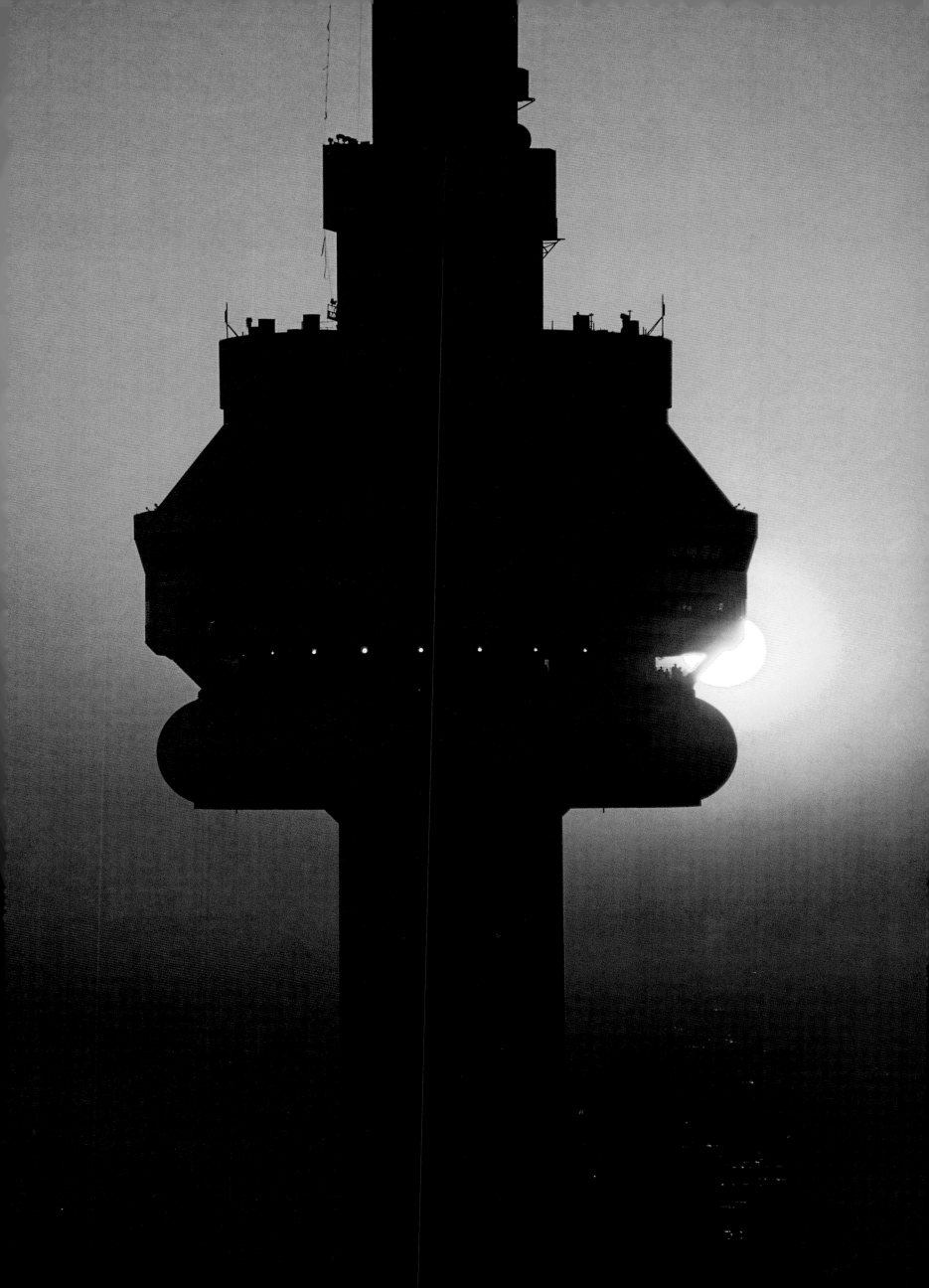

ON LOCATION

Hovering over Niagara Falls

The roar of the water thundering over the rocks below is audible even through the sound-blocking headphones, even over the steady whine of the helicopter engines and rotor blades. More than 150 million litres of water tumble over Niagara Falls every minute; the helicopter carrying photographer Russ Heinl hovers above this tumult, just back from the lip where the Niagara River plummets into a plume of mist and spray.

Below and level with the lip, a second helicopter, the red-and-white Twinstar used by the crew shooting the *Over Canada* high-definition film, hangs scant metres from the falling water, appearing and disappearing in the spray. Heinl leans against his safety harness, one foot out the open door of this Twinstar, seeking the best position from which to photograph the scene below. "Let's go a little higher," he says to pilot Dave Tommasini. "I'm having trouble with our blades getting into the frame." Then, via Dave to *Over Canada* pilot Jim Filippone, "Yeah, ahead, ahead, that's it, that's it, hold your spot! You're looking good."

But maybe not feeling so good. Air turbulence off the tumbling water can be unpredictable, and they're flying awfully close to the canyon walls. Heinl quickly completes his shoot, and the video crew films his helicopter as it sweeps along the Niagara River gorge.

This is one of the few times in their cross-country marathons that Heinl and the film crew working on the *Over Canada* project have met to photograph each other. Niagara Falls is a natural and expected highlight on everyone's list of sites that must be included in this documentary that shows Canada from the air. The Canadian falls, at 54 metres high and 675 metres wide, are more impressive by far than the smaller American falls, and have been a Canadian icon from the moment visitors first viewed them in the 17th century. The largest falls in the world by volume, Niagara shows up in the works of Charles Dickens, in a Czech folk song of longing for the wilderness, and in the honeymoon snapshots of millions of visitors.

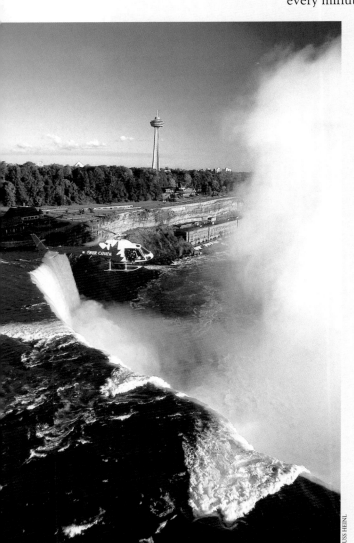

RUSS HEINL.

above:

The Over Canada *video helicopter hovers over Niagara Falls.*

above:

More water tumbles over
Niagara Falls, between Lake Erie
and Lake Ontario, than at any other
cataract in the world.

following pages:

The Niagara Peninsula and
distant Lake Ontario lie beneath
puffy clouds. The peninsula provides
some of Ontario's best land for
vineyards and orchards. *RUSS HEINL*

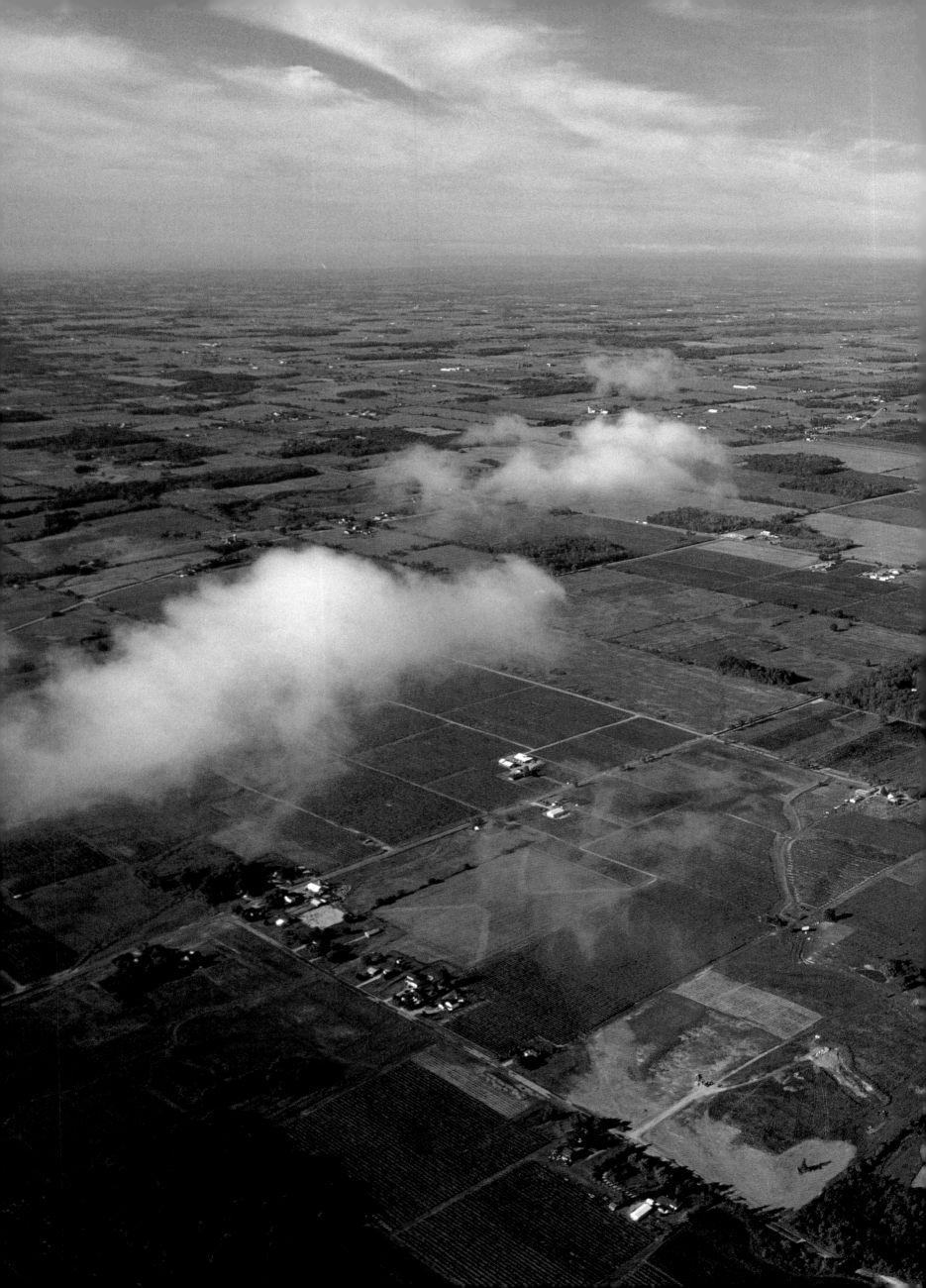

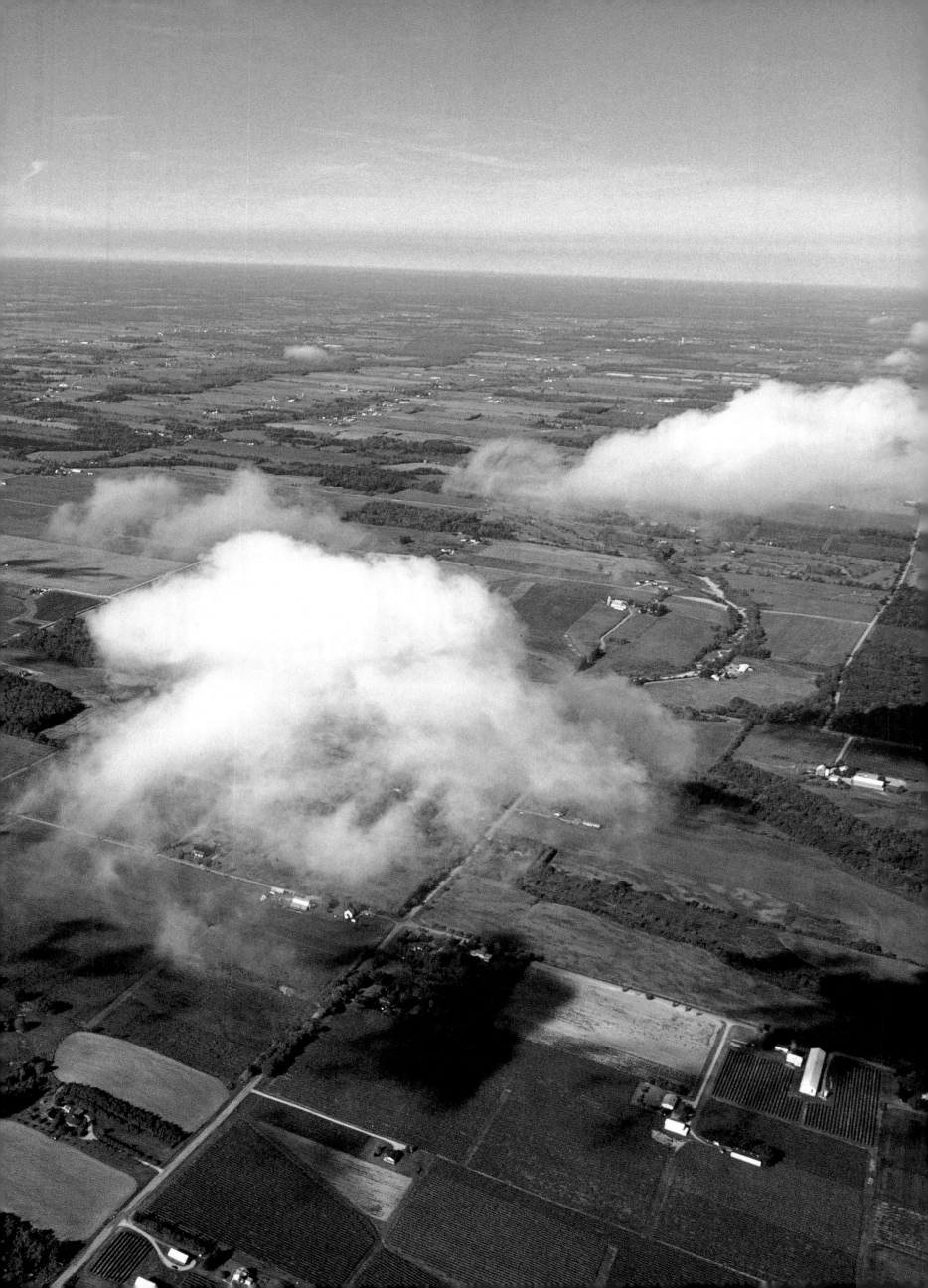

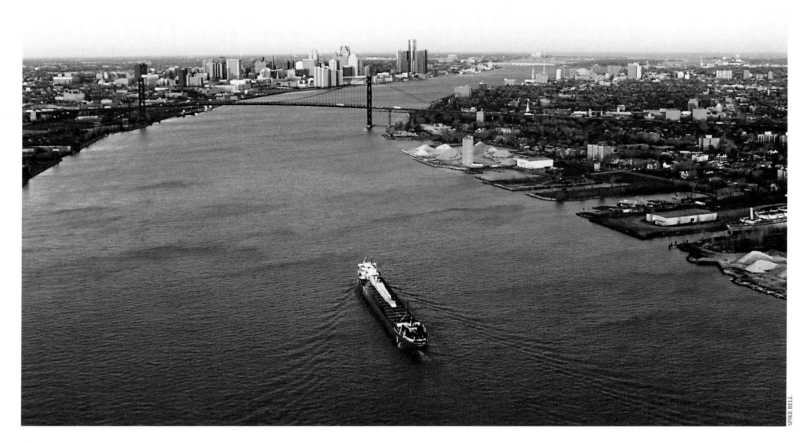

SPIKE BELL

above:

*T*he Detroit River, between Windsor, Ontario, and Detroit, Michigan, divides Canada from the United States.

right:
Farm fields show their autumn colours south of Peterborough, Ontario.

opposite:
The longest freshwater sandspit in the world, Ontario's Long Point stretches 40 kilometres out into Lake Erie. Recognized as a United Nations biosphere reserve, Long Point Provincial Park is a haven each spring for as many as 10 million migrating birds. The peninsula, its shoreline always growing and changing, has been built by sediments carried by southwesterly wind and shore currents. KAREN SMITH

BARRY FERGUSON

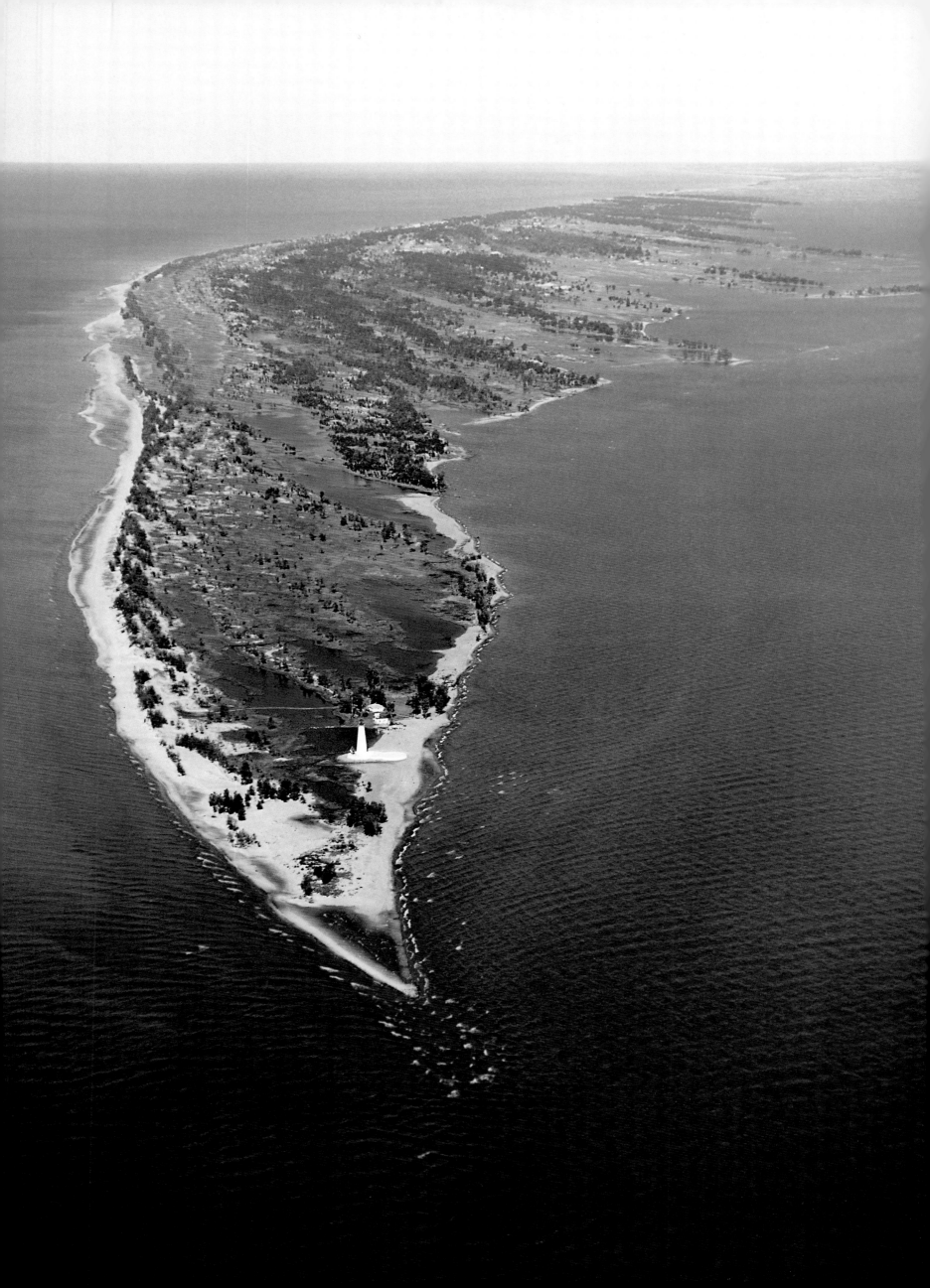

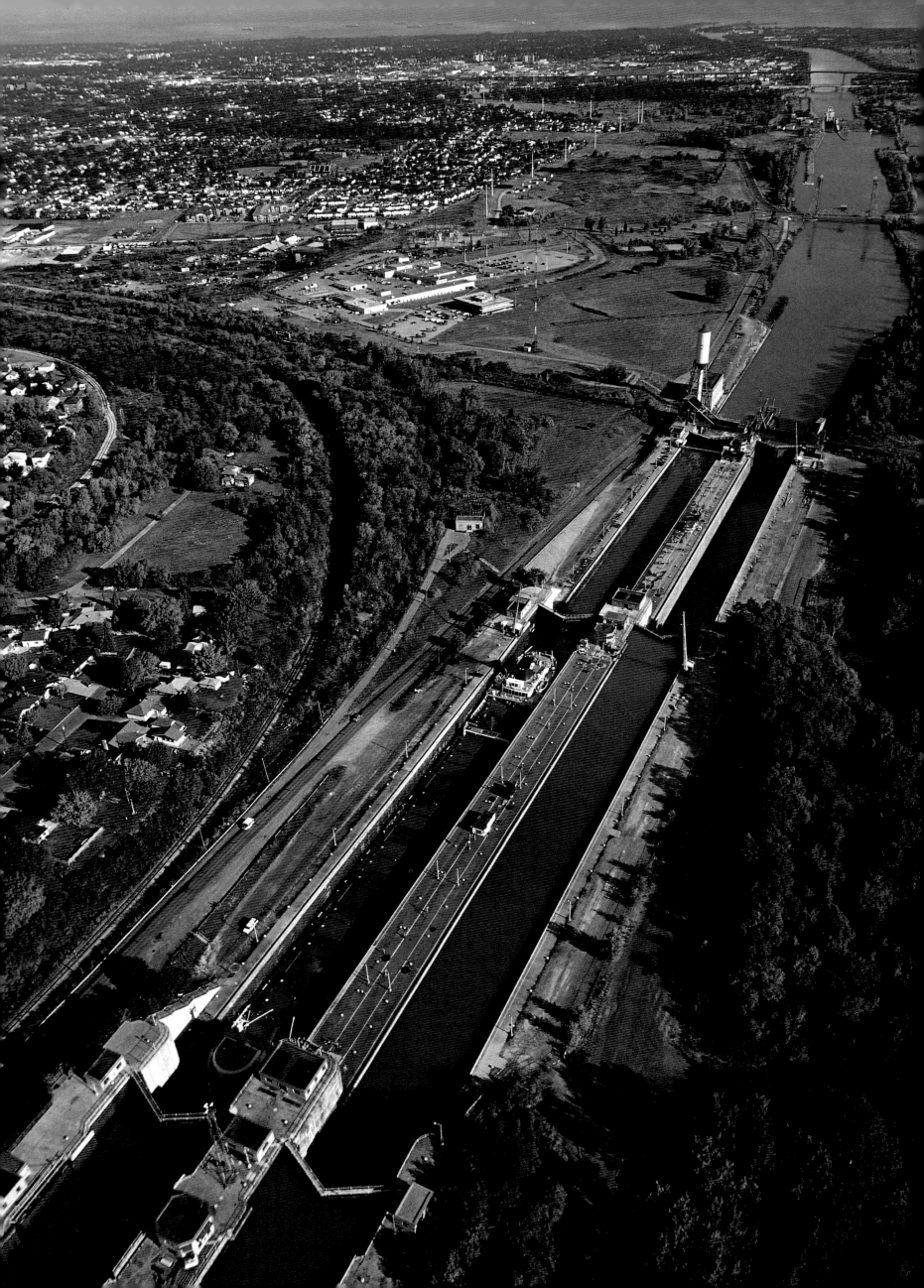

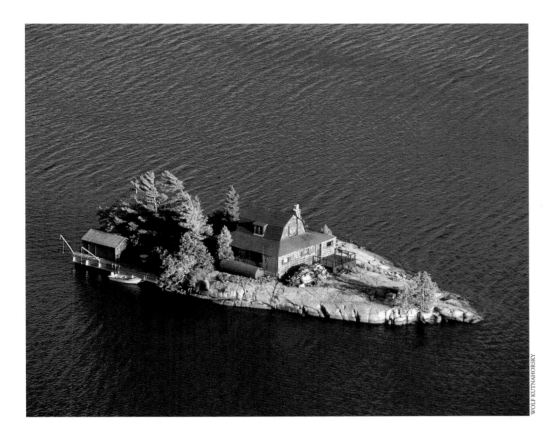

WOLF KUTNAHORSKY

left:

This cottage has tiny Pushwah Island all to itself, near Pointe au Baril on Georgian Bay, in the Thirty Thousand Islands region of Ontario's cottage country.

below:

This 1907 cottage sits on Lloyd Island, on Mississauga Lake in Ontario's Kawarthas.

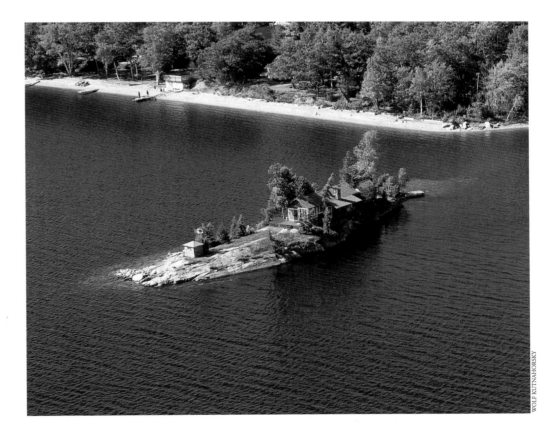

WOLF KUTNAHORSKY

opposite:

The 42-kilometre Welland Canal links Lake Ontario and Lake Erie across the Niagara Peninsula. The canal allows ships to bypass Niagara Falls, which had previously been an absolute barrier to through navigation on the Great Lakes.
RUSS HEINL

right:

The wharves of Thunder Bay, Ontario, mark the end — or the beginning — of the 3,700-kilometre St. Lawrence-Great Lakes waterway. It takes ships nearly nine days to make the journey via rivers, canals, and lakes.

opposite:

Ontario's Cove Island lighthouse, off Tobermory on Lake Huron, is one of Canada's best-known lighthouses. In Fathom Five National Marine Park, the beacon was built in 1858 to signal the entrance to Georgian Bay and the shoals and rocks that lie in wait for unwary mariners. RUSS HEINL

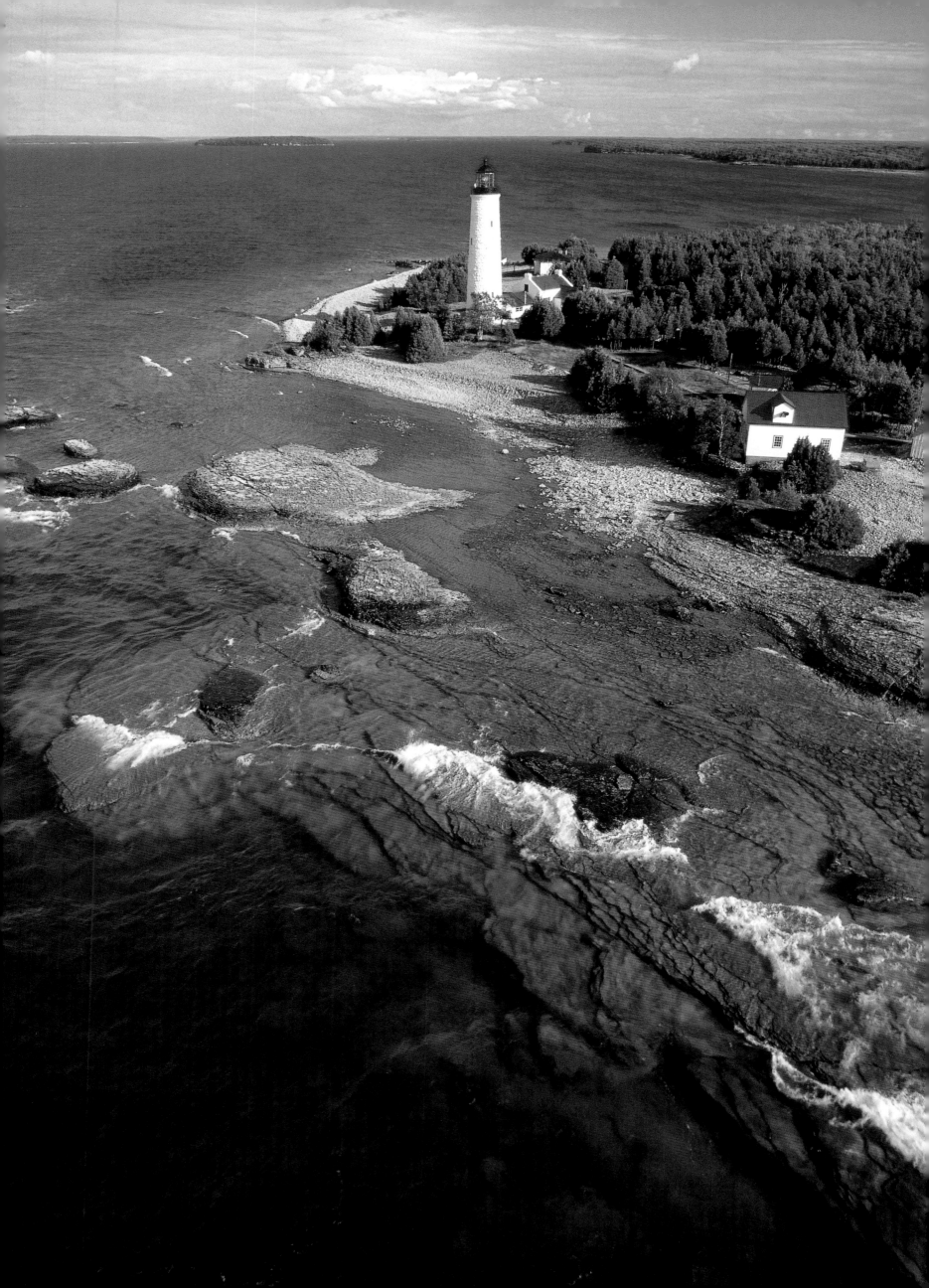

THE
CANADIAN
SHIELD

THE CANADIAN SHIELD
OUR QUINTESSENTIAL WILDERNESS

The lily pads and marsh plants show bright and paler green against the dark still water and its sinuous edging of shore. From the air, the scene is almost abstract art, an unruly pattern of colour and light that arrests the hovering eye.

The image is sister to photographs of scattered muskeg lakes, the muted tapestry of the barren lands, the silvered backs of a thousand caribou: aerial glimpses of the Canadian Shield. Of all of Canada, this region is uniquely suited to the aerial view: it often hides its beauty from those on foot, but reveals itself to those who fly above.

"When you're at ground level in boreal forest, you can't see 10 feet in front of you," says aerial photographer Tom Thomson. "From the air, you can see the patterns, you can watch the light and shadow move across the landscape. And it gives you such a sense of what it took to open this country up. How did the explorers and traders find their way through that mass of lakes and streams and bogs?"

Biologist Arthur Twomey flew north along James Bay in 1938. "I get an impression of the vastness of this country now such as I could get in no other possible way," he wrote in *Needle to the North*, thus becoming one of the first — but by no means the last — to note the way the landscape of the Canadian Shield unrolls below the wings of an airplane or the rotors of a helicopter. Now that Air Creebec and Air Inuit carry residents and visitors across the roadless wilderness of northern Quebec and Ontario, now that geologists and surveyors and tourists routinely tour the Shield country by helicopter, it has become almost commonplace to declare that only the aerial perspective can give a true picture of this enormous land of lakes, forest, muskeg, and rock.

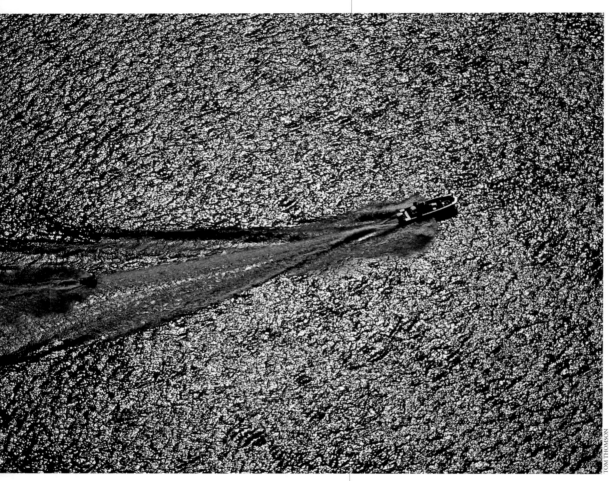

above:

Water sports attract residents and visitors alike to northern Ontario's thousands of lakes, where boating, swimming and fishing are time-honoured activities.

previous pages:
Aquatic plants form patterns along the Lake of the Woods shoreline in northwestern Ontario.
TOM THOMSON

opposite:

Algonquin Provincial Park, north of the most heavily populated areas of Ontario, has meant wilderness for the generations of city residents who value its forests, lakes, and wildlife. Established in 1893, it is Canada's oldest provincial park. RUSS HEINL

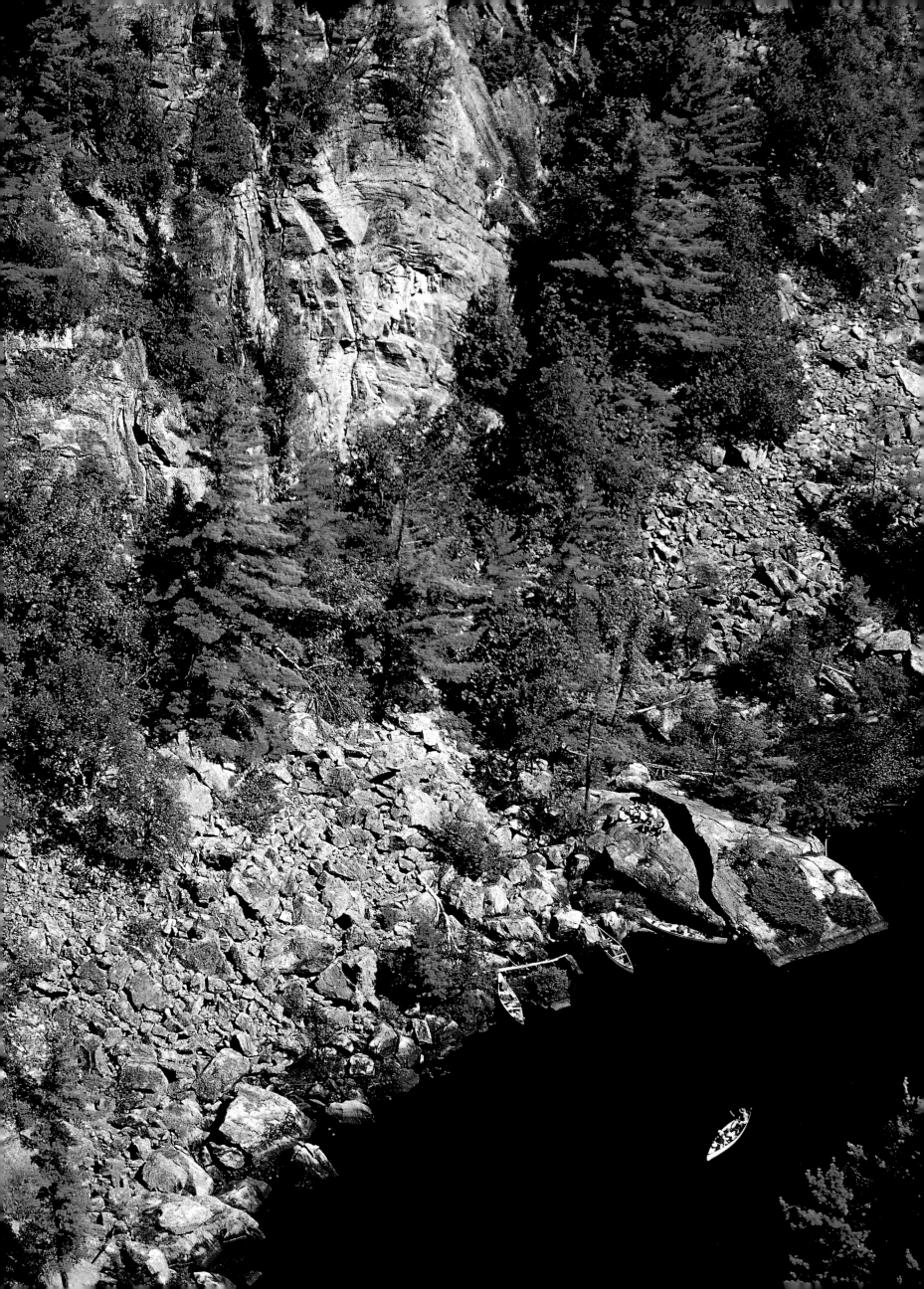

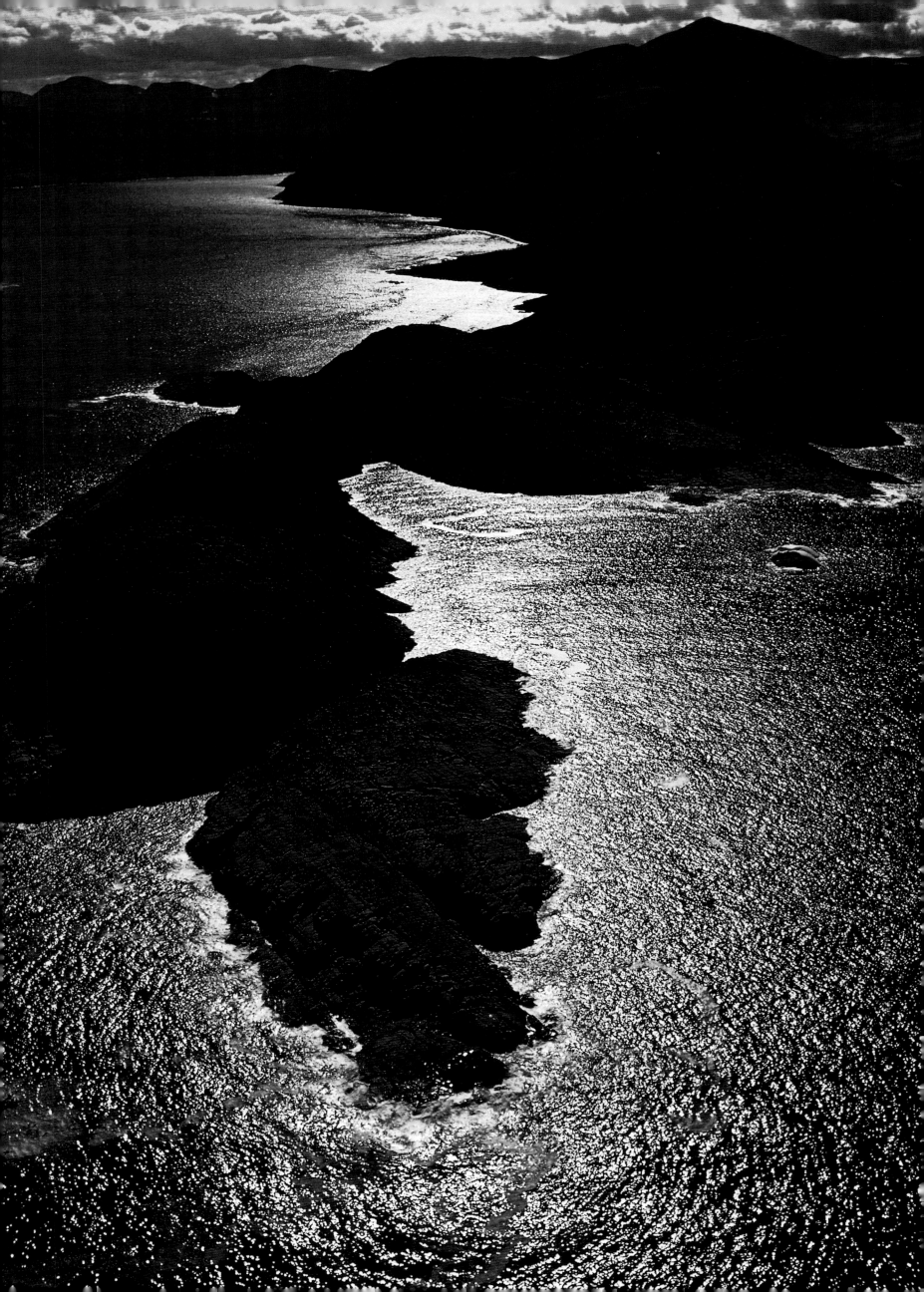

The definition of the Canadian Shield varies. In geological terms, it extends over almost half of Canada, from the St. Lawrence to the western Arctic. In this book, it is defined as the region north of the St. Lawrence River valley, the Great Lakes, and southern Ontario, south of the 60th parallel, east and north of the Prairies. By any definition, it is immense: it stretches more than 3,000 kilometres from east to west, and as many as 1,400 kilometres from north to south.

It is truly ancient Canada, the nucleus of the North American continent. It contains some of the oldest rocks in the world, forged in fire and fury up to 3.5 billion years ago, long before the collisions that glued the country's margins to the centre. For many Canadians, it is the quintessential wilderness, the land of the beaver and the voyageur taught in the nation's classrooms. We know it in some fundamental way, though we may have done no more than follow a highway across its southern edge, canoe one of its myriad lakes and rivers, or marvel at the striking starkness of a Group of Seven landscape painting.

The Canadian Shield has no truck with political boundaries, drawn straight and arbitrary across its smooth and ancient rock. The boundaries it recognizes are those of bush and barrens. The boreal forest covers almost all the southern Shield, shifting from a mixed forest of fir, spruce, and pine, with some deciduous trees, to repetitive, top-knotted black spruce that grow ever shorter as you move north. On the northern edges of the Shield are the barrens — treeless, rocky, thronged with lichens and daubed with dwarf willow.

On its eastern edge, the Shield rises from the Labrador Sea, where pack ice crushes against the shore from December to May, and icebergs trail along the coast in a complex journey that follows the ocean currents from Greenland. The Torngat Mountains rise starkly from the Labrador Sea, a fiord-indented bulwark on the wild northeastern coast. This is a rugged land, the mountains seem to say — enter at your own risk.

In 1903, American outdoor writer Leonidas Hubbard Jr. set out with a colleague and Cree guide George Elson to penetrate from the coast and north to Ungava Bay. Two months later, Hubbard was dead, his companion severely frostbitten and saved only by Elson's resourcefulness. To read today about their experience recalls the era before bush flying, when the wilderness of the Shield was all but inaccessible.

West from the coast, the land slopes into northern Quebec and the tundra land that is home to Innu, Inuit, and some of the world's largest caribou herds. Farther south, the Shield extends, rocky and forested, north of the St. Lawrence River and the Great Lakes. Along the Shield's southern edge in Quebec and in Ontario, the forests, lakes, and rivers serve as a playground for the people who live in the St. Lawrence Valley and in southern Ontario. Canoeists and hikers head out for the wild rivers and hills of Parc Jacques Cartier in the Laurentian wilderness, north of Quebec City; city dwellers thrill to the call of the wolf in Algonquin Park.

The towns and cities of central Quebec and Ontario — from Chicoutimi to Rouyn-Noranda to Timmins and Kapuskasing — live from timber cutting, milling, and mining the minerals of the Shield. Beyond the cities is the land of the Cree, whose vast traditional territories stretch from Hudson Bay's shores to the Shield's southern edges.

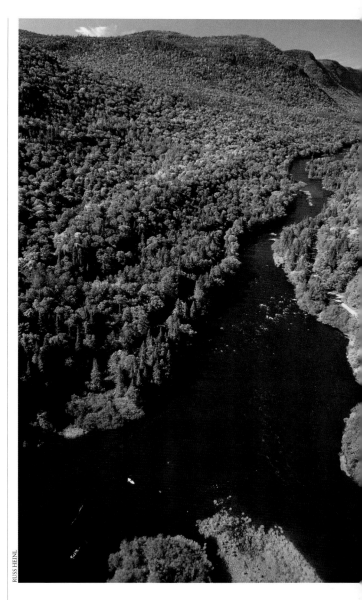

RUSS HEINL

above:

*J*acques Cartier Conservation Park, in the Canadian Shield north of Quebec City, is a recreational destination for city dwellers. Visitors come to hike, canoe, watch for moose, and listen for wolf calls.

opposite:
The word Torngat comes from the Inuktitut words for "home of the spirits." It is a fitting name for the forbidding Torngat Mountains that extend across northern Labrador from the Atlantic coast to the Quebec border. JANET FOSTER/MASTERFILE

below:

In Kenora, Ontario, residents don't put their canoes away at freeze-up, but keep them ready for the annual winter carnival. Participants in the annual ice-canoe race shown here have navigated open water and are crossing the ice to return to shore.

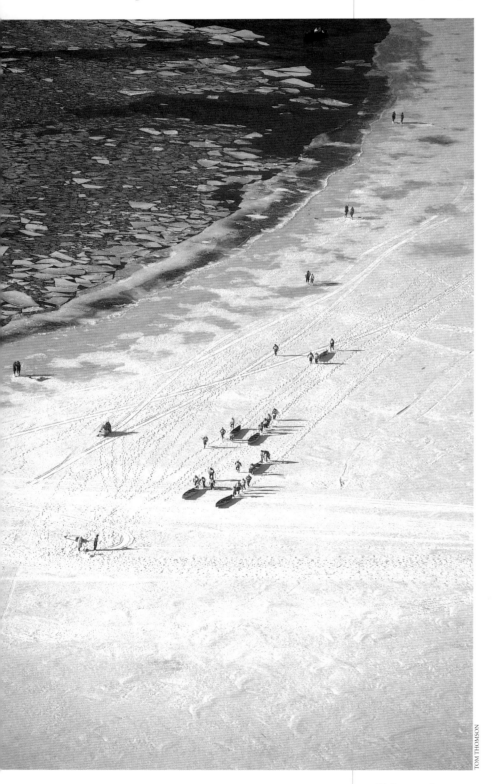

TOM THOMSON

Farther west, lodged between the western tip of Lake Superior and the eastern edge of Lake Winnipeg, the region of lakes and forest encompassing Kenora, Keewatin, and Lake of the Woods and cut through by the Trans-Canada Highway is popular with cottagers, fishermen, hunters, and other outdoor enthusiasts.

The farther north you travel, the fewer roads, the fewer people. Writer Paulette Jiles spent seven years in northern Ontario; in her book, *North Spirit*, she describes coming into the region by air: "Out the window, the Canadian Shield granites were tumbling into hills and distant cloud-blue shadows on the snowed-in forests. We were flying into wilderness, beyond the rail lines and the highways and the mines and the timber cuttings. It was one of the last places on earth where the environment was undisturbed, was moving in its long, original cycles of weather and animal life and vegetation."

Though the environment Jiles wrote about is increasingly touched by logging and other evidence of human intrusion, these northern realms still radiate a sense of wildness.

The Shield forms a huge U-shape around Hudson and James bays, whose western and southern shores are known as the Hudson Bay Lowlands. In *Marshwalker*, Manitoba poet John Weier depicts the region: "Flat, and hills and rough . . . masses and fields of rock, in jumbles, in piles and scattered. Grey rock, black rock, copper and golden-brown rock. Beaches of rock And trees. Stunted spruce and willow, dwarf birch. Krummholz near the shore, those one-sided spruce trees trained by wind and flying ice particles. Farther inland . . . miles of tundra, marsh, so many puddles and ponds."

Hudson Bay is a fabled name in Canadian history. On its shores almost 400 years ago, the men of the Hudson's Bay Company built their first forts; from here, they ran the fur trade in all the vast territory drained by the "rivers that run down to Hudson's Bay." The ruins of their empire still survive in the stone walls of Fort Churchill. Those who travel north these days come by train or plane, for there still are no roads to Churchill. Though some are lured by the intrigue of history, most come to see the polar bears that mass here in October and November.

The Canadian Shield anchors northern Manitoba and Saskatchewan and the northeast corner of Alberta. The northern boreal forest holds sway among the rivers and lakes that dominate the landscape. Here, where the Peace River drains down to the Slave River, many towns still bear the name of "fort," or are in French or native languages, and forest and sand dunes form fantastic patterns that enchant the visitor who looks down from the air. And each new pattern underlines the almost mythic fascination that the Shield provides. 🍁

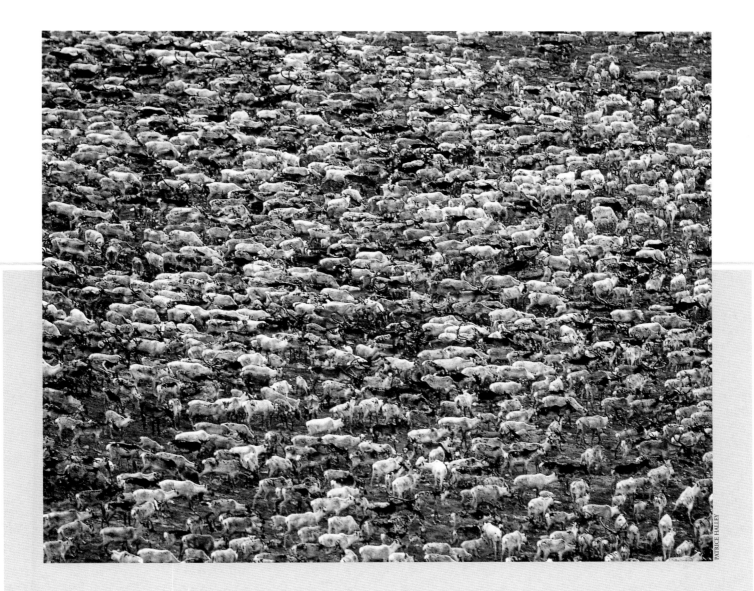

PATRICE HALLEY

THE CARIBOU OF GEORGE RIVER

A coursing mass, a Canadian symbol

At a cursory glance the photograph looks almost like rippled water, so tightly packed are the caribou that course through the frame. This George River herd that migrates across the barrens between northern Labrador and Hudson Bay is the world's largest, some 800,000 of the ungulates that have come to symbolize Canada's subarctic and Arctic regions.

Canadians see caribou every day, on the Canadian 25-cent piece. Woodland caribou live across the country in forests and mountains. Peary caribou make their homes in the Arctic islands. Barren-ground caribou — among them the George River herd — live near and north of the treeline, feeding on the lichens that grow in abundance in these regions.

Caribou have long been a mainstay of Canada's northern native peoples for food, clothing, and tools, as they have for native people in the boreal and subarctic belts around the Northern Hemisphere. Inuit are experimenting with herding caribou, in an attempt to ensure a stable food supply.

The George River herd migrates annually across northern Quebec and Labrador, pushed by the changing seasons and the availability of food. The number of caribou in the herd has been growing steadily. Some biologists and Inuit who rely on caribou for food suggest that the herd has grown too fast and too large: they think that overcrowding and stress on the herd's food supply may soon greatly reduce its numbers.

above:

The George River caribou herd in northern Labrador, Newfoundland, is awe-inspiring in its numbers.

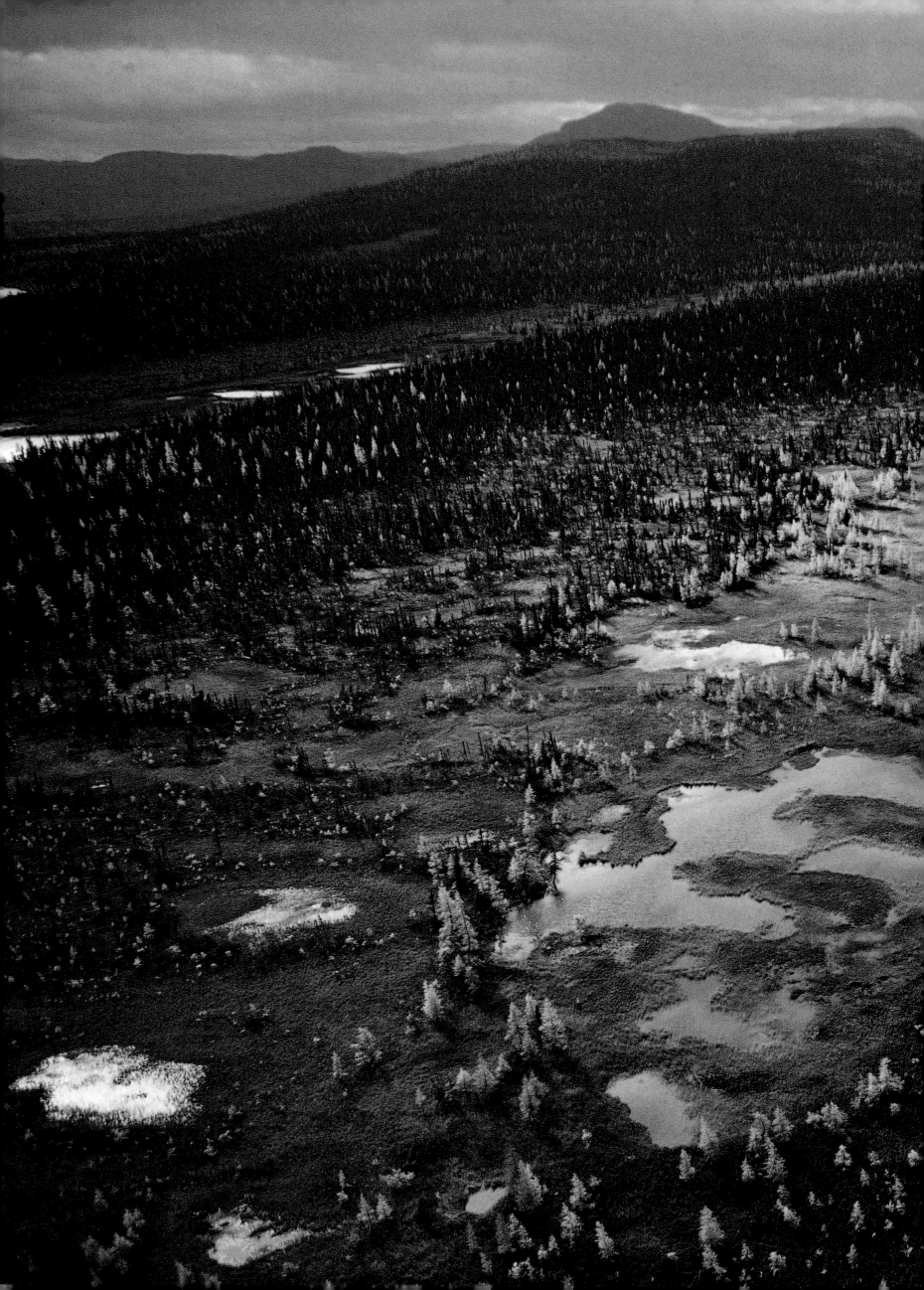

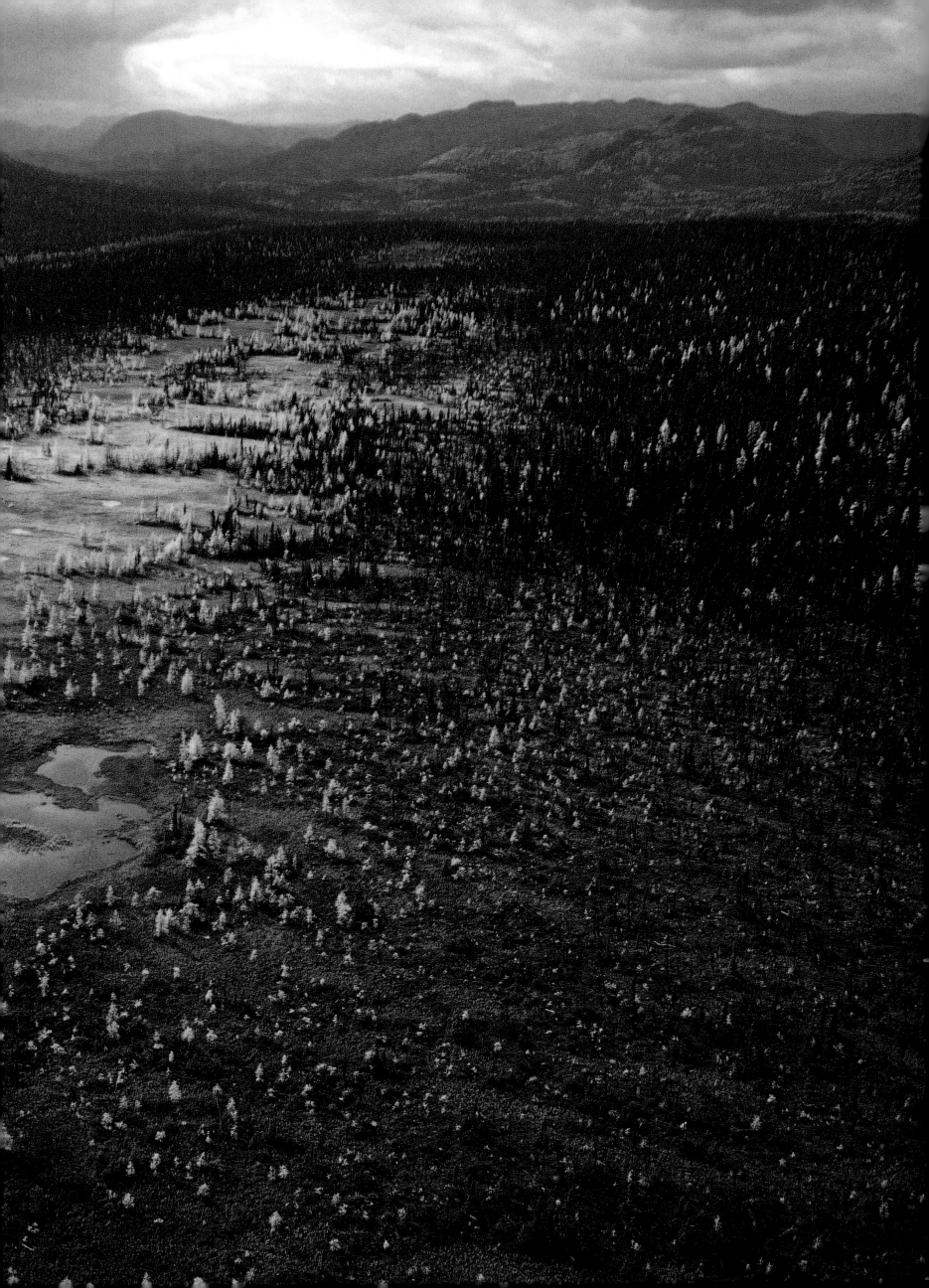

previous pages:

Sparse trees and low-lying vegetation weave a muted tapestry in Labrador's coastal hills inland from Davis Inlet.
OTTMAR BIERWAGEN/
SPECTRUM STOCK

MUSKEG
The great leveller of the Shield

For the builders of the Canadian Pacific Railway in the 1880s, the muskeg of northern Ontario had an almost monstrous presence, that of a great, greasy, sucking mouth that swallowed roadbeds and tracks, or spat them, twisted, into the air. Muskeg is the great leveller of the Canadian Shield, a boggy, peaty, moss-hummocked, watery landscape that ensnares those who try to cross it on foot, and blocks those who travel by canoe. More than the forest, more than the climate, more than the thronging insects, muskeg is the reason that the complete mapping of the Shield had to wait upon the coming of the airplane.

For muskeg to form requires a fairly flat environment, where more rain falls than can escape — a perfect description of much of the northern Shield. Plants such as sedges and shrubs grow in the standing water. The plants die, but do not decay completely, because there is little oxygen or bacteria available in the acidic water. Instead, they form peaty deposits that over time become a spongy layer at the bottom of the wetland.

Sphagnum mosses — their tiny leaves capable of holding 20 times their weight in water — grow upon this base, forming hummocks as much as half a metre above the water. In their turn, they die and partially decay, making the peaty layers at the bog's bottom ever thicker. Some areas of muskeg are pocked by these hummocks. In others, the mosses and sedges form long lines separated by water, in what biologists term patterned fens.

No one knows exactly how many square kilometres of muskeg exist on the Canadian Shield. But everyone who lives there knows just how much of a barrier it poses.

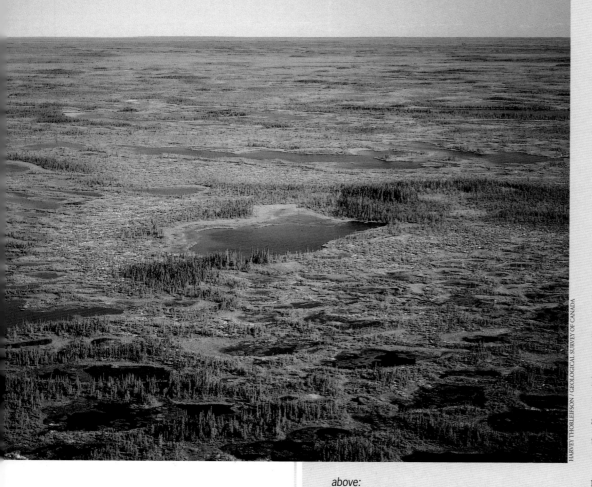

HARVEY THORLEIFSON / GEOLOGICAL SURVEY OF CANADA

above:

Muskeg covers the land near Attawapiskat, northern Ontario.

opposite:

Cross-country skiers in the Abitibi region of northwestern Quebec write birthday greetings in the snow at the Lake Abitibi nordic ski crossing.
GAÉTAN FONTAINE

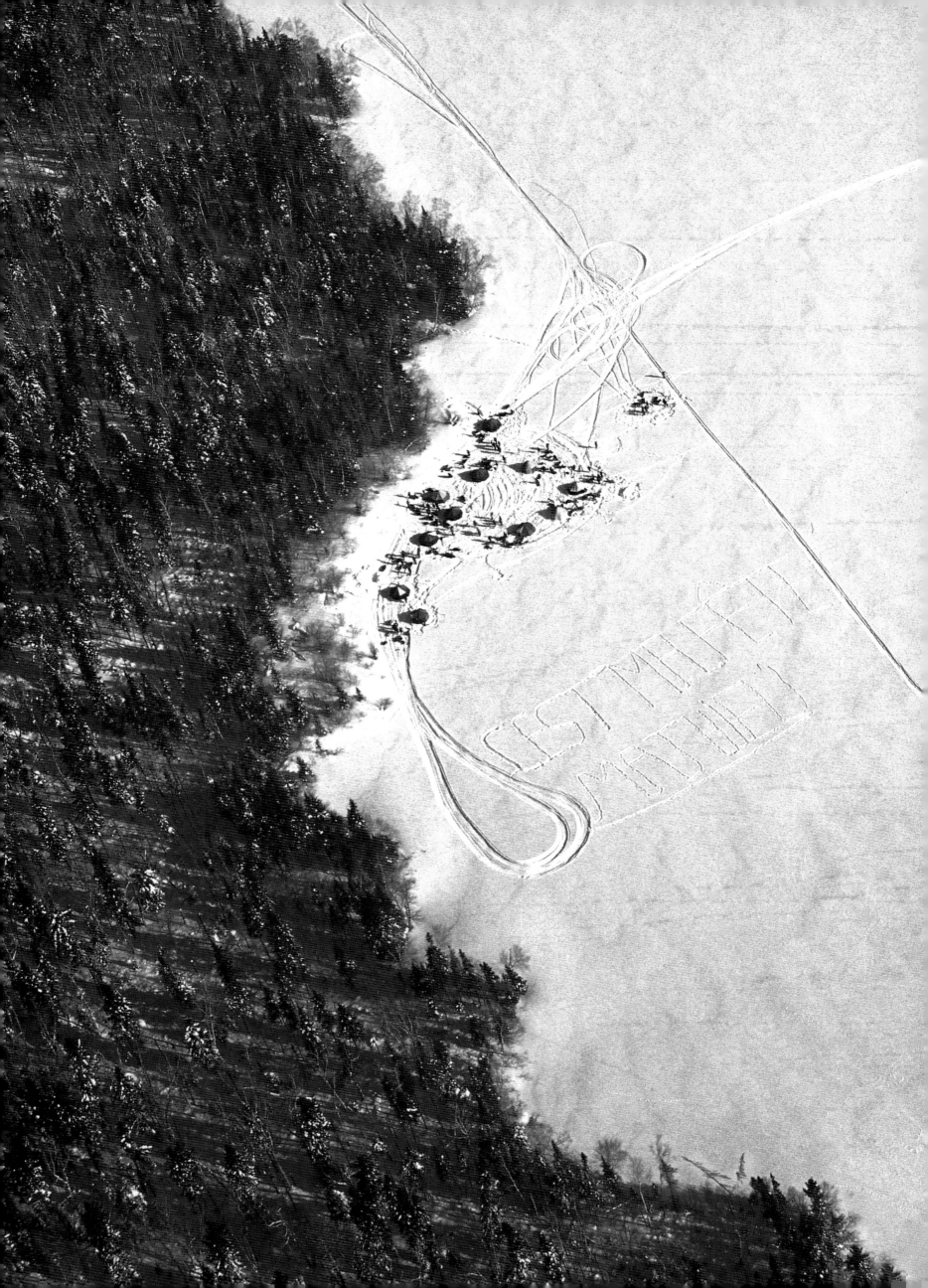

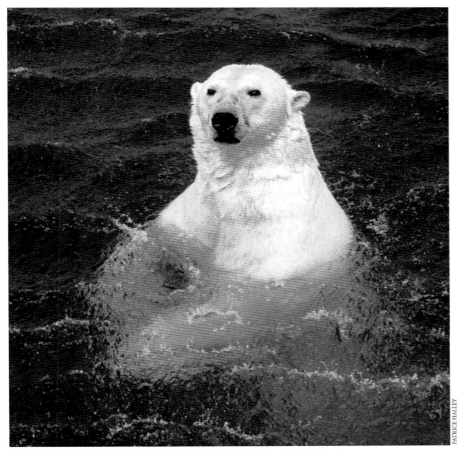

PATRICE HALLEY

A polar bear enjoys a bath at Ontario's Polar Bear Provincial Park on the western shores of James and Hudson bays. As many as 200 bears spend late fall and early winter here, in the largest and farthest north of Ontario's provincial parks.

Near Keewatin in northwestern Ontario, birds wheel above the shoreline of a Canadian Shield lake.
TOM THOMSON

An excursion train rides the rails on the Agawa Canyon run, northwest of Sault Ste. Marie, Ontario.

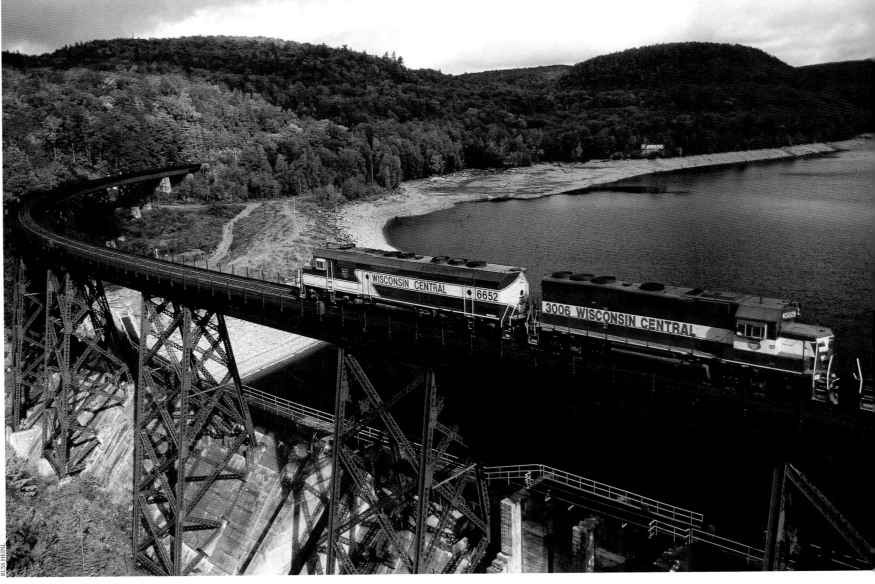

RUSS HEINL

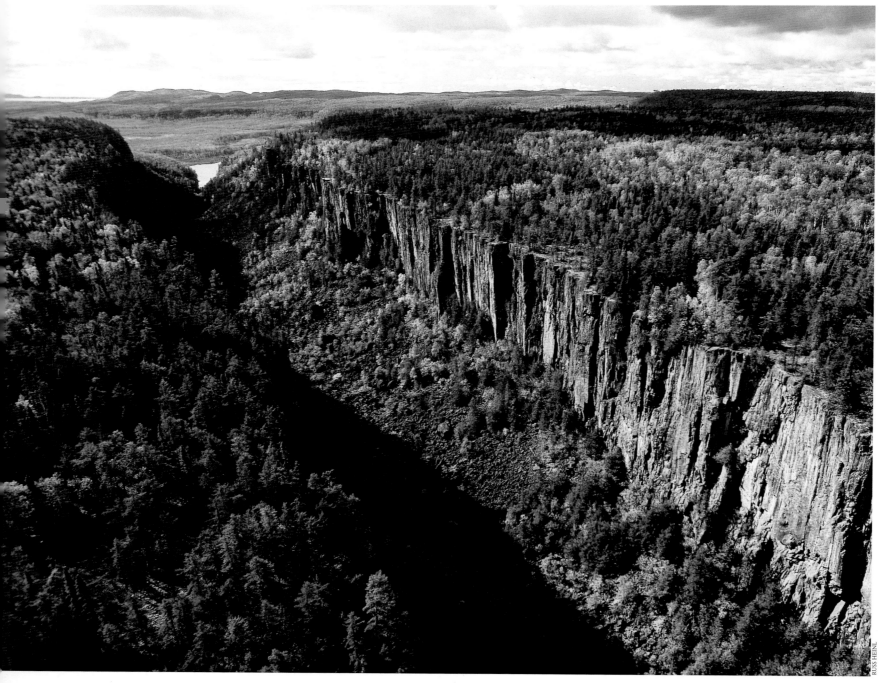

RUSS HEINL

above:

*O*uimet Canyon cuts deeply into
the rock north of Lake Superior,
northeast of Thunder Bay, Ontario.
The walls of the spectacular canyon,
150 metres across and 100 metres
deep, display a columnar appearance
characteristic of volcanic rock.

opposite:

*F*ort Chipewyan was founded on
the red granite shores of Lake
Athabasca in 1788 as a fur-trading
post, and is the longest continuously
inhabited settlement in Alberta.
Some 800 Cree, 250 Athabasca
Chipewyan, 180 Métis, and 170
others live in the area. RUSS HEINL

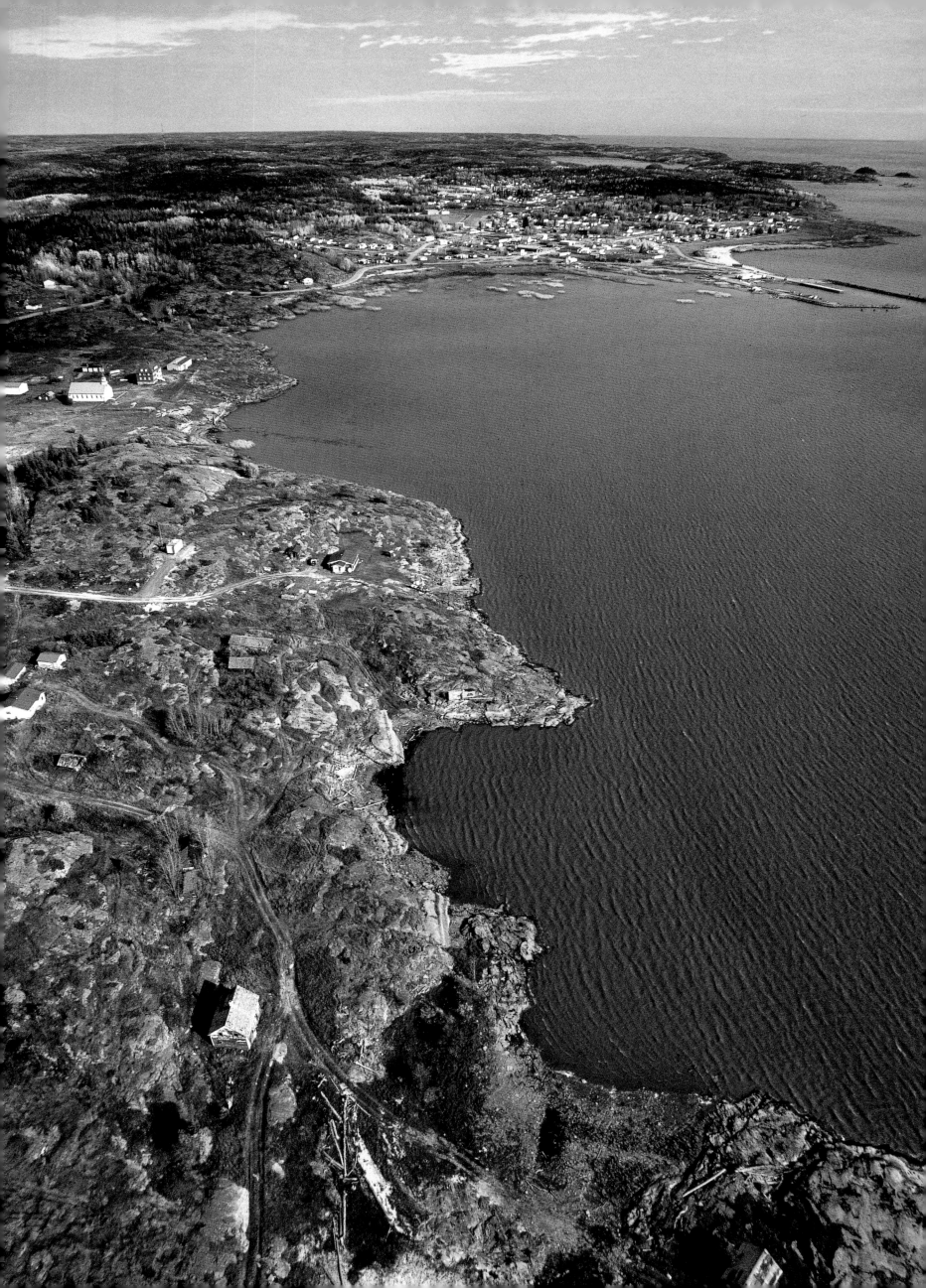

ON LOCATION

The Athabasca Sand Dunes

Photographer Russ Heinl had come by helicopter from Edmonton to Athabasca country, and it was turning out to be a long day. Already he had photographed the Alberta oil sands, Wood Buffalo National Park, and Fort Chipewyan, all of which more than rewarded his expectations. Now he had to decide whether it was worthwhile to journey on to the south side of Lake Athabasca to photograph the sand dunes.

"I've photographed a lot of sand dunes, from Portugal to Oregon," he recalls, "and they looked flat and featureless from the air." But the dunes were on his must-get list, so he decided to travel on.

What he saw overwhelmed him. "We came up on this thing, and I couldn't believe it was in Canada. It looks like the Sahara — you expected a camel to come walking along. And once I got over the shock of how big it was and how exciting it was, there was the problem of how to photograph it. I was bent on making it look as much like the Sahara as possible, as big as possible, to show it from as low as possible and to use the shadows to make it look high."

These dunes in northern Saskatchewan have astonished most who have come upon them. "If we had to choose one word to describe the Athabasca Sand Dunes," write Robin and Arlene Karpan in *Northern Sandscapes*, "it would surely be 'magical'."

These are Canada's largest active dune fields. Growing and changing as the wind sweeps the sand across the landscape, they stretch for about 100 kilometres along the lakeshore. They originated from sandstone exposed when the glaciers retreated 10,000 years ago; the sediments on the old river delta were swept into parabolas and ridges that today are as high as 35 metres. The forces of erosion have also carved changing channels in the William River that runs through the dune landscape, creating fantastic patterns in the braided riverbed.

left and right:

An unexpected sight in Canada's wilderness is the windswept expanse of the Athabasca Sand Dunes in northern Saskatchewan.
RUSS HEINL

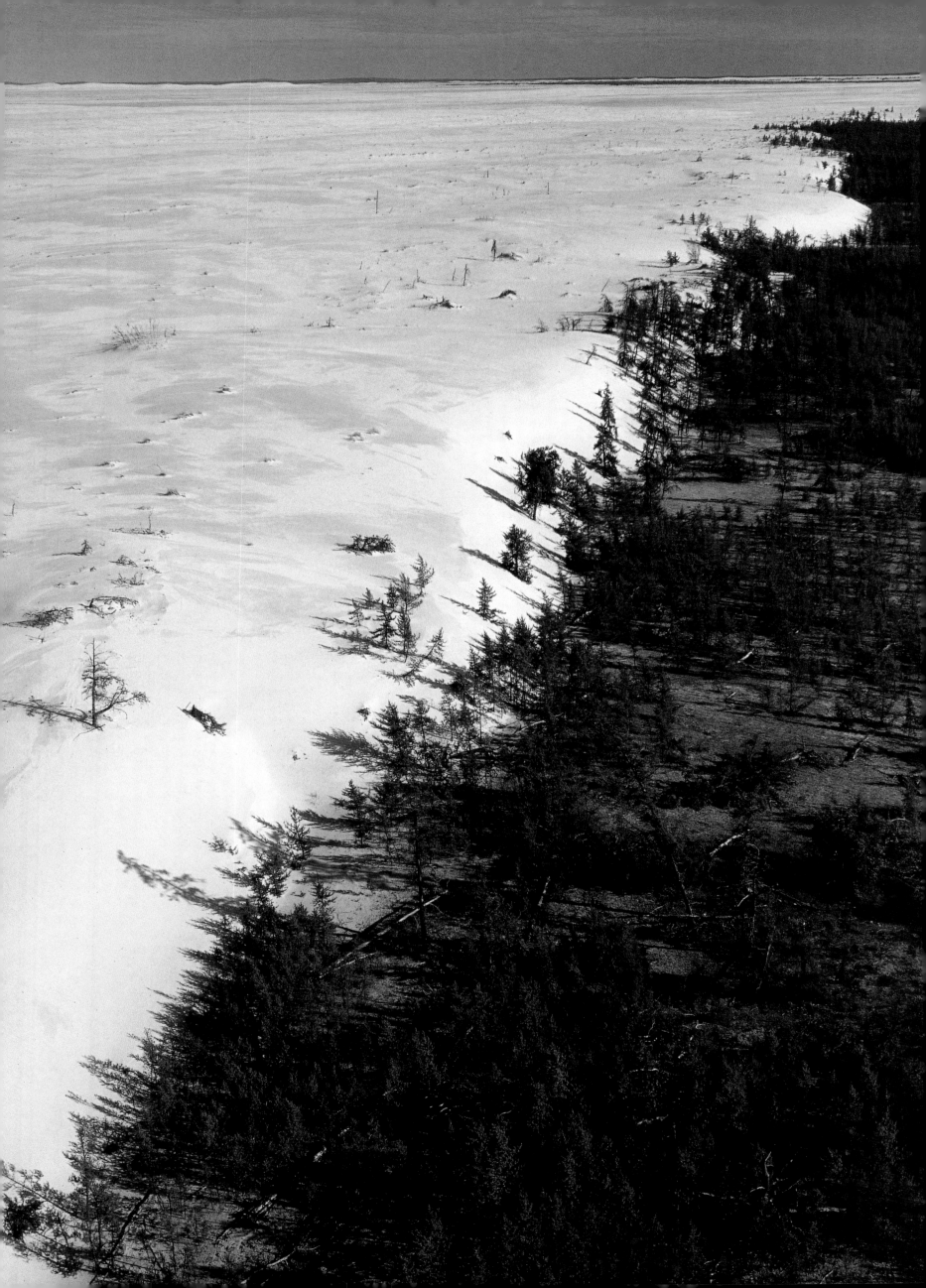

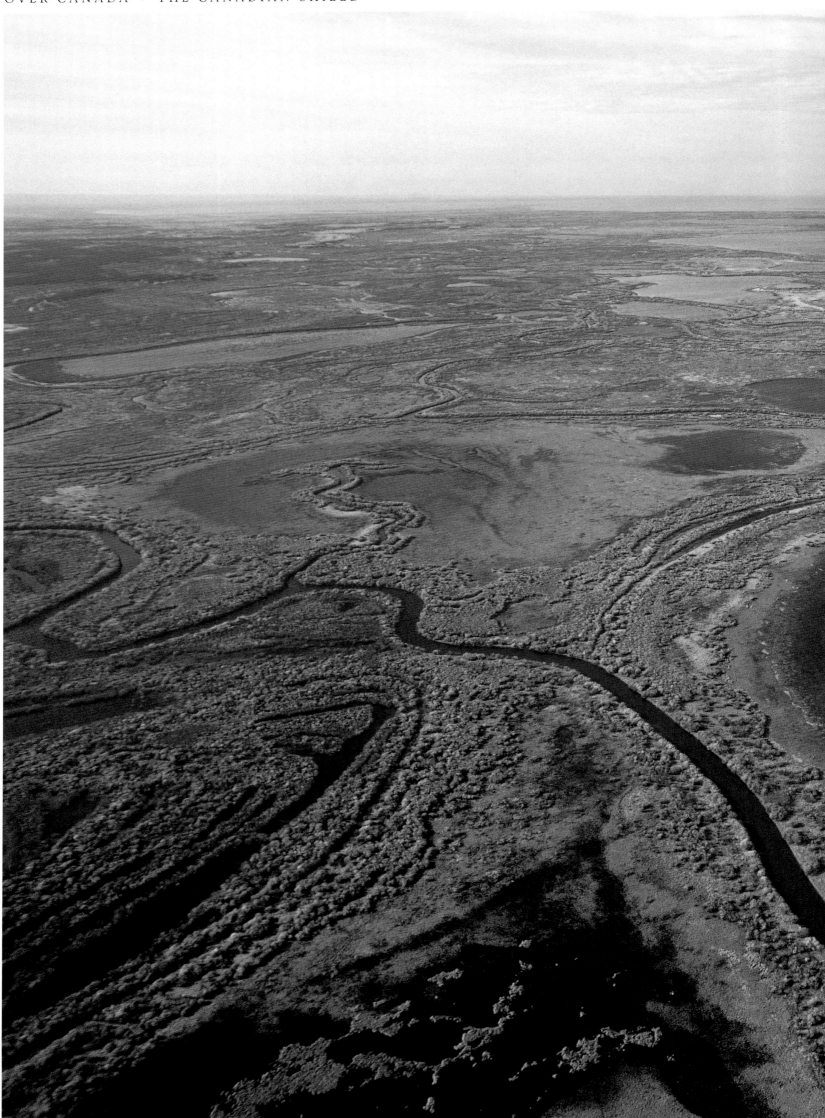

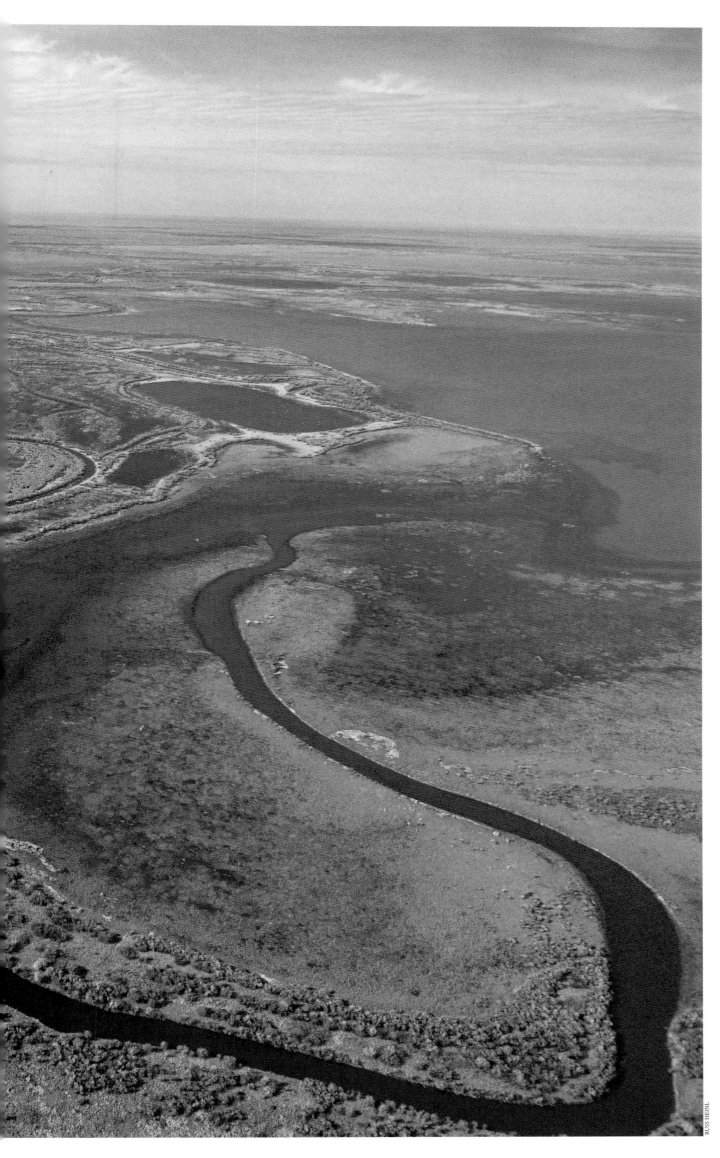

RUSS HEINL

left:

Alberta's Peace-
Athabasca delta is
one of the world's
largest inland deltas.
Its marshes, where
river channels curve
and shallow lakes
spread, are key habitat
for migratory birds,
especially waterfowl.
The Peace and
Athabasca rivers flow
into Lake Athabasca
while, just to the north,
the Slave River flows
out of the lake north
toward the Northwest
Territories' Mackenzie
River.

THE
PRAIRIES

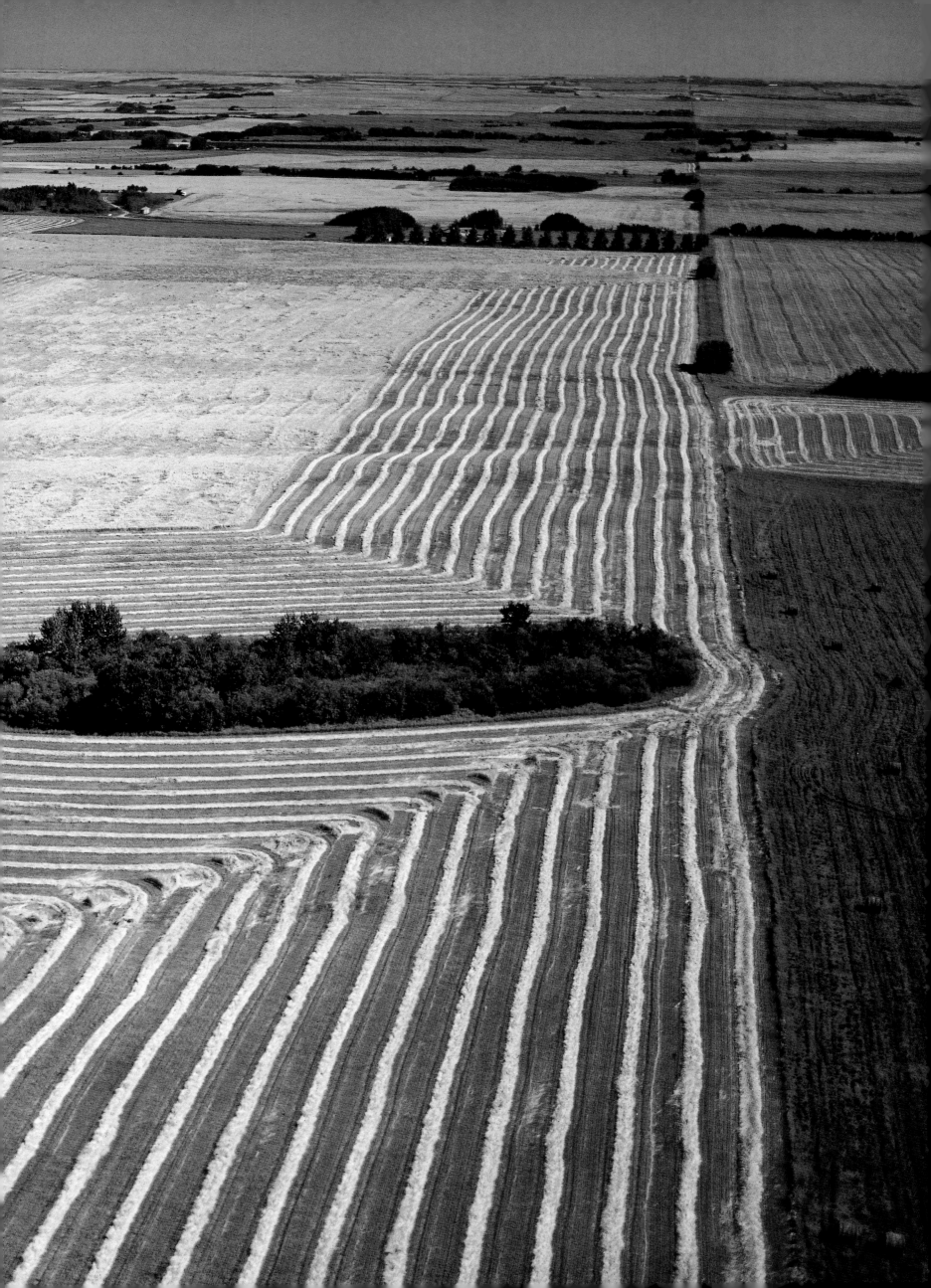

THE PRAIRIES
OUR CULTIVATED HEARTLAND

previous pages:

Swath by swath, a field becomes a giant geometric pattern on farmland near Torrington, Alberta, south of Red Deer.
RON GARNETT/BIRDS EYE VIEW

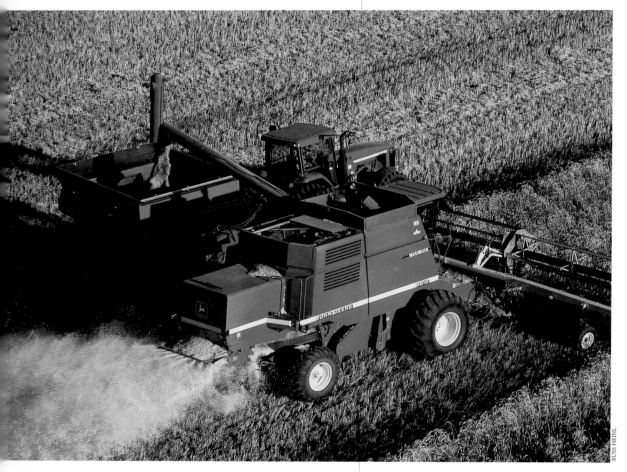

above:

A south Saskatchewan farmer glances up to watch an aerial photographer take his picture.

opposite:
Bales of hay on a southern Manitoba field look like pieces on a board game. RUSS HEINL

Dust swirls over a combine threshing wheat in the late-summer sun. The air is desert-dry and heat lines blur the horizon like a mirage. The farmer squints up at the helicopter and waves through the window of his air-conditioned cab.

The fields are swathed and orderly, laid out like rows of corduroy running off the frame into a cloudless prairie sky. In a landscape as far reaching as an ocean, the solitary man and machine look like a ship alone at sea.

"The great North American prairie has a noble quality in its vast spaces and sensuous sparseness," notes Canadian architect Arthur Erickson in *The Architecture of Arthur Erickson.* "A single tree becomes a monument in such a landscape; a house, a fortress; fences and roads and the ploughlines of the fields form an overlying, pervasive geometry."

A helicopter at cruising speed feels almost stationary as it follows the fields over the curvature of the Earth. On and on . . . and on. For all their space and sparseness, the Canadian Prairies are merely the upper fringe of North America's Great Plains: you could fly this patchwork of crops and cattle lands right down through the continent's heartland to Texas.

Hardly a sod has been left unturned. Across the southern reaches of Manitoba, Saskatchewan, and Alberta, remnants of true Prairie diversity — sloughs and wetlands, salt lakes, badlands, and the odd surviving pocket of original grassland — are anomalies in the cultivated landscape.

Rivers — riparian contours of trees and greenery — disrupt the furrowed uniformity. Wandering in contrary curves and s-bends, they slice deep into soils left by retreating glacial lakes. Some begin as ice-blue meltwater in Western Canada's Rocky Mountains and flow east over a succession of plateaus, turning the colour of clay as they reach the Manitoba lowland. Others run up from the United States, pouring into Lake Winnipeg then out through the Nelson River to the sea at Hudson Bay.

The confluence of the Assiniboine River from the west and the Red River from the south has been a meeting ground for Prairie people for 6,000 years. "The Forks" at the centre of modern-day Winnipeg is still a place to gather, these days for concerts on the lawn or picnics along the Riverwalk through town.

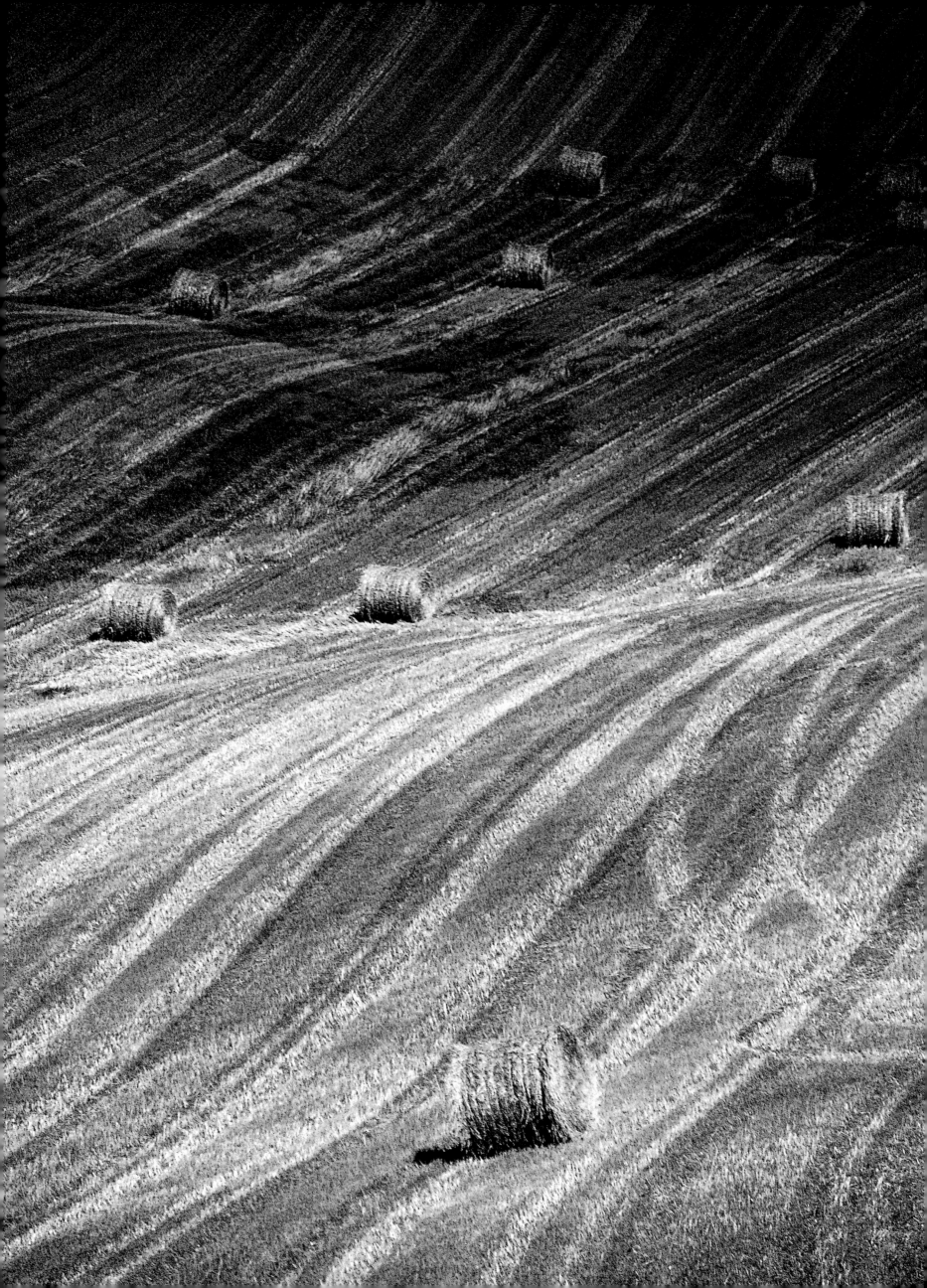

From an aircraft over Winnipeg's tallest buildings, you see how a metropolis of 640,000 is so easily engulfed by the prairie. Five hundred square kilometres of urbanization here are landlocked in an endless grid of straight roads and rectangles that covers the landscape all the way to the Alberta Foothills.

A helicopter following the Assiniboine westward out of Winnipeg soon encounters one of those natural anomalies in a land so thoroughly transformed. Upstream from Portage la Prairie the river bisects Spruce Woods Provincial Heritage Park, where the Spirit Sands rise above the surrounding terrain. These incongruous wind-blown dunes were delivered here by rivers that fed a huge delta on prehistoric Lake Agassiz, which covered most of Manitoba 12,000 years ago.

Now lakes Winnipeg, Manitoba, and Winnipegosis are virtual inland seas. They form the southeastern end of a vast wetland complex extending into the boreal forests of Saskatchewan and the Northwest Territories. At Spruce Woods, and farther north in Riding Mountain National Park, bogs and woodlands sustain myriad wildlife — wolves, elk, moose, and unusually big black bears.

below:

Once a mainstay for native hunters, bison were nearly eliminated from the Prairies by the turn of the last century. This herd in Saskatchewan's 20-square-kilometre Buffalo Pound Provincial Park, west of Regina, is now the quarry of wildlife watchers who view the animals from a nearby tower.

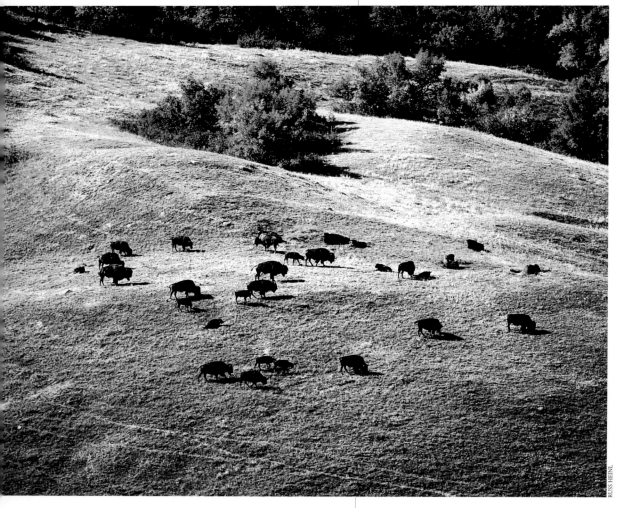

RUSS HEINL

The most notable landform is the handiwork of tireless beavers. Nearly eliminated from this area by fur traders, they were reintroduced in the 1930s by Grey Owl, a conservation-minded Englishman who was Canada's most famous "full-blooded Indian." Today, 18,000 beavers have created thousands of ponds at Riding Mountain.

Farther north the wetlands spread through Duck Mountain Provincial Park into Saskatchewan. Thousands of lakes and potholes here are vital to millions of ducks, geese, shorebirds, songbirds, and other migrants.

From the air, you can see how the Prairie hydrography has been rearranged for towns and industries. Creeks and rivers have been dammed and diverted for irrigation, flood control, and electricity. Lake Diefenbaker on the South Saskatchewan, Buffalo Pound Lake downstream on the Qu'Appelle, and other big reservoirs were added to the natural geography.

Wascana Lake, the focus of downtown Regina, is a manmade widening of the creek that flows through the heart of Saskatchewan's capital city. Trees along its banks are among 350,000 planted to create a shady oasis in the midst of the sun-baked plains. Like other Prairie cities, Regina springs up from the flatness, and on a clear day you can see it from an aircraft 80 kilometres away.

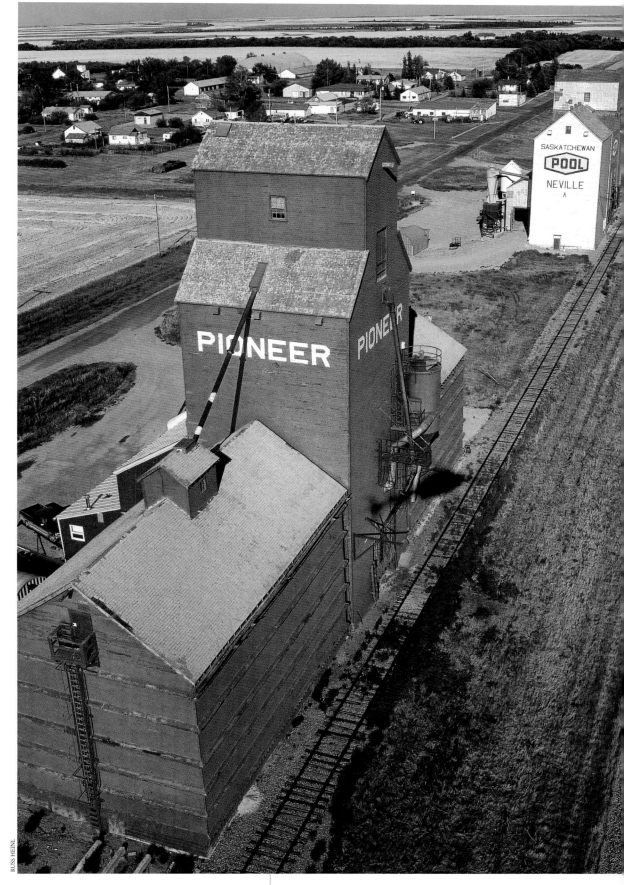

Moments beyond the city limits the high-rises fade as abruptly as they appeared, and as in W.O. Mitchell's *Who Has Seen the Wind*, you feel "as utterly alone as it is possible to be only upon a prairie." Isolated clusters of trees and outbuildings pinpoint the homesteads, each one joined to the next by a ribbon of gravel as straight as the fields. Traffic appears as a cloud of dust here, another over there.

At Neville, south of Swift Current, nearly everyone in town pours onto their roads and porches to watch a photographer hang out the open door of a helicopter hovering over their grain elevator. Time is running out for shots like this. These "Prairie Cathedrals" once numbered close to 6,000 in Canada; the 21st century begins with about 1,000, and more are scheduled to come down. As Canadian grain is handled more efficiently by new mega-terminals, these familiar landmarks of local prosperity and stability will be added to the last millennium's history.

Country people continue the exodus to the cities that began in the 1940s, when W.O. Mitchell first wrote of these places. Most of the population was rural then, working family farms not far from a village and a grain elevator. Now more than two-thirds of the people live in town, and fewer, but bigger farms are run by corporations with state-of-the-art equipment and smaller workforces.

above:

The stately old grain elevator at Neville, south of Swift Current, remains part of the Saskatchewan scenery.

South of Neville, Grasslands National Park is another vestige of the era before Prairie agriculture. Hills of pastel greens and greys tumble into the Frenchman River valley, sweeping in hairpin turns down through the Montana badlands. This is one the largest remaining tracts of natural mixed grassland, a refuge for pronghorn antelope, swift foxes, rattlesnakes, and the last of the black-tailed prairie dogs.

The Frenchman originates farther west in the Cypress Hills, where an interprovincial park straddles the Saskatchewan-Alberta border. From an aircraft overhead, you can imagine families camped in the coulees, smoke whispering up from tepees of lodgepole pine and bison skins.

This was once prime bison territory. Herds in the thousands wintered here, and in the Foothills on the Rockies' eastern slopes. Now it's cattle country, but fewer each year graze the open range. Growing numbers are "finished" in high-density feedlots: the largest concentration — "Feedlot Alley" near Lethbridge — has more than 200 operations fattening more than half a million head at a time.

A few sprawling cattle ranches still raise beef by traditional methods, but agricultural technology, and diversification into new industries, is rendering the Prairie cowboy a diminishing breed. The transition from Cowtown to Oiltown began in Calgary as far back as 1914, with Alberta's first big oil strike in the Turner Valley. Construction cranes are still hoisting materials to the tops of new office towers, suggesting the momentum has never slowed. Calgary's population will undoubtedly surpass one million early in the next millennium.

The oiling of Edmonton came later. In 1947, discovery of huge oil fields at nearby Leduc launched Canada into the modern petroleum industry. The capital city had already been Alberta's "Gateway to the North" since the Klondike Gold Rush in the late 1890s. It stayed true to its roots as a northern service centre — for bush pilots in the 1930s, for Alaska Highway builders in the 1940s, and for oil-and-gas companies and farmers today.

If you fly out of Edmonton through Grande Prairie, you'll find oil derricks and harvesters working side by side in the rain shadow of the Rocky Mountains. Here in the Peace River country the Prairies spill across the border into British Columbia, where grain elevators in Fort St. John and Dawson Creek are emblazoned with "Alberta Wheat Pool." It's the only part of B.C. that lies east of the Rockies, the only place where the Canadian Prairies connect to the Pacific province, 2,000 kilometres from their opposite end on the Manitoba lowland. ❧

RUSS HEINL

above:

*T*he world's largest, single-line bleached kraft mill is operated by Alberta-Pacific Forest Industries near Athabasca, in northern Alberta. The mill produces 500,000 tonnes of hardwood and softwood pulp a year.

opposite:
Trees and greenery bring a coolness to the intense summer heat of the prairie outside Yorkton, in southeastern Saskatchewan.
RUSS HEINL

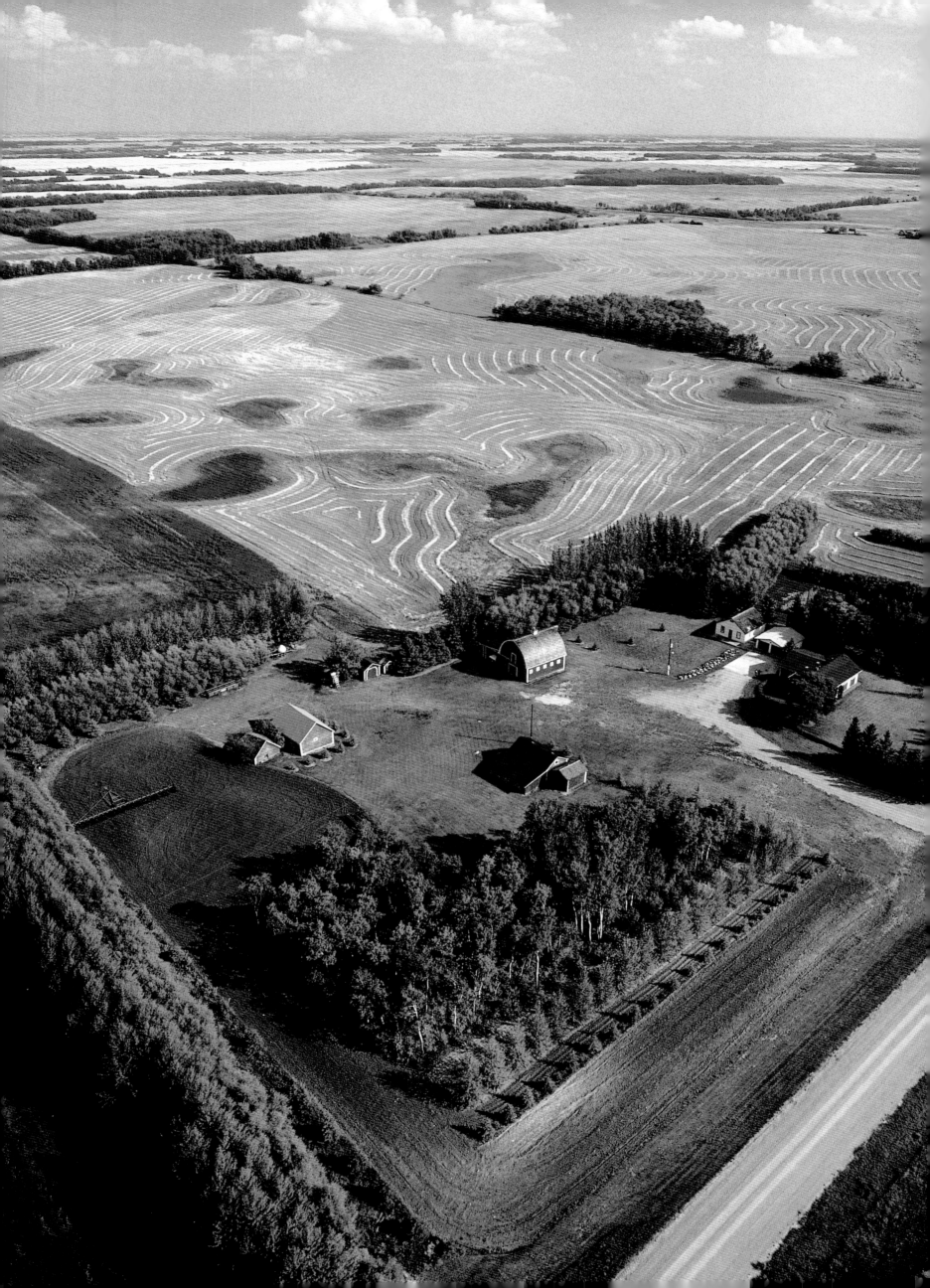

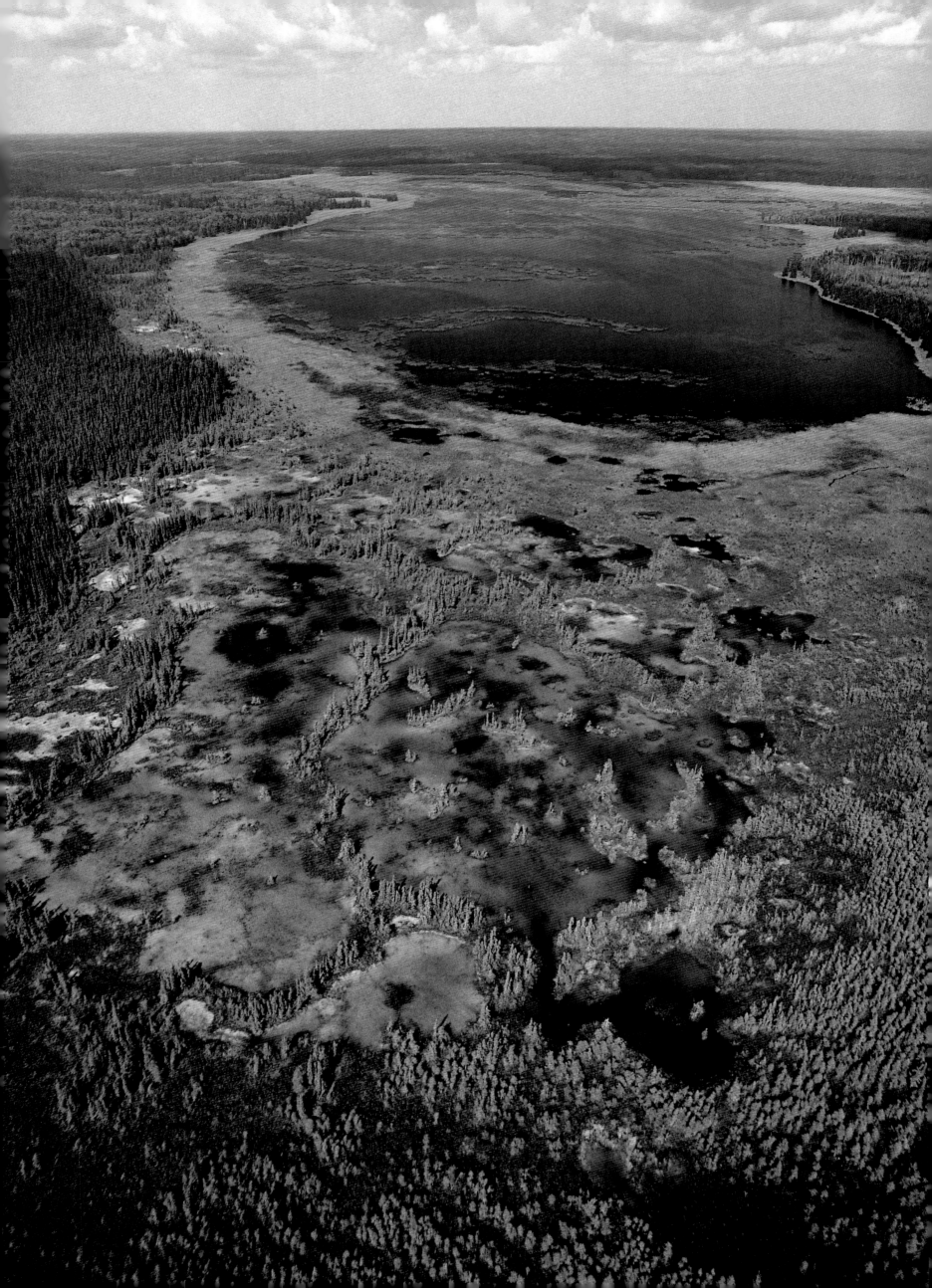

opposite and above:

Described as "an island of nature amidst a sea of agriculture," Manitoba's Riding Mountain National Park is a total of 2,973 square kilometres protecting the headwaters of 13 watersheds. Thousands of beaver lodges here, and farther south in Spruce Woods Provincial Heritage Park, conspicuously dot the swampy landscape. RUSS HEINL

following pages:

Smoke from a stubble fire billows above the fields near Portage la Prairie, Manitoba. Some cereal farmers burn stubble to rid their land of unwanted residue, while others allow leftover straw to be used in the manufacture of particle board, paper, and other products.
RUSS HEINL

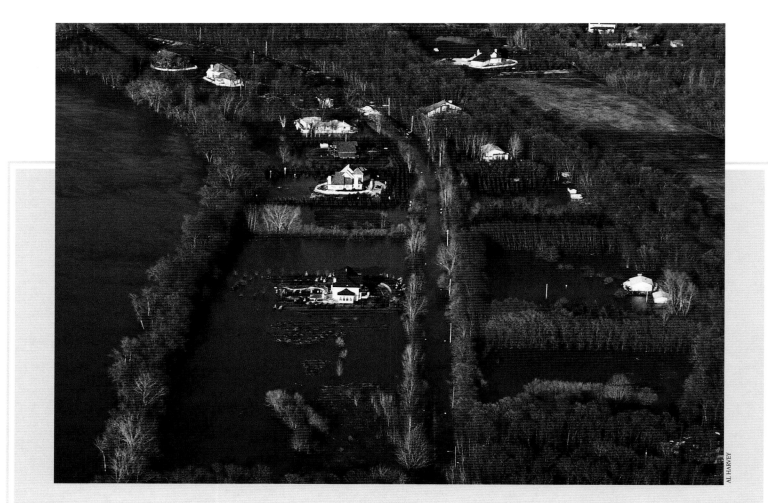

AL HARVEY

THE RED RIVER

Fending off the deluge

Southern Manitobans have a long-standing habit of heading for high ground when the Red River overshoots its banks. Early settlers witnessed the ruin of the original Red River Colony in 1826, when the water rose to its highest level in recorded history. They awaited spring freshets with trepidation, knowing they were helpless to fight the inundation of the fertile soils that sustained them.

It wasn't until 1950, when 100,000 people fled their homes, that flood control was given top priority. Protective walls of clay were built along the banks of the Assiniboine and Red rivers in Winnipeg, where the two waterways converge. Seven hundred homesteads and eight communities, including Winnipeg, were encircled with permanent dikes. In 1968, a 47-kilometre channel — the Red River

Floodway — was completed, diverting water around the eastern edge of the capital city. By 1997, when the river swelled to its second-highest level ever, the floodway had been opened for spring freshets 17 times.

Despite the elaborate safeguards, 2,000 square kilometres between the U.S. border and Winnipeg were flooded in 1997; 200,000 hectares on 800 farms were submerged. In the largest unarmed military operation in Canadian history, 8,600 soldiers helped to build temporary dikes with eight million sandbags. More than 25,000 people were evacuated and damage exceeded $150 million.

It's hard to imagine the Red River running dry. But it has, on occasion, been parched to a trickle in the worst of the midsummer droughts.

Such hydrographic extremes were only part of the hardship for stalwart settlers in the Red River basin: after the colony was founded in 1812, and before the ruinous flood of 1826, locusts destroyed the crops in 1818 and 1819. But the colony endured to become the province of Manitoba in 1870, when Winnipeg's population was less than 300. In four decades, it grew to 140,000, becoming Canada's third-largest and fastest-growing city in the early 1900s.

above:

Manitoba's Red River rose to its second-highest level in recorded history in the spring of 1997.

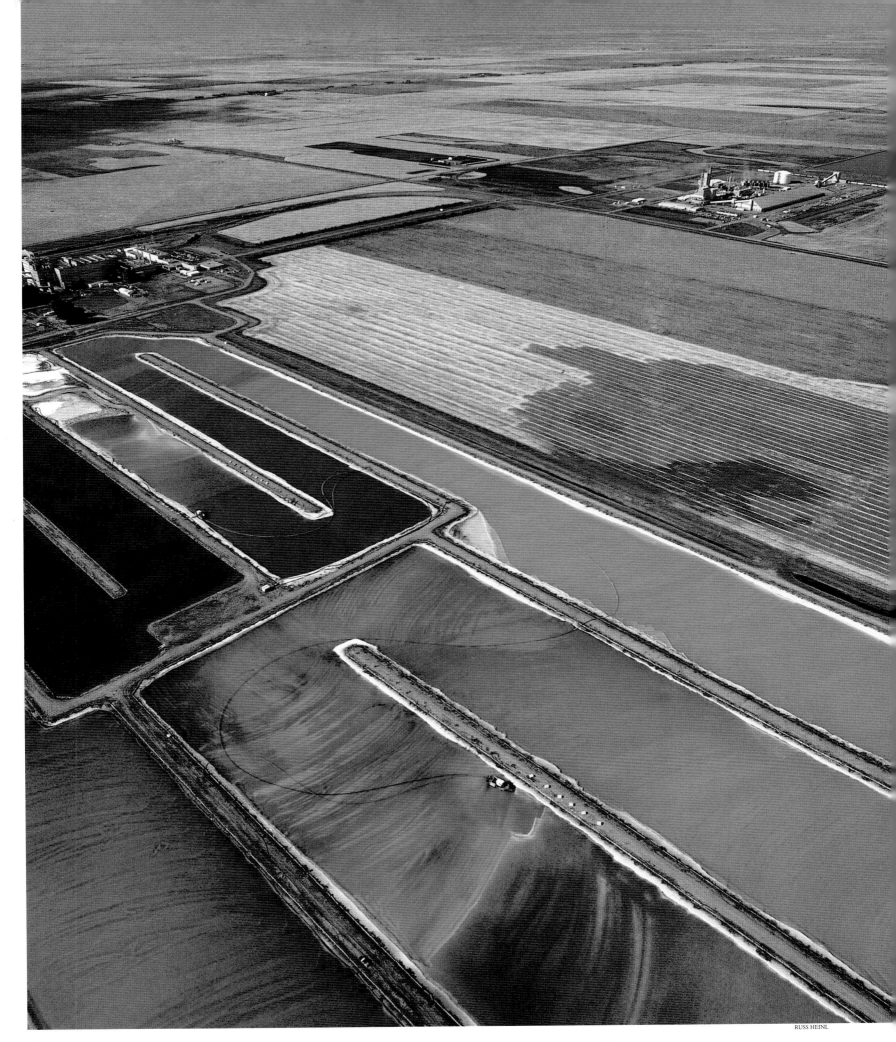

RUSS HEINL

*P*roducing fertilizer is a major industry in Saskatchewan. Since 1964, IMC Kalium Canada has operated the province's largest solution potash mine, shown here in the foreground, at Belle Plaine, west of Regina. In the upper right is the nearby Saskferco Products' nitrogen plant, which began production in 1991.

*T*rains are received, inspected, and assembled at Canadian National Railways' Symington yard on the east side of Winnipeg, one of half a dozen yards operated in the Manitoba capital by CN and Canadian Pacific Railway. Several thousand cars may be here at one time. RUSS HEINL

CANADA'S BREADBASKET

Golden wheat shimmers in the prairie wind

The "Breadbasket of Canada" is a fitting honorific for Saskatchewan. The province grows well over half the nation's wheat, which is known worldwide for its high protein and top baking quality of its flour.

Wheat is our most important cultivated crop, and Canada is one of the world's major wheat producers. Millions of tonnes are shipped through ports at Vancouver and Prince Rupert to the west, Churchill and Thunder Bay to the east.

Prairie travellers are invariably overwhelmed at the sight of all that golden wheat shimmering in the wind. It mesmerizes like waves on the sea, soothing some, boring others. "The bald headed Prairie indeed," Agatha Christie said disparagingly of her travels here in 1922, "interesting to those interested in wheat, but not otherwise."

The biography that quotes Ms. Christie doesn't mention whether the British mystery writer was a cereal eater. Wheat fills more cereal bowls than any other grain.

With farms averaging 445 hectares, a total of 12 million hectares on the Canadian Prairies are planted in wheat, according to Statistics Canada. Another 17 million hectares are seeded in oats, barley, canola, hay, and other crops.

The Prairie provinces, particularly southwestern Saskatchewan and southern Alberta, are also good livestock land. About 17 million hectares of pastureland support as many as 10 million cattle and calves, as well as 370,000 sheep and lambs. Prairie farms also raise more than four million pigs and nearly 20 million hens and chickens.

In all, more than 140,000 "census farms" encompass over 55 million hectares of land on the Canadian Prairies.

above:

*P*rairie wheat is harvested in the late-summer sun.

DOUGLAS E. WALKER

opposite:

*T*he Frenchman River is the centrepiece of Grasslands National Park on the Saskatchewan-Montana border. Encompassing 420 square kilometres, the park is one of the last reserves for undisturbed mixed prairie grassland. *RUSS HEINL*

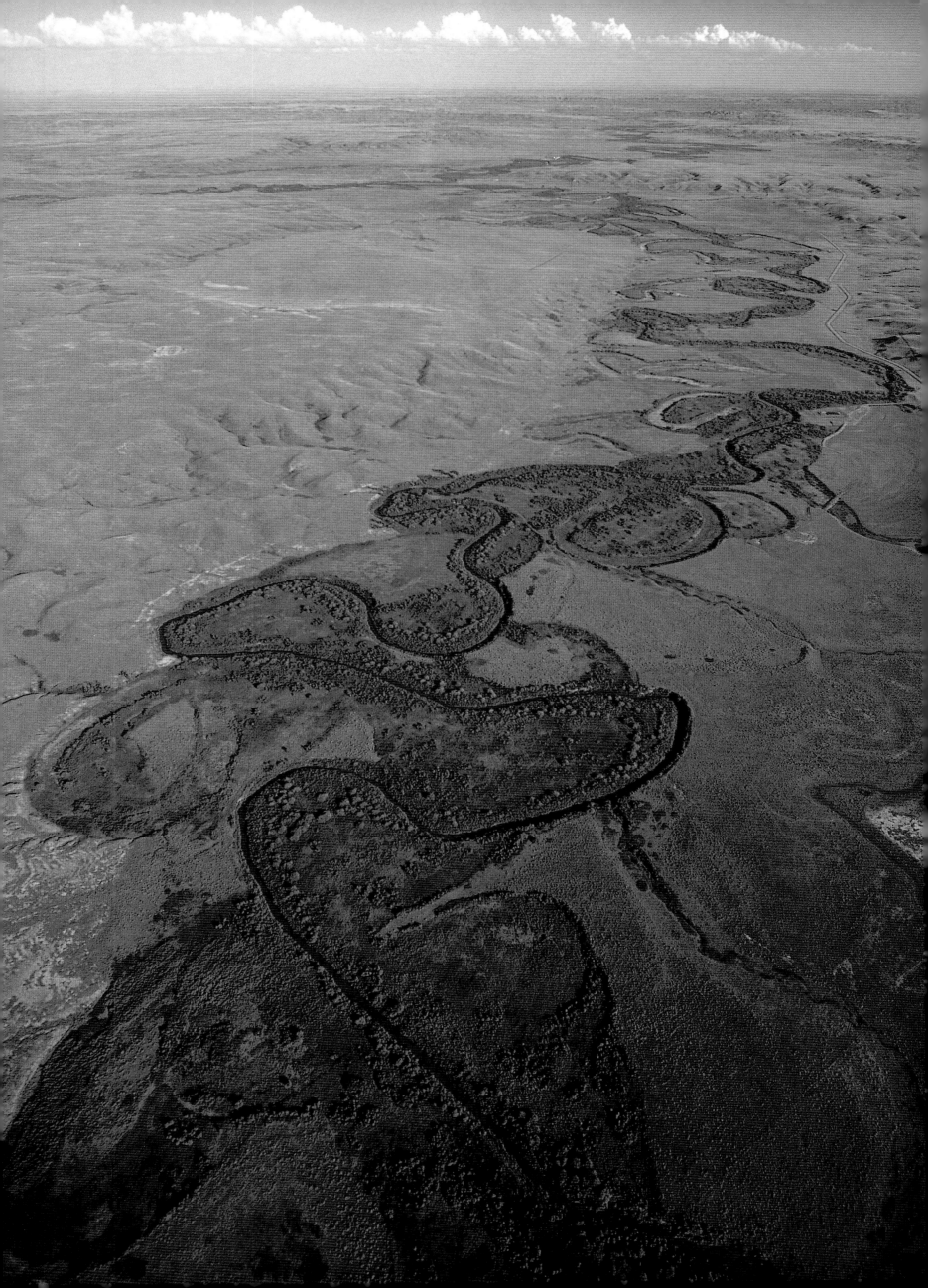

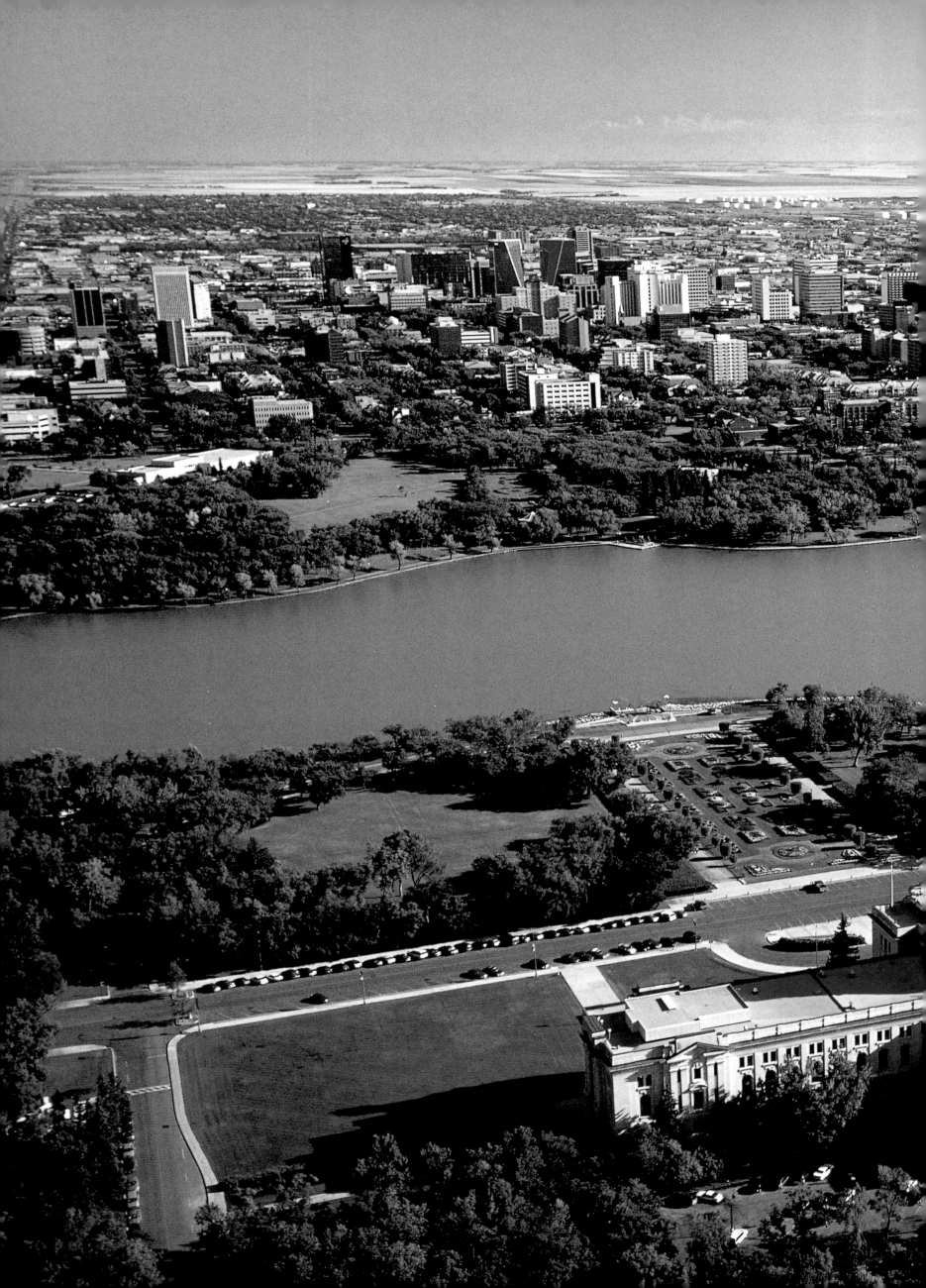

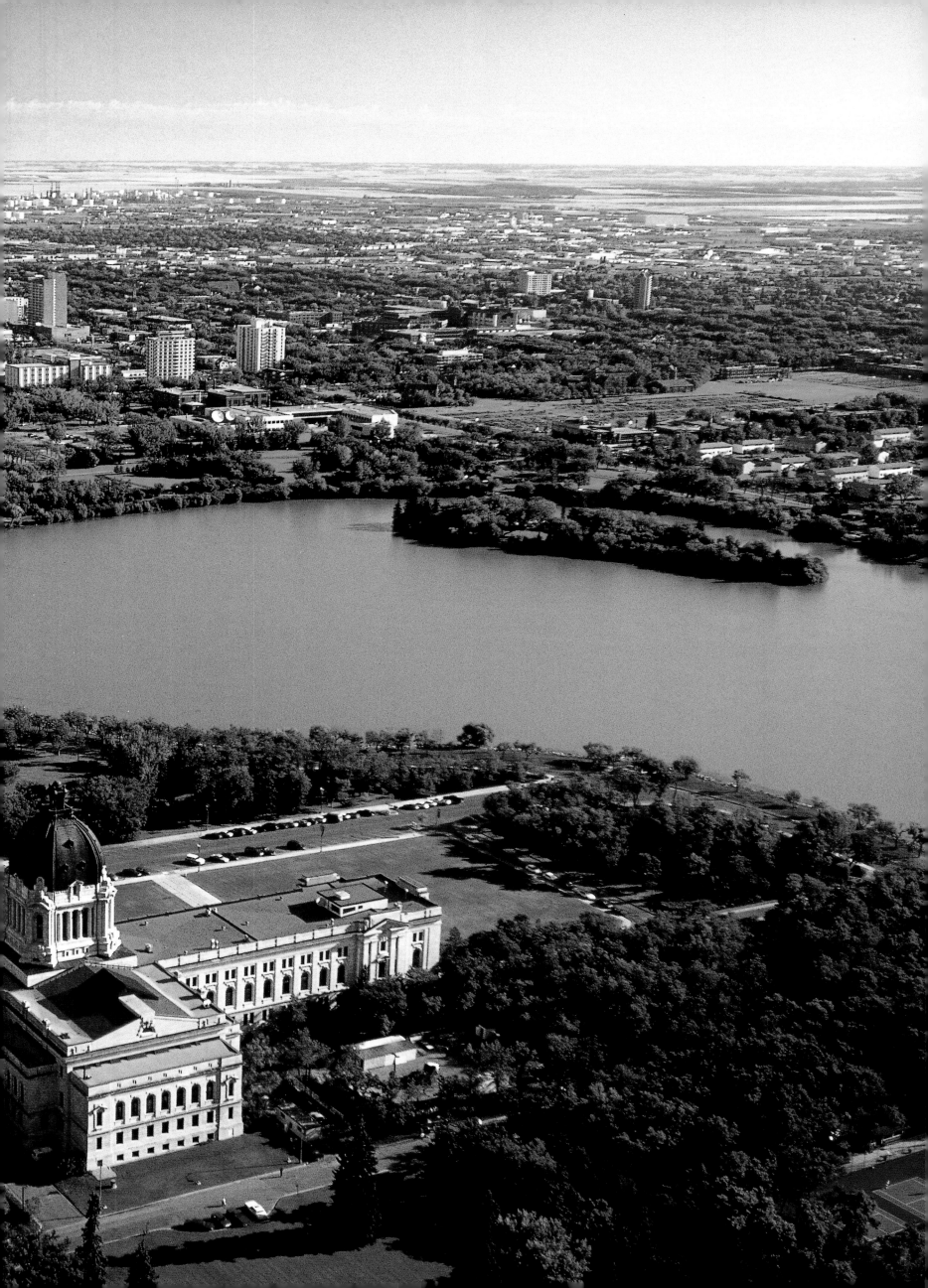

RUSS HEINL

above:

*M*ore than a million spectators may take in the annual Calgary Exhibition and Stampede. Founded in 1912, the 10-day rodeo and agricultural fair is billed as the "Greatest Outdoor Show on Earth." The hosting city, right, has become the largest on the Canadian Prairies, with a population of about 820,000. It is expected to exceed one million within the first decade of the new millennium.

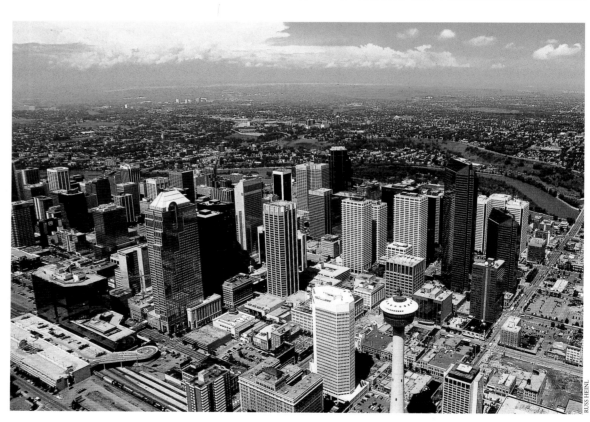

RUSS HEINL

previous pages:

*T*he Saskatchewan Legislative Building overlooks picturesque Wascana Lake, a manmade widening of the creek that runs through downtown Regina. Now a city of 190,000, this is headquarters for both the Royal Canadian Mounted Police and the Saskatchewan Wheat Pool.
RUSS HEINL

opposite:

*F*ifty-two wind turbines at Alberta's Cowley Ridge Windplant, near Pincher Creek, generate enough electricity for a community of more than 15,000. Each is 24.5 metres tall and has three 17-metre fibreglass blades weighing about one tonne apiece.
RUSS HEINL

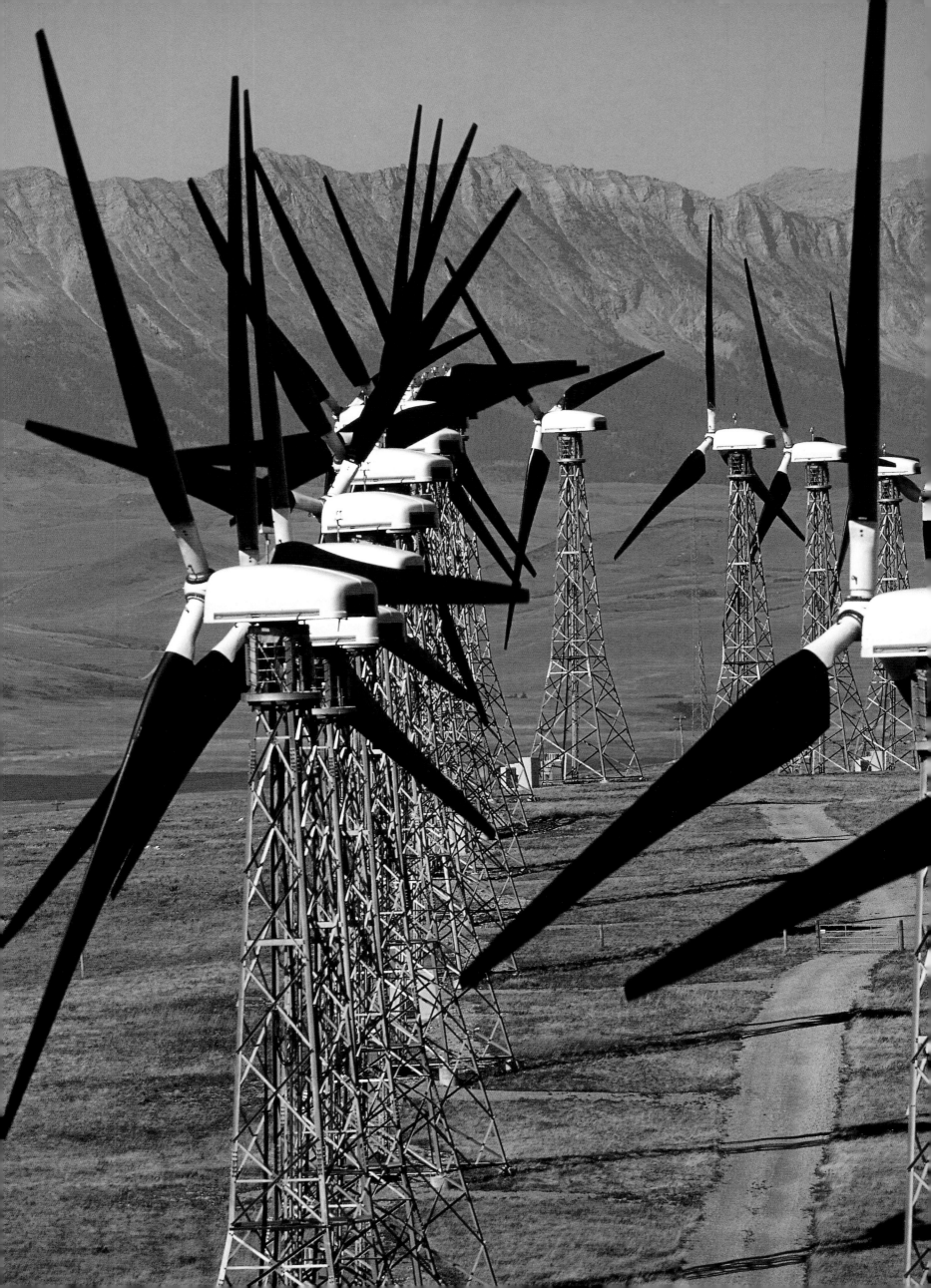

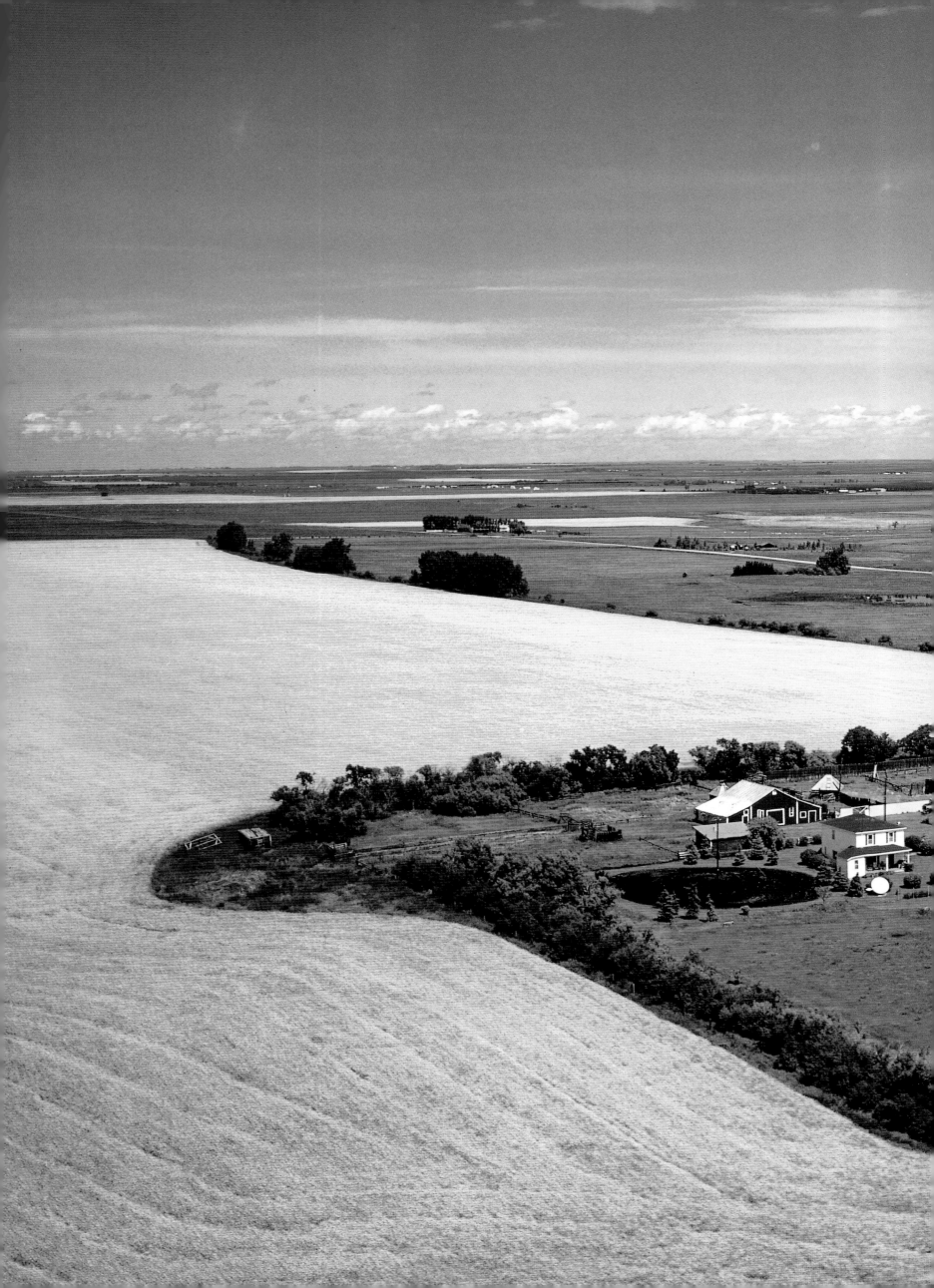

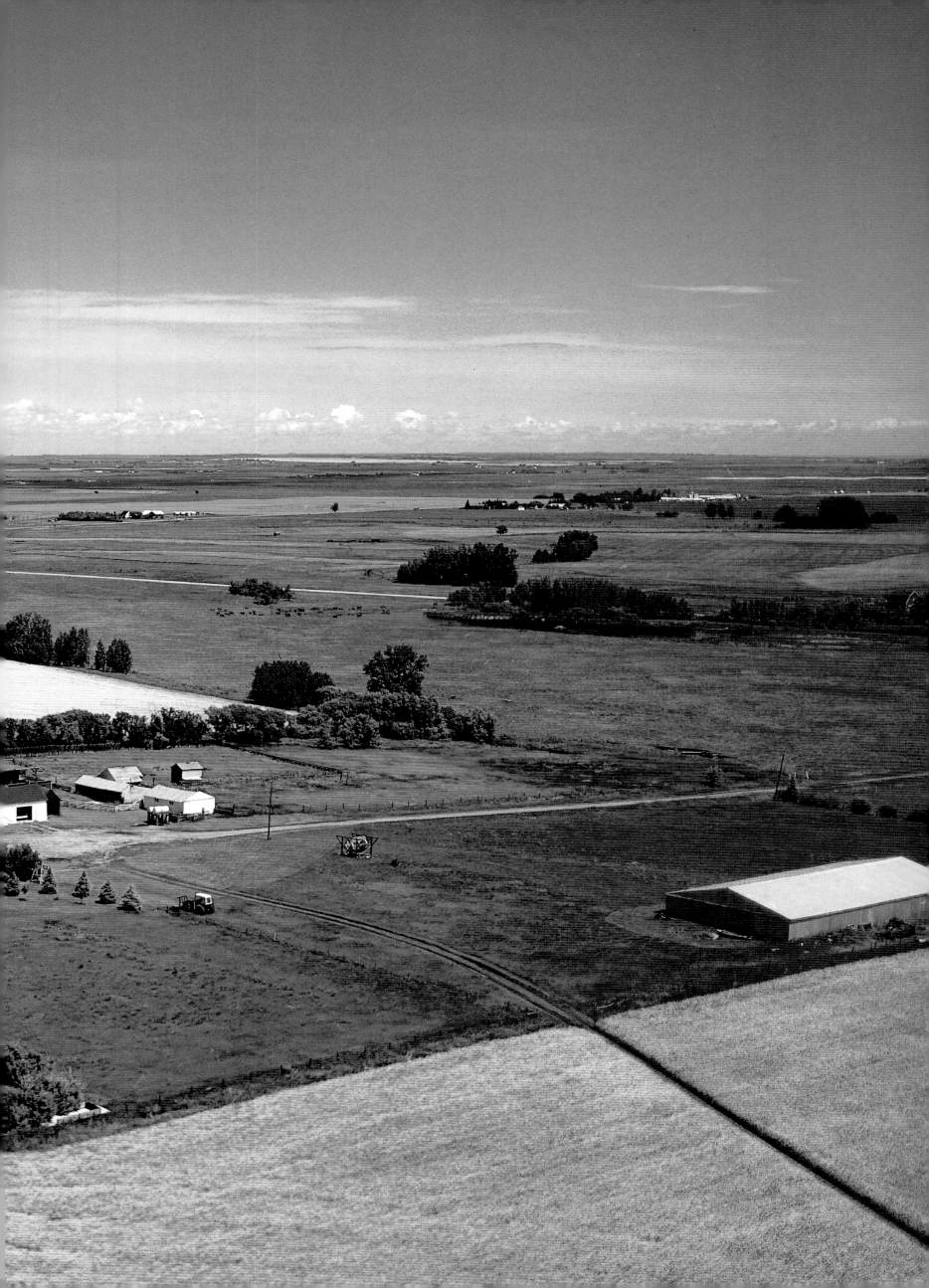

previous pages:

Lemon-coloured canola brightens the landscape near the hamlet of Lyalta, Alberta, east of Calgary. Canola, a variety of rapeseed, is grown on more than 20,000 square kilometres across the Canadian Prairies.
RON GARNETT/BIRDS EYE VIEW

ON LOCATION
Alberta badlands

It's like falling back in geologic time — from the 21st century to the last Ice Age — as you slip off the edge of the cultivated prairie into the eerie abyss of the badlands.

"It's definitely bizarre," says photographer Russ Heinl. "You're flying over these beautiful flat fields of canola and wheat, under a big blue prairie sky, and all of a sudden there's a huge hole. Complete opposite landscapes." The hole, in the Red Deer River valley of southern Alberta, is "like a big scar cutting through the land." Inside it are hills of barren rock, fragmented by trenches and gullies etched out by the runoff of melting glaciers.

Les mauvaises à traverser, French fur traders called them — "bad lands to cross." For 300 kilometres southeast of Red Deer, Alberta, the best of Canada's badlands follow the Red Deer River down through Drumheller into Dinosaur Provincial Park. Designated a UNESCO World Heritage Site in 1979, the park and surrounding environs hold the world's largest concentration of Late Cretaceous dinosaur fossils. Bones of animals that died 75 million years ago lay locked in the Earth until glacial ice scraped off the surface rocks 14,000 years ago.

The fossilized remains of three dozen dinosaur species have been retrieved from these badlands. The largest collection of skeletons is at the Royal Tyrrell Museum of Paleontology, near Drumheller.

"The badlands remind me of dinosaur skin, the scaly texture," says Heinl. "The ground looks tortured, full of holes. It's beautiful, but grotesque and twisted looking."

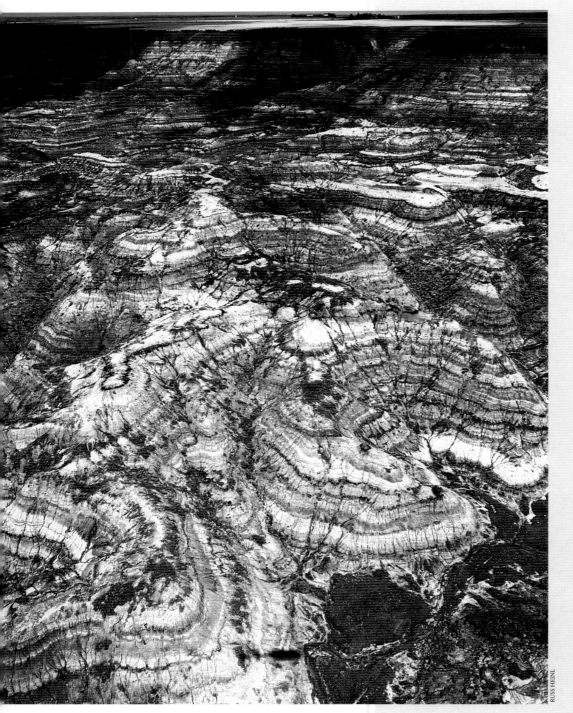

RUSS HEINL

above:

The Alberta badlands near Drumheller are part of an ancient landscape that flanks the Red Deer River valley for 300 kilometres.

opposite:

Multi-lane highways and cloverleafs lead to bridges crossing the North Saskatchewan River in the centre of Edmonton, Alberta. With 640,000 residents, this capital city is about the same size as Winnipeg, Manitoba's capital. RUSS HEINL

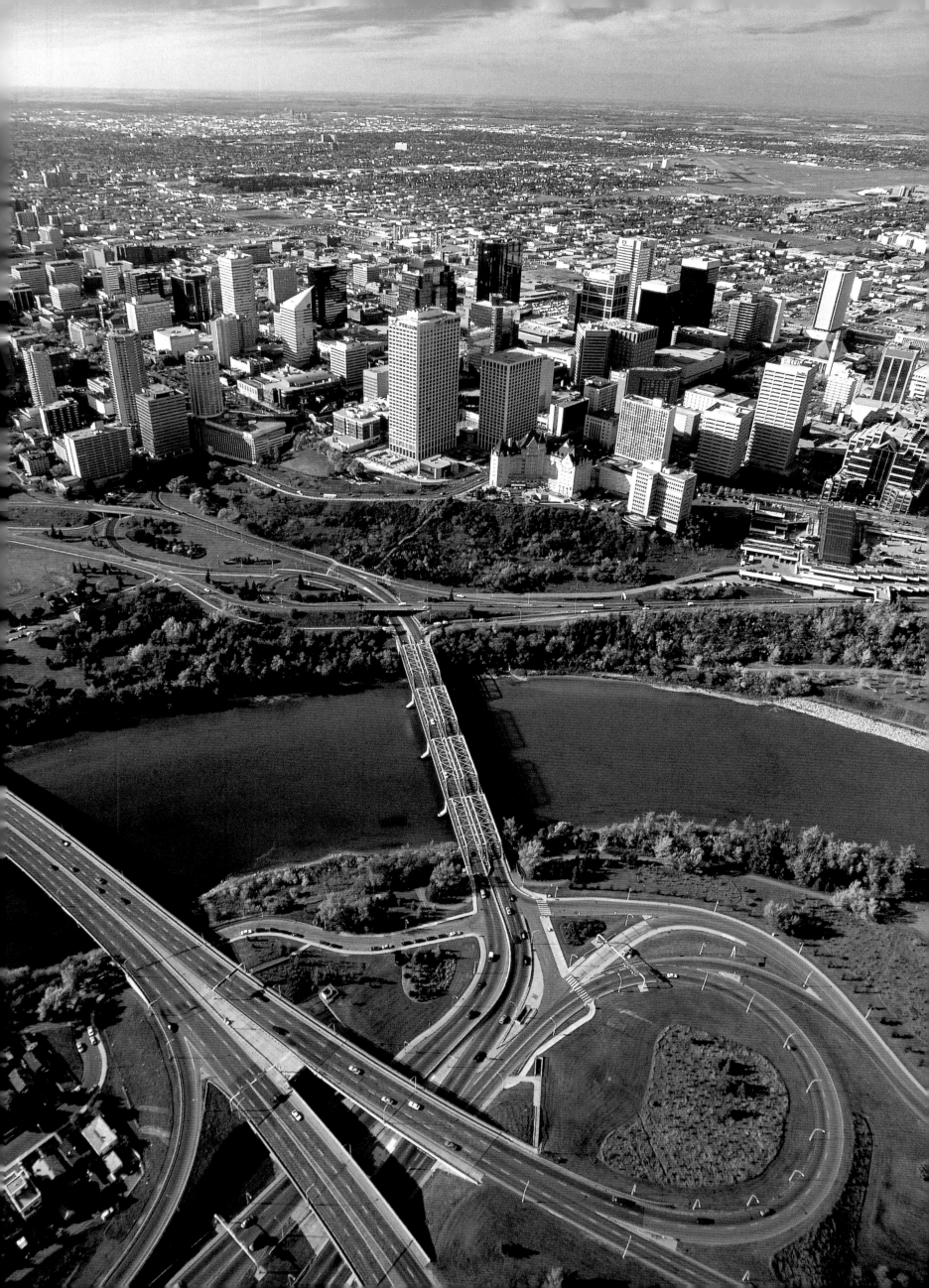

RON GARNETT

left:

A solitary thicket of trees casts a shadow in the evening light on a Saskatchewan field near Basin Lake, northeast of Saskatoon.

131

THE NORTH

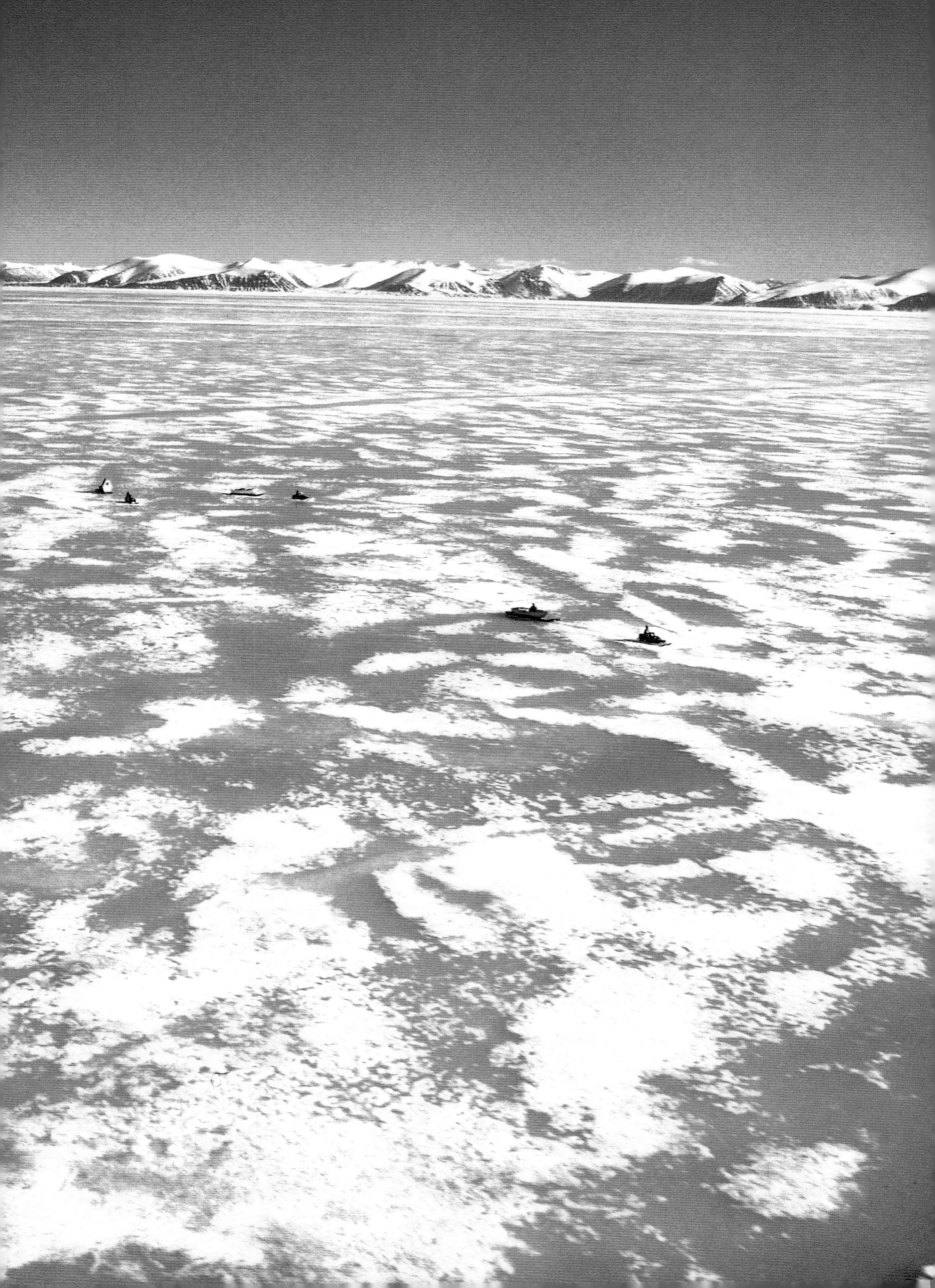

THE NORTH
CANADA'S OTHER HALF

MIKE BEEDELL

above:

"*I*gloo houses" accommodate workers at the zinc-and-silver mine in Nanisivik, Nunavut, near Admiralty Inlet on north Baffin Island. About 300 people live in Nanisivik, and 600 inhabit the nearby hamlet of Arctic Bay.

previous pages:
Ice-choked Pond Inlet, between north Baffin and Bylot islands in Nunavut, is a highway for Inuit hunters until summer breakup. Many of the 1,200 residents in the community of Pond Inlet continue to live a traditional native lifestyle.
MIKE BEEDELL

The sea ice looks as hard and permanent as the rock walls of north Baffin Island. It's frozen beyond the mouth of Admiralty Inlet, past the bleak plateaus of Brodeur and Borden peninsulas, out into Lancaster Sound.

Much of it is multi-year ice, and the aerial view is a puzzle of white mounds and azure pools of meltwater, encased in shores of lifeless rock. The beauty is stark, the aura foreboding, as if the Arctic landscape could swallow you without remorse.

Baffin is Canada's largest island, the world's fifth largest. Its north coast on Lancaster Sound is as far from its south end as a drive across Ontario. This is the eastern edge of the Canadian Arctic, where the fiords of Auyuittuq National Park — "the land that never melts" — face the desolate coast of Greenland.

Beyond Baffin Island, the Queen Elizabeth Islands are the most northerly of the Arctic archipelago. Cape Columbia, on Ellesmere Island, is 720 kilometres shy of the North Pole. It's the nation's most northerly land, as far from Ottawa as Vancouver Island. The sun sets here in mid-autumn, and legend says if you're alone on the ice, you can hear a sigh when it dawns again in late winter.

From the Arctic archipelago west to the Yukon-Alaska border, three northern territories cover nearly as much of Canada as its 10 provinces. But diversity, not size, distinguishes the country's other half: high Arctic mountains and plains, frozen ocean, barren grounds and subarctic tundra, muskeg, forest, and the colossal ranges of the Western Cordillera. "Up here" national superlatives come naturally: highest peak, longest river, deepest lake, biggest bears.

Also thinnest population, just over 100,000. Three hundred times as many Canadians live south of the 60th parallel, most within reach of the U.S. border. These Northerners live in six dozen communities scattered around an area half the size of Australia. The capital cities of Whitehorse, Yukon, and Yellowknife, Northwest Territories, each have close to 20,000 citizens. Fewer than 4,000 live in the Nunavut capital of Iqaluit, on south Baffin Island; the other 23,000 residents of Canada's newest and largest territory are spread over nearly two million square kilometres. Isolated pockets of civilization may be little more than tiny settlements of Inuit families.

"Travelling among the 28 towns of Nunavut was like flying from planet

opposite:

*B*affin Island's Borden Peninsula, Nunavut, is part of the Lancaster Plateau in Canada's Arctic Lowlands. Beyond its desolate shores, in Admiralty Inlet and Lancaster Sound, seals, narwhals, and belugas help sustain local Inuit settlements. ROY TANAMI/URSUS

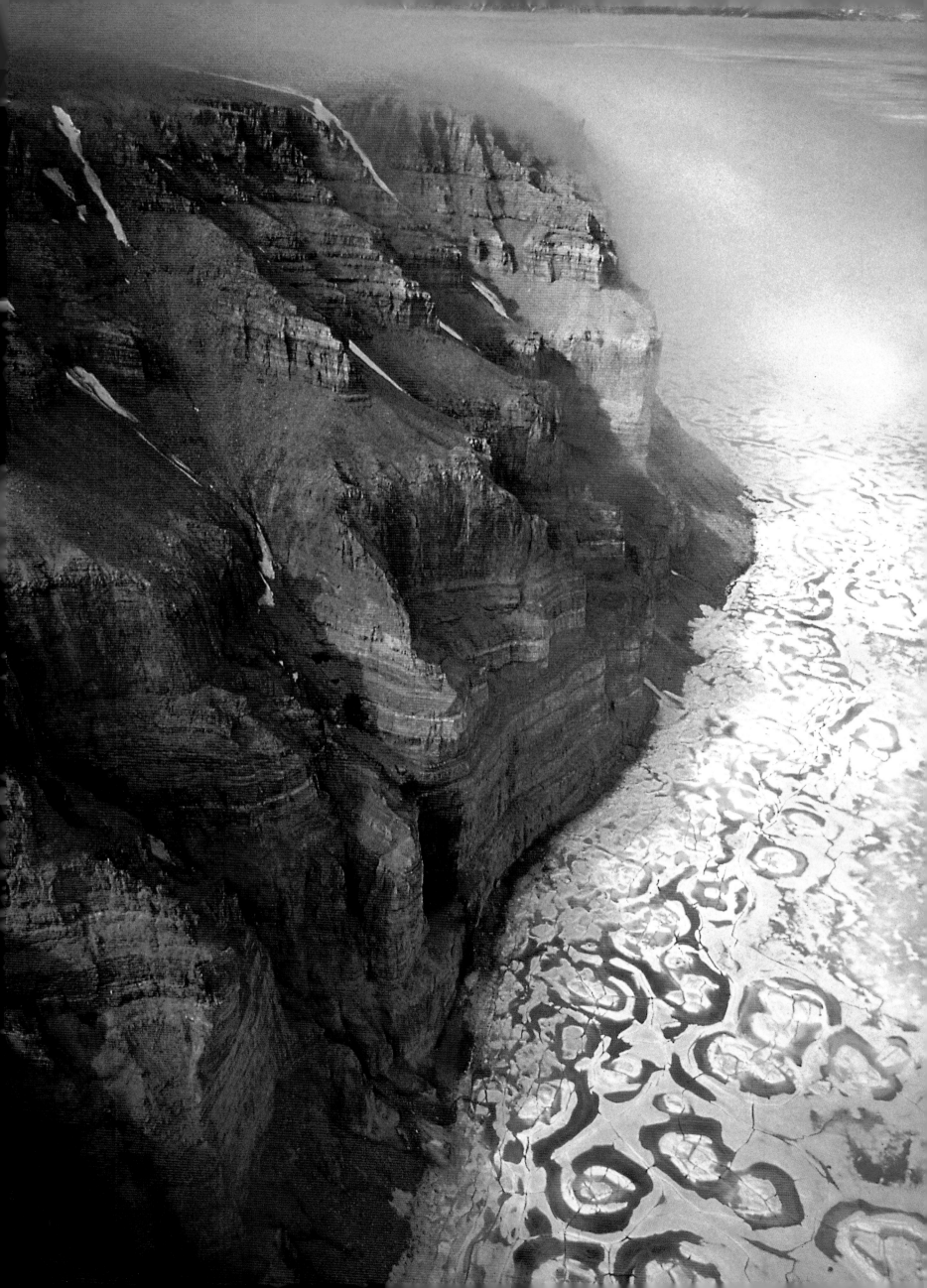

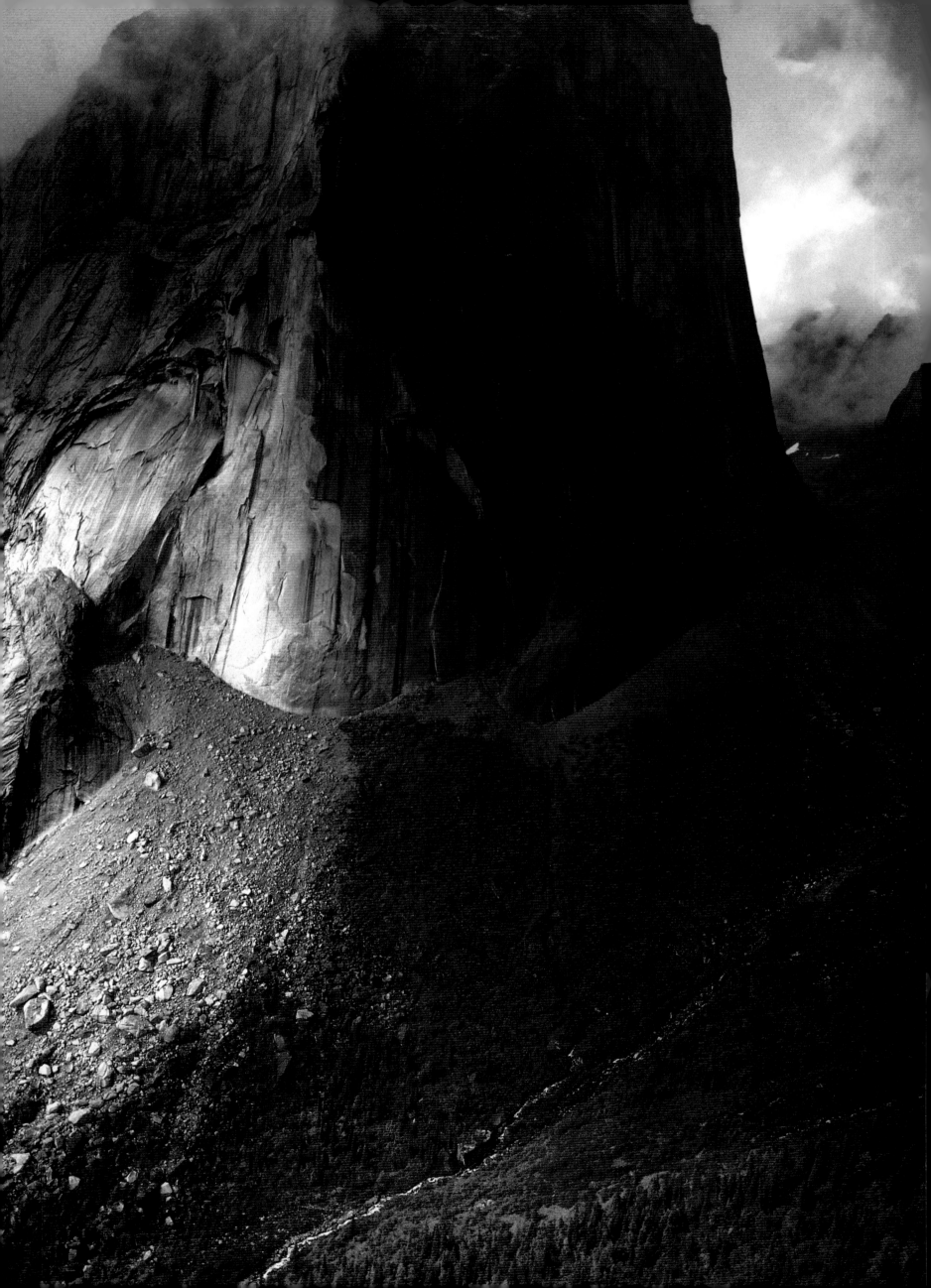

to planet across empty space," reports pilot Michael Parfit in the September 1997 issue of *National Geographic*. "I would leave one tiny cluster of boxy government-built houses and fly for hours across icebound bays, glaciers, or frozen swampland before the next little village showed like a handful of pebbles on the horizon."

Half the population in the North — compared to about 3 percent nationally — is of native ancestry, mainly Inuvialuit, Inuit, Dene, Cree, and Métis. Their languages — Dogrib, Chipewyan, Gwich'in, Cree, Slavey, and Inuktitut — are spoken as much if not more than English and French. In Nunavut, which is 85-percent Inuit, almost three-quarters of the people speak Inuktitut. Services are offered in their native tongue and English, and signs are written in the syllabics of both languages.

It's no surprise the Inuit have more than 20 terms for snow and many more for ice. They evolved as creatures of an unforgiving environment that is almost perpetually frozen. Winter lasts nine months and temperatures may fall to -50 C. One formidable blizzard in Iqaluit, in 1979, kept people housebound for 10 days. What is surprising, though, is that snowfall in an average year is less than half that covering much of British Columbia. Parts of the most northerly islands — Ellesmere, Axel Heiberg, Little Cornwallis — are a polar desert, getting less precipitation than the North African Sahara.

Northern aboriginals have lived from the land for millennia and the land remains the foundation of their cultures. Despite government efforts since the 1950s to urbanize natives, many Inuit hunters still live much of their lives in outpost camps. "Country food" — *nattiq*, the ringed seal, *ugjuk*, the bearded seal, *tuktuk*, the caribou — provide all the nourishment for healthy human survival.

For natives across the North, caribou are a traditional staple. Flesh and fat are sustenance, skins are clothing and blankets. Most plentiful and far-ranging are barren-ground caribou: in summer, hundreds of thousands forage above the treeline; in winter, some migrate 1,000 kilometres or more, down to the northern fringes of the boreal forests in Saskatchewan and Manitoba.

Beneath their relentless hooves is a rich repository of minerals — gold, diamonds, lead, zinc, natural gas, and oil. Mounting pressure to unearth those resources is as much a threat to wildlife as to the people who depend on country food. Recent agreements give northern aboriginals better control of the use and management of resources and wildlife. As they begin a new millennium, they look for a balance between the promise of modern employment and the independence of their ancient nomadic ways.

Northern Canada is one of the last places where expansive tracts of

opposite:

Mount Harrison Smith, at the entrance to the Cirque of the Unclimbables near Glacier Lake, Northwest Territories, is about 10 kilometres northwest of Nahanni National Park. ROBERT SEMENIUK

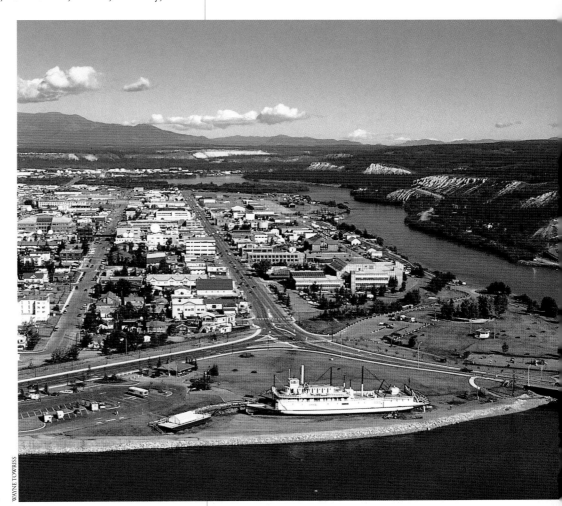

WAYNE TOWRISS

above:

Beached on the bank of the Yukon River, the SS Klondike is a National Historic Site in the Yukon capital of Whitehorse. The ship, retired in 1957, was one of several sternwheelers that travelled the river in the first half of the 20th century.

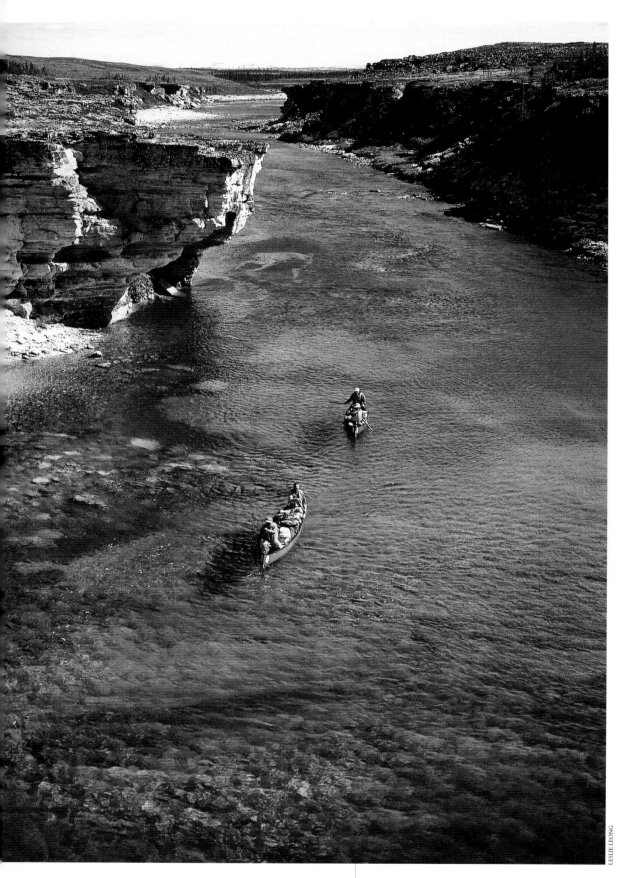

above:

*C*anoeists in the Northwest
Territories paddle a tributary to the
Thelon River in the Thelon Game
Sanctuary. Fly-in trips from Fort
Smith or Yellowknife are part of a
growing northern tourism industry.

wilderness can still be preserved. Conservation is a priority: Queen Maud Gulf Bird Sanctuary, on the mainland's coast, is the largest protected area in Canada, 62,000 square kilometres of nesting habitat for geese, swans, and other migratory waterbirds. Caribou habitat, and nesting sites for millions of birds, are preserved south of Queen Maud in Thelon Game Sanctuary, and near the mainland coast in Tuktut Nogait, Vuntut, and Ivvavik national parks. Farther north, on Banks Island, the densest concentration of musk-oxen in the world roams the hills above the sea cliffs in Aulavik National Park.

Nearly all of the Northwest Territories lies within the Mackenzie watershed, Canada's most extensive river system. Its farthest headwaters are more than 4,000 kilometres upstream from the sea, in B.C.'s Finlay River, a tributary to the Peace. Halfway to the Arctic Ocean, the Peace, Athabasca, and Slave rivers merge into a chaos of sloughs, streams, and shallow lakes, forming an immense inland delta at the western end of Lake Athabasca. This is Wood Buffalo, Canada's largest national park, straddling the Alberta-Northwest Territories boundary. It was established in 1922 for a herd of free-ranging bison, but it is also a waterbird nesting and staging area of global significance, recognized as a UNESCO World Heritage Site in 1983.

The wild lands continue well beyond the park, up through Great Slave Lake, where the Mackenzie proper begins. From here it runs 1,500 kilometres to Inuvik, gulping in the Liard, Great Bear, Tsiigehtchic, Peel, and other huge

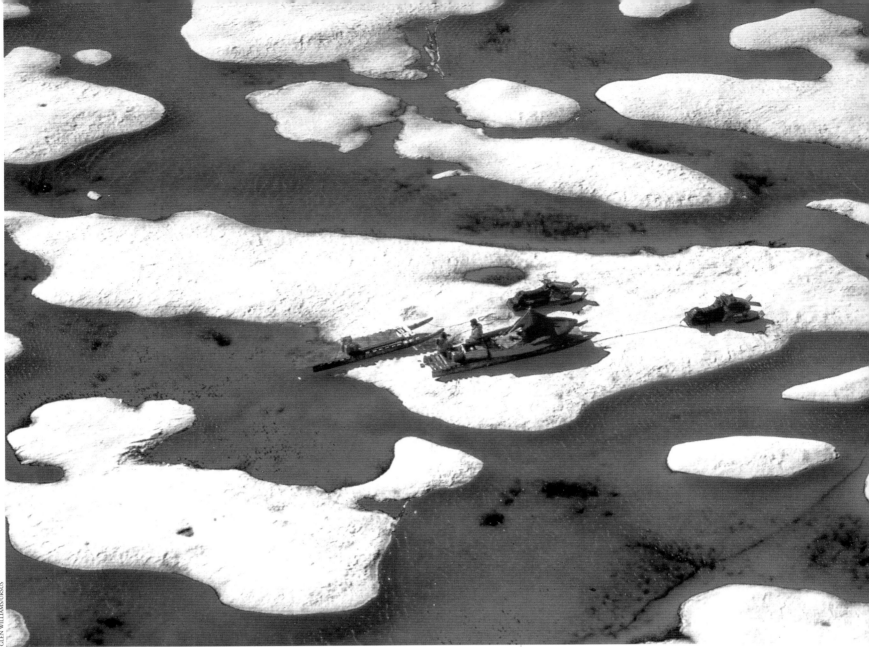

GLEN WILLIAMS/URSUS

tributary rivers, draining an area the size of the Northwest Territories and Yukon combined. Treeline and tundra meet not far from the Beaufort Sea, and the Mackenzie fans across a delta 80 kilometres wide, fragmenting into a labyrinth of channels, islands, and shifting sandbars.

The Mackenzie River, and the Yukon River in the mountains to the west, are historic and prehistoric trade routes. Long and navigable, they continue to tempt the restless, but *canots du nord* and York boats have been replaced by today's inflatable rafts, and fibreglass kayaks and canoes.

Outback travel is a growth industry in the North, and though a few highways have penetrated the hinterlands — the Alaska, Dempster, Klondike, Liard, and Mackenzie — aircraft provide the main mode of transport. People who fly the North today are more likely to see musk-oxen, grizzlies, moose, or mountain sheep than other humans. But it's becoming increasingly common to encounter tents pitched on the barren lands, or paddlers on month-long outings. For some, the mountains of the southwest Yukon present the greatest challenge. A hundred or so mountaineers register with Kluane National Park each year to scale Mount Logan, the nation's highest peak; about half are successful.

Much of the summer tourist season is illuminated by midnight sun. In the Arctic, children play outside at 3 a.m.; hunters and hikers travel by night and sleep through the days. But summers are as short as winters are long; by autumn, interior lakes and rivers are frozen, and sea ice chokes the channels and inlets of the Arctic Ocean. Land and water become one, and in the far North, daylight dwindles to darkness, and people wait for the sound of a sigh and the first glimmer of light on the Arctic horizon. ❧

above:

*I*nuit hunters tow komatiqs with snowmobiles across frozen Admiralty Inlet, Nunavut. On excursions of several days, sometimes weeks, hunters travel many miles out into Lancaster Sound to hunt seals and small whales.

following pages:

*T*he Ogilvie Mountains, about 100 kilometres northeast of Dawson, Yukon, overlook Chapman Lake and the Blackstone River along the Dempster Highway to Inuvik.
WAYNE TOWRISS

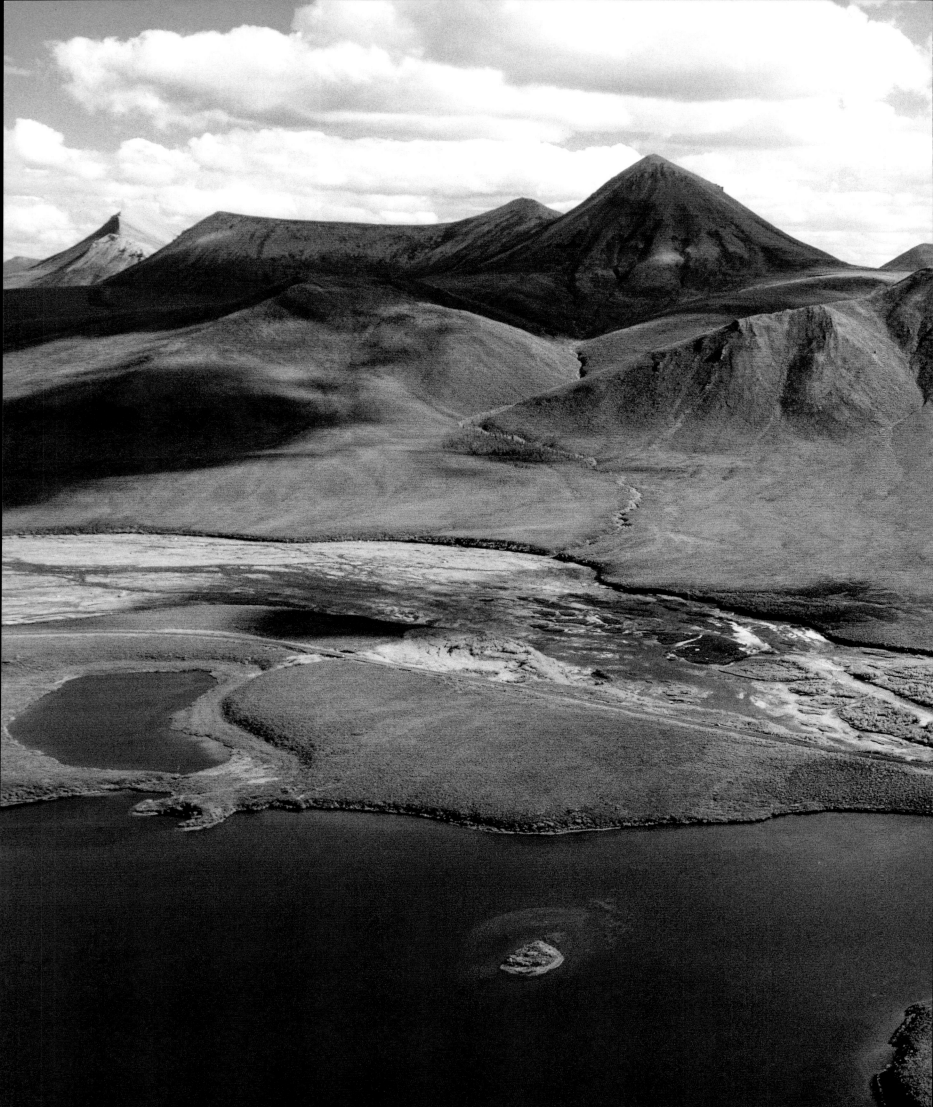

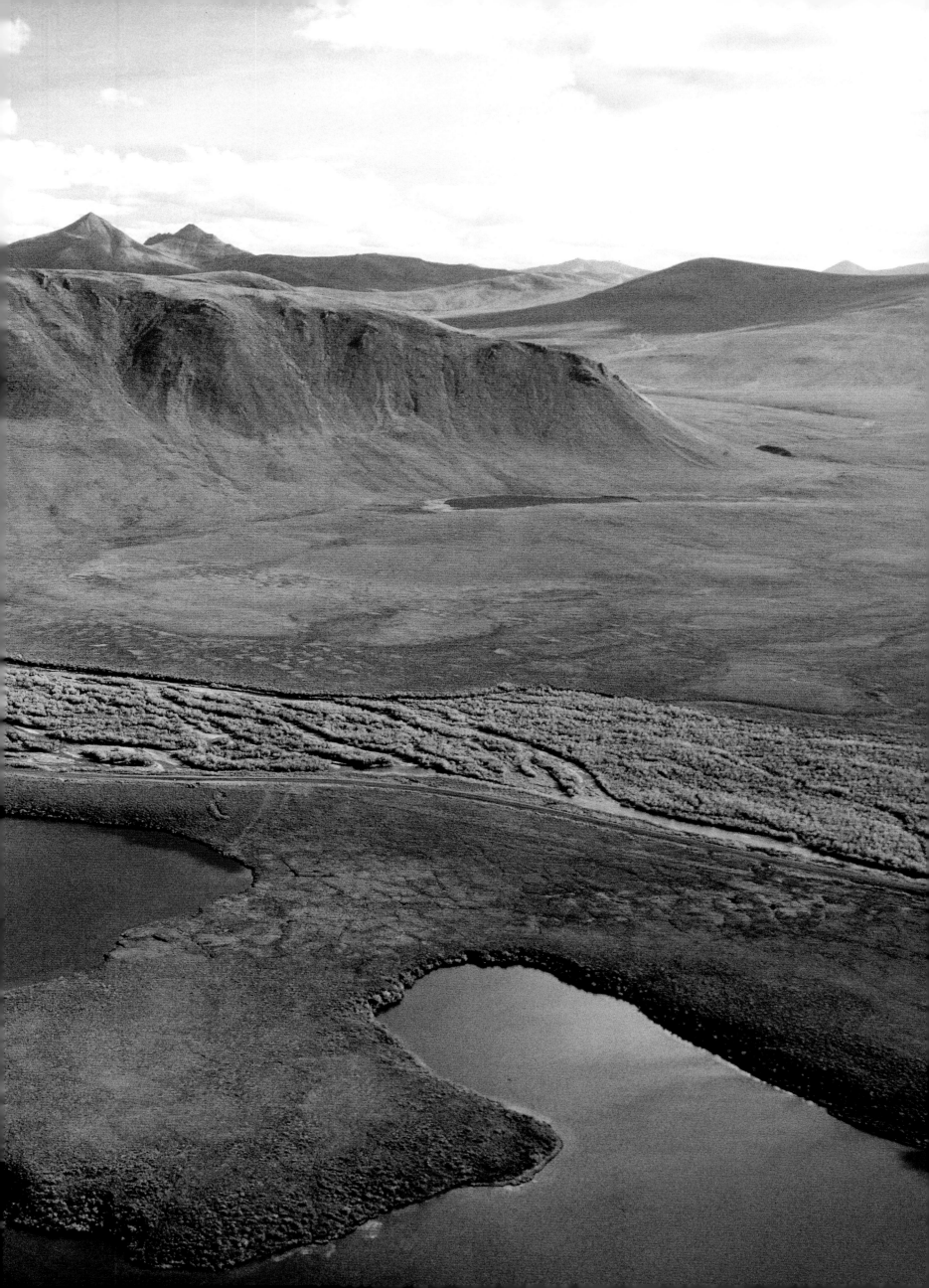

NANUQ

Canada's bear of the sea

It is from *nanuq*, the polar bear, that the Inuit of Arctic Canada have learned much about catching seals. They have watched the patient bear "still hunting" on the ice, lying in wait near a breathing hole for a seal to come up for air. Timing and speed are critical, and even when hunting is good, *nanuq* may succeed only once or twice a week.

Hunting is best in spring when pregnant seals dig birth lairs in the snow above their breathing holes. The pups are fat with their mothers' milk and too young to know the polar bears can smell them under the snow from a kilometre away. When summer melts the snow, basking seals are stalked on the ice, or snatched from the edges of ice floes by bears that swim up from the ocean.

The polar bear is the world's largest land carnivore. A big male can weigh 800 kilograms and measure three metres from nose to tail. Feeding its massive body occupies half its time, and, when seals are scarce, *nanuq* may turn to walruses, belugas, or narwhals.

Ursus maritimus — "bear of the sea" — is the most aquatic bear, and in the United States is protected under marine-mammal legislation. It often swims long distances, and leaves the sea ice only when it melts, or to give birth in winter dens dug into snowdrifts on land. Researchers travelling to the North Pole have seen polar bears and cubs on multi-year ice many miles from shore. Tissue samples from tranquillized bears reveal traces of PCBs, DDT, and other environmental contaminants that originate far from the Arctic Ocean.

No one is sure how many polar bears inhabit the Canadian Arctic; perhaps 12,000 to 20,000, probably half the world population. There are 14 subpopulations in Canada, ranging from Yukon to Labrador, and from James Bay to the Arctic Archipelago.

For the Inuit, *nanuq* is both teacher and provider. About 600 permits to hunt polar bears are issued to Canadian aboriginals each year.

above:

A polar bear shakes off seawater.

142

above:

A polar bear seems unfazed by the passing Kapitan Khlebnikov, a Russian icebreaker carrying tourists.

143

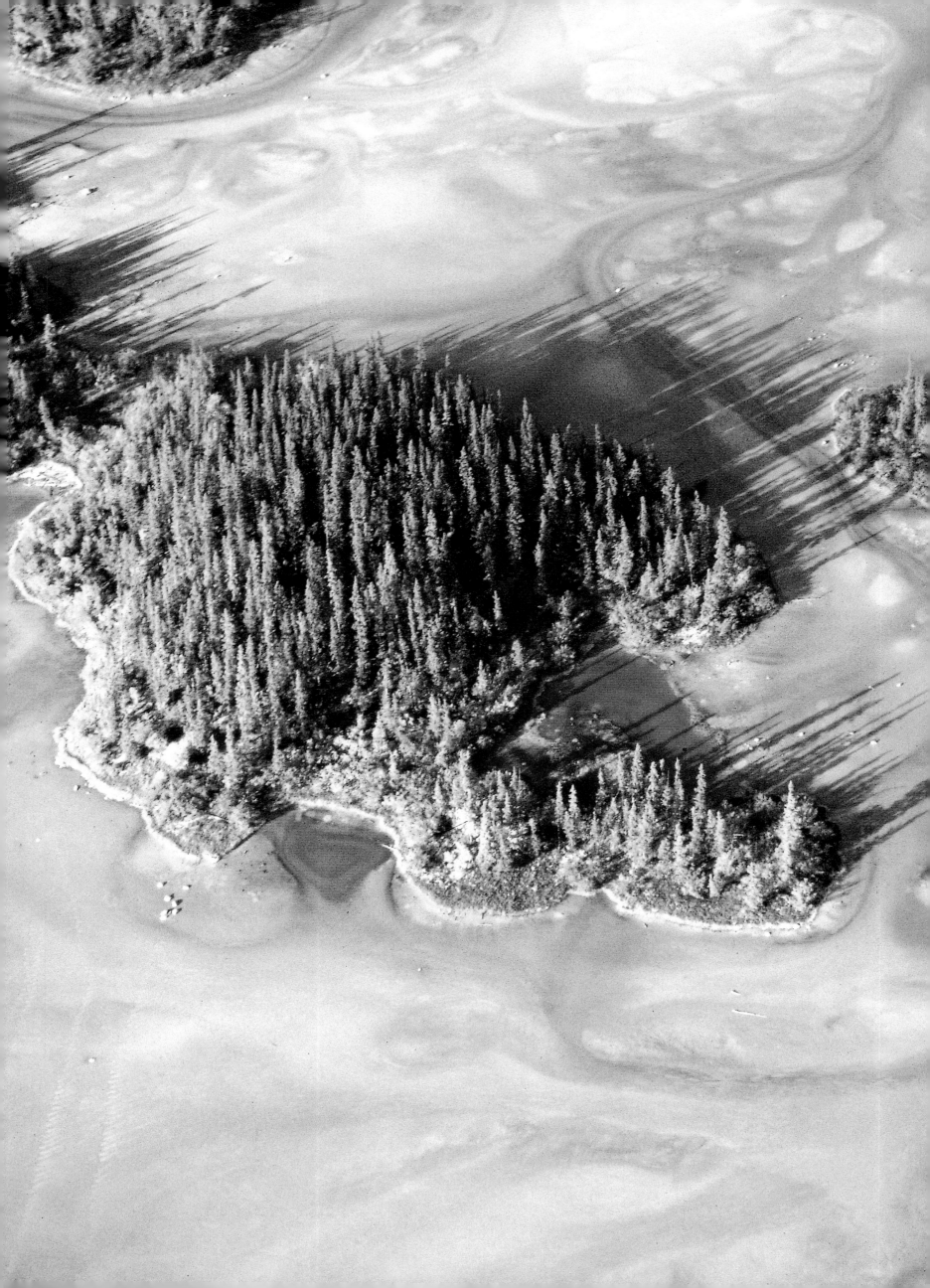

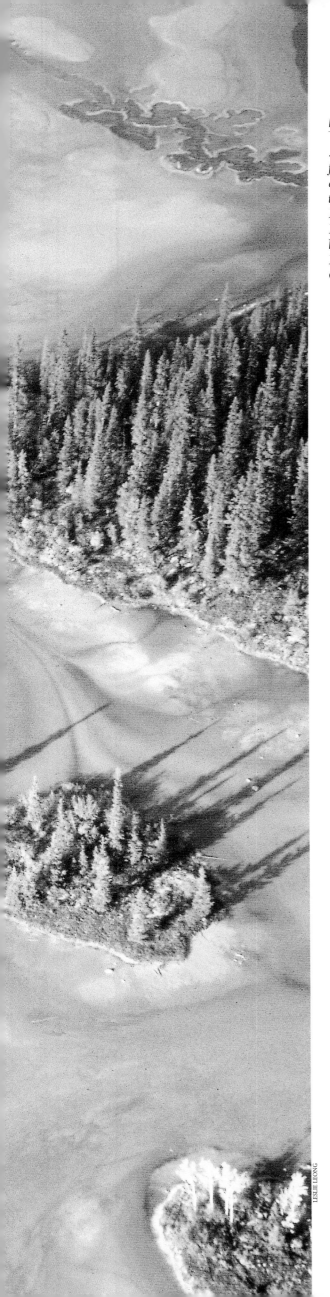

*F*reshwater springs laden with salt from ancient seas rise to the surface of the ground, creating salt plains at the base of an escarpment in Wood Buffalo National Park. Encompassing 44,902 square kilometres on the Alberta-Northwest Territories border, this is Canada's largest national park.

above:

*A*fter wintering along the southern edge of the pack ice, beluga whales on both sides of the Canadian Arctic migrate north to congregate off river mouths, where cows give birth. As Arctic seas begin to freeze, the whales return to open feeding waters for winter. Some belugas survive the high Arctic winter in polynyas, areas of open water surrounded by sea ice.

following pages:

M'Clure Strait, in the western Arctic, forms the northern boundary of Aulavik National Park, encompassing 12,200 square kilometres on Banks Island, Northwest Territories. Protected in 1992, this parkland contains the world's richest habitat for tens of thousands of musk-oxen, and is a staging area for brant and lesser snow geese that gather in the streams, lakes, and ponds of the Thomsen River basin. WAYNE LYNCH

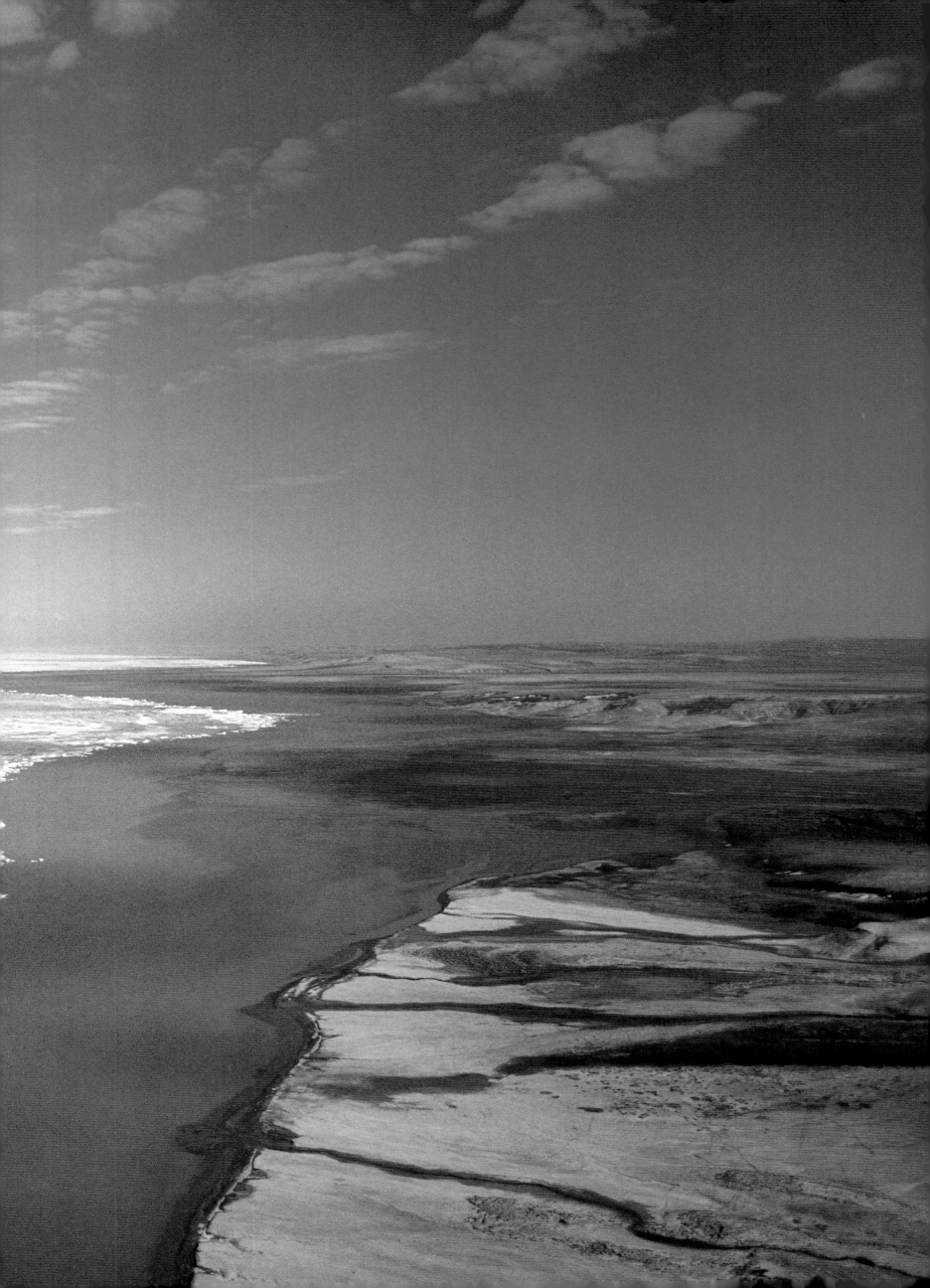

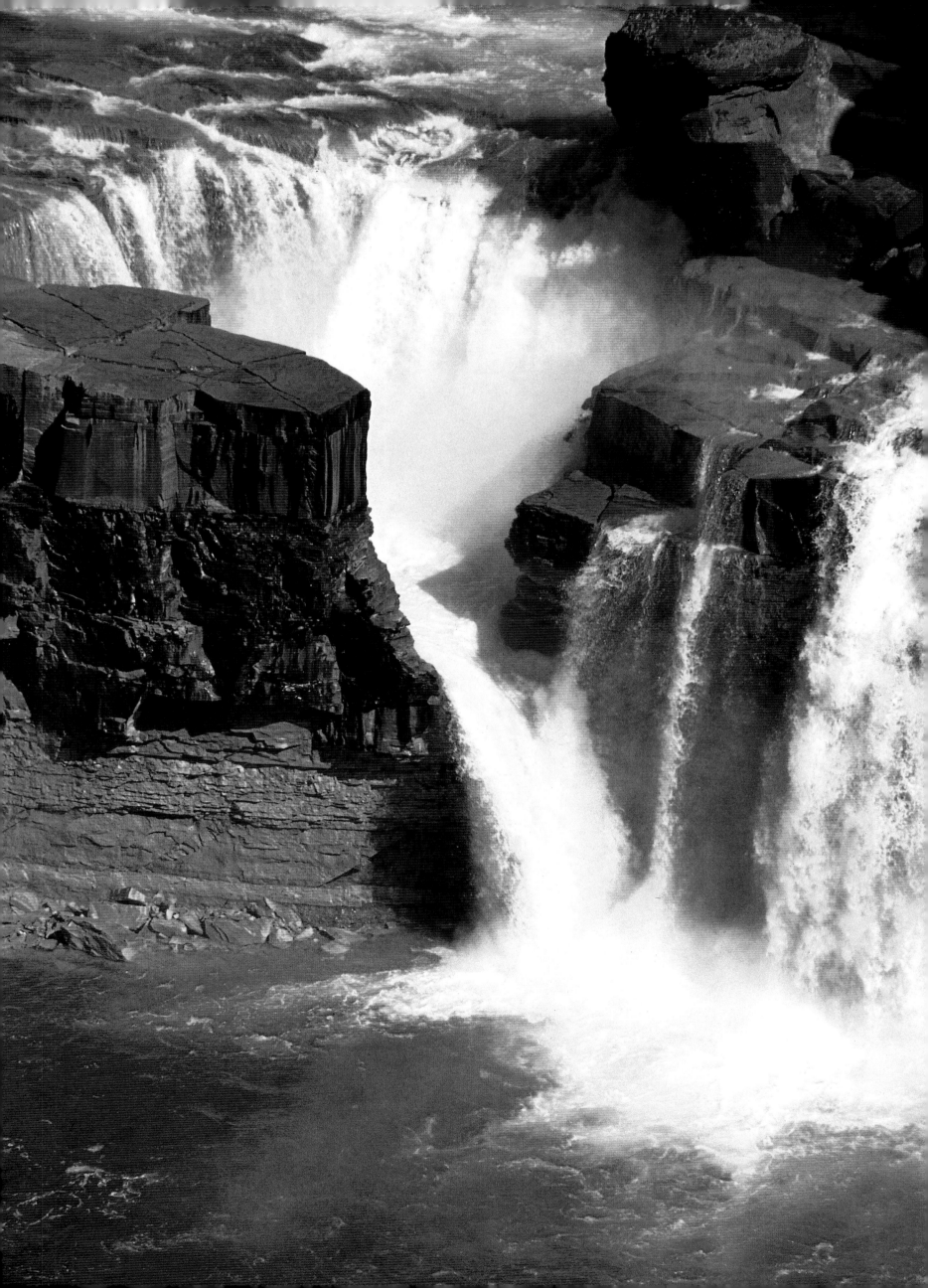

La Roncière Falls, on the Hornaday River, is the best-known landmark in Tuktut Nogait, a 16,340-square-kilometre national park established in 1998. The park, near the mainland coast on the Northwest Territories-Nunavut border, has been described as "an Arctic version of the Grand Canyon." LESLIE LEONG

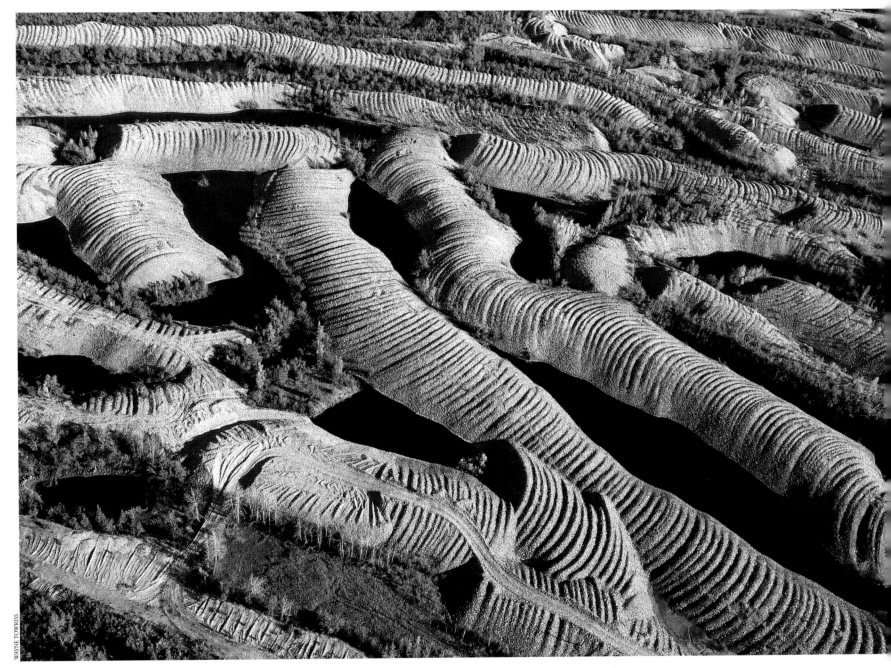

WAYNE TOWRISS

Gravel tailings are part of the landscape south of Dawson, in Yukon's Klondike River valley. Giant dredges tore the river bottom to bedrock in the early 1900s when miners removed nearly $13 million worth of gold from the area.

MOUNT LOGAN

The measure of a mountain

Mount Logan is yet another superlative among the biggest, farthest, longest, and most remote in the geography of the Canadian North. Protected within Kluane National Park, the nation's highest mountain is an immense massif in the St. Elias Range of southwestern Yukon. It is not one summit but a series, surrounded by glaciers that make up the Earth's largest non-polar icecap.

Harsh weather, isolation, and sheer size had made measuring Mount Logan from the ground an almost impossible task. Since the first ascent of its "High Peak" in 1925, there had been considerable disagreement about its height, with published elevations varying from 5,950 metres to 6,050. So large a discrepancy for such a prominent national icon was unacceptable to the Geological Survey of Canada, which in 1992 — its 150th anniversary — launched an expedition to re-measure the mountain named for the survey's first director, Sir William Logan.

Sponsored by the Royal Canadian Geographical Society, a 13-member team of mountaineers, scientists, and national park wardens was flown to a base camp 3,200 metres below the summit. Besides food and fuel for 40 days, their 1,300 kilograms of gear included a laptop computer, batteries, solar panels, and most importantly, Global Positioning System receivers to measure the mountain with help from satellites.

Often stormbound for days by 90-kilometre-an-hour winds that chilled the air to -40 C, the first team members reached the summit on the 27th day. They stood on the pinnacle of the nation and looked over the tops of Canada's highest mountains to the Gulf of Alaska, and down to the British Columbia and Yukon icefields.

"The scale, the immensity of the area is quite amazing," recalls expedition leader Michael Schmidt, an engineer with the Geological Survey. "You're looking down on these big mountains — ones that are great climbing objectives in their own right — and they seem like little hills."

The official elevation of Mount Logan now is 5,959 metres, give or take three metres.

right:

Mount Logan stands above Kaskawulsh Glacier in Yukon's Kluane National Park.

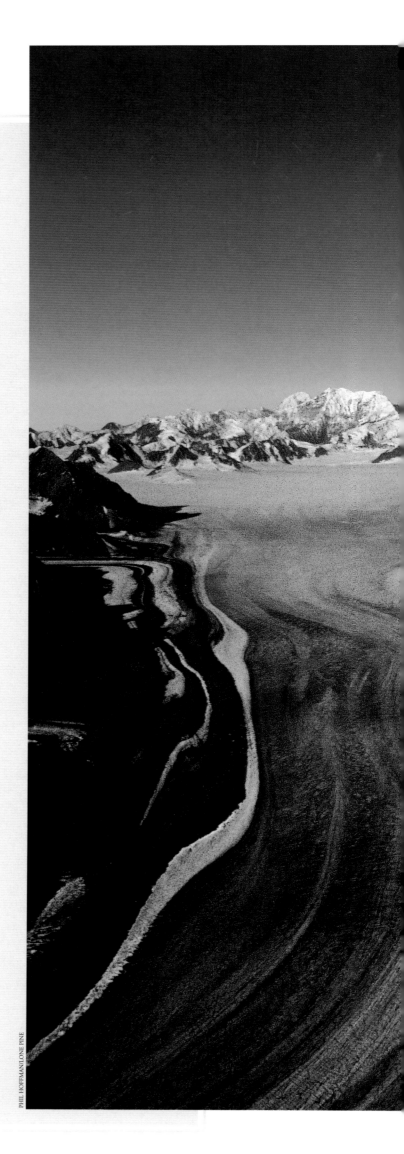

PHIL HOFFMAN/LONE PINE

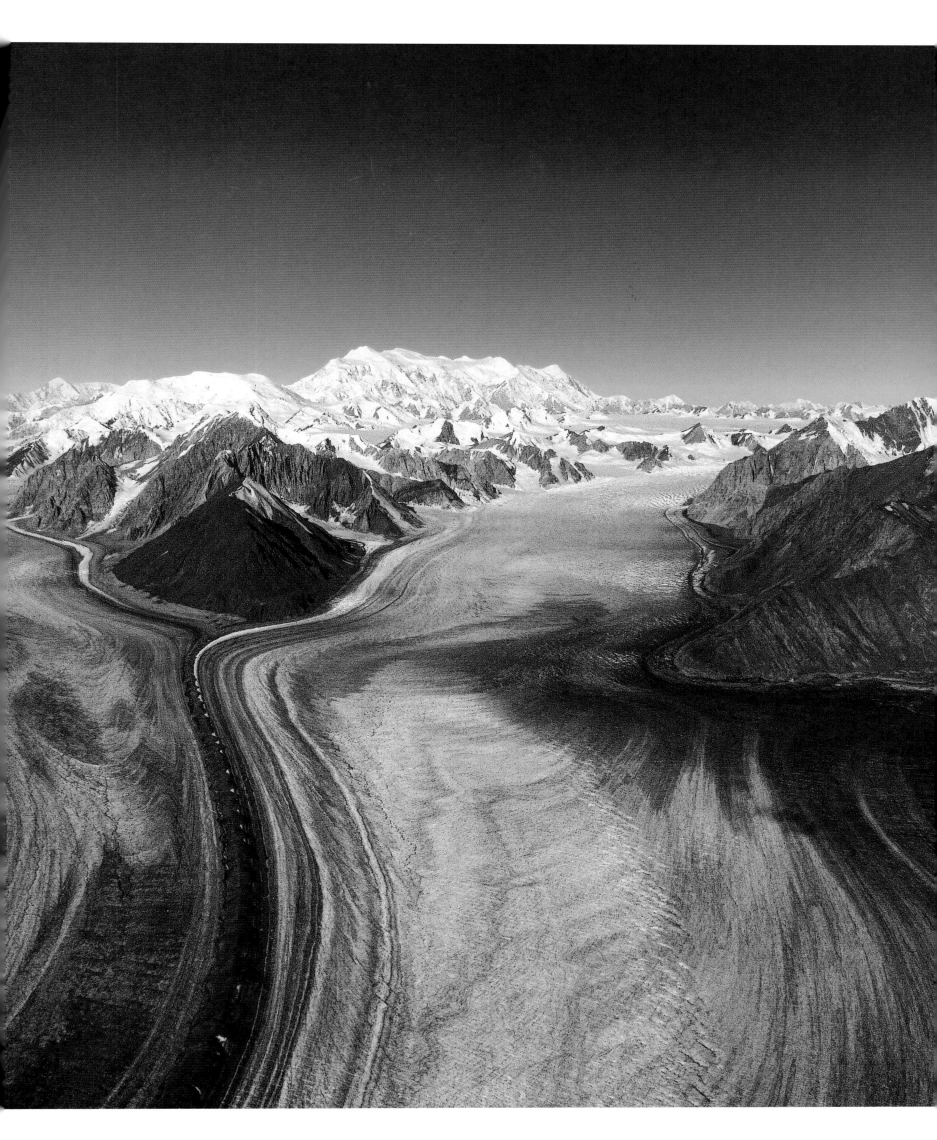

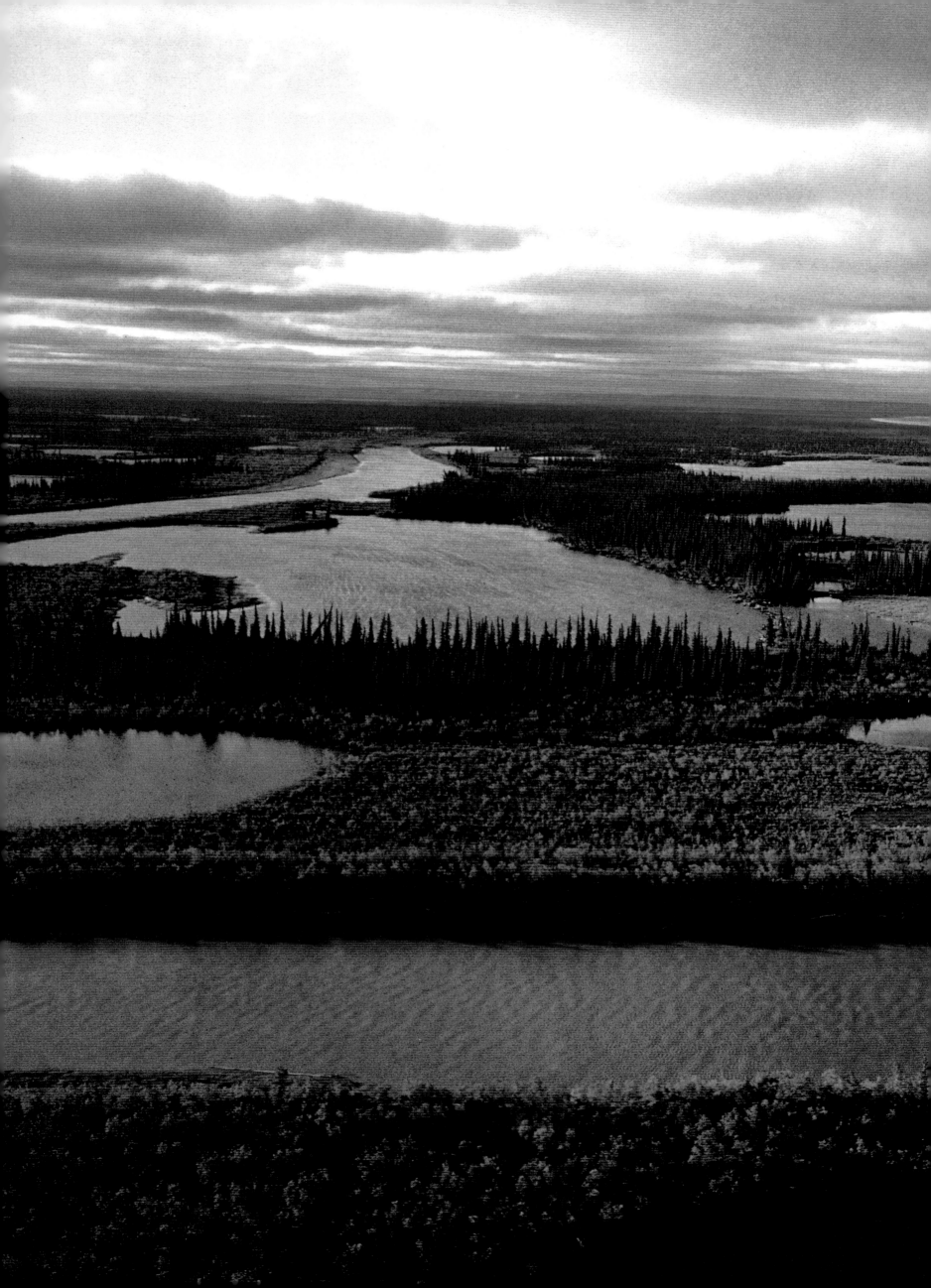

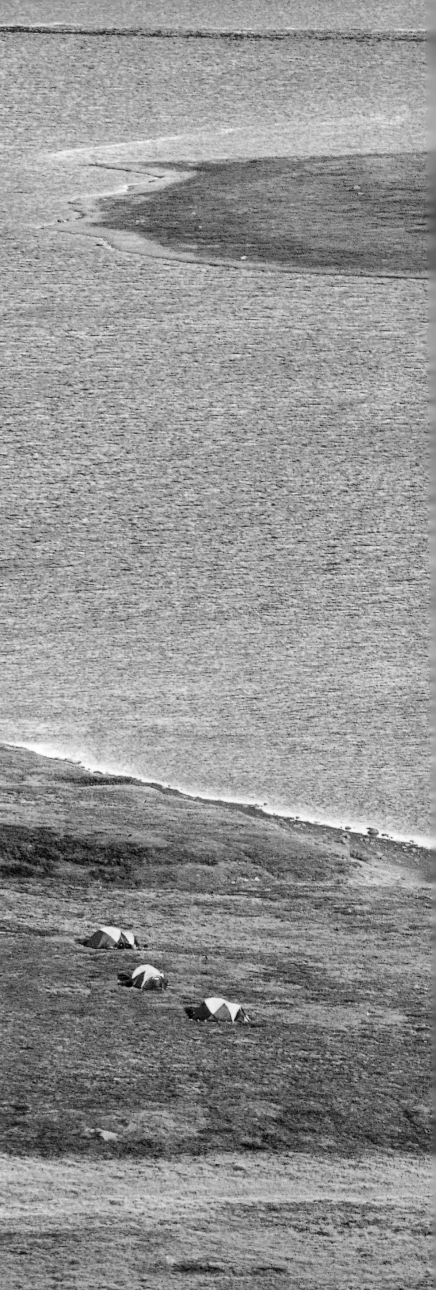

TERRY A. PARKER/FIRST LIGHT

previous pages:

*T*reeline gives way to tundra in the Mackenzie Delta, not far from Inuvik in the Northwest Territories. Encompassing 4,600 square kilometres, this immense maze of channels and islands lies near the mouth of Canada's longest river.
WAYNE LYNCH

ROBERT SEMENIUK

above:

A grizzly fishing for spawning salmon is one of about 7,000 Yukon grizzlies. An estimated 25,000 grizzly bears — nearly half the world's population — roam the Canadian wilderness.

right:

*C*ampers pitch tents beside the Burnside River, which crosses the Arctic Circle at a latitude of 66 degrees 32 minutes north and flows across the barrens to Nunavut's Bathurst Inlet.

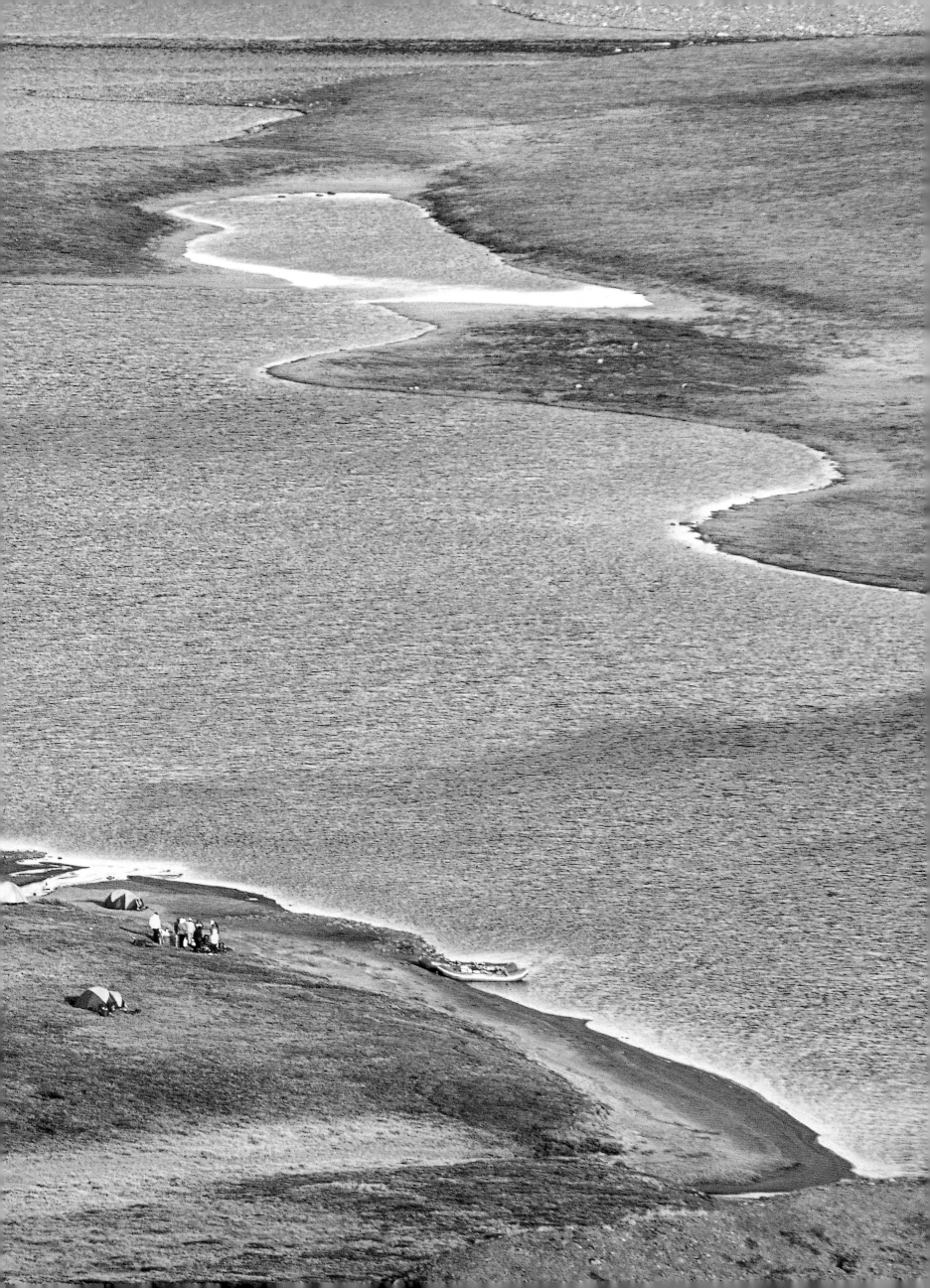

THE WEST

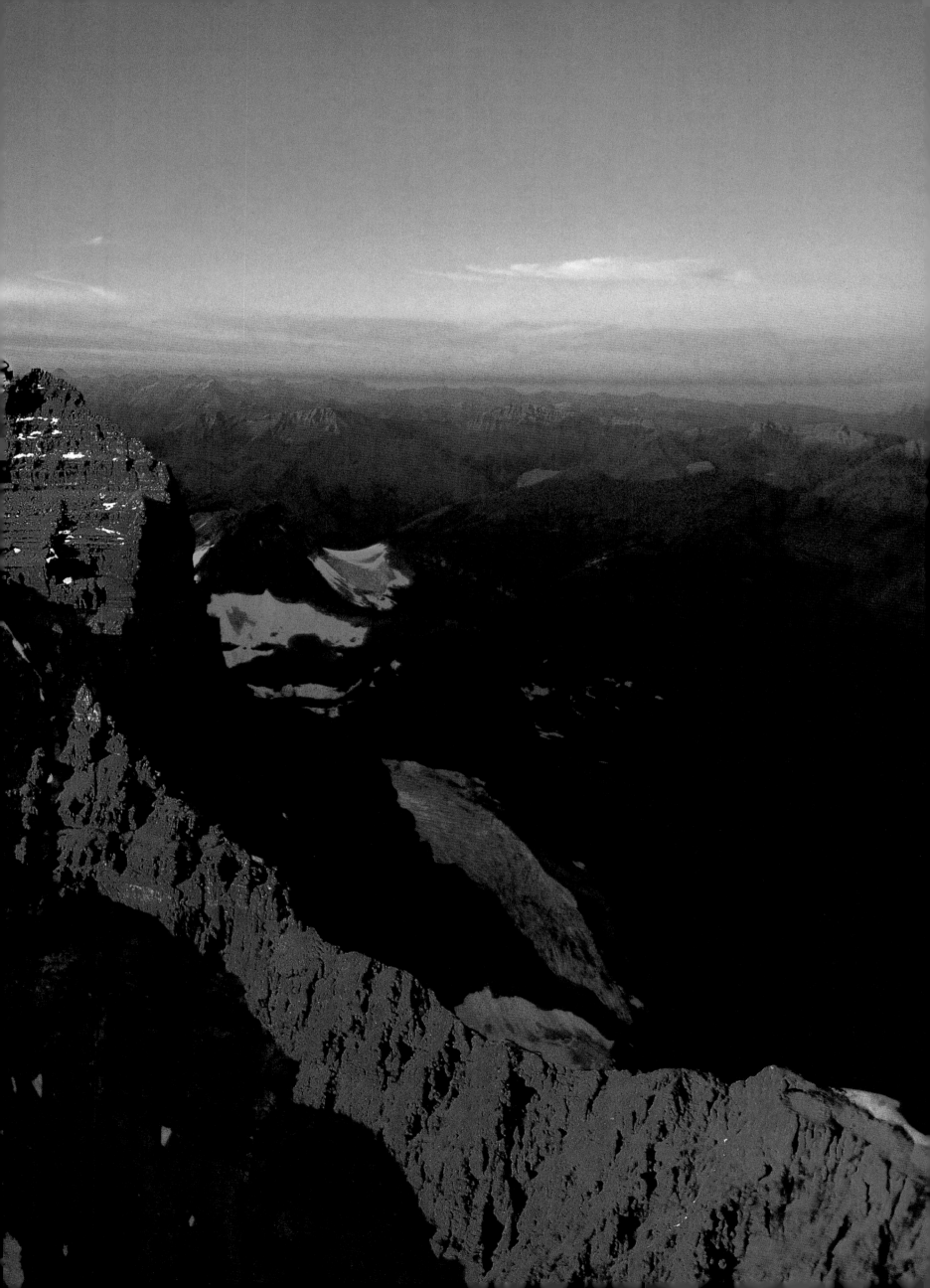

THE WEST
CROSSING THE GREAT DIVIDE

previous pages:

*B*ritish Columbia's Mount Assiniboine, touted as a counterpart to Switzerland's famous Matterhorn, is actually 860 metres lower. But at 3,618 metres, Assiniboine is the sixth-highest peak in the Canadian Rockies.
RUSS HEINL

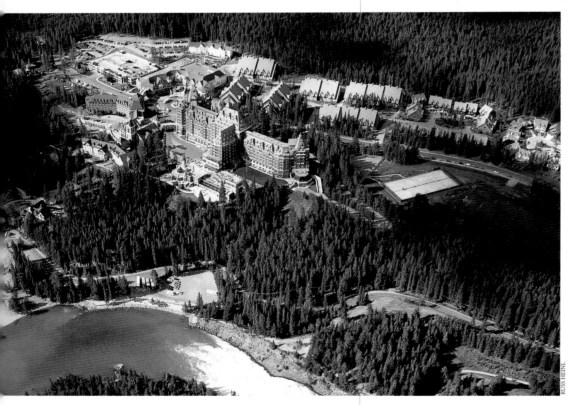

above:

*L*ike a castle above the Bow River, Alberta's Banff Springs Hotel brings an architectural elegance to the wildness of the southern Rockies. Built by Canadian Pacific Railway, it was the world's largest hotel when it opened in 1888.

opposite:
British Columbia's Blackcomb Glacier, at Whistler north of Vancouver, can be skied year-round. With two mountains and 13 high-speed lifts, Whistler is ranked among the world's top five ski resorts.
RANDY LINCKS/IMAGE NETWORK

The stone-grey face of Mount Assiniboine has turned the colour of ochre in the soft glow of a setting sun. Long dusky shadows sharpen the ridges running up to the peak. It looks as if the whole mountain has been pushed up into the daylight from the darkened valleys below. In the distance behind, a scattering of rusty-red summits reflects the last of the evening glimmer in Banff National Park.

Even in the warm light of sunset there is a chill to this scene. It's a disquieting kind of grandeur, overwhelming, wild, and humbling. Anyone who travels here is awed by the powers that mould such dishevelled landscapes: mountains, glaciers, more mountains; braided streams, canyons, waterfalls, and peaks of naked rock crudely chiselled against a cold blue sky.

"The scenery in the Rocky Mountains doesn't quit. It's full-throttle all the time," says *Over Canada* photographer Russ Heinl. "Every corner, every bend, your heart goes again." Aerial shooting here is exhausting. Each manoeuvre presents a fresh challenge; every jump in altitude brings more subjects to the picture, more detail pouring in over the edges. "When you're in the air you see the whole dynamic of the range. You have a sense of scale, and it is, in a word, 'vast.' It's a huge, living thing that you're flying through."

The imposing pyramidal peak of Mount Assiniboine is sometimes called Canada's "Matterhorn." In the earliest days of railroading, Canadian Pacific lured trainloads of affluent globetrotters to the Rockies with a promise of "fifty Switzerlands in one." This was the Western Frontier, with summits to be conquered and named, and imported Swiss guides to lead those with money and fortitude to the mountaintops.

Today, parks and reserves in the Canadian Rockies would cover nearly all of Switzerland. Banff, Jasper, Kootenay, and Yoho national parks were declared a World Heritage Site in 1983. B.C.'s Mount Robson, Hamber, and Mount Assiniboine provincial parks were added in 1990 to encompass an unbroken tract of mountain parkland bigger than Lake Ontario. And there's more: Alberta's Waterton Lakes National Park and Kananaskis Country in the south; Willmore Wilderness north of Jasper, and a string of B.C. backcountry parks from Akamina-Kishinena in the south to Muskwa-Kechika in the north.

Through 40 degrees of latitude, from Yukon to Mexico, the Rocky Mountains are North America's geographic backbone. This is the Great Continental Divide, where the interminable flatness of the interior collides with the Western Cordillera, a major mountain system of the world. From the

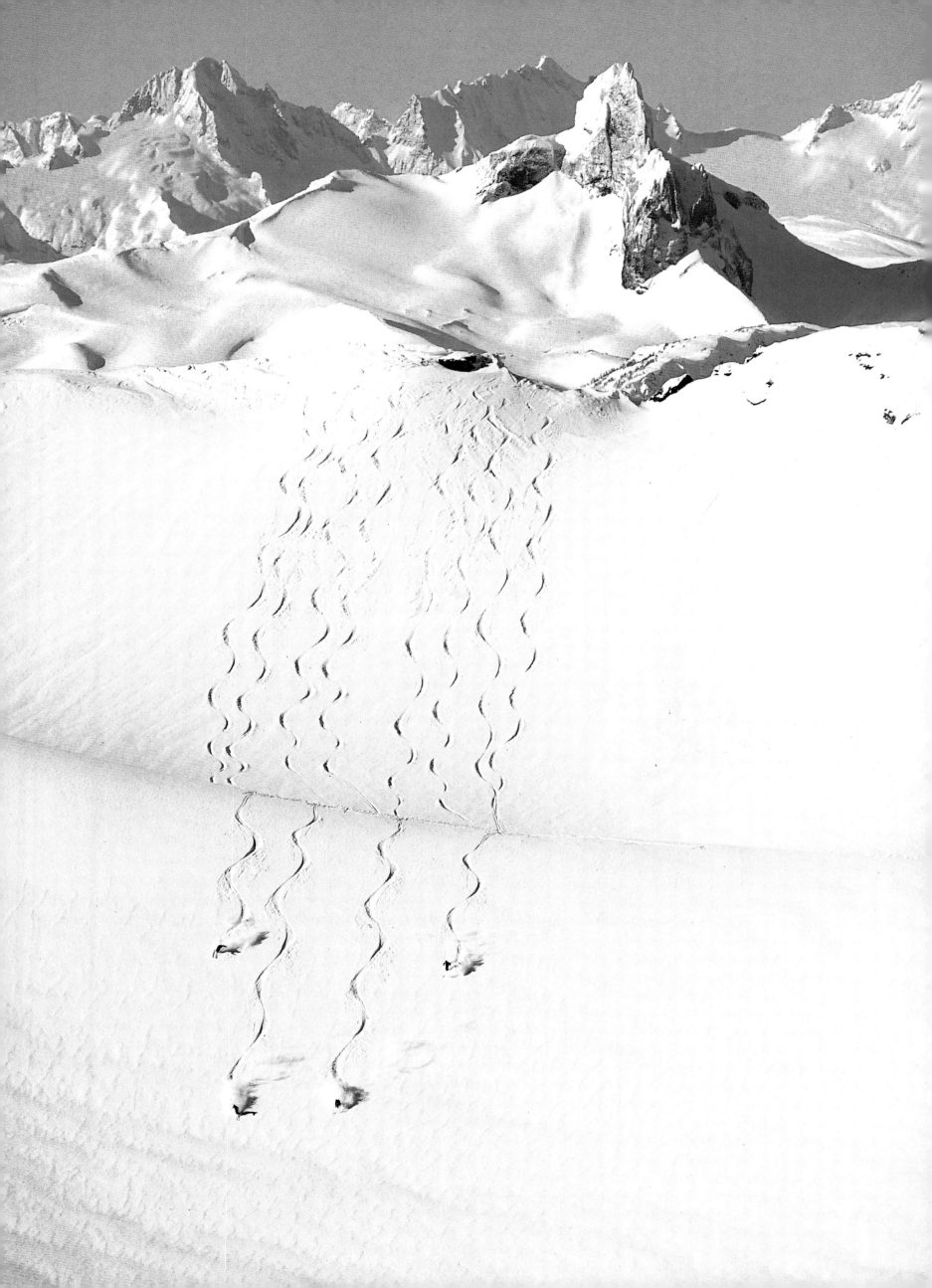

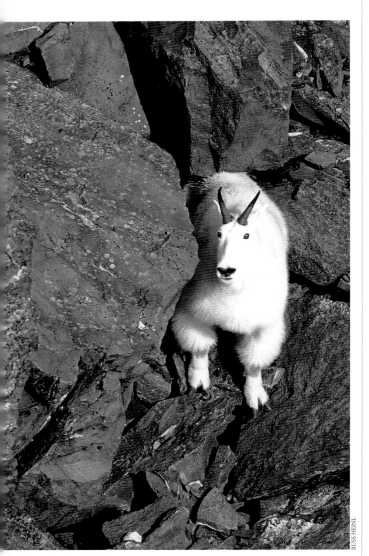

RUSS HEINL

above:

The ranges of Western Canada have some of the densest mountain goat populations in the world. Skid-proof, shock-absorbent soles on their two-toed hooves allow these woolly climbers to inhabit the region's roughest terrain.

highest ridges of the Rockies, the rivers flow to opposite corners of the land — north to the Beaufort Sea, south to the Gulf of Mexico, east to Hudson Bay, and west to the Pacific.

Though not our highest, the Rockies are Western Canada's most accessible mountains and their status as our preeminent natural attraction is undisputed. They have been climbed, hiked, skied, paddled, and gawked at by millions of tourists since Banff became Canada's first national park in 1885.

For newcomers to the West, they are a glimpse of more to come, a gateway to a succession of mountains, valleys, and high plateaus that cover British Columbia to the Pacific. More than 40 ranges, each as unique and dramatic as the next, are the essence of the natural West. Like big prairie skies, they dominate, setting the mood as much as the scene, setting the West apart from all other landscapes east of the Divide. "Crossing the Rockies, you are in a new country, as if you had crossed a national frontier," wrote B.C. journalist Bruce Hutchison. "Everyone feels it, even the stranger feels the change of outlook, the tempo, the attitude."

From alpine tundra to coastal estuaries, the mountains of B.C. preside over an environmental diversity unequalled in North America: broad valleys and alluvial floodplains, grasslands and desert, rainforests, beaches, and 24,000 lakes and streams that catch almost a third of Canada's freshwater runoff.

Tectonic forces built the mountains and glaciers did much of the finishing, sculpting raw rock into sawtooth ridges, hanging valleys, and deep-water fiords. The most indelible scratch is the Rocky Mountain Trench, the longest, straightest valley in the province. Never widening to more than 20 kilometres, it skirts the western edge of the Rockies for 1,400 kilometres from Montana to Yukon. Each of B.C.'s four largest rivers — the Columbia, Fraser, Peace, and Liard — travels through parts of the trench.

Most pervasive is the Fraser, the lifeblood of B.C. with arteries that reach deep into the province's heart. From its headwaters near Mount Robson to the sea at Vancouver, it collects the runoff from mountains on opposite sides of B.C. through its massive tributaries, the Nechako, Quesnel, Chilcotin, Thompson, and other rivers. Nearly 1,400 kilometres long, the Fraser is Canada's fifth-largest river system, draining a quarter of B.C.

No other waterway in Canada encounters such varied landscapes in the course of its wanderings. Downstream from the Rockies, the Fraser slices across the Interior Plateau through the arid grasslands in the rain shadow of the Coast Mountains. Rattlesnakes bask in the dust here, and bighorn sheep are easy prey for cougars in the open terrain. Cactus and sagebrush cover a near-treeless countryside at the confluence of the Chilcotin and Fraser rivers. This was a meeting place for tribes from either side of the Fraser, marked by ancient petroglyphs carved in riverside rocks. Hoodoos stand sentinel on the banks, and just downstream is a monumental wall of limestone columns deemed "an immense pile of natural architecture" by explorer Simon Fraser.

To follow the Fraser from the plateau down to Vancouver is to travel from driest to wettest, from field to forest, from Stone Age to downtown. Nearly two-thirds of B.C.'s four million people live within the Fraser River watershed. Almost two million live around its estuary, in the City of Vancouver and its suburbs.

From the air you can see the pace picking up as the skyline of Canada's third-largest metropolis comes into view. Commuters clog the highways, jets and helicopters vie for air space over Vancouver International Airport, and barges, tugs, and fishboats crowd the Fraser's lower reaches. Downtown on the harbour, another Alaska-bound cruise ship heads out under the Lions Gate Bridge. An escort boat nudges a foreign freighter toward the Port of Vancouver loading docks, and floatplanes are touching down in front of Canada Place.

The nation's gateway to the Pacific, Vancouver is our busiest port, as well as a mecca for Asian immigrants and entrepeneurs. It's not the big-city bustle, however, that's most striking to the aerial eye, but the wildness around it. "The city has a sumptuous sea-and-mountain setting rivalled only by Rio's and Hong Kong's," writes Paul Grescoe in his book, *Vancouver: Visions of a City.*

The scenery carries on into the Strait of Georgia where ferry travellers bound for Victoria are setting their watches to Island Time. B.C.'s capital city has about one-sixth the population of Greater Vancouver and is separated by a moat that's too wide for a drawbridge. Vancouver Islanders live by a different rhythm, and many shudder at the thought of a bridge to the traffic and noise of the mainland.

Victoria is by no means an isolated backwater. It's the size of Halifax, with 300,000 people, half of Vancouver Island's population. Snuggled in the lee of Washington's Olympic Mountains, the city's agreeable climate and Old World ambience aren't just legendary, they're real. Flower counts begin in February when diehard gardeners mow their lawns and cricket pitches are readied for the season.

But violent Pacific storms may idle the ferries and douse the manicured gardens with endless rain. It's the outer shores of Vancouver Island that bear the brunt. If you fly into Pacific Rim National Park and over the West Coast Trail, you find hikers walking under sea arches bashed through rock by

RUSS HEINL

above:

A cruise ship heads out of Vancouver Harbour under the Lions Gate Bridge. About two dozen luxury liners carry some 900,000 passengers through Vancouver each year. Most are travelling British Columbia's Inside Passage to Alaska.

incessant waves. Campers pitch their tents in a clutter of driftwood logs heaved upon the beach by winter gales.

Driftwood and other flotsam piles against the seaward edge of the rainforest at Long Beach in Pacific Rim Park, where the sweeping arc of Wickaninnish Bay is constantly battered by surf. From the air, you can watch the combers rolling out of the swells and breaking into overlapping lines of foam as they shoal up onto the sand.

If you hover over the ocean and look toward the land, you see North America's largest Pacific island, with mountains higher than the Russian Urals or the Appalachians. And if you climb higher, you see beyond Vancouver Island to the Coast Mountains on the mainland, where the granite spires of Mount Waddington stand above all other peaks within B.C.

Mountains that face the sunset here are penetrated by inlets that compare with the famous fiords of Norway, New Zealand, or Patagonia. Steep, deep, narrow, and long, these waterways are seagoing extensions of glaciated valleys. Icefields that sprawl below the summits of the coastal ranges feed the inlets, turning the seawater a powdery green.

The inlets are absorbed into a maze of channels, islands, and reefs that make up Canada's fragmented Pacific coast — 6,500 islands and 27,000 kilometres of shoreline.

The Queen Charlotte Islands — Haida Gwaii — are the remotest, perhaps the wildest, and most alluring of islands. The cliffs in Gwaii Haanas National Park are streaked by the guano of seabirds that nest by the thousands. In the ocean below, sea lions raise pups on offshore islets, and transient killer whales sometimes grab them off the rocks.

This far-flung archipelago is the ancestral domain of the Haida Nation, a seafaring aboriginal people who widely travelled the North Pacific in canoes carved from giant cedars. Twelve hundred Haida and 4,000 others live in these islands now, but the ancient villages have been abandoned. Kaisun, Kiusta, Tanu, and other sites have been left to the ravages of nature, their weatherworn totems reclaimed by the rainforests from which they were taken. Ninstints, described by UNESCO as "the most impressive and remarkable Indian site in the Pacific Northwest," has been named a World Heritage Site, representing "a vanished culture of great richness and significance."

The ocean off the western shores of Haida Gwaii is Canada's last horizon. It's here, beyond the rolling swells of the North Pacific, that the sun sets on a Canadian day that dawned over the Atlantic, 5000 kilometres and six time zones away. ❦

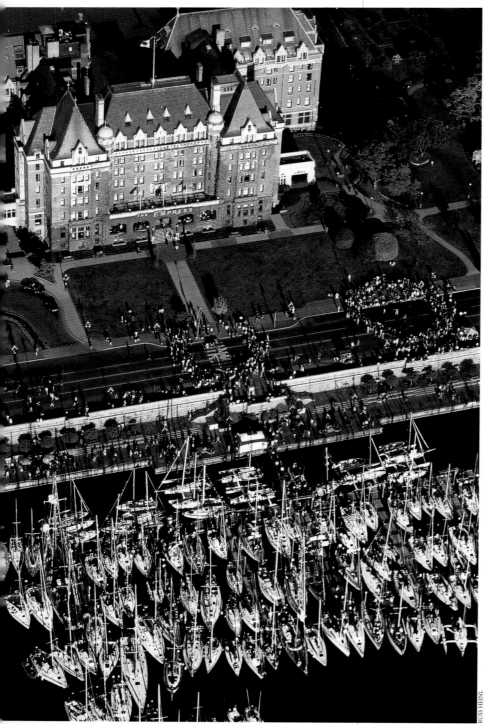

below:

Boats sailing in the Swiftsure Lightship Classic, a 220-kilometre race in Juan de Fuca Strait, crowd the docks in Victoria Harbour, while onlookers gather around performers in front of the Empress Hotel.

RUSS HEINL

opposite:

Upper and Lower Kananaskis lakes, in Alberta's Kananaskis Range southeast of Banff National Park, are protected within a complex of Rocky Mountain parks.
RUSS HEINL

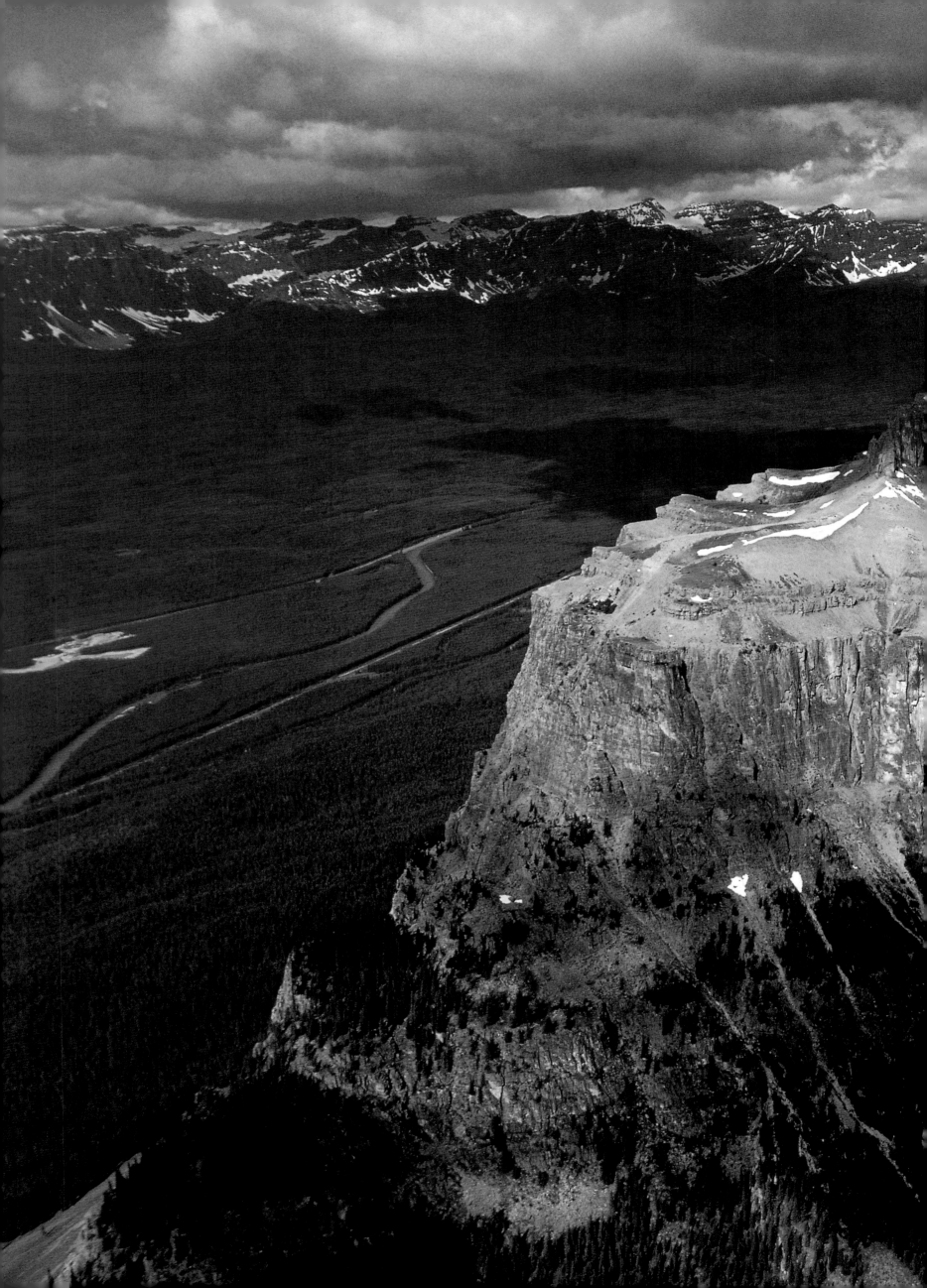

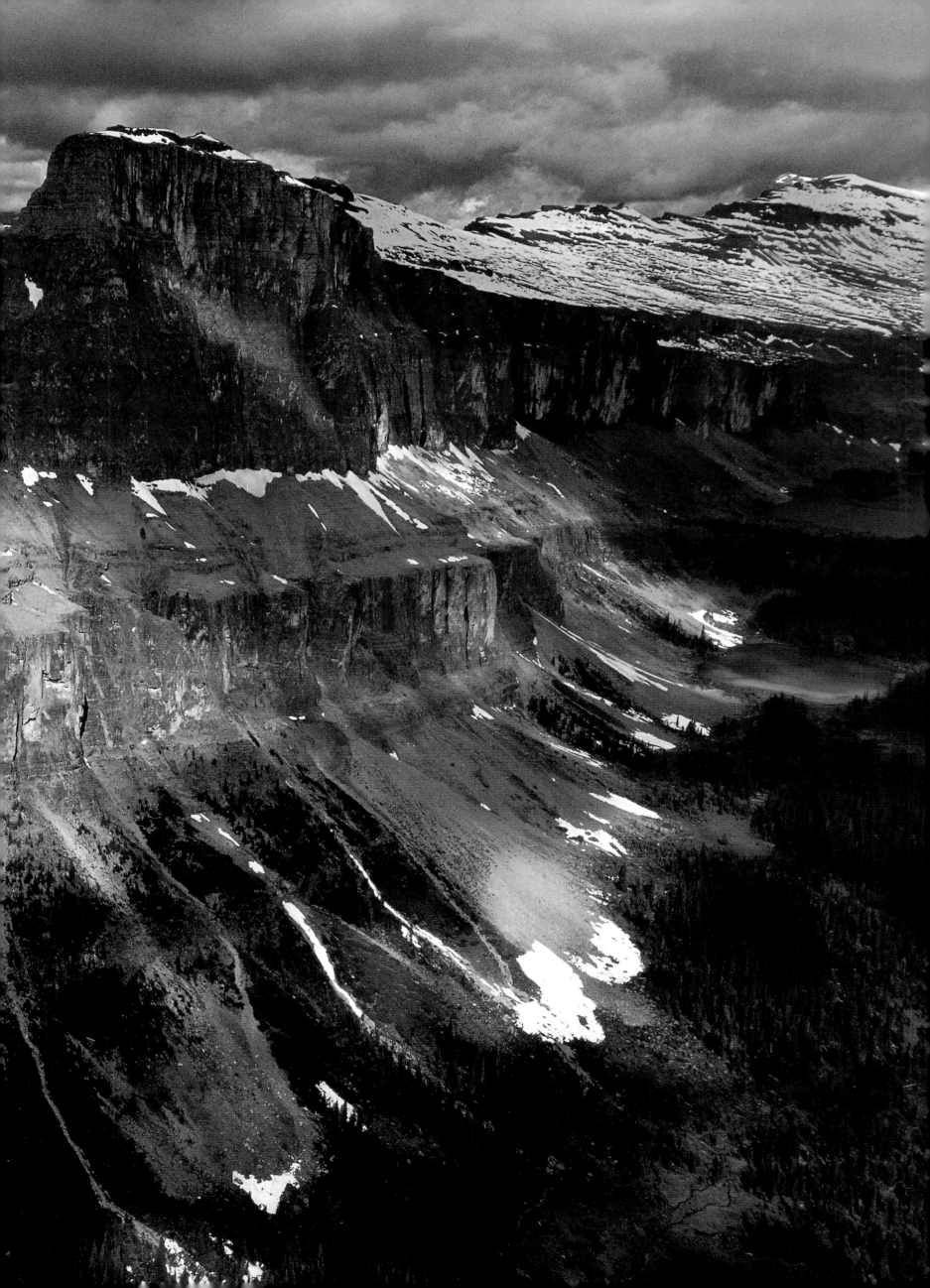

previous pages:

Castle Mountain's eastern face is a perspective rarely seen by travellers in the Alberta Rockies. The mountain, an imposing landmark in Banff National Park, is most commonly viewed from Highways 1 and 1A, seen in the background here following opposite sides of the Bow River.
RUSS HEINL

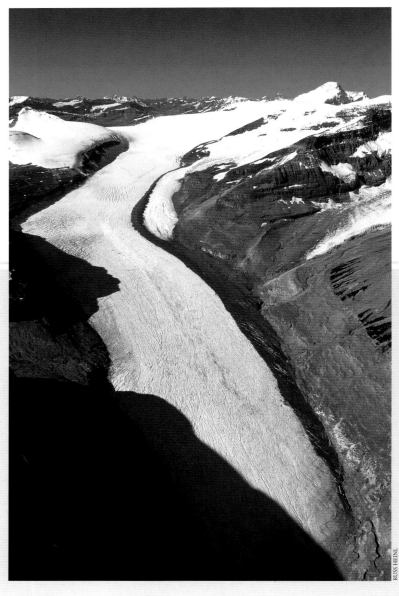

left:

On the British Columbia-Alberta border, the Columbia Icefield is the largest in a string of icefields straddling the Continental Divide.

RUSS HEINL

COLUMBIA ICEFIELD
Great Canadian headwaters

It's from the Columbia Icefield — Canada's "Mother of Rivers" — that oceans on three sides of the nation get that Rocky Mountain flavour.

The Columbia is the largest in a string of more than a dozen icefields straddling the Continental Divide through Jasper and Banff national parks. A remnant from the great ice sheets that once covered most of Canada, it is now reduced to 325 square kilometres. Deeper than 300 metres in places, it is a massive collection of glaciers at the hydrographic apex of the country.

Meltwater trickling off the toe of the Saskatchewan Glacier eventually passes through Edmonton via the North Saskatchewan River. It continues over the Prairies and beyond Prince Albert, then merges with the South Saskatchewan, already swelled by the waters of Alberta's Oldman, Bow, and Red Deer rivers. The runoff from nearly 270,000 square kilometres of land is dropped by the Saskatchewan River into Cedar Lake, which flows through Lake Winnipeg and out the Nelson River into Hudson Bay.

Just north of the Saskatchewan River's headwaters, the Athabasca Glacier is the start of a 1,230-kilometre northern run for the Athabasca River. It flows through Fort McMurray and the Alberta Tar Sands into Wood Buffalo National Park, where it adds water from a drainage basin of 95,000 square kilometres to the Mackenzie River system, which pours across the Arctic tundra into the Beaufort Sea.

West of the Great Divide, the Columbia Icefield is the birthplace of the Columbia River. It fills the southern reaches of the Rocky Mountain Trench, and drains more than 100,000 square kilometres of southeastern British Columbia before it arrives at the Pacific Ocean on the Oregon coast.

Since 1948, "snowcoaches" have carried tourists over the frozen surface of these great Canadian headwaters. Some 250,000 people a year get a 45-minute glimpse of the Columbia Icefield, where some of our mightiest waterways cross paths before running separate courses into opposite ends of Canada.

166

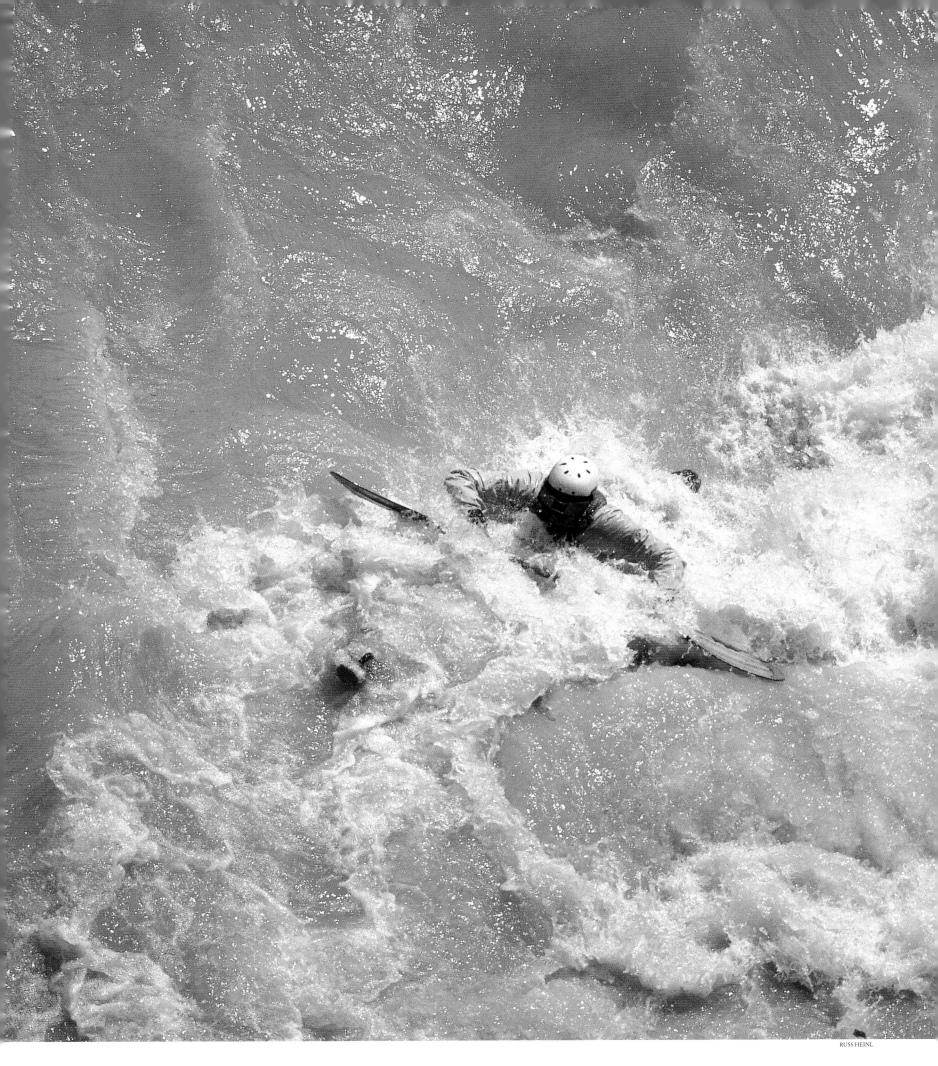

above:

*S*teep and rugged terrain makes the Kicking Horse River, in the British Columbia Rockies, a tempting challenge to whitewater kayakers. Kicking Horse Pass, near the head of the river, was equally daunting to early railway builders.

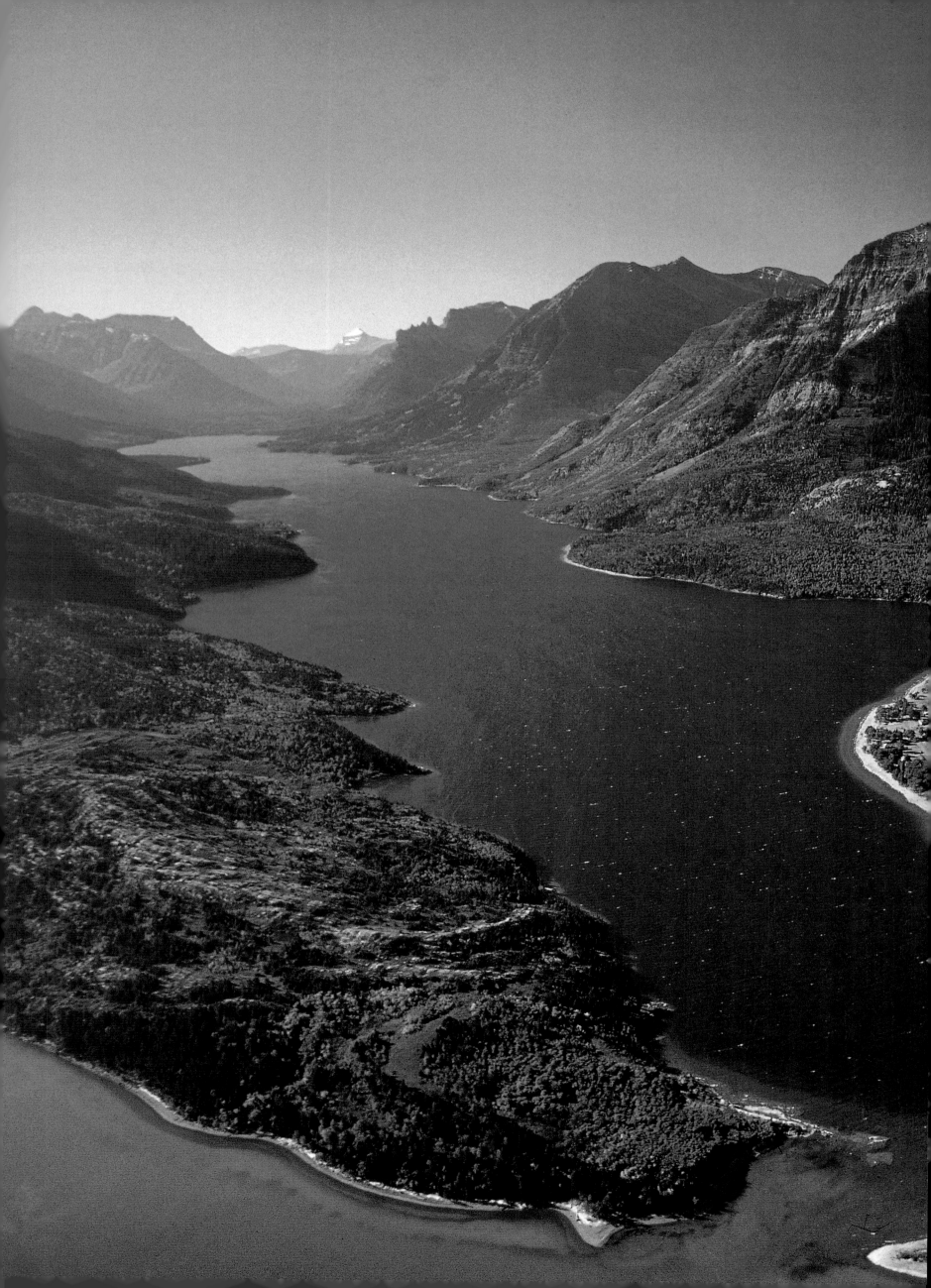

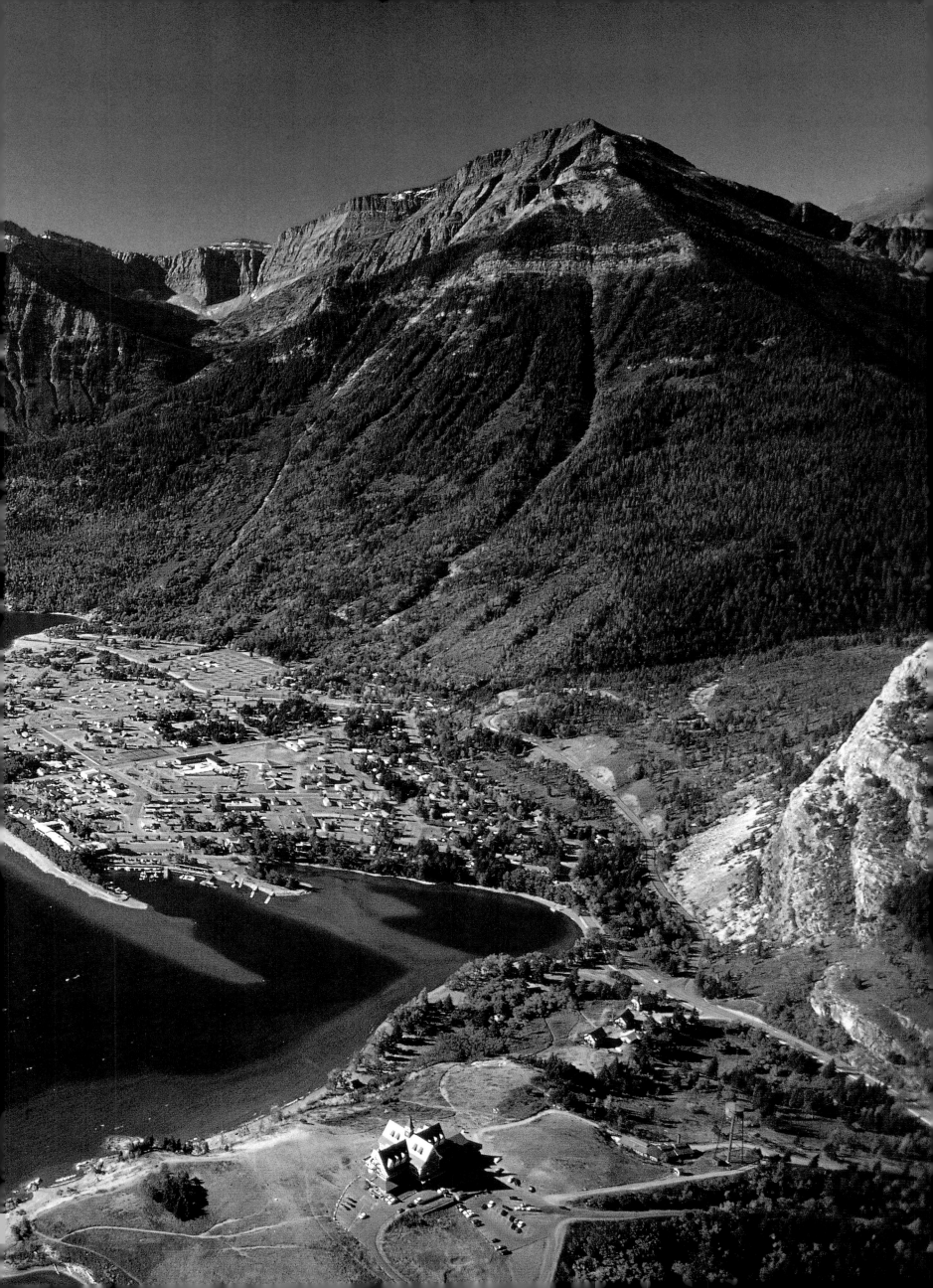

previous pages:

*U*pper and Middle Waterton lakes meet below the historic Prince of Wales Hotel in the southern Alberta Rockies. Opened in 1927 by the Great Northern Railway, the seven-storey inn overlooks Waterton townsite, in Waterton Lakes National Park. Established in 1895, it is one of Canada's smallest national parks at 525 square kilometres. RUSS HEINL

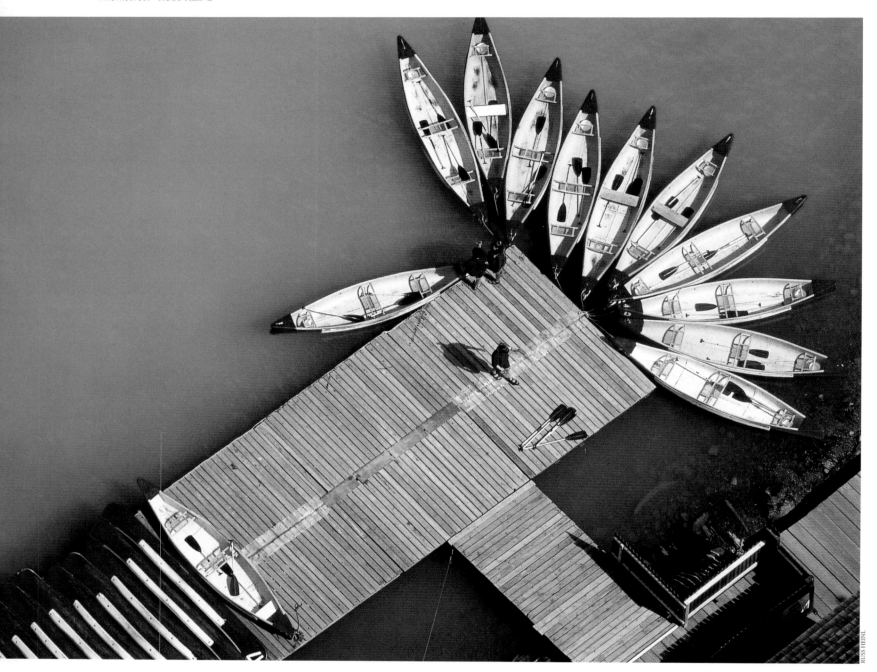

RUSS HEINL

above:

*C*anoes await Rocky Mountain paddlers at Lake Louise in Alberta's Banff National Park.

opposite:

*J*ust west of the Continental Divide, Mount Robson is the highest peak in the Canadian Rockies. At 3,954 metres, it dominates British Columbia's Mount Robson Provincial Park, established in 1913, the year the summit was first climbed. In 1990, Mount Robson Park was added to the Canadian Rocky Mountain Parks World Heritage Site. RUSS HEINL

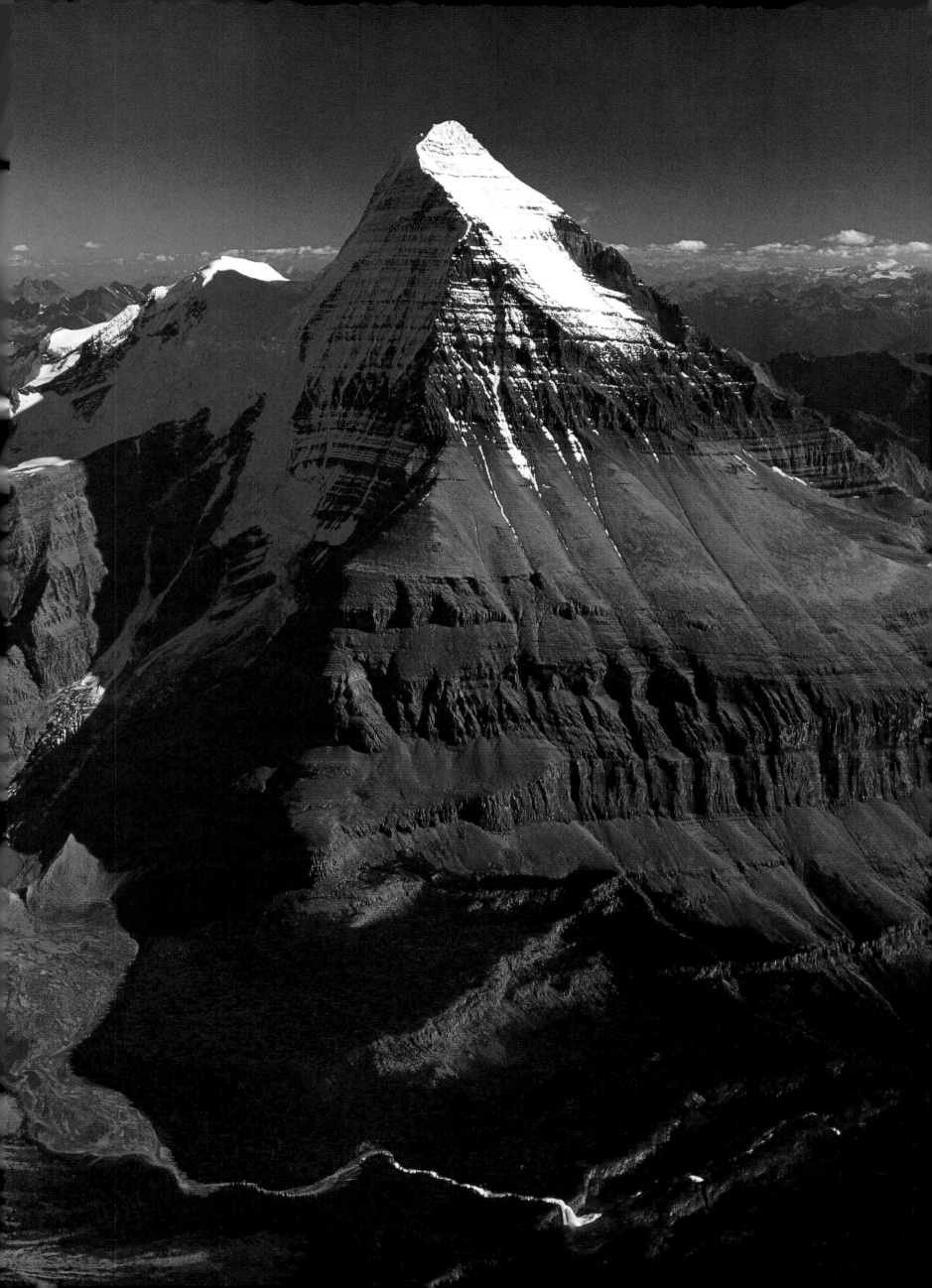

ON LOCATION

Volcanoes of the West

The volcanic landscapes of northwestern British Columbia form a desolate, inhospitable scene as eerie as the badlands of Alberta. "It looks prehistoric," says photographer Russ Heinl, "as if something at one time was going on there and it essentially burned itself out."

In Mount Edziza Provincial Park, Heinl flew into the defunct crater of Eve Cone, the newest of several cinder cones that have popped up through the Tahltan Highland in the last four million years. It erupted just 1,300 years ago, leaving a monumental pile of crumbling black rock.

South of Eve Cone, the underlying layers of multicoloured lava lend hues of yellow, white, purple, and ochre to the Spectrum Range. Rivers appear as sinuous coloured stains on the land. "There's no sign of life," says Heinl, "and I couldn't imagine anything living there."

Western Canada sits on the "Ring of Fire," a seismically restless zone that girdles the Pacific Ocean. It is within this ominous circle that some of the most disastrous eruptions, earthquakes, and tsunamis have happened.

About 400 years ago, 2,000 natives were killed by molten lava that buried two villages in the Nass River valley, south of the Spectrum Range. In the late 1800s, Canada's most recent eruption occurred when magma spewed from an open vent in the remote Unuk River system, north of the Nass. It tumbled over granite cliffs and into the Alaska Panhandle, filling 20 kilometres of riverbed. And only two decades ago, Vancouver Islanders heard the explosion 250 kilometres away, when Mount St. Helen's blew in Washington State. That active volcano system arcs through the Cascade Mountains into southern B.C.'s Coast Ranges near Vancouver.

All of B.C.'s 140 volcanoes are considered extinct now, but eruptions as close and devastating as Mount St. Helen's make one wonder for how long.

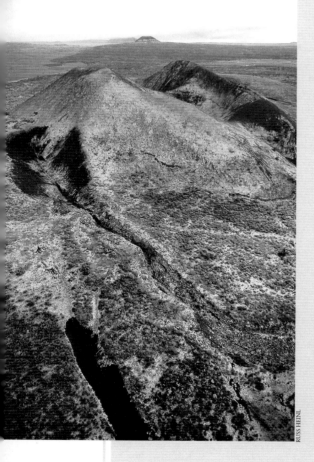

RUSS HEINL

above:

The volcanic landscapes of northern British Columbia dominate Mount Edziza Provincial Park. Eve Cone, in the distant background, is the park's newest volcano.

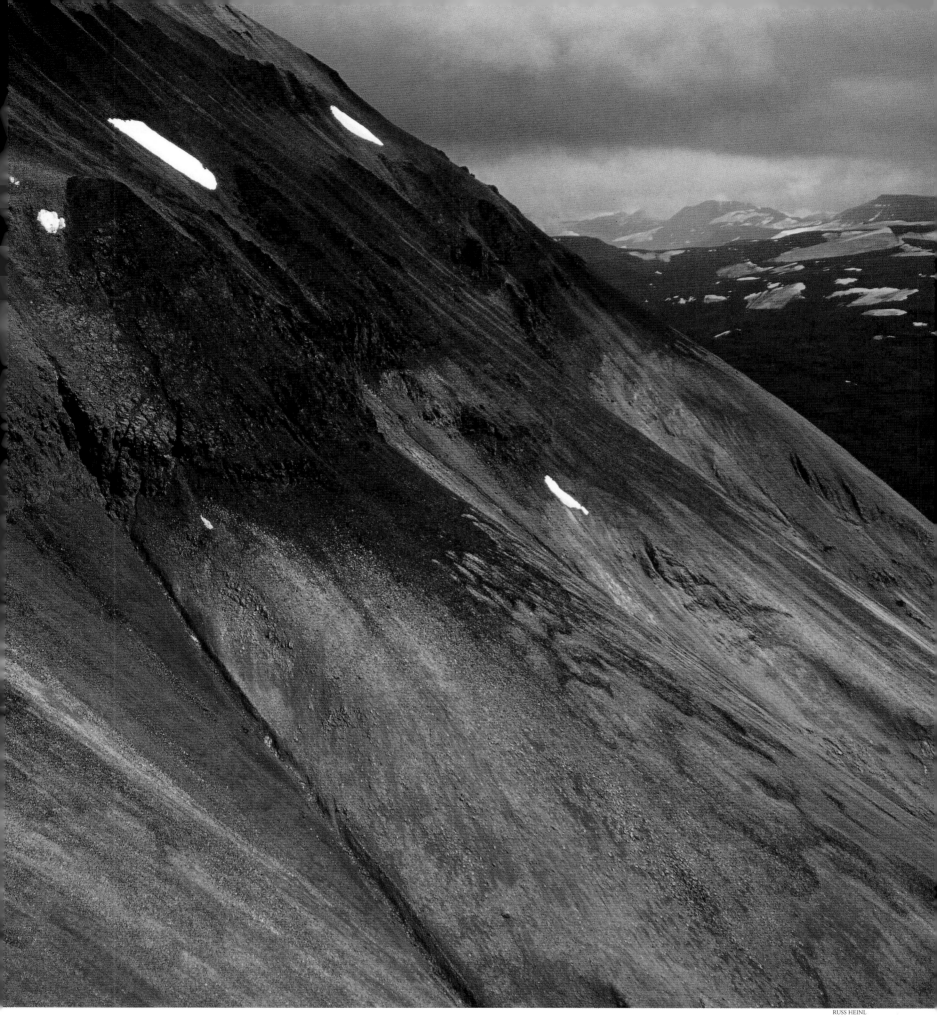

RUSS HEINL

above:

The unusual hues of the Spectrum Range, in Mount Edziza Provincial Park, are caused by layers of multicoloured lava.

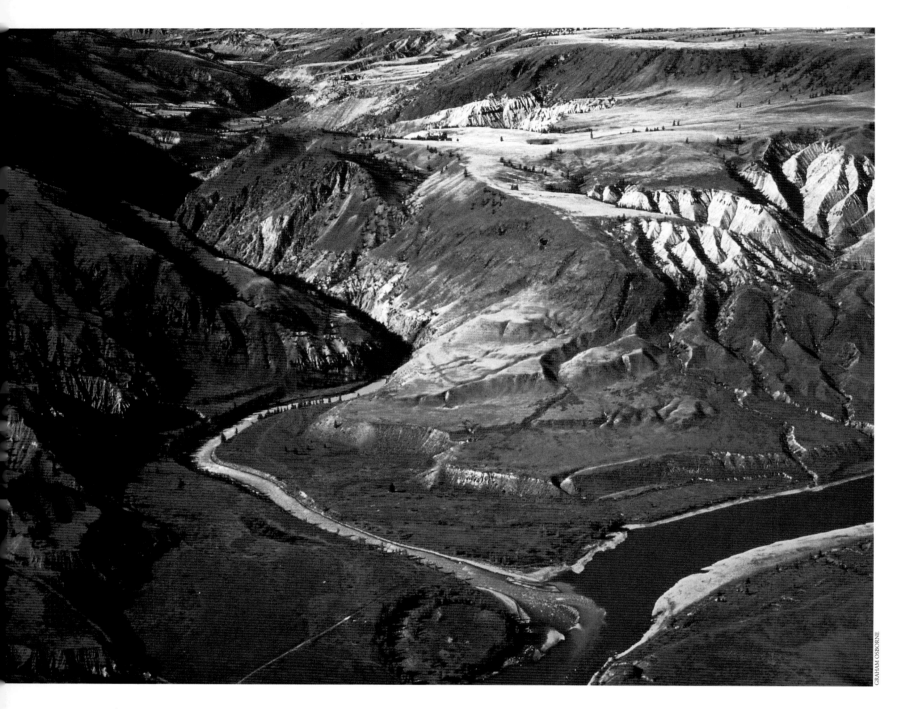

GRAHAM OSBORNE

above:

*T*he ice-blue waters of the
Chilcotin River are absorbed by the
Fraser, British Columbia's largest
river, in the arid hills of the Interior
Plateau.

opposite:

*G*laciers that feed the
Tatshenshini-Alsek watershed of
northwestern British Columbia form
the largest non-polar icecap on
Earth. The 9,580-square-kilometre
Tatshenshini-Alsek Wilderness
Provincial Park established here in
1993 is part of a World Heritage
Site that includes neighbouring
Kluane National Park in Yukon,
and Alaska's Wrangell-St. Elias
and Glacier Bay national parks.
RUSS HEINL

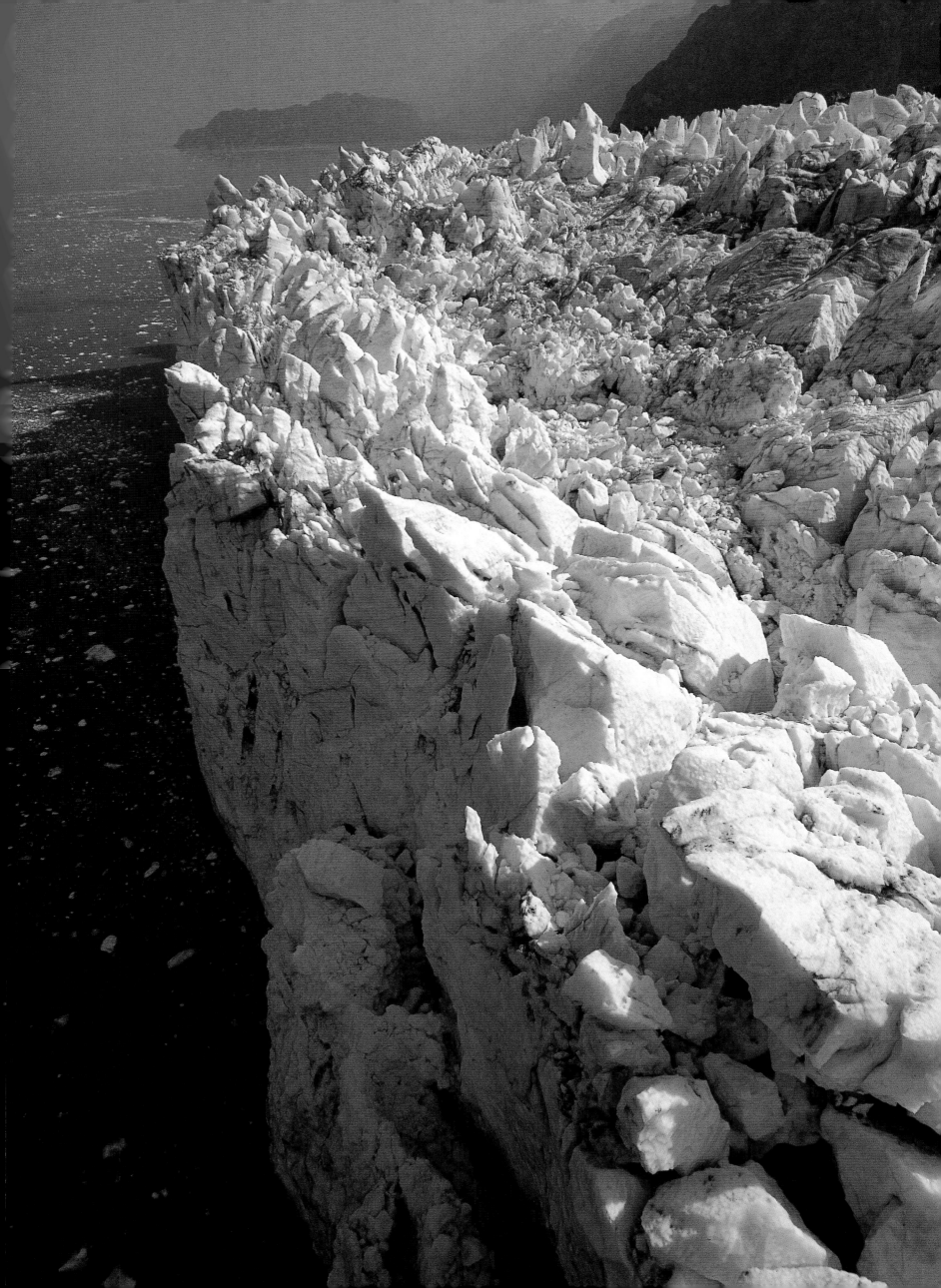

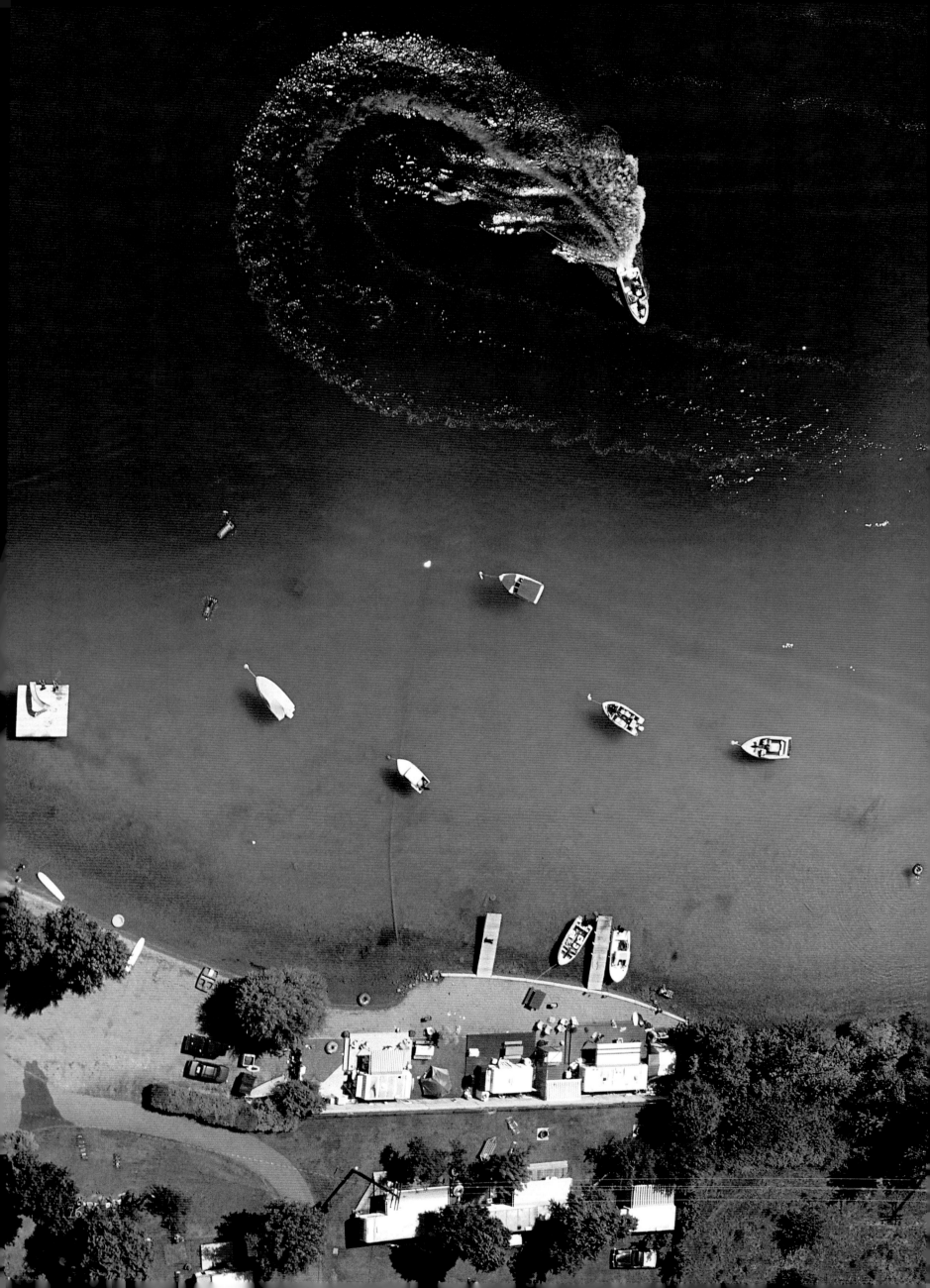

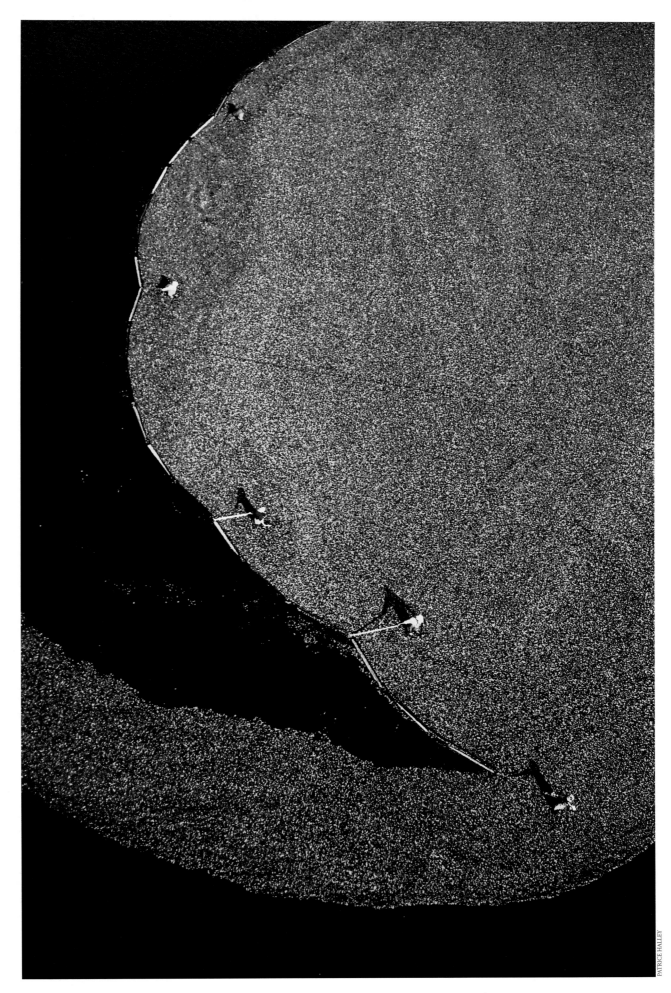

PATRICE HALLEY

above:

*C*ranberries, or "bog rubies," are harvested in the Fraser Valley and elsewhere in southwestern British Columbia. The Pacific province grows 80 percent of Canada's cranberries and is the third-largest producer in the world.

opposite:

*K*alamalka, known as the "Lake of a Thousand Colours," is a prime area for summer recreation in British Columbia's Okanagan Valley. AL HARVEY

177

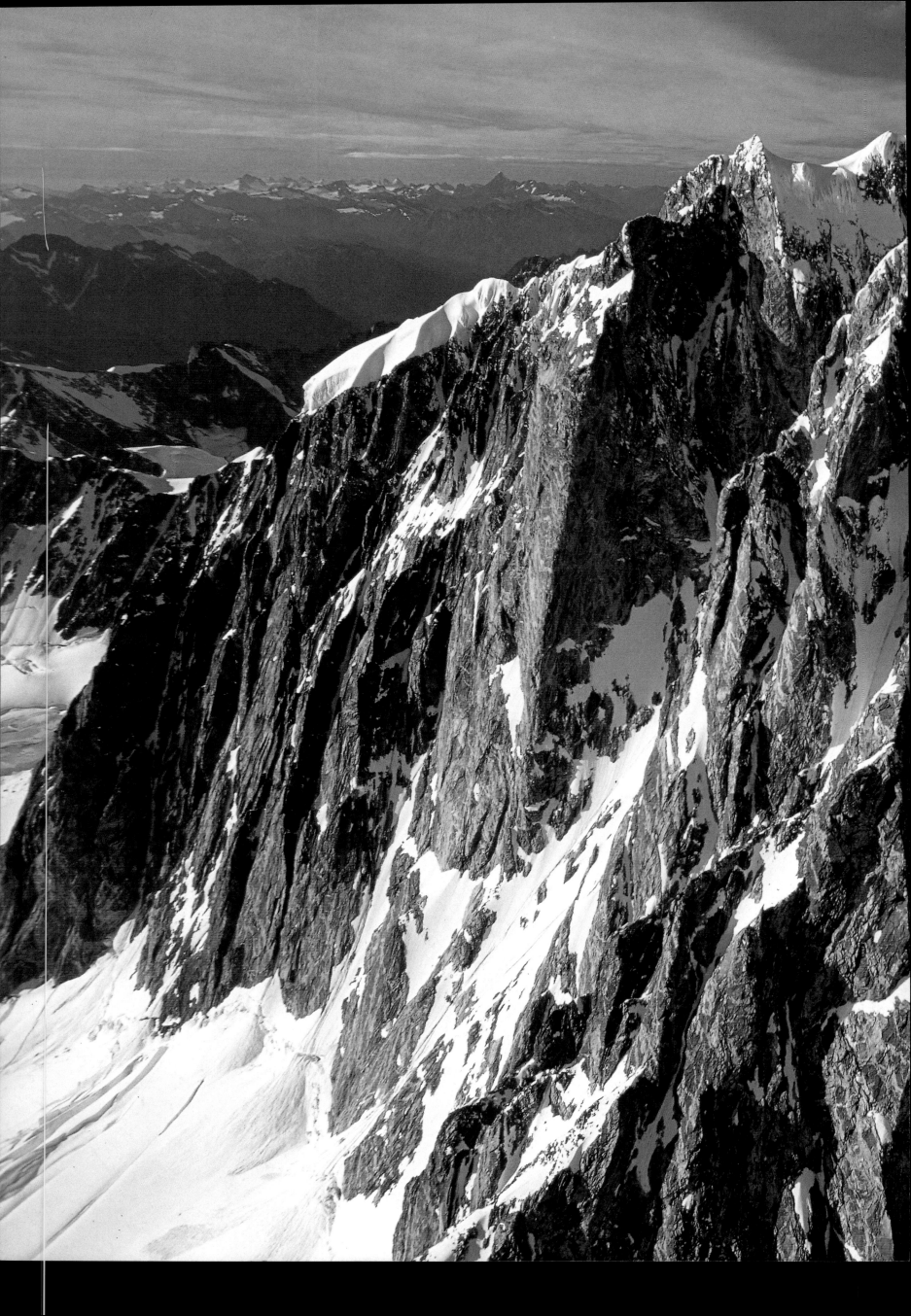

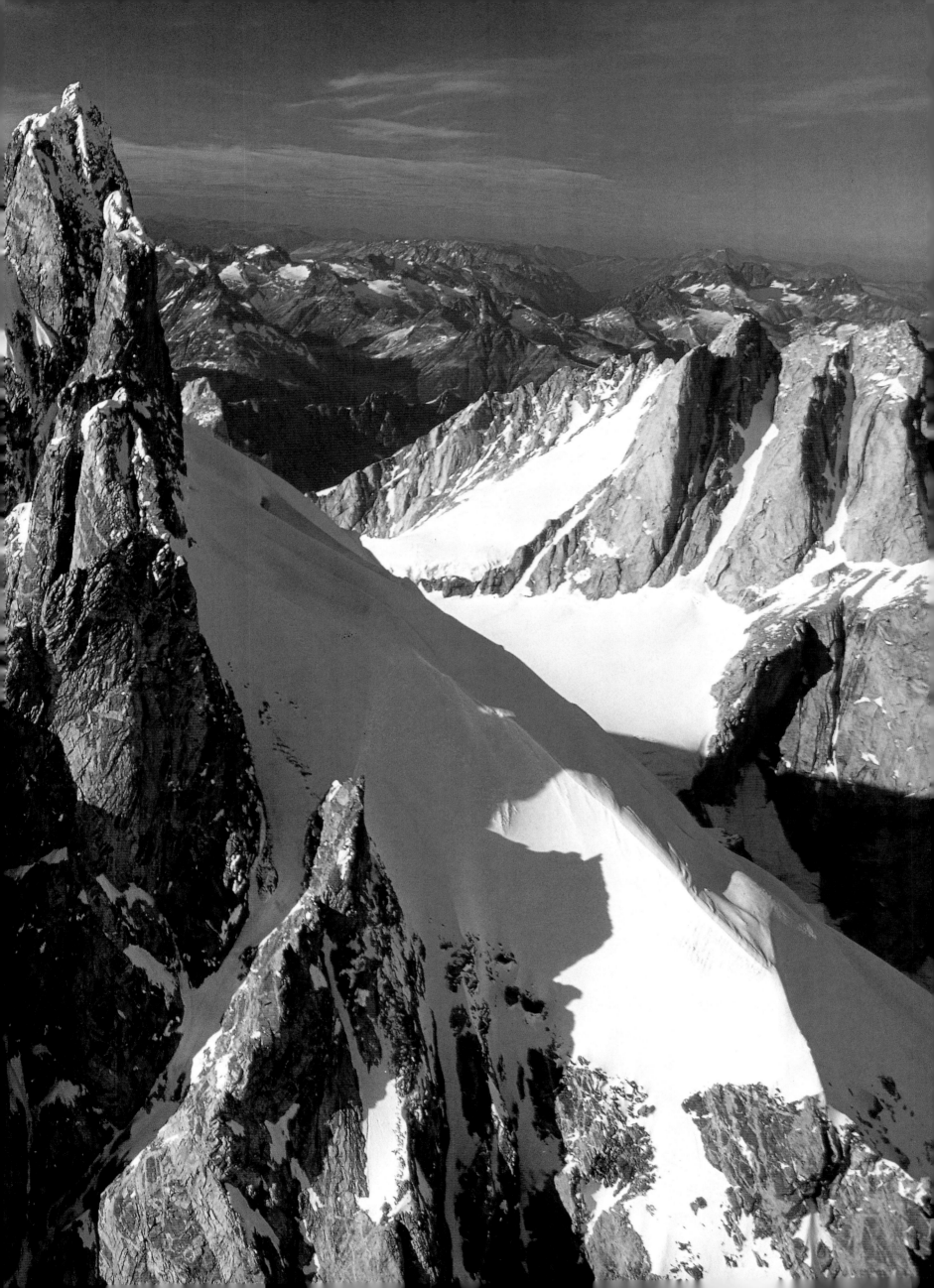

previous pages:

Reaching 4,016 metres, Mount Waddington is the highest peak entirely within British Columbia. Its granite spires tower over the heads of Bute and Knight inlets in the southern Coast Mountains. One of Canada's most challenging climbs, Waddington's pyramidal peak was first ascended in 1936. RUSS HEINL

left:

A cargo ship is guided into Vancouver Harbour, British Columbia, under a passing floatplane. This is Canada's busiest seaport, handling more than 70 million tonnes of cargo some years.

opposite:

A 16-millimetre fisheye lens compresses downtown Vancouver into a single frame. In the foreground, beyond the photographer's feet, a bridge across False Creek leads to the 60,000-seat B.C. Place stadium, nicknamed the "Giant Pincushion." Vancouver's Stanley Park, a wooded 405-hectare peninsula on Burrard Inlet, appears between the city buildings and the North Shore mountains in the background. RUSS HEINL

GORDON J. FISHER/IMAGE NETWORK

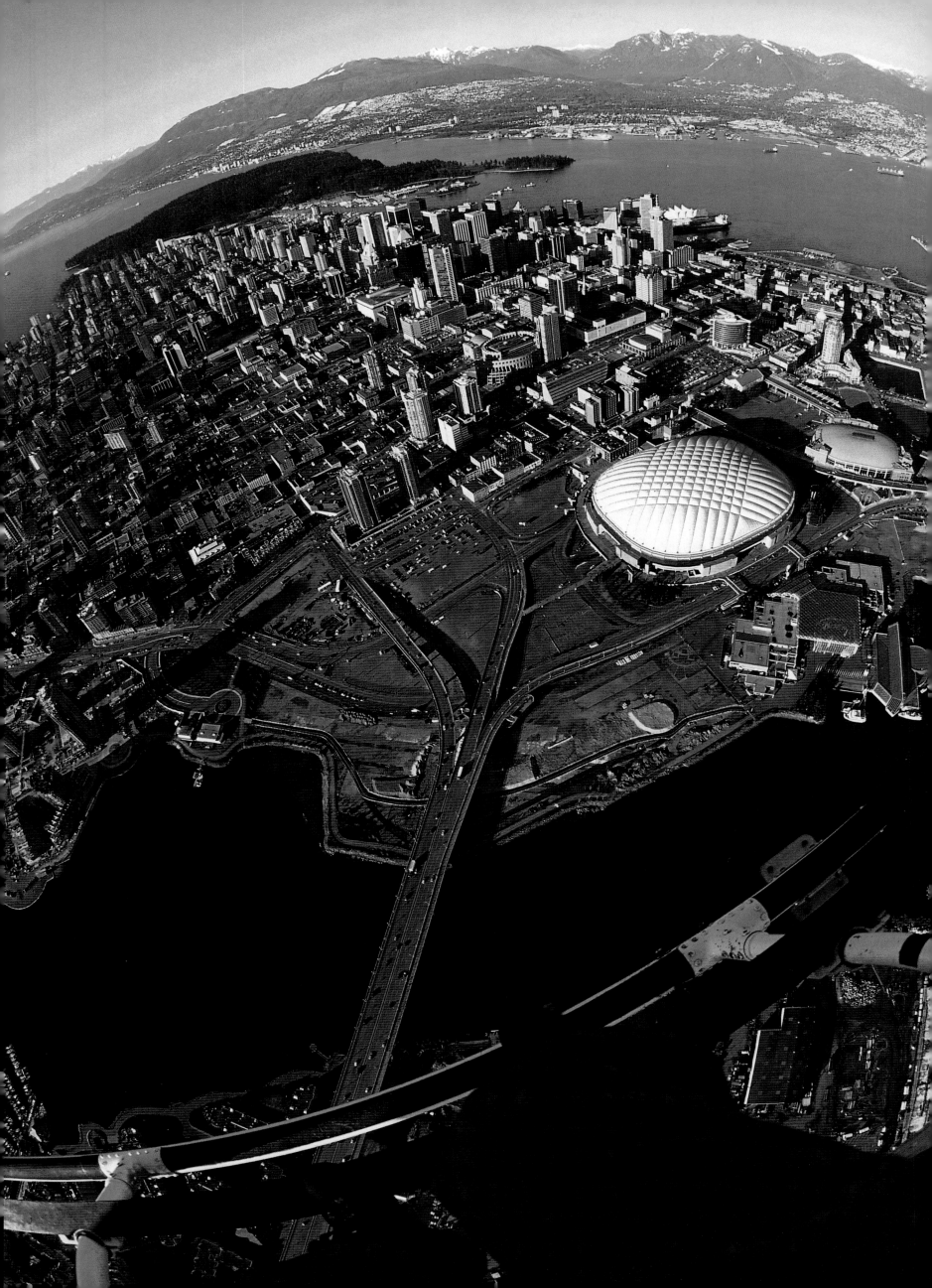

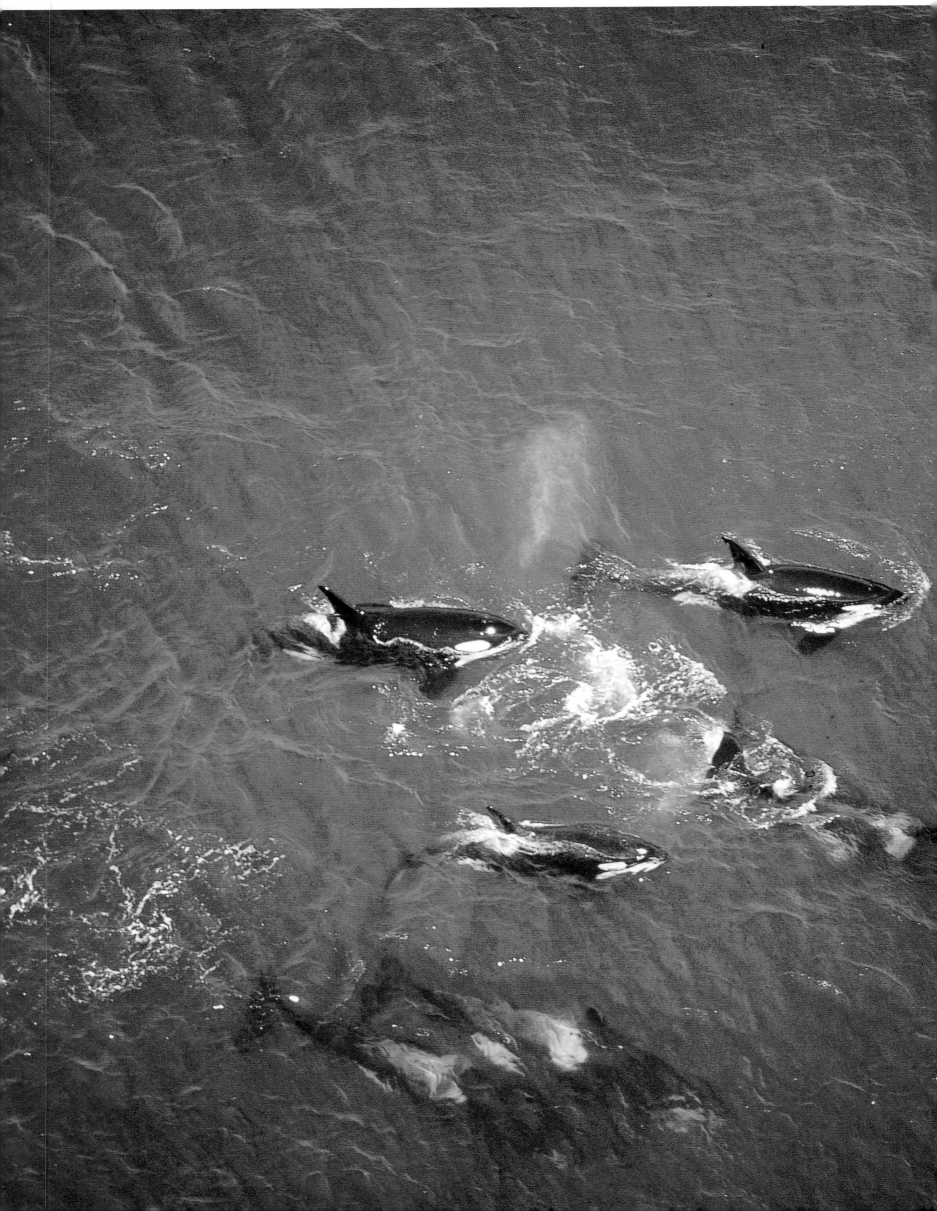

KILLER WHALES
Prime prey for nature cruisers

From the air you can see the orcas underwater, fluid blurs of black and white tinted by the green of the sea. They linger in the murky depths between darkness and sunlight, and the outlines of their flukes and dorsal fins sharpen as they surface to breathe. Plumes of mist explode from their blowholes, but the sound is lost in the whir of the helicopter blades. It's like watching a video without the audio — impressive visually, but half the sensation is missing.

Getting closer to killer whales, close enough to hear those explosive chuffs, is a multimillion-dollar industry on the Pacific coast. By simply coming up for air, orcas entice a stream of summer tourists into an ever-growing fleet of whale-watching boats running from both sides of the B.C.-Washington border. With kayakers, yachters, even cruise liners increasing the traffic, free-roaming orcas sometimes find themselves swimming in the midst of 100 boats.

Though West Coast killer whales may number fewer than 1,000, they have become a symbol of the Pacific Northwest. They breach month-by-month on innumerable kitchen calendars, grace the pages of books and magazines, and are featured in posters, company logos, and brochures.

They are undoubtedly the most followed, photographed, and studied marine mammals on Earth, unwitting subjects of ongoing research that began with a census in the early 1970s. Through photographs and recordings of their unique calls, more than 700 individual killer whales and three distinct West Coast races have been identified.

The densest populations of *Orcinus orca* roam between California and Alaska. Others make rare appearances in the Beaufort Sea and Gulf of St. Lawrence, and small numbers are known to hunt open waters in the eastern Arctic during summer.

left:

*K*iller whales hunt the waters of Haro Strait, between Vancouver Island, British Columbia, and the San Juan Islands of Washington State.

GARY GREEN

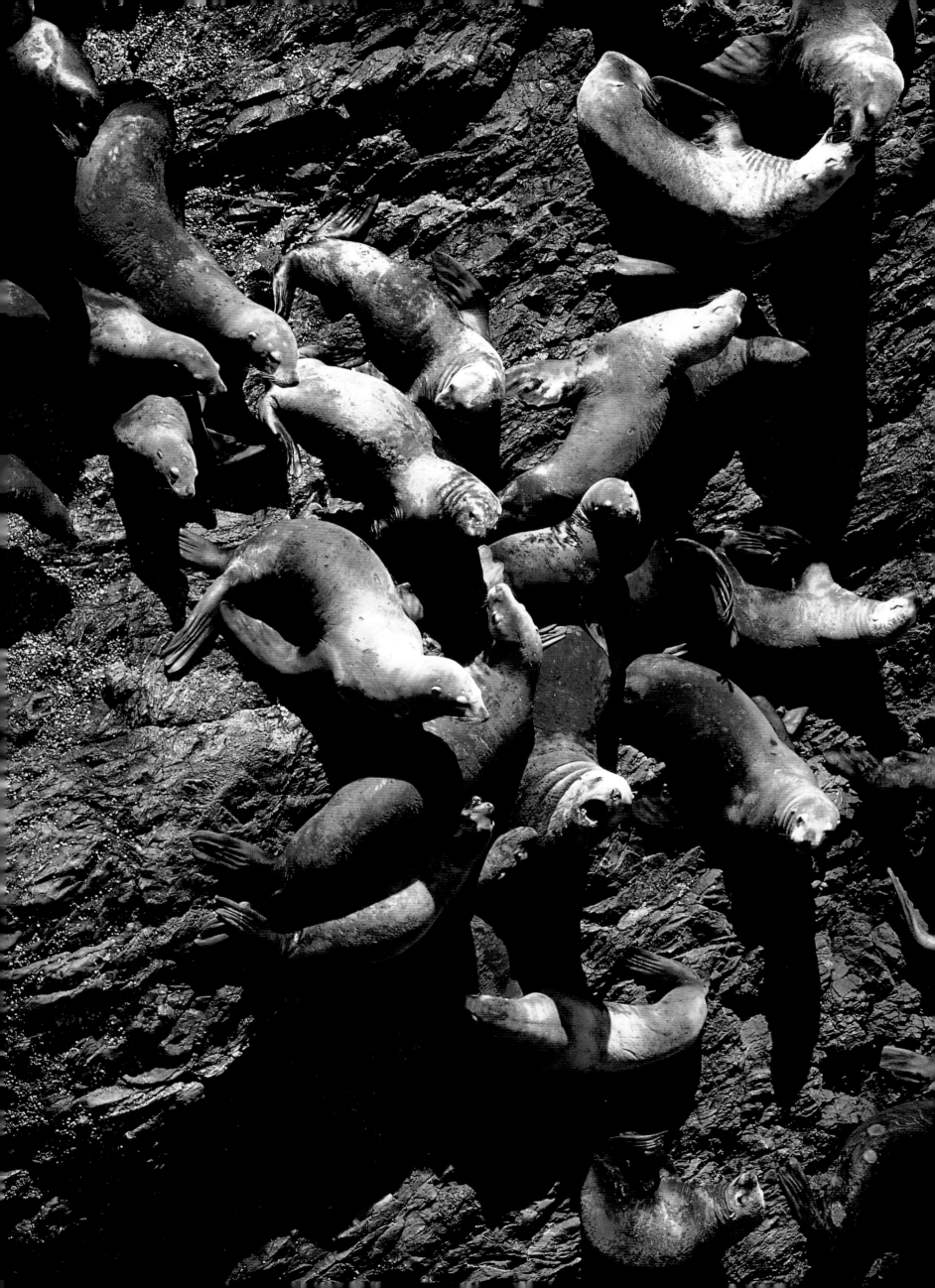

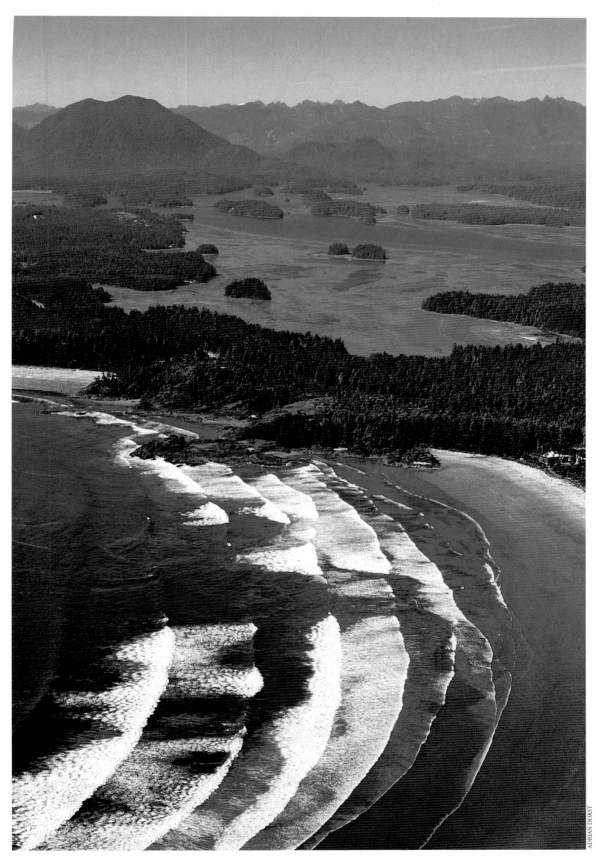

ADRIAN DORST

left:

*T*he surf-swept shores of Cox Bay, just outside Pacific Rim National Park on Vancouver Island, British Columbia, are separated from the more placid waters of Clayoquot Sound by Esowista Peninsula. The park itself, dedicated in 1970, preserves 850 square kilometres of wild coastline terrain.

following pages:
Isolated and largely wild, the Queen Charlotte Islands lie 100 kilometres off British Columbia's northern mainland coast. Ancestral domain of the Haida Nation, Haida Gwaii — their original name for the Charlottes — is inhabited by about 1,200 natives and 4,000 other islanders. The ancient village of Ninstints, on Anthony Island at the archipelago's southern end, is a World Heritage Site within 1,470-square-kilometre Gwaii Haanas National Park Reserve. RUSS HEINL

opposite:

*S*ince their protection in 1970, Steller's sea lion populations have climbed to about 12,000 on Canada's Pacific Coast. Some of their rocky haulouts are shared with 3,000 California sea lions that migrate up to Canadian seas for the winter. RUSS HEINL

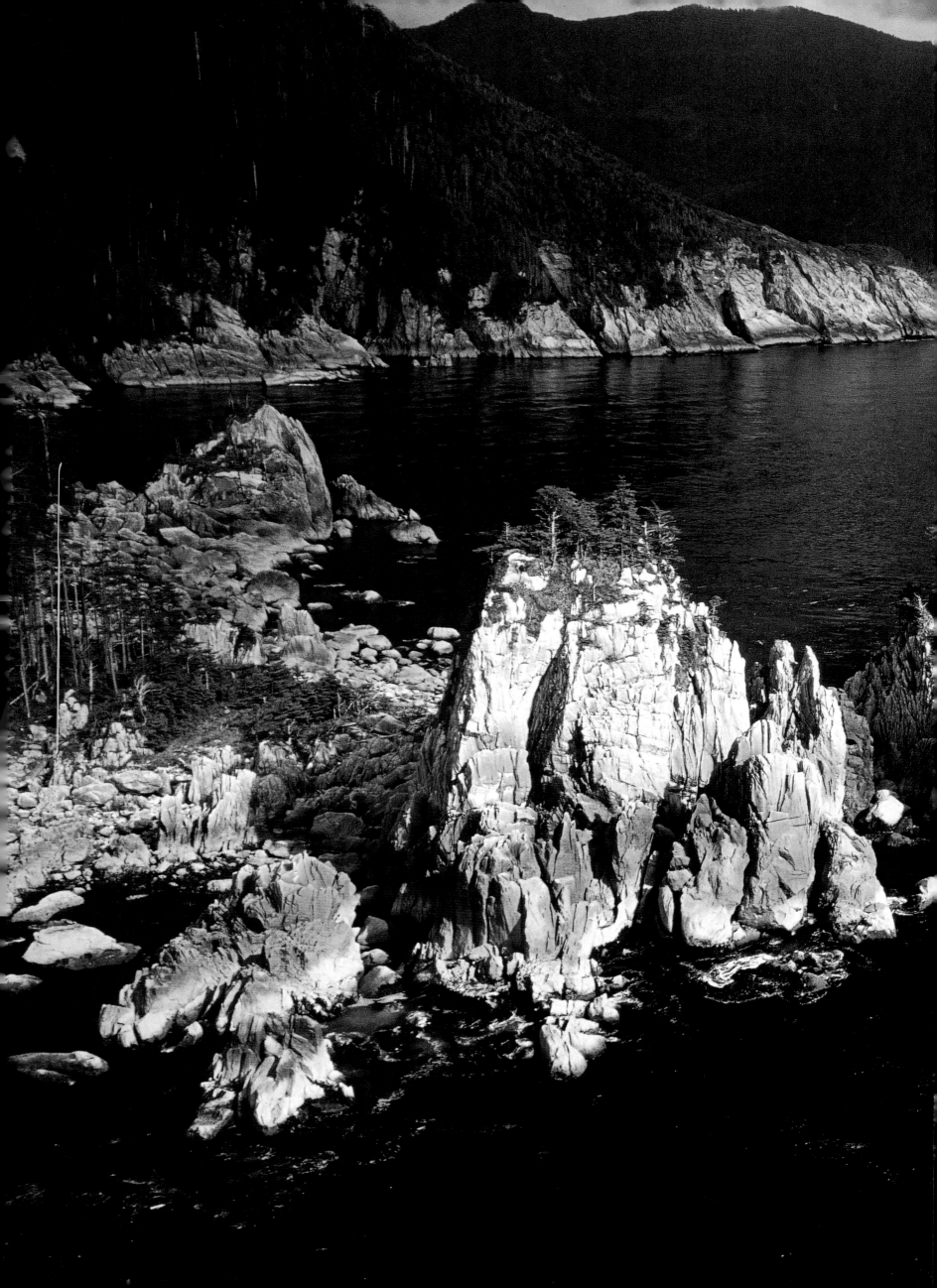

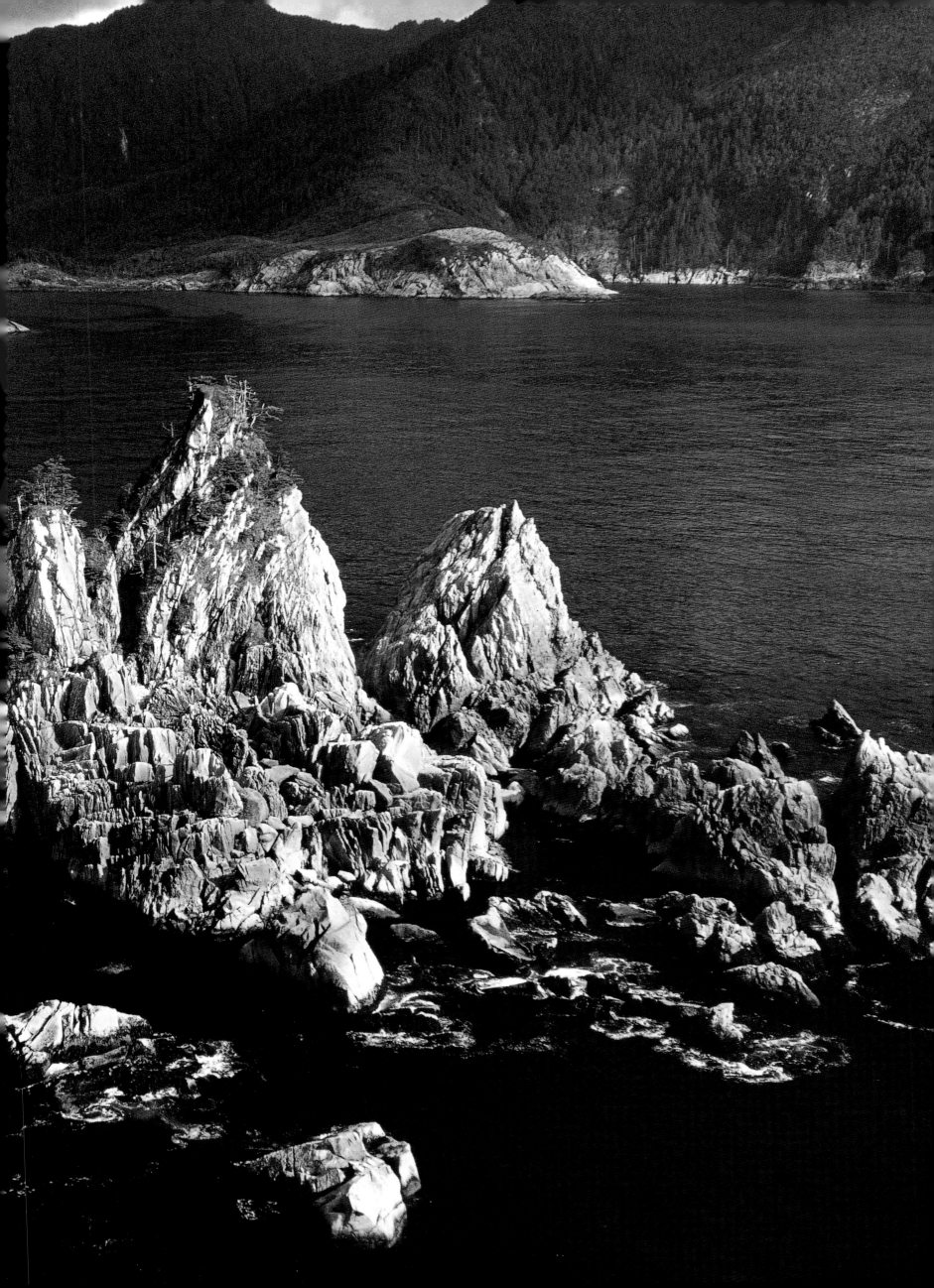

BEHIND THE SCENES

Cameraman Marc Pingry shoots from the Over Canada helicopter in New Brunswick.

Portraying the world's second-largest country in a book of 192 pages was a daunting assignment, even for a seasoned aerial adventurer like Russ Heinl. He'd been principal photographer in 1996 for *Over Beautiful British Columbia*, and had produced five other books of aerial photography, but none had covered an area so vast and changeable. Plagued by Atlantic fog, Prairie hail, and West Coast winds, Heinl continuously rearranged his shooting strategies to suit the weather.

"*Over Canada* was the most demanding, most logistically difficult project," says Heinl, who began with a spring shoot in Toronto, where he'd lived his first 40 years. Then he was up to Newfoundland, down through the Maritimes, and soon into a summer of Canada coast-to-coast.

From Yarmouth, Nova Scotia, to Neville, Saskatchewan, from Lake Louise to Vancouver, thousands of curious, and sometimes skeptical, Canadians looked up with wonder at the photographer leaning out an open door of a helicopter, his feet planted outside on the skids. "I'm actually afraid of heights," Heinl admits. "I can't walk across a trestle, or look over the edge of a skyscraper. But I'm comfortable hanging out of a chopper as long as my harness is fine."

With his camera mounted on a hand-held gyrostabilizer to minimize vibration, he shoots at shutter speeds as slow as one-fifteenth of a second. His autofocus lenses vary from a 16-millimetre fisheye to a 300-millimetre telephoto that can be doubled to 600. With the exception of night shots, taken on Fuji Provia 400 ISO film, all of Heinl's *Over Canada* images are shot on Fuji Velvia 50 ISO film.

When he returned to his Vancouver Island home in autumn, Heinl had logged 400 helicopter hours and flown 50,000 kilometres. He'd worn out two Nikon F4 cameras, replaced them with F5s, and shot 2,500 rolls of film — 90,000 pictures.

While Heinl covered specific targets on the *Over Canada* shot list, other photographers were asked to contribute their best and most recent aerial images. Nearly 100 photographers submitted 8,000 pictures, which were viewed alongside 17,000 provided by Heinl. The resulting *Over Canada* portfolio is the work of 32 photographers.

Zigzagging above the country, Heinl occasionally crossed paths with the *Over Canada* film team. As photographs were being assembled for the book, a one-hour high-definition video and television special was in the making, with funding from Royal Bank Financial Group. Following a similar target list over a two-year shooting schedule, the film crew spent more than 500 hours aloft. They travelled 80,000 kilometres and shot more than 200 hours of high-definition film.

"There's so much incredible material — places you'd never believe were in Canada — it's heartbreaking to cut it down to one hour," says Gary McCartie, the project's producer and creative director. "Yet I think the film does represent the country. There's enough that you get a real feeling for Canada."

McCartie co-ordinated the shoots from the ground while cameraman Marc Pingry flew with Robert Brunelle, a high-definition TV engineer, in a Eurocopter AS 355 F-1 Twinstar. Operated by Vancouver Helicopters, a division of Helijet Airways, the twin-engined helicopter was the official *Over Canada* aircraft, painted the conspicuous maple-leaf red and white of a Canadian flag.

"The project was a natural fit for us," explains Daniel Sitnam, president and CEO of Helijet Airways Inc., *Over Canada*'s aviation partner. The company had been handling much of Vancouver's aerial film, video, and photography work, and the Twinstar was already in its fleet. Cruising at a comfortable 200 kilometres an hour, it has a range of more than 660 kilometres. Its open-cabin design provides broad views, allowing the cameraman and engineer to work closely with the pilot.

Besides good business, Sitnam adds, "it's a feel-good project. As a Canadian company, it's great to be participating in something like this."

At the controls of the Twinstar was Jim Filippone, of Allstar Aerial Services, a veteran pilot who specializes in aerial photography work. "You have to be fairly flexible with the aircraft, and to know what the cameraman wants, what he's looking at," Filippone notes. "Even with stabilizers, Marc uses wide lenses to alleviate vibration. So for anything to look big the aircraft has to be super-close."

Filippone would categorize the Niagara Falls air-to-air shoot with dual helicopters as super-close. "Not everyone gets the opportunity to fly along the lip of Niagara Falls about 10 feet off the edge," he grins. "It's pretty amazing."

Entitled Royal Bank's *Over Canada*, the television special features music by Canadian composers, and script and sound track by Emmy winner David Hoole. The program is to be aired in Canada by CTV and the French-Canadian network, TVA, and in the U.S. by KCTS, Seattle, Washington, as well as other Public Broadcasting Stations.

The ROYAL BANK FINANCIAL GROUP

Millennium Tribute

Over Canada is a cross-country venture that has captured the hearts and imaginations of Canadians. The Royal Bank Financial Group has taken a lead role in helping to make this once-in-a-lifetime millennium project a reality.

Over Canada reflects a vision of the future combined with regional and national interest – qualities that reflect the Royal Bank's own philosophy, its regional roots, and national heritage. As one of Canada's most prominent financial institutions, the Royal Bank Financial Group serves 10 million customers nationwide and, by providing funding for the project, it is supporting a tribute to all Canadians – a legacy for generations to come.

NATIONAL POST

We wish to acknowledge the significant contribution of the *National Post* to the success of the Over Canada project. As Canada's first truly national newspaper, the *National Post* shares the values expressed in these extraordinary photographs and evocative words celebrating our nation. Our mutual goal is to speak to all regions of Canada, from all regions of Canada, with a strong and optimistic sense of patriotism.

THE FILM

A co-production of Beautiful British Columbia and Over Canada Productions Inc., divisions of The Jim Pattison Group of Vancouver, B.C., and Gary McCartie Productions, and KCTS Television.

Executive Producers:	ROBERT HUNT, GARY MCCARTIE, WALTER PARSONS
Creative Director:	GARY MCCARTIE
Director of Photography:	MARC PINGRY
High-Definition Engineer:	ROBERT BRUNELLE
Helicopter Pilot:	JIM FILIPPONE
Sound Design:	DAVID HOOLE
Associate Producer:	JEFF GENTES
Assistant to the Producer:	COLIN MCCARTIE
Field Production Manager:	ALICE IKEDA
Film Project Manager:	MARGARET MCCARTIE
Production Co-Ordinator:	TRUDY WOODCOCK
Editor:	DEANE BENNETT
Music Score:	TERRY FREWER
Music Supervision:	S. L. FELDMAN & ASSOCIATES
Presenting Sponsor:	ROYAL BANK FINANCIAL GROUP
Partners:	HELIJET AIRWAYS INC. CTV TELEVISION INC. GROUPE TVA, INC.

INDEX

Photographs in italics

following page:

A solitary Roosevelt elk bull looks up from the forests of Vancouver Island, British Columbia.
GORDON J. FISHER / IMAGE NETWORK

back cover:
The Over Canada video helicopter hovers near the lip of Niagara Falls.
RUSS HEINL